By Arthur C. Danto

Philosophy

Analytical Philosophy of History
Nietzsche as Philosopher
Analytical Philosophy of Knowledge
What Philosophy Is
Analytical Philosophy of Action
Mysticism and Morality
Jean-Paul Sartre
The Transfiguration of the Commonplace
Narration and Knowledge
The Philosophical Disenfranchisement of Art
Connections to the World
Beyond the Brillo Box
The Body/Body Problem
Philosophizing Art
After the End of Art
The Abuse of Beauty

Art Criticism

The Madonna of the Future
Embodied Meanings
The State of the Art
Encounters and Reflections

Monographs on Art

397 Chairs (with photographs by Jennifer Levy)
Mark Tansey: Decisions and Revisions
Robert Mapplethorpe: Playing with the Edge
Saul Steinberg's The Discovery of America
Cindy Sherman's Untitled Film Still
Cindy Sherman's Untitled History Portraits

Unnatural Wonders

Unnatural Wonders

Essays from the Gap Between Art and Life

Arthur C. Danto

Farrar • Straus • Giroux New York

Farrar, Straus and Giroux
19 Union Square West, New York 10003

Distributed in Canada by Douglas & McIntyre Ltd.
Printed in the United States of America
First edition, 2005

Most of these essays were published in *The Nation*, and the author is grateful for the magazine's permission to have them published here. The essay on Robert Mangold appeared in *Robert Mangold: Curled Figure and Column Paintings* (New York: Pace Wildenstein, 2003), pp. 6–11. The essay on Jeff Koons appeared in *Astrup Fearnley Museet*, pp. 125–34. The essay on Joshua Neustein's *Light over Ashes* appeared in *Joshua Neustein: Light over Ashes*, Southeastern Center for Contemporary Art, 1961, and the essay on *Domestic Tranquility* appeared as an addendum in *Joshua Neustein: Five Ash Cities*, Herzliya Museum of Art, Herzliya, Israel, pp. 72–78. "*Kalliphobia* in Contemporary Art" appeared in *Art Journal* 63.2 (Summer 2004), pp. 25–35. "The World as Warehouse: Fluxus and Philosophy" appeared in *What's Fluxus? What's Not! Why.*, edited by Jon Hendricks (Rio de Janiero: Centro Cultural Banco do Brasil, 2002), pp. 23–32.

Library of Congress Cataloging-in-Publication Data
Danto, Arthur Coleman, 1924–
 Unnatural wonders : essays from the gap between art and life / Arthur C.
Danto.— 1st ed.
 p. cm.
 Includes index.
 ISBN-13: 978-0-374-28118-2
 ISBN-10: 0-374-28118-1 (hardcover : alk. paper)
 1. Art—Philosophy. I. Title.

N66.D26 2005
700'.1—dc22

 2004016794

Designed by Jonathan D. Lippincott

www.fsgbooks.com

10 9 8 7 6 5 4 3 2 1

For John E. Postley, M.D.,
in appreciation of his skill and his humanity

Contents

Preface

P ainting relates to both art and life," the artist Robert Rauschen-
berg said in 1961. "I try to act in that gap between the two." The
expression "the gap between art and life" was to become current
in the avant-garde discourse of the sixties, when boundaries of every
sort were coming under attack. "Overcoming the gap between art and
life" had at once the ring of a metaphysical battle cry—like closing the
gap between body and mind—and a political slogan promising to
abolish privilege. For Rauschenberg, however, it more or less meant
giving himself license to make art out of anything: "A pair of socks is
no less suitable to make a painting than wood, nails, turpentine, oil,
and fabric."

Earlier in the century, Guillaume Apollinaire, a poet and critic in
Picasso's circle, had written that "one may paint with whatever one
likes, with pipes, stamps, postcards, playing cards, candlesticks, bits of
oilcloth, collars, wall paper, daily papers." Apollinaire was speaking of
collage. With the exception of pipes and candlesticks, the items in his
inventory were flat and could be pasted into compositions without
greatly disturbing the flatness of their surfaces. Even if Picasso or
Georges Braque were to have added a real pipe or candlestick to a col-
lage, its placement would be constrained by pictorial imperatives: The
whole composition would in effect be a picture of a tabletop, the pipe
or candlestick placed where an image of it would make pictorial
sense, even if, as a by-product of Cubism, the forms would have been
broken up and rearranged. But Rauschenberg went far beyond picto-

rial limits. In *Monogram*, for example, he garlanded a stuffed angora goat with a used automobile tire around its stomach, creating a disturbing presence. In *Canyon*, a stuffed eagle, its wings spread, is affixed to the bottom edge of a paint-smeared canvas, as if poised to fly into the surrounding emptiness. In *Octave*, he brought a kind of homemade ladder from life into art by attaching it to the surface of what could have been exhibited as a painting a few years earlier, under Abstract Expressionist conventions. Rauschenberg invented the name "combines" for these unprecedented objects, which consisted, in part, of things that had their natural location in everyday life: tires, goats, eagles, ladders—each of them rich in metaphorical association. The combines, bringing life and art together the way monsters bridge the boundary between humans and animals, are good examples of unnatural wonders.

A work that particularly captured my attention was Rauschenberg's *Bed*. Its label reads, "Combine Painting: oil and graphite on fabric," which could hardly more eloquently proclaim the blindness to "life" of a museum registrar's perception of art, since the work consists of an actual bed—sheet, pillow, and quilt fitted into a narrow vertical frame. The upper part of the bed is scribbled over in pencil ("graphite"), and the bedclothes ("fabric") then thickly covered with dripping paint ("oil"). What engaged my interest was the fact that beds had served as a pivotal example in one of the most famous philosophical texts of all time, Book X of Plato's *Republic*—one of the earliest and certainly one of the most fateful writings on art. There can be few readers who have not read *The Republic*, but a brief description of Plato's argument may help explain why I found *Bed* so exciting as a work of art.

In Plato's scheme, beds are ranked into three types, with differing degrees of reality. To begin with, there are the familiar beds in which we spend a third of our lives and some of the moments that define us as human: we dream, make love, are born and die in the kinds of beds that belong to the world of everyday experience. Plato postulated another world, which contains what he designated "ideas," from which the things of everyday experience derive their forms. In Plato's philosophy, the idea of the Bed is eternal and inalterable: Every bed in the

world of daily experience must embody the same basic form, however beds may differ in detail. There are finally the beds that appear in works of art—in vase paintings, for example, picturing persons doing the kinds of things people do in bed. Now bed builders must grasp the idea of the Bed and make their products conform to it. They possess practical knowledge of how beds have to be built, in order to support the bodies of those who use them. But artists who want to paint pictures of beds merely know how beds appear. They don't really know anything about beds beyond how they look. Plato argued that pictures are of the same order as dreams, shadows, reflections, and illusions: not as real as the beds in bedrooms, far less real than the Idea of Bed in the realm of Ideas. Plato's metaphysics is essentially a put-down of artists, who are meant to be seen as inferior to carpenters and even more so to philosophers, whose sphere is the realm of ideas. His is a systematic effort to trivialize and marginalize art. *The Republic* is a philosophical masterpiece on which pretty much the whole of Western philosophy is based. It is a singular fact that the history of philosophy virtually begins with a text that is organized around the metaphysical suppression of works of art.

In 1964, I noticed that actual three-dimensional beds were beginning to make their appearance in or as works of art, Rauschenberg's *Bed* being a case in point. It was exactly as if the slogan "overcoming the gap between art and life" had taken on a philosophical meaning. I began to feel that the history of art had evolved to the point that Plato's distinction between the beds of art and the beds of life was no longer compelling. "Acting in the space between art and life" could be seen as an effort to reverse the philosophical disenfranchisement of art that was so central an item in Plato's agenda. That, I came to think, gave the art of our time an import far in excess of a mere fresh chapter in the history of art. In overcoming the gap between art and life, artists, it seemed to me, were engaged in dismantling a kind of metaphysical prison in which philosophers had sought to confine them since ancient times. Rauschenberg and his intrepid peers were not merely beginning a new era of art history—they were at the same time beginning a new era in the philosophy of art. Plato had tried to diminish art by treating it as no better than illusion. And really, by

confining painting to the making of pictures, artists had acquiesced in this assessment. Even with the invention of abstraction, art found itself struggling with the illusoriness of pictorial space. Perhaps it was with a sense of this that the critic Clement Greenberg decreed in 1960 that painting could achieve autonomy only by embracing absolute flatness. So recycling actual beds—or ladders, eagles, goats, and tires—as parts of actual works of art was an acknowledgment that art had to be redefined. And philosophers were going to have to begin all over in finding a definition of art. At the very least that definition would have to explain what made the difference between a bed that was a work of art and a bed that was an article of domestic furniture, when the same object could, as in *Bed*, play either role.

The essays that compose this volume were written in the space between art and life, which has been my intellectual habitat since the 1960s, as philosopher and as art critic. As a philosopher, the "unnatural wonders" of artists since the sixties have furnished me with example after example of a kind that hardly could have been imagined in earlier periods either of the history of art or the history of the philosophy of art. The wonderful image on the cover of this book represents the task perfectly. I like to think that the manuscript it shows is an essay on the philosophical definition of art submitted to my publishers, Farrar, Straus and Giroux—perhaps my own manuscript, since it bears my title. The pages of the manuscript are transpierced with real pencils that cross the line between philosophy and life. Like the arrows that martyrize St. Sebastian and elevate him onto a higher plane, the pencils, bringing reality into thought, exemplify what the philosophy of art must aspire to. The cover of the book depicts the kind of object with which anyone who sets himself up either as critic or as philosopher of art today is going to have to deal. It *shows* what the book is about. The book deals with art and life together.

Most of the critical pieces here first appeared in *The Nation*, whose art critic I have been for the past twenty years. There exist very few magazines that would make themselves hospitable to the philosophical exploration of art in the guise of critical reviews, all the more so in view of the urgent political matters that clamor each week for editorial comment. But as our encounter with Plato demonstrates, the

philosophy of art began with the political suppression of art and, as readers of *The Republic* know, with the expulsion of artists from the ideal society. Since its first issue, published on July 4, 1865, *The Nation* has published art criticism, as if in the awareness that it is in the gap between art and life that the consciousness of what we are is constantly being reshaped. I am immensely privileged to have been able, like Rauschenberg, to act in that gap, to make available to the magazine's readership what I think has been happening there and to explain the way, in my view, the unnatural wonders of artistic production may be approached.

The remaining pieces are mostly of a more explicitly philosophical nature. "Art Criticism After the End of Art" inaugurated a conference on contemporary art theory and art criticism held over the course of three days in Murcia, Spain, in December 2003. I want to thank Francisca Perez Carreno of the Philosophy Department of the University of Murcia, who, together with Miguel Hernandez-Navarro and Pedro Cruz Sanchez, of the Centro de Documentación y Estudios Avanzados de Arte Contemporáneo, organized and sponsored that extraordinary event. "The World as Warehouse: Fluxus and Philosophy" was commissioned by the Gilbert and Lila Silverman Foundation for a volume on Fluxus—that international polymorphic movement of art, music, and performance that made the closure of the gap between art and life part of the agenda and form of life of its adherents. "Painting and Politics" was presented as part of a symposium organized in celebration of David Rhodes's twenty-fifth year as president of the School of Visual Arts in New York. "The Fly in the Fly Bottle" was delivered at the Guggenheim Museum of Art in October 2003, in a series dedicated to how critics make judgments of artistic value. "*Kalliphobia* in Contemporary Art" was published as part of a symposium on aesthetic/antiaesthetic in *Art Journal*, Summer 2004, at the invitation of James Meyer and Toni Ross. The essay on Jeff Koons was written at the invitation of Gunnar Kvaran, director of the Astrup Fearnley Museum of Art in Oslo, Norway, for the catalog of an exhibition of that artist. The essay "Light over Ashes" was originally published as a catalog essay in *Joshua Neustein: Light on the Ashes*, Southeastern Center for Contemporary Art, 1961. "Domestic Tran-

quility" appeared as an addendum in *Joshua Neustein: Five Ash Cities*, Herzliya Museum of Art, Herzliya, Israel. "Reflections on Robert Mangold's Curled Figure and Column Paintings" was published as a catalog essay for an exhibition of the same name, Pace Wildenstein Gallery, 2003.

I am greatly indebted to Paul Elie at Farrar, Straus and Giroux for his editorial gifts and for his general enthusiasm for my writing on art. Paul came up with the title for this book, as he had for its predecessor, *The Madonna of the Future*. I must mention as well the help given this volume by his assistant, Kathryn Lewis. The pieces for *The Nation* had the benefit of two marvelous editors, Art Winslow and Adam Shatz. Finally, I once again express my profound appreciation for the spirit of enthusiasm, comedy, happiness, and love embodied in the person of my wife, Barbara Westman, a remarkable artist and the best person to share a life with that I can imagine.

Unnatural Wonders

Introduction:
Art Criticism After the End of Art

Around midyear 1984, I published an essay titled "The End of Art." In October of that same year, I began a career as an art critic, publishing my first piece in *The Nation*. The view has sometimes been expressed that if the end of art has really come, there should be nothing to write art criticism about any longer, so my new practice was somehow inconsistent with the thesis of my essay. But it was never part of my thesis that art would stop being made—I had not proclaimed the *death* of art! "The End of Art" had rather to do with the way the history of art had been conceived, as a sequence of stages in an unfolding narrative. I felt that that narrative had come to an end, and in this regard, whatever art was now to be made would be posthistorical. The only kind of criticism the thesis ruled out was the not uncommon practice of praising something as showing what was to be art history's next stage. I felt that my thesis was liberationist— that now that the end of art had come, artists were liberated from the burden of art history. They were no longer constrained by an imperative to carry the narrative forward. Nothing in art could any longer be invalidated by the criticism that it was historically incorrect. Anything and everything was now available to artists. Though it took awhile for the fact to dawn on me, I was in a sense the first posthistorical critic of art. There were of course plenty of art critics in the period we had now entered. What was special about me was that I was the only one whose writing was inflected by the belief that we were not just in a new era of art, but in a new kind of era. That meant that I had to be

as open as the art world itself had become. If nothing was ruled out as art, I could rule out nothing as art.

As it happens, I was not the first philosopher to announce the end of art and then go on to write art criticism. Early in his *Lectures on Aesthetics*, delivered in Berlin for the last time in 1828, the great German metaphysician Georg Wilhelm Friedrich Hegel claimed that art "in its highest vocation, is and remains for us a thing of the past." But Hegel, no more than I, supposed that the practice of art criticism was invalidated by this thesis. Indeed, in the tremendous text that followed, he showed himself to be one of art criticism's greatest practitioners. His critique of Raphael's *Transfiguration*—until then regarded as a deeply flawed masterpiece—is an unparalleled exercise in artistic analysis. And the pages he devotes to the criticism of Dutch painting have never, to my mind, been matched. I would be very gratified indeed to believe that anything I have written as an art critic has come within range of what Hegel achieved in this genre. The difference is that Hegel did not attempt to write criticism of the art of his own time—of art after the end of art. In fact, his philosophy of art history really implied that he was living in an age when, for the first time in history, the approach of the art critic was exactly what the art being made called for. Art criticism as a modern practice was not very old in 1828. The fact that it existed at all was almost proof that Hegel's theory of the end of art was true for his time. It will help clarify the difference between my views and Hegel's—as well as of our era and his—if I take some time to explain what his views actually were.

What would Hegel have said had the actual future of art history been revealed to him—the great sweep of art history from Goya, Ingres, and Delacroix through Manet, Courbet, and the Impressionists, the Post-Impressionists and the early Modernists, down to the art of our own time? Would he have considered that his declaration of the end of art was perhaps hasty and, not to put too fine a point on it, false? I think he would have said that it was not, that he was not making predictions about artistic production at all. Rather, it was a claim about our relationship to art, whatever its actual future. His point, as he says explicitly, was that art "has lost for us genuine truth and life. And has rather been transferred into our *ideas* instead of maintaining

its earlier necessity in reality and occupying its [previous] higher place." In brief, it is a thesis less about art than about us. He goes on to write, "What is now aroused in us by works of art is not just immediate enjoyment but our judgment also, since we subject to our immediate consideration (i) the content of art, and (ii) the work of art's means of presentation, and the appropriateness or inappropriateness of both to one another." And he concludes, "The *philosophy* of art is therefore a greater need in our day than it was in days when art by itself as art yielded full satisfaction. Art invites us to intellectual consideration, and that not for the purpose of creating art again, but for purposes of knowing philosophically what art is."

Hegel believed, in a sense, that we have outgrown art. It no longer gives us what we need:

> It is certainly the case that art no longer affords that satisfaction of spiritual needs which earlier ages and nations sought in it, and found in it alone, a satisfaction that, at least on the part of religion, was most intimately linked with art. The beautiful days of Greek art, like the golden age of later Middle Ages, are gone . . . The point is that our whole spiritual culture is of such a kind that [the artist] himself stands within the world of reflection and its relations, and could not by any act of will and decision remove himself from it.

Whereas in ancient Greece or medieval Europe, Hegel believed, art satisfied humankind's highest spiritual needs, he now believed that we have evolved beyond that and require what he called "reflection," by which he meant, in effect, philosophy. In those golden ages art made vivid, through images, what men and women needed to know about themselves and the world they believed they lived in. We moderns, Hegel would have said, have to interpret what they understood immediately and intuitively. When Hegel was forming his views on art, he could see from his doorstep Karl Friedrich Schinkel's great museum (today called the Altes Museum, the "Old Museum") rising up. It would contain works of art from many historical periods, which in their time could be understood by those who lived a form of life in

which their art sufficed what Hegel believed could now be derived
only from philosophical reflection. Standing in the museum, we have
to learn what the art means—what its content is—and why it presents
that content as it does. We are external to that art and confront it as
art critics or art historians. It has lost the power to communicate on its
own. Really, we have no need for that art. Nor, more radically, have
we need for any art. We now move on a higher, more intellectual
plane than did those men and women for whose spiritual needs the art
was sufficient. Even if the art of his time had been flourishing and
stunning, Hegel would have felt that we had moved on to other,
higher—more intellectual—things.

That, I think, was Hegel's view, which I have tried to convey in his
own words. His thesis was that whatever art now might do for us, it
can no longer compare with what it once did for those who came be-
fore us. "Neither in content nor in form is art the highest and absolute
mode of bringing to the mind the true interests of the spirit." Rather,
Hegel writes, "Thought and reflection have spread their wings above
fine art." And the reason that art remains, so to speak, earthbound is
that it displays "even the highest [reality] sensuously." It is tethered to
the experience of some object or other—the material object in which
the artwork is embodied—whereas philosophical reflection delivers
us to a realm of pure abstract thought, which cannot be reduced to
sense experience at all. We in effect have to translate what the senses
show us into thought, through interpretation. We have to put art into
words to grasp what it means. That is what Hegel did as an art critic,
and I have to say that is what I try do as an art critic as well.

But my view of the end of art is radically different from his. I
don't, for example, believe that we have outgrown art. I believe,
rather, that we have outgrown certain views of artistic experience that
render it intellectually inadequate to our needs. And we have accord-
ingly, I believe, outgrown Hegel's invidious view of the relationship
between art and philosophy. He felt that art is limited through its de-
pendence on material objects grasped through the senses. His con-
tempt for matter has a long philosophical genealogy, going back into
ancient times. He was a philosophical idealist, which meant that he
saw the universe as spiritual through and through. He saw that it was

possible to think in the medium of matter, and indeed his conception of art acknowledges as much. But he believed this limits art in a disfiguring way since in its nature it *must* think in the medium of matter. His philosophy of art was hostage to his metaphysics.

I, to the contrary, believe that art has been able, through its evolution, to take us to the heart of its philosophy. My thesis on the end of art really is not a metaphysical thesis but a historical one. We have, as I say, not outgrown art at all. But art has certainly outgrown anything Hegel would have been able to conceive of as art in the 1820s! Indeed, had art not had the internal development that led to the art I experienced in the early 1960s—and most acutely in 1964—my view of the end of art would never have arisen. I felt, in specific connection with that art—Pop, Minimalism, and Conceptualism—precisely what Hegel declared: that the *philosophy* of art was needed in an especially urgent way.

To be sure, philosophy in the second half of the twentieth century was a far cry from the robust practice it had been in Hegel's day. It had fallen very far away from something that could pretend to satisfy the highest needs of the spirit. Metaphysics of the sort that Hegel practiced had been declared intellectually bogus, and the sharpest philosophical minds of my time had been dedicated to its definitive overthrow. Ludwig Wittgenstein wrote, "Most propositions and questions that have been written about philosophical matters, are not false but senseless. We cannot therefore, answer questions of this kind at all, but only state their senselessness." The main philosophical movements of the century were based on a radical skepticism regarding philosophy itself and sought to provide something that philosophers could do instead of what Hegel believed was philosophy's "highest vocation." Phenomenology sought instead to describe the logical structure of conscious experience. Positivism dedicated itself to the logical clarification of the language of science. "Philosophy recovers itself," the pragmatist John Dewey wrote, "when it ceases to be a device for dealing with the problems of philosophers and becomes a method, cultivated by philosophers, for dealing with the problems of men." Nietzsche regarded philosophy as little but the disguised autobiographies of its exponents, and Derrida evolved his concept of Deconstruc-

tion to lay bare the hidden agendas that lay behind philosophical systems.

If there was any group of figures who tried to deal with the deepest concerns of the spirit, it would not have been the professional philosophers at all but the great painters of my younger years, the Abstract Expressionists, who, in the words of one of them, Barnett Newman, aspired to find, through painting, a path to the Absolute. And when, as in a legendary encounter between artists and philosophers in Woodstock in 1952, the aestheticians there dared imply that they had something of interest to tell the artists, Newman contemptuously declared that aesthetics was for art what ornithology was for the birds. They were no longer in awe of philosophy, if they ever had been, and no longer felt they needed it.

In particular, the question of the nature of art, which had long preoccupied philosophy and constituted a traditional topic in aesthetics, was felt not to require an answer. Around that time, there was a view in philosophy that definitions of art were either useless or impossible. That view too derived from Wittgenstein, who had offered an almost paralyzing example in his posthumously published masterpiece, *Philosophical Investigations*. How would you define games? Wittgenstein asked. Is there anything common and peculiar to the set of games, as philosophers would have supposed the concept of games required? Don't say there must be something, Wittgenstein said—*Look and see if there is something.* He then listed lots of games, and in such a way that there really was nothing obvious that they all had in common. Yet, he goes on to say, we all know which are the games. A definition will make us none the wiser. For those who felt insecure at this, Wittgenstein offered the idea of what he termed "Family Resemblances." The set of games is a Family Resemblance class. His followers proposed that artworks constitute just such a class.

What struck me with the force of revelation in 1964 was that this view was entirely wrong. It hit me in particular with the exhibition I have so often written about, in which Andy Warhol displayed a large number of facsimiles of shipping cartons, among which the Brillo Box was the star item. What was thrilling for me in that show was the way it opened up, I thought for the first time, a way to think philosophi-

cally about art. Up until then, it seemed to me, works of art were thought to have a strong antecedent identity. They had gold frames around them, or were posed on pedestals, and one was expected to look upon them as pretty significant. Everyone knew, more or less, how to tell when something was a work of art, which could be picked out in much the same way shipping cartons could be picked out, and nobody could confuse the two. And now all at once here was a work of art that could not interestingly be told apart from a shipping carton. But that meant that recognizing something as a work of art was a perceptually more complex transaction than anyone had supposed. What family resemblance could be greater than that between *Brillo Box* and the Brillo boxes? They were like identical twins! And yet one was an artwork and the other just a throwaway container. In a recent essay I wrote on the Fluxus movement, I pointed out how games had become part of the Fluxus oeuvre. Not beautifully crafted chess sets, but the dumb little "Made in Japan" kinds of games in which you kill time by seating little metal balls in a set of holes in a cheaply printed picture of a clown. Who would have chosen that as an artwork? But in the Silverman Collection of Fluxus works in Detroit, there they are along with the other joke-shop items that bear the stamp of Fluxus taste. All at once, it seemed to me, the definition of art had become urgent. And all at once, it became clear that the great philosophical truth that Warhol had bestowed upon us was that you cannot base a philosophical definition of art on anything visual—or sensual in the extended use philosophers make of that term—since most of the visual properties of his *Brillo Box* are shared with the Brillo cartons of the supermarket, and those that are not shared—his are made of plywood—cannot conceivably ground a distinction as momentous as that between art and reality.

But this has the form of a classical philosophical question. My paradigm for this is the vexing question with which Descartes opens his magnificent work, *Meditations*. It is freshman philosophy but in a way all philosophy is freshman philosophy. The problem is one with which everyone is familiar. Descartes is sitting in his study, in his dressing gown, next to a stove on a winter day in Germany, writing his thoughts on a piece of paper. And now it occurs to him that he might

be dreaming all this and that he is really naked, snuggled beneath his down comforter, dreaming that it is all taking place the way he has just described it. There is no internal difference between the two experiences. Any test you propose can easily be dreamt as having been performed. So here we have two pictures exactly alike, one a dream, the other waking experience. The difference between dream and waking experience is momentous. In my book *Connections to the World*, I argued that every philosophical problem has this form. That is what makes philosophy so fascinating and so difficult, and so different from science. That is why you cannot treat philosophical questions the way you treat scientific questions, as my teachers, who were logical positivists, believed that you could. They thought that meant that philosophical questions were meaningless—pseudoquestions. Whereas it was my view that the *Brillo Box*–Brillo box problem means that we can finally begin to understand what the definition of art should look like. My 1980 book, *The Transfiguration of the Commonplace*, takes the problem up in the intractable form I have just presented and manages to finesse two or three components of what seemed to me—and what still seems to me—to belong to a successful definition of art.

Interestingly, that definition coincides precisely with what Hegel said that our approach to art now must be: we are to concern ourselves with "(i) the content of art, and (ii) the work of art's means of presentation, and the appropriateness or inappropriateness of both to one another." The view I arrived at not only formulated a provisional definition of art, it also formulated the approach I was to take to art criticism. A work of art must in the first instance be about something—have a meaning—and it must somehow embody that meaning in the way it presents itself to the viewer's awareness. I sloganized this by saying that works of art are *embodied meanings*. As a critic, it seems to me, we need to ask what the meaning of a work is and then how the work embodied that meaning, and if, in Hegel's terms, meaning and embodiment are "appropriate or inappropriate to one another." With the art of the past, of course, when works of art constituted part of the form of life that those for whom the works were made actually lived, their users had no need for these questions. The works ad-

dressed them with an immediacy that left nothing further to do than to respond in the prescribed ways. But we do not and cannot relate to them in this internal way. The works were not made for museum display. They were not intended to be appreciated but, say, prayed to or worshipped. There was no room in their case for issues of connoisseurship. Consider, as an example, the furor caused by the exhibition "Primitivism and Modern Art" at the Museum of Modern Art in 1985, which juxtaposed Modernist works with figures from Oceania or Africa that had inspired them. The question was raised whether this was even a proper way to look at the latter works, which played so different a role in their cultures than Cubist or Fauve painting did in Europe or America. The very idea that they are "primitive" is the result of a forced and distorting comparison. There is no way we could relate to these objects as do those whose cultures they define or once defined.

When Hegel said that art invites us to intellectual consideration but *not for the purpose of creating art again*, I think he genuinely felt that there was no longer any way we could relate to art the way people had related to it in the past. He may very well have supposed that art could continue to be made for other purposes, for what he describes at one point as "the indulgence and relaxation of the spirit." As such, "art appears as a superfluity" and a downright luxury that he found it difficult to defend. That is not an uncommon view—think of the way art is presented in the "Art and Leisure" or "Art and Entertainment" sections of important newspapers today. Think of the way it is widely regarded as frill when the place of art in the curriculum is addressed in school budgets. What Hegel obviously could not countenance was that works of art could play in modern life the central role he assigned to philosophy! But that is the role, as I see it, that art has increasingly insisted upon for itself, by raising the question of its identity as forcefully as I feel *Brillo Box* did, demanding a kind of intellectual engagement with itself. In truth, I felt that art had carried the responsibility of the philosophy of art further than the philosophers of art would have been capable. It was as if artists had to become their own philosophers in order to be taken seriously.

I am sometimes alleged to have said that art came to an end in

1964 with the appearance of *Brillo Box*, and I have to accept a certain measure of responsibility for this caricature. The truth is that my ideas on the philosophy of art began with that experience forty years ago. Warhol awoke me, to use a phrase of Kant's, from my dogmatic slumber. That slumber was due as much as anything to my overall ignorance of much that was happening in the art world at that time. All across the art world in the early 1960s were examples that so closely resembled things that were not artworks that it would have been difficult to tell which was which. In music, John Cage was subverting the difference between musical sounds, narrowly considered, and the noises of mere life. Many of the members of Fluxus were students of Cage in his course on experimental composition at the New School. The Judson Dance Center was conducting experiments in the boundaries of dance: By what criterion, if any, can we tell when something is a dance movement? Can a dance not consist in someone just walking across the stage, or sitting in a chair for a certain length of time? It was an ambition of the New York avant-garde to "overcome the gap between art and life," and many of its adherents derived inspiration from Dr. Suzuki's seminars in Zen Buddhism at Columbia University. I too listened to Dr. Suzuki, and I know that when I wrote my first essay in the philosophy of art, I applied to the *Brillo Box*–Brillo box question certain ways of thinking that I derived from Zen. The difference between me and the avant-garde artists who were my contemporaries, and in a sense my peers, is that for them it was enough to erase the boundaries between the works of art they made and objects from ordinary life. That was not enough for me. My problem was what made such works of art *art*, when the objects they so exactly resembled were what I called mere real things? All that I knew is that the differences, whatever they were, could not meet the eye.

The best that I was able to do in that first essay, the title of which was "The Art World," was to attempt to spell out some nonvisual differences. I thought that in order to see *Brillo Box* as art, one would need to see how the history of art had evolved to a point where it was now possible for such a work to exist. And one would have to know something of the state of discourse of the art world, within which that possibility existed. You would have to know about Duchamp, for ex-

ample. You would have to know something about Clement Green-
berg. And so on. None of this applied to Brillo cartons. They were sit-
uated in history in a very different way from *Brillo Box*, however
much alike they looked. Imagine that someone close to you dies. Sup-
pose someone tells you that there is a company that manufactures du-
plicates of anyone in the world. You can order a duplicate of your
husband or your child. It takes a few weeks and costs a lot less than
you would imagine. Would you order one? Would you love the dupli-
cate just as much as its indiscernible "original"? This is the same kind
of problem.

It may well be asked what this has to do with the end of art, and I
realize now how completely philosophical my way of thinking at the
time was when I consider what my reasoning was. I had begun to
think of the history of modern art as a kind of Bildungsroman, to use
the German term for a novel in which the hero or heroine attains an
understanding of what he or she is. There is a kind of feminist novel,
for example, in which a woman arrives at an inner understanding, or
consciousness, of the meaning of her identity as a person as well as a
woman. The end of the story is this advent of self-consciousness.
What happens after that point, what she does in the light of this
knowledge, is up to her. This idea is very Hegelian, which shows how
really indebted to his thought mine has been. Hegel held a view that
history ends in self-consciousness, in that state of affairs in which what
he calls Spirit knows that it is Spirit, knows, that is, that it has miscon-
strued its nature but now has achieved self-knowledge. His great
work, *The Phenomenology of Spirit*, is just such a story, in which Spirit
goes through various adventures and misadventures of false knowl-
edge until, at the end and as the climax, it breaks through into this
kind of self-consciousness, which means the end of that history. Spirit
will never again have to pass through such an agenda of self-
education. The story is over though history will go on and on.

This was my view of the history of Modernism, which I read as a
series of efforts at self-definition, in which each in a series of successive
movements raised the question, What is art? There were so many
movements, many of them accompanied by manifestos, in which art,
so to speak, declares, This is what art is, this is what the past was and

this is what the future will be, now that art knows what it is. As the sixties wore on, it seemed to me that such movements as were taking place were increasingly philosophical in nature. One of the exhibitions that affected me, if less momentously than Warhol's, was a show of large, simple boxes, painted in dull industrial grays or tans, by the Minimalist artist Robert Morris, at the Green Gallery. In 1966 an important show of comparable sculptures was shown at the Jewish Museum—at that time the main venue for avant-garde art—under the title "Primary Structures." As Minimalism evolved as a self-conscious movement, the objects in which it consisted grew less and less interesting, visually speaking, and more and more dependant upon texts, philosophical in nature, written by the artists, who often had the objects themselves fabricated in workshops. The objects were industrial: rows of bricks, areas of plain metal squares, fluorescent lightbulbs, plain metal modules, sections of prefabricated buildings. Unless you read the texts, you could have gotten very little out of the art, from which almost everything of visual interest had been expunged. One might almost suppose that the objects could have been dispensed with, leaving just the texts. In 1969, Conceptualism emerged as a movement. It really did away with objects altogether—or the objects were increasingly vestigial, as the thought became the fulcrum for the art. An extreme example was an untitled work of Robert Barry, consisting of "All the things I know but I am not at the moment thinking—1:36 PM; June 15, 1969." The work would have consisted, among other things, in the Empire State Building, the Alps, and the Brooklyn Bridge, unless Barry was thinking of them, since they were among the things he clearly would have known.

Now Minimalism and Conceptualism were really both far more philosophical in intention than Pop Art ever was. The intention of Pop was more social than philosophical—it was initially concerned to overcome the difference between high art and popular or vernacular art. Indeed, Lawrence Alloway, who coined the term "Pop Art," was persuaded that popular art—its music, films, literature, and art—is every bit in need of critical analysis as high art is. But all three of the movements of the mid- to late sixties served to purge the conception of art from many of the features it had acquired in the course of its

history. Art no longer needed to be made by some specially gifted in-
dividual—the Artist—nor did it require any particular set of skills. It
no longer needed to be difficult to make. And it no longer, as Robert
Barry's untitled work shows, had to be an object of some special kind.
A sculpture could be a hole in the ground, as in a work by Dennis Op-
penheim. It could be a hole in a wall, as in a work by Lawrence
Wiener. It was, beginning with Fluxus, as if the sixties was a period of
radical philosophical experimentation in which it was sought to dis-
cover how much could be subtracted from the idea of art. As with the
Brillo Box–Brillo box problem, the artists were doing the philosophi-
cal work that the philosophers were unable or unwilling to do for
them, so that it was not entirely a caricature to say that art, or at least
avant-garde art, had turned into philosophy through the 1960s and
into the next decade. By the 1970s it was possible to say, with Warhol,
that anything could be a work of art, though much the same thing
was said by the Conceptualists. It was possible to say, with Beuys, that
anyone could be an artist. None of this meant that everything was art
but that anything could be. It was no longer necessary to ask whether
this or that could be a work of art since the answer would always be
yes. And with that, it seems to me, there was no further need for this
order of experiment. The concept of art had been purged of every-
thing inessential. It would remain for philosophy to say what was left,
if philosophers cared to worry about the problem. Artists were now
free to make art out of anything in any way they chose.

 This was the situation at the beginning of the 1980s, when I pub-
lished "The End of Art." I really had tried to identify, in *The Transfig-
uration of the Commonplace*, the few rather weak conditions that
remained in the concept, or in the "definition" of art. They were so
weak and general that they could be compatible with any work of art
whatever, traditional or contemporary, Western or non-Western. The
definition was sufficiently nonexclusive to be compatible with the
recognition that there were otherwise no constraints on what a work
of art look like, and with the situation that there would be no way of
knowing when or whether one was in the presence of art. Since any-
thing could be art, it seemed to me, we were in what one might call an
end-of-art situation. It was the first time civilization had been in such

a situation. It was a situation of perfect freedom. Artists could make of art what they wished. That at least was, to use a philosophical expression of the time, the deep structure of the art world we had lived into. The reason that the End of Art was not immediately embraced was that, for a time, the *surface* structure seemed rather different from the deep structure. This requires some comment.

In the early 1980s, there was a huge resurgence of painting. There was a sense of joy that painting was back, in the form of what was labeled Neo-Expressionism. Collectors, for example, who felt that they had missed the chance to acquire art in the fifties, when the New York School was turning out masterpiece after masterpiece, did not want to miss the opportunity to acquire an example of the new art and watch it appreciate in value over the years. Here was painting in the same heavily pigmented mode, large and brushy *and* figurative as well! The paintings went with the huge loft spaces that defined a new vision of urban life, in the kinds of lofts that artists had taken over from manufacturers when the art world colonized SoHo through the 1970s. The streets of SoHo were thronged at openings of figures like Julian Schnabel and David Salle. And the style seemed international—the inaugural exhibition of the redesigned Museum of Modern Art in 1984 made it appear as if Neo-Expressionism was a world phenomenon. It was a moment of institutional transformation in the art world, as two recent issues of *ArtForum* dedicated to the 1980s showed. Money flowed into art, and artists began to live like sovereign princes, patronizing the best restaurants, crossing the globe, with studios in spaces large enough to shelter a substantial workforce when they had been factories. The Neo-Expressionist label disguised deep differences, of course. The style had political causes in Germany that had no counterparts in New York. German artists deliberately painted badly in the hope of thwarting the market, but despite the fact that it was bad, "Bad Painting" was collected and cherished for its originality. In America, the idea of quality was felt in any case to be politically incorrect and unacceptably elitist. The leading theorists of the time, writing chiefly but not exclusively in the journal *October*, contended that painting was dead, largely because the society that patronized it— "Late Capitalism"—was believed to be in its last throes, to be replaced

by a new Socialist society, whose art would be drab enough to be acceptable to Maoist aesthetics, under which none of those writers could live for five minutes.

Though I believed that art had come to an end, I did not believe that painting was dead. I merely felt that the new painting culture of the world was not an unfolding moment in the history of art, since that structure of history seemed to me to have played itself out. We were living in an end-of-art situation that, I had come to realize, was deeply pluralistic. Of course, painting was to be expected in such a situation. It was too deeply ingrained in our idea of art to pass out of the picture. Painting became sharply contested in the 1970s, largely for ideological reasons. In the associationist psychology of radical politics, it had become identified with the white male, colonialism, and all the bad things. And in the effort to purge the discourse of art of such concepts as the Masterpiece, the Genius, and even talent as unacceptably elitist, painting became charged with too many resentments to be any longer accepted as the defining medium of art. But there were no reasons inherent in the concept of art for painting not to exist, and if artists were prepared to face the heat of radical critique, there was nothing to keep them from painting, and a great deal to encourage them—like the very thing radicals found repugnant: money, acquisition, the pride of ownership, the art market. The fact that these forces even subverted Bad Painting in Germany is evidence for how powerful these are.

Notwithstanding these considerations, Neo-Expressionism did not last into the second half of the 1980s. Instead, artists began to work as though the idea of the end of art, as I had formulated it, had begun to define their consciousness of making art in the contemporary world. This of course does not mean that I was in any sense responsible for the way things worked out. My text on the end of art, though it gave me a certain fame, was not much read. It was not an influential text at all. What I had done is what Hegel said philosophers ideally do. We are all children of our times, he writes, but it is the task of philosophers to grasp their times as thought. I believe that is what I did in "The End of Art." What I had not expected was to see what I grasped as thought become so palpably the way that art began to be practiced,

when the deep structure I had intuited began to inflect the surface structure—not because I had intuited it but because it had finally to break through into general consciousness. It was the art that was created in terms of this consciousness that I was to face as a critic.

My practice as a critic has been to address art after the end of art in the way that Hegel addressed art before the end of art—to look for the meaning of the art and then to determine how the meaning is embodied in the object. From the perspective of this practice, writing about Leonardo or Artemisia Gentileschi does not differ from writing about Gerhard Richter or Judy Chicago. All art is conceptual art (with a small *c*), and always has been. Even in those golden ages that Hegel sentimentalized, there had to be a discourse that exactly resembled that of art criticism as he understood it. This would have been the discourse of the artists themselves, who needed to be able to discuss what they made with reference to the effect they meant their art to have. What Hegel's discussion lacks is the conception of art that is made by artists with certain ends in view. The critic today occupies a double perspective, that of the artist and that of the viewer. The critic must recover what effect the art was to have upon the viewer—what meaning the artist meant to convey—and then how this meaning is to be read in the object in which it is embodied. I see my task as mediating between artist and viewer, helping the viewer grasp the meanings that were intended. There may have been ages when critics were not needed to interpret the art for the viewers, but as the history of art has evolved, the critic is needed more and more to explain to the viewer what is being seen. We have to treat the art of today the way Hegel treated the art of the past, when artist and viewer constituted—or ideally constituted—an actual community.

What the end of art means is only that we are at last conscious of this truth.

Whitney Biennial 2000

A woman I know once agreed to take a young Asian child to visit a school in New York, to which her distant parents considered sending her. The visitors were shown a chapel, no longer greatly used for devotional purposes but deemed a sight worth seeing. The child was shaken by a picture of Jesus, bleeding and nailed to the cross. "What have they done to that poor man?" she asked, in pained incredulity. I somehow thought of her response to what is after all a standard image in the Western artistic canon when I saw a sign that the Whitney Museum has placed at the admissions desk to Biennial 2000: "Sections of the exhibition present artwork or other material that may not be appropriate for some viewers, including children." Nothing on view could possibly have the impact on a sensitive child of a routine depiction of Christ's unimaginable agony. Such a warning sign might far more suitably be placed outside any of the West's great museums, where images of cruelty and torment are found on every corner. People lined up to buy cappuccino and biscotti at one of the Metropolitan Museum's convenient coffee bars wait patiently beneath the altogether inappropriate sculpture by Carpeaux of Dante's Ugolino, devouring his children. Imagine if it were learned that the Whitney was showing a statue of a guy eating his kids!

The fact that the museum regards it as necessary or prudent to post warnings at the threshold of a playful and largely friendly display of contemporary art is an emblem of how fearful of the art of our time

we have been made by the forces of artistic repression in our society. It
is for just this reason that I find it difficult to be especially upset by
Hans Haacke's widely deplored intallation, *Sanitation*, in which decla-
rations by various politicians, hostile to contemporary art, are lettered
on the wall. The lettering, as the media have made it impossible for
anyone not to know, is in the spiky Fraktur in which the Third Reich
posted its own proclamations. Though as a result Haacke has been
charged by some with "trivializing the Holocaust," it cannot be de-
nied how central a role artistic suppression has played in all the totali-
tarian movements of the twentieth century. "Hans always goes too
far!" someone said—but the presence of the little warning sign at the
threshold of the show is internally related to the messages in and of
Haacke's work. There is no internal connection, on the other hand,
between any other work I can think of in the show and the warning
on the sign, which can be interpreted only as a gesture of deference to
the politicians Haacke has quoted.

I wished that there were somehow an internal connection between
the sign and the witty work *Banner Yet Wave*, which the Whitney
commissioned from Kay Rosen, in lieu of a banner on its facade. It
refers to a banner, and indeed to the only banner with an identity in
common American consciousness—the Star-Spangled Banner, about
which, at the beginnings of baseball games, sopranos always ask
whether it yet waves o'er the land of the free and the home of the
brave. Jasper Johns's celebrated triplet of American flags, which the
museum used as a logo for its exhibition "The American Century,"
perhaps deserves a rest. It appears in two of the works on view—one
of them an ant farm by Yukinori Yanagi ("Blurring the distinction be-
tween art and entomology," the solemn catalog might say), the other
Sanitation itself (in which the smallest of the superposed flags has a
turned-down corner, like a napkin). Rosen selected certain letters
from the phrase "banner yet wave" and distributed them, white on
red rectangles, across the stepped tiers of the building's facade, as if
notes on musical staves. A alone on the top stave, A NER on the next
one down, BA YE below that, ET WA below that, and AVE at the
bottom, to the sign's right. Sign, *Sanitation*, and *Banner Yet Wave* con-
stitute an unintended political installation—and we may as well enlist

the free, brave artists of the rest of the show as a fourth component, collectively answering Yes! to the anthem's question.

A fifth component might be required to give us a full picture of the state of our art, namely, the way the Biennial is represented in the media. Modern art has made good copy since the Armory Show of 1913 handed reporters an irresistible opportunity to crack up their readership—or to appall it—with the antics of artistic nutcakes. Biennial 2000 is not an American "Sensation," and one almost felt sorry for the disconsolate camera crews prowling the press opening in unrewarded pursuit of visual scandals to spice up the evening news. Haacke's piece was hardly more sensational in content than the editorial pages of most newspapers when they deplored Mayor Giuliani's attack on the Brooklyn Museum. Lisa Yuskavage, who paints young women meditating upon their own swelling bodies, provided perhaps the nearest thing to a piquant image with a woman in profile, showing part of a bare breast. Cynics might wonder whether the selection committee might not have gone out of its way to render its warning empty—but in fact Biennial 2000 comes closer than any of its recent predecessors in showing the way the art world of its moment really is. Artists today are an especially serious group of what one ought properly to think of as visual thinkers. Probably even the artists of "Sensation" were bent less on shocking the populace than in pleasing the owner/collector Charles Saatchi. When a reporter asked Chakaia Booker, a handsome black woman in an elaborate headdress, standing proudly in front of her work, whether it bothered her that Hans Haacke had taken all the attention away from the other artists, she replied that she did not think that Haacke had. Her work is an immense and imposing wall-piece of worn and twisted rubber tires, artfully arranged. Why had he not asked her to explain the work and especially the relation to it of its title, *Homage to Thy Mother (Landscape)*? Is it a landscape of devastation and ruin, which, even so, the artist has managed to make into something intricate and powerful, swept by pulsing rhythms and graceful arabesques? Hence an allegory of art's transformative powers?

If one looks at the art through the clarifying lens of the ample wall texts—or listens through the headsets the museum distributes free of charge to what the artists themselves have to say about their own work—the evidence is overwhelming that most of the art has a certain high moral and intellectual purpose. The artists portray themselves as engaged in conceptual exploration, calling boundaries into question, seeking to bring to consciousness the way we think about many things. It is as if the works exist on two levels—the level of object and the level of argument—and the wall texts, or catalog entries, assist us in grasping what the work is through explaining what the object means. Often the distance between object and argument is so wide that without the text we would badly misread the object. This is not that different from traditional art as one might suppose. Think, for example, of how little a realistic seventeenth-century crucifixion scene tells us about the meaning of the man-and-cross it shows or why it is appropriately hung in chapels. Who would know—who really could understand by means of visual perception alone—that the twisted figure is redeeming through physical suffering the taint of original sin humanity until then allegedly carried? The meaning of much of the work is at just such a level of abstractness, relative to the object intended as its vehicle. In this respect, contemporary art and traditional art have a great deal more in common with each other than either has with Modernist art, which sought to convey its meaning by visual means alone—so much so that with such work as Matisse's or Cézanne's, the very presence of wall texts was considered supererogatory. The difference between traditional and contemporary art is that with the former, a certain common culture enabled viewers to know the arguments under which objects were intended to be seen, whereas this cannot be counted on in connection with what artists do today. So without the explanation we have no way of knowing what we are looking at.

Sometimes, it must be admitted, the object is stronger than the work. I greatly admired, for example, a painting by Ingrid Calame, in reddish-pink enamel on a very large Mylar sheet, cascading down the wall and then spreading out onto the floor. The forms themselves have the look of spilled and splashed pigment impulsively swept onto

the surface with brooms or wide brushes, in an Abstract Expressionist manner. This proves to be an illusion. The forms derive from tracings of "the lacy stains left by the evaporation of nameless liquids" that the artist found on Los Angeles streets. She has compiled an archive of these, noting the location of each stain and the date on which it was found. The forms are the result of careful transcription rather than of impulsive expressive brushwork—and monumentalize pre-existing splotches. So we have to rethink our response to the object, which turns out to be far more intellectual and calculated than emotional and impulsive.

A comparable distance separates object from argument in Ghada Amer's *Untitled (John Rose)*. Her paintings look, the catalog concedes, "like finely drawn, delicate abstractions." The informed eye leads one to surmise that her work shows the influence of Cy Twombly. But as with Calame's work, the eye is a very poor guide to what we in fact see. First, the lines are not drawn or painted but sewn. Second, the forms are not abstract but derived from images of women in porno-graphic magazines. One can, once instructed, see that these are stitch-ings, but I found it as difficult to make out that I was looking at "sexually suggestive postures" as I did to identify as female body parts—cut from the same genre of magazines—the things with which the Holy Virgin Mary is surrounded in Chris Ofili's controversial painting from the Brooklyn "Sensation" show. In any case, Amer is making, by means of stitched prurient imagery, some statement about the representation of women. One would not know this without help. Aesthetics is almost consistently subverted in much of today's art— especially when aesthetics seems initially to be the point of what we are looking at. That subversion is in the service of the larger moral meanings that the works are designed—with the help of explana-tion—to convey.

Sometimes explanation in fact intensifies the experience of the ob-ject. Consider a remarkable work by Paul Pfeiffer—a tiny (3-by-4-inch) video set into a wall.

At first glance it shows a black athlete standing alone on a stadium

floor, distantly surrounded by crowds of spectators. The athlete's fists are held in front of him, and his head is bent back in what appears to be a shout, perhaps of victory. The film is a very short loop: The athlete endlessly advances, retreats, advances, retreats, advances, retreats. One could let it go at that, until one notices the title: *Fragment of a Crucifixion (After Francis Bacon)*—and one begins to wonder what they have done to that poor man. The artist began with a short clip from a video, showing an episode from a sporting event. He has modified this through digitalization, transforming it into something enough like a painting by Bacon to convert the shout into a scream. The whole scene becomes something resembling the lonely space of a Roman arena in which someone has suffered or is undergoing suffering for the entertainment of the prurient crowd. The endlessly repeated movement of the figure has the quality of a fantasy or a trauma, from which the mind cannot break free, enacting, over and over, the same charged happening. The work, repetitive and obsessive, has some of the qualities of the mental state it represents. And it is very successful in using technologies that may hardly have existed when the last Biennial took place—digitalization, DVD players—to present us with an image of which traditional art would have been incapable. It draws on art-historical images and historical imagination, and effects a metaphorical transformation of what in its own right is a fairly banal image from contemporary culture.

There is a lot of video in the Biennial, some of it more successful than others but all of it requiring an investment of real time on the viewer's part with no real guarantee that there will be an artistic payoff comparable to that in Pfeiffer's piece. No such reservation is in order with Shirin Neshat's powerful video installation, *Fervor*, which lasts for eleven intense minutes. Many readers who expressed regret at not having been able to see her earlier masterpiece, *Rapture*, will be able to encounter it at the P.S. 1 Contemporary Art Center in Long Island City, where it has a room to itself in the exhibition "Greater New York." *Rapture* is enacted on two facing screens, respectively occupied by women wearing chadors and by men wearing neat white shirts and black pants. The two groups are engaged in parallel symbolic actions. There are again two screens in *Fervor*, this time set side by side. No in-

dividual stood out in *Rapture*—it was as if there were two choruses, as in a very ancient dramatic form, segregated by gender. In *Fervor*, two individuals—a Woman and a Man—stand out as characters. Unlike the other men, the Man stands out by the fact that he wears a suit. The Woman is in a chador, like the others. We first see Man and Woman approaching and passing each other on a rocky road. Each is clearly mindful of the Other. They soon join a crowd, to enter a place of assembly in which the genders are separated by a black cloth partition. The groups are addressed by a man who appears to discourse on a somewhat primitive painting in the style of a Persian miniature, showing a prince with a falcon on his wrist and a lady with courtiers. The audience (congregation?) responds with chants—this must be the fervor to which the title refers—but Man and Woman, though they cannot see each other, are more involved with each other's invisible presence than with what the Speaker says. At the same moment, each rises and leaves the building. We finally see them—and they again see each other—outside the building. They still do not overcome whatever separates them, though one is left with the hopeful sense that they will. The compelling, urgent music, sung and composed by the same singer as in *Rapture*—Sussan Deyhim—intensifies the feeling of the work, which by itself justifies a visit to the exhibition.

Neshat is one of the few widely known artists in Biennial 2000, as she is in "Greater New York." Both exhibits include a handful of such figures, but for the most part, the artists selected are virtually unknown even to those fairly familiar with the art world today. This somewhat indemnifies the Biennial against the otherwise irrepressible critical complaints about who and what is left out. Both exhibitions are made up primarily of what the organizers of "Greater New York" call "evolving" artists—artists who are doing evolved work without yet having attained an evolved reputation. P.S. 1, interested in seeing what was being done in the metropolitan area, issued an open call; two thousand emerging artists submitted work, from which 140 artists were selected. Of course, it is not entirely a fair representation of art in greater New York, simply because the criteria of admission excluded evolved artists. This was not Biennial 2000's policy, but it is its effect. Taken together, the two exhibitions give us a remarkable

picture of what is being done in America today. It is astonishing, in view of the sullen suspiciousness toward art of which Hans Haacke's work reminds us, how many artists are out there, engaged in making work of impressive ambition.

I have heard the complaint that Biennial 2000 gives us no sense of the direction of art today, but we might care to distinguish between the direction *of* art and directions *in* art. It is the mark of our moment that the direction of art is simply the aggregate of the directions of individual artists, taken one at a time. This means that most of the ways we thought critically about art in less pluralistic times are of little help today. We are as much on our own as the artists are, so each viewer has to be his or her own critic. I enormously enjoyed Josiah McElheny's *An Historical Anecdote About Fashion*, which is a display of fictional glass. It is fictional in the sense that, though real enough and even brilliant as examples of contemporary glassblowing, it pretends to exemplify a set of objects made in an imaginary Venetian glass factory, executed in homage to Christian Dior's "New Look" of 1947. The work combines art, craft, and literature to create a work as philosophically arresting as it is visually stunning. But everything in the show, really, is rewarding if one takes the time to think it through.

May 8, 2000

"Making Choices" at MoMA*

Beneath the dazzle of individual exhibitions with which it is celebrating the year 2000, the Museum of Modern Art is setting in place a philosophy of Modernism that will define its agenda for the century just begun. MoMA has divided the history of modern art into three forty-year segments, to each of which it is dedicating a cycle of exhibitions. Just now, an amazing array of twenty-five exhibitions opens equally as many perspectives on the choices made by artists in the period 1920–60. MoMA has, indeed, given the name "Making Choices" to this phase of its extraordinarily ambitious year-and-a-half-long program. It was preceded by "Modern Starts," which drew on work done roughly between 1880 and 1920, and is to be followed by "Open Ends," which will take modern art from 1960 to the present moment. It is extremely important to the philosophy of art history that MoMA is eager to defend that these are merely stretches of time rather than distinctive historical periods, and that the divisions are therefore entirely arbitrary.

The date 1880 cannot be defended as the beginning of modern art, nor is there any consensus as to when modern art began. Nor can that question be separated from the deeper question of how Modernism is to be defined. The art historian T. J. Clark recently proposed that

*Members of Local 2110 of the UAW are on strike at the Museum of Modern Art; this review may serve as both an alternative to viewing the exhibition and an incentive for those who do wish to see it to urge the museum to settle the differences with its employees.

The Editors

modern art began with *The Death of Marat*, completed by Jacques-Louis David in October 1793—but that is because he construes Modernism politically, as art "no longer reserved for a privileged minority." Clement Greenberg thought it began with Manet, whose flat, thinly shadowed forms were derived from photographs—a modern technology of representation. MoMA, for its own reasons, is talking not about Modernism as such at all but about modern art, toward whose history it is taking an exceedingly nominalist stance. Modern art is simply the art made in the years 1880 to the present, whether it was in any further sense Modernist and whether there was modern art before that or not. Indeed, it is the thesis of perhaps the most important component exhibition in "Making Choices" that art can be modern despite not being Modernist. This effort to bracket Modernism as a movement or style is connected with a metaphysical thesis toward history itself: that history is entirely plastic, in the sense that it can be given any shape whatsoever. Thus the twenty-five separate exhibitions in "Making Choices" merely exemplify different ways works from 1920 to 1960 can be grouped. MoMA means in particular to imply that there is no grand narrative of modern art. The substance of art history is simply that of individual artists making individual choices.

It is not difficult to appreciate why MoMA has taken this stand, particularly in distinguishing modern art from Modernism. Its identity is as the Museum of Modern Art—not the Museum of Modernist Art. We can sense this in the defiance implied by the title of the final show, "Open Ends." Modern art is not something that is historically finished. Modernism may be over as a period, and it may or may not have been succeeded by something called Postmodernism. These simply represent different sets of choices modern artists have made. But modern art cannot be reduced to just these sets of choices. Modern art will go on and on, and the Museum of Modern Art will be its showcase and temple long after Postmodernism has faded, if it has not faded already.

Each cycle of exhibitions draws exclusively on works from MoMA's own extraordinary collections, and in "Making Choices," most of the museum is given over to the twenty-five constituent exhibitions. A great many of the works on view have rarely, and some per-

haps never, been seen by the public. One can imagine a museum in which every work owned is a work shown, but in practice decisions have to be made between the two sets: Even after its planned expansion, MoMA will have to select which of its holdings to display. What criteria should be used? One natural answer might be: only the greatest and the best. To have made it to the walls of modern art's greatest museum is to have achieved the supreme accolade. And this indeed was the implication of the great narrative exhibition through which modern art was until recently presented on the museum's second floor—a narrative of high moments. The composition of the present show seems to make it clear that a new way of presenting modern art has been adopted. The second-floor galleries in which the great narrative was unfurled have been reassigned to a plurality of exhibitions, and their works have been redistributed. The history of modern art we now see is a complex network of crisscrossing streams and streamlets rather than a single mighty river, flowing forever between the banks of time. If we wish to use the word "Modernism," it must lose its capital letter. There are many modernisms: "The bulging accumulation of modernisms currently mingle, overlap, circle back, and collide with each other," writes Peter Galassi, MoMA's curator of photography and one of the architects of "Making Choices." It is this revolution in philosophy that makes it, in my view, the most important show in MoMA's recent history.

The revolution was not evident in the first cycle of exhibitions. It felt as though MoMA had laid out an overpowering show of its greatest treasures, like a display of crown jewels. There were efforts at ingenious juxtaposition—the works were allowed to "communicate" with one another—but the show was somehow unreviewable. The works were in the main too familiar for the contexts in which they were placed to release fresh perceptions. And they were drawn from the heroic years of the great movements that constitute the Story of Modern Art—Impressionism, Post-Impressionism, Cubism, Futurism, Cubo-Futurism, the Fauves, Suprematism, Constructivism, and even Dada. The art felt rearranged rather than reconsidered. Nor did

it greatly help to sort them into the three categories of Persons, Places, and Things. That triad maps smoothly onto the three main genres of early modern art—figure studies, landscapes, and still lifes. Modern painting fell naturally into these divisions, once it was no longer "reserved for a privileged minority." These were the subjects the affluent middle classes were willing to buy. Even so, the works in "Modern Starts" somehow resisted being assigned to one or another of the three classes. They apparently longed for their proper historical places in the story made familiar through MoMA's official narrative.

In "Making Choices," by contrast, we are to understand that there is no one story of modern art. History is many things happening all at once, all the time. There are the stories of individual artists, like Giorgio Morandi, Jean Arp, and Man Ray, to whom three of the different shows of "Making Choices" are devoted. There are the stories of different groups, the School of Paris and the New York School, each of which receives a separate show, and the New York Salon and Paris Salon on the third floor. The kinds and number of such chronicles are limited only by curatorial imagination. There are shows that quite transcend the one-person and one-movement exhibition, as may be seen from such titles as "The Marriage of Reason and Squalor," "Useless Science," and "The Raw and the Cooked," all on the fourth floor, or "Anatomically Incorrect" and "The Rhetoric of Persuasion" on the third floor. Each of these merits a review of its own. But "Making Choices" as a whole is for me more interesting than its component sections, since it forces a distinction between a pluralistic and a monist conception of modern art.

The chief proponent of a monistic philosophy of modern art has to have been Clement Greenberg, and while I have never counted myself among his followers, I have greatly admired his effort to impose a clear narrative structure on the art history of a century. Greenberg spoke of "Modernist" art, which, as said, he supposed had begun with Manet in the 1860s. He thought of Color-Field Abstraction in the sixties as Modernism's most recent stage, but he was concerned, when I met him in the nineties, that nothing much had happened

since. It was as though Modernism had been in hibernation for thirty years! In any case, it was Greenberg's account of beginnings that was especially compelling. Modernism, he felt, started with the advent of a certain kind of self-consciousness. Modern philosophy, one might say, began when Descartes turned from an inquiry into reality to an inquiry into inquiry itself. Modernist art began with a parallel ascent to consciousness: Instead of simply depicting the world, artists became preoccupied with the conditions of depiction. Thus, on Greenberg's account, Modernism consisted in art's raising the "question [of] its own foundations." The task of Modernist art was to make its own identity explicit, and "each art, it turned out, had to perform this demonstration on its own account."

Greenberg settled for an exceedingly narrow conception of what the result of this self-inquiry was in the case of painting: He saw it in "the stressing of the ineluctable flatness of the surface." It was certainly true that in the 1880s and 1890s, much of the most advanced painting emphasized its own flatness—but this in the main was because painting aspired to the condition of decoration. To this end, artists aimed to liberate painting from the illusion that had been the triumph of traditional art in the West. Whatever the art-historical explanation of such flatness, it was, I thought, a brilliant achievement on Greenberg's part to see it as but a stage in the internal unfolding of artistic self-consciousness.

In my view, Greenberg had so closely identified the history of modern art with Modernism that he was unable to recognize that modern art went on after Modernism had more or less come to an end. We were, then, in a new period of art history, in which it had become plain that there was no longer any special way that art had to look—that anything could be a work of art, that nothing external need mark the difference between works of art and anything else. This was the combined result of the thought of Marcel Duchamp, Andy Warhol, and Joseph Beuys. If art could look any way at all, though, I felt that there was no longer the possibility of any special direction for art, a situation I attempted to describe in my book *After the End of Art*. Contrary to Greenberg, I believed that Modernism was over with rather than merely interrupted. Or better, I believed that

Modernist art remained as an option, but one of an indefinite number of options rather than the defining drive of modern art.

What is interesting about the diversity to which "Making Choices" draws attention is that even in the period of its ascendancy, Modernism was never more than one set of artistic choices. It must be conceded that MoMA's narrative of modern art included a great deal that Greenberg would never have considered Modernist at all. Whole groups of modern artists could be described as preoccupied with the pursuit of flatness only if we apply to the history of art something of the strategy psychoanalysis applies to our individual histories—that whatever we think we're doing consciously, what is really driving us forward is the need to overcome unconscious conflicts. But it is exceedingly difficult to see in such miniexhibitions as "The Marriage of Reason and Squalor" or "The Raw and the Cooked" the unconscious pursuit of flatness deflected onto another plane. Included in the first of these, for example, are Robert Rauschenberg's illustrations for the *Divine Comedy* of 1959 and Piero Manzoni's *Artist's Shit No. 014*, a can of what I take on faith abides by the principle of truth in advertising. And "Making Choices" helps us realize that more was happening in modern art than Greenberg's highly formalist account could recognize. In fact, it is very difficult to see how even the paradigm figures of modern art were Modernist in Greenberg's sense at all. "Picasso, Braque, Mondrian, Miró, Kandinsky, Brancusi, even Klee, Matisse and Cézanne derive their chief inspiration from the medium they work in," he wrote as early as 1939, in "Avant-Garde and Kitsch." "The excitement of their art seems to lie most of all in its pure preoccupation with the invention and arrangement of spaces, surfaces, shapes, colors, etc., to the exclusion of whatever is not necessarily implicated in these factors." This seems a highly unlikely account, or at the very least an account that leaves out almost everything of significance in these artists. One could insist that what it leaves out is not part of the story, or that what really makes these works modern is that which makes them Modernist. But this is in effect to indemnify the account against falsification.

———

The key contribution to MoMA's new pluralistic philosophy of modernisms is Robert Storr's exhibition "Modern Art Despite Modernism," which is like a Salon des Refusés for all the marvelous modern artists who can be counted Modernist only by means of extreme casuistry. Greenberg, for example, was disinclined to consider the Surrealists as Modernist at all. When I first moved to New York, my friends and I were overwhelmed by Pavel Tchelitchew's painting *Hide and Seek*. We held it in the same awe as Van Gogh's *Starry Night* or Rousseau's *Sleeping Gypsy*, not to mention Picasso's *Guernica*, which we never tired of seeing and talking about when we visited "the Modern." Greenberg had only contempt for Tchelitchew, as well as for Surrealism "of Dalí's kind." The Surrealists, he claimed, "did not try to hide their own retreat from the difficult to the easy." What Greenberg essentially held against them was their persistent use of deep illusionist space, which in his view Modernism ought instead to have eliminated. Storr is entirely right when he in effect says that if we attempt to include these figures in Modernism, the Greenbergian account collapses. Better not to try: They are "modern despite Modernism." And this is true of most of Greenberg's heroes. None of the paintings Storr included could have been painted before the twentieth century. In that respect, they are modern beyond question. Balthus's portraits of André Derain, or Joan Miró and his daughter Dolores, are as unmistakably modern as Max Beckmann's self-portrait or John Graham's cross-eyed sisters or Giacometti's *The Artist's Mother*—or Philip Guston's *City Limits* or the mysterious *Whisk* by Jim Nutt, which shows a woman's head on what may be a landscape or may be a dress, covered in points. Whatever it is that makes them self-evidently modern, it seems to have little to do with formalist considerations. These works address us in our own modern humanity and somehow have more to do with the modern soul than with abstract deployments of shapes and surfaces. *Hide and Seek*, I must concede, seems quite as shallow a work as Greenberg accused it of being, if not for the reasons he had in mind. It corresponds to the callowness of my distant youth.

The other antimonistic exhibition at MoMA is "Walker Evans and Company," curated by Peter Galassi. The American artists who first

claimed a Modernist identity for themselves belonged to the group around the photographer Alfred Stieglitz in the early years of the twentieth century. Stieglitz was Modernist primarily through the fact that he was zealous that photography be considered a high art. To achieve this status, an artistic photograph had to be developed, differing palpably from vernacular photographs—from postcards and snapshots and portraits for the yearbook—which Stieglitz would not have considered art at all. "There are two distinct roads in photography—the utilitarian and the aesthetic," said Charles Caffin in his distinctively Stieglitzian *Photography as a Fine Art* in 1901: "The goal of one being a record of facts, and of the other an expression of beauty." In photography after Stieglitz's era, beauty was often considered a critical disfigurement, as it was, for many advanced photographers, in Robert Mapplethorpe's work. The serious photographer instead achieved purity by aesthetic renunciation, as with what Caffin had classed as utilitarian pictures, which merely record the facts. Photography as a fine art, Caffin believed, "will record facts, but not as facts." It was Walker Evans, primarily, who translated beauty into vernacular terms, which meant that he defined the art of photography in largely anti-Stieglitzian terms. Galassi has constructed a show based on the aesthetic of the vernacular photograph, which carries us from Evans through Pop Art to such contemporary figures as Cindy Sherman.

The history of that aesthetic did not figure in the grand narrative of Modernism, which explains the place of Galassi's show in the new philosophy of many modernisms. "The dominant histories of modern art have been written virtually without reference to the work of Walker Evans (or of any other photographer), because," Galassi explains, "they are histories of painting and, to a lesser degree, of sculpture and drawing and printmaking. These histories generally ignore photographers for the very good reason that painters generally have done so." Photography began to make inroads into painting with the work of Robert Rauschenberg, and in large part it is through the Postmodernist dominance of photography that much of contemporary

pluralism is to be explained. That is a story we may take up again in the third phase of MoMA 2000, when "Open Ends" goes up in September. One hopes that when it does go up, the strike that will prevent many of *The Nation*'s readers from visiting the museum will be over. (Fortunately, I was able to see the two main shows on which I have based this essay before the strike began.) But it would be wrong to suppose that all there is to "Making Choices" is a conflict in the philosophy of Modernism. MoMA is packed wall to wall with wonderful art, and just from the perspective of pleasure, it should be one of the summer's treats for everyone, once the labor dispute has been settled.

July 17, 2000

Chardin

iderot's *Salons*, with which modern art criticism began, were extensive, sometimes book-length reviews of the official biennial exhibitions of the French Royal Academy of Painting and Sculpture, written for wealthy, noble, and sometimes royal subscribers too distant from Paris to see the art for themselves. They learned from the *Salons* what was hot in the art capital of Europe and what should be added to their collections to keep them up-to-date. "No connoisseur can dispense with owning at least one Chardin," Diderot wrote in the *Salon* of 1765, adding that Chardin was getting on in years and that a certain still life with a duck and jar of olives was the one to snatch up. Diderot was nothing if not ingenious in finding devices to aid his readers in visualizing the works under description, but in the case of Chardin, his invention somewhat betrayed him. "Select a spot, arrange the objects on it just as I describe them, and you can be sure you'll have seen his paintings." Here is his description of the painting he has just recommended: "Hang a duck by one leg. On a buffet underneath, imagine biscuits both whole and broken, a corked jar full of olives, a painted and covered china tureen . . . a pâté on a rounded wooden board, and a glass half filled with wine . . . The biscuits are yellow, the jar is green, the handkerchief white, the wine red, and the juxtaposition of this yellow, this green, this white, this red refreshes the eyes with a harmony that couldn't be bettered." Can you be sure, having had one's valet arrange these objects to conform to Diderot's description, that you will have seen the paint-

ing he has starred? What's the point of buying it, then? You can ask yourself when you stand before this very painting, on view in the exhibition of Chardin's work at the Metropolitan Museum in New York. What does the painting have that the arrangement of objects lacks, even if painting and arrangement resemble each other exactly?

Pascal wrote a famous indictment of the frivolity of painting, which attaches us to images whose originals would engage us not at all. Why should one fall in love with a painting of a dead duck, when the sight of that very duck would leave us more or less indifferent? This paradox of mimetic art has been familiar since Aristotle (Diderot was to write a great essay on the question, "*Paradoxe sur le comédien*," a few years later). In the *Salon* of 1767 he wrote that Chardin's paintings have "a handling so magical as to induce despair." It is a double despair: How to put the magic into words if you are a critic, how to achieve the magic for oneself if a painter? Chardin's "magic" was a matter of art-world speculation in his own time: "It is said . . . that his technique is totally idiosyncratic and that he uses his thumb as much as his brush," Diderot reports. "I don't know if this is true, but I'm sure of one thing, namely that I've never known anyone who's seen him work." I am sure of one thing as well: If we can't account for the magic of Chardin's paintings, we shall have not understood the first thing about them. Getting the ornithology right will carry us only so far. On the other hand, the magic could not have been entirely independent of its subject matter. My feeling is that Chardin was able to make objective in his paintings what it was that drew him to these, after all, humble objects.

His paintings are acts of transfiguration—what I have elsewhere called transfigurations of the commonplace. Transfiguration is not much of an improvement on magic, but it at least gives us a model: Christ appears to his disciples as transfigured, at once recognizably human and something more than human. "His face did shine as the sun," the evangelist Matthew reports, but "they saw no man save Jesus only." It will probably never be understood how, by means of paint and varnish, Chardin could achieve this miracle. The question is, What more than a duck or a jar of olives does the transfiguration

bring out? That, if you like, is the miracle of painting that underlies Pascal's paradox.

Jean-Siméon Chardin was accepted into the Académie Royale in 1728 as a painter of "animals and fruit"—about as low a category as the official hierarchy of the day recognized. Still life was one of the genres to which women painters were restricted, not that there was anything especially feminine about the subject matter in question— the ducks and rabbits were shot by men, for example—but because women were barred from studying the male nude. Understanding male anatomy was a condition for executing history paintings, which defined the highest and most prestigious of academic categories. The irrepressible Diderot, in his *Salon* of 1767, reports stripping for the benefit of a female artist, Madame Therbouche: "I was nude, completely nude. She painted me, and we conversed with a simplicity and innocence worthy of the first centuries," he writes, before noting how worried he was that he might get an erection. There is some evidence that Chardin's gifts were limited in ways that made it difficult for him to work in the more esteemed categories. Even portraiture (which *was* open to women artists) presented him with difficulties. There is a portrait of 1734 of a fellow artist dressed up in the fur-trimmed robes of a scholar and reading in his study. It is titled *The Philosopher*, and it clearly lay beyond the artist's powers. Its faults have to be defined in terms of the magic it lacks. Whatever it was in copper pots and glazed earthenware—or hanging ducks—that elicited Chardin's unparalleled transfigurative powers, it was evidently lacking in philosophers.

There is a well-known anecdote about Chardin depicting a dead rabbit. "This subject may seem of scant importance; but the manner in which he desired to depict it made it into a serious study. He wanted to depict it with the greatest veracity in all respects, yet tastefully, giving no appearance of servitude that might make its execution dry and cold. He had never painted fur before . . ." What I trust in this anecdote is the thought that Chardin achieved what the French would

call *l'effet* of fur right away—that it was a gift, like perfect pitch, and not something that he either learned (neither of his otherwise competent teachers possessed it in any degree) or could transmit to others. I would contrast the effect with the illusion of fur, which can be taught. His paintings of dead rabbits are not trompe l'oeil. No one would say, You can see each hair! No one would believe it a real rabbit. The various wicked kittens Chardin liked to show filching an oyster would hardly be deluded into attempting to filch one of his painted oysters, the way that birds went after painted grapes, according to the ancient anecdotes. This is how dead rabbits look, one might say, but that too is something of a misdescription. Everyone, from hunters to scullery maids, knew how dead rabbits looked. What Chardin somehow did was bring these animals into a kind of moral focus. He vested them with the meaning of taken life. Stripped of movement, they hang between a dead partridge and a Seville orange, in a sort of spare stillness. "There's no confusion, no artificiality, no distracting flickering effects . . . calm and serenity are everywhere," Diderot writes. Trompe l'oeil, by contrast, is a kind of gimmick.

He also writes, "One stops in front of a Chardin as if by instinct, just as a traveller exhausted by his trip tends to sit down, almost without noticing it, in a place that's green, quiet, well watered, shady, and cool." There is a wonderful *View of the Salon of 1765*, by Gabriel de Saint-Aubin, showing its huge history paintings, its scenes of victory, its portraits of famous personages, its bronze and marble figures. One can imagine how refreshing it must have been to come upon a basket of grapes or plums by Chardin, and how reluctant one would be, as an art critic who loved painting, to move on to *Marcus Aurelius Ordering the Distribution of Bread and Medicine to the People in a Time of Famine and Plague*, by Joseph-Marie Vien, or to Carle Van Loo's *Augustus Closing the Doors of the Temple of Janus*. I would feel the same relief that Diderot did: "Here you are again, great magician, with your silent arrangements!" What Chardin returned his viewers to was the tranquility of domestic life, the peace of households, the abiding satisfaction of the everyday—to, discounting the king's powerful mistresses and given the realities of his era, the world of women. France had been defeated in the Seven Years' War and humiliated by the Treaty of Paris in 1763. In foreign policy and in domestic affairs, the

monarchy sustained a growing opposition that was to end only with
its overthrow. Little wonder that Louis XV was among Chardin's pa-
trons. There is a powerful consolation in the quiet rituals of the
kitchen pantry, where most of Chardin's scenes are set.

It is, I think, as vehicles of such consolatory assurance that Chardin
seems to have selected the household objects that figured in his char-
acteristic compositions. It is not, thus, merely as an occasion for show-
ing the "effect of copper" that he did what I think of as two similar
portraits of a tinned copper pot, placed in a simple composition with a
pepper mill, a glazed casserole, three eggs, and a single limp scallion.
The paintings appear to have been in the estate inventory of Chardin's
first wife, Marguerite Saintard, and it is a plausible inference that the
pot belonged to her kitchen. One wonders, Pascal notwithstanding,
whether Marguerite was not attached to these images because she was
attached to the pot itself. After all, Chardin, not particularly affluent
at the time, let her keep these pictures. Whatever the reality, each
painting is a quiet miracle. The pot had been used and scoured, over
and over, until, one feels, usage and polishing had penetrated the
metal, and Chardin's image embodied this patina, so that the pot sits
like a monument to domestic virtue and the beauty of loving use. One
problem with *The Philosopher* is that Chardin had no feeling for the
various scientific instruments in the thinker's chamber. There is an al-
chemist's retort, for example, on the shelf behind him. Retorts, so far
as I know, would not have figured in the household. They were used
for distillation, and the presence on the philosopher's table of what
may be some gold coins makes one wonder if he is looking up the
recipe for turning base metal into gold in the heavy tome in front of
him. Chardin could really paint only what he understood, and what
he loved. Against the rich world of meanings in which the women of
the household led their lives, the artificial postures of martyrs and he-
roes were empty and abstract—even if that's where the commissions
were. The fact that Chardin became so successful is testimony to the
fact that the powerful collectors who read Diderot felt drawn to the
same plain truths.

Chardin's *A Lady Taking Tea*, of 1735, in fact portrays his wife, who died two months after the painting was done. It is an extremely affectionate picture, with perhaps a private joke in it between husband and wife: The steam, curling up from the lady's cup, echoes the white curls of her hair. The light comes from behind and above her, falling on her cheek, casting her face in soft shadow. There is light along the top of her hand, the front of the cup, the edges of the red lacquered table, the top edge of the open drawer. It is reflected in highlights on the teapot and on the corner of the table. One tries to see if there is any internal evidence that Chardin was aware that his wife was soon to die. Does the fact that she is sitting refer to the condition of her health or to her social status? The elegant table, the painted porcelain beaker, and the glazed teapot are the attributes of a lady, as the sword and musket are the attributes of a soldier. One would not suppose that it was Madame Chardin herself who scoured the tinned copper pot! No household in France was too poor to be without a servant or two. Madame Chardin, in her silk shawl and ribboned headcloth, is the overseer of the domestic order. She is painted, as it were, in state. There is no sign of her imminent mortality.

What I have referred to as a world of women cannot but evoke a comparison with the paintings of Vermeer. The lady taking tea is a distant sister to those amazing female presences Vermeer painted but somehow more down-to-earth. Vermeer's women have an aura comparable to angels or muses. They exist in an atmosphere of eroticism and art, playing instruments, flirting, composing letters, and they interact with men who are their willing if dangerous subordinates. There are no children in Vermeer's paintings, but they figure importantly in Chardin's. Males are entirely absent from Chardin's interiors, except as adolescents absorbed in tranquil leisure pursuits, building houses of cards, blowing bubbles, spinning tops, sharpening pencils. Otherwise they appear only as kitchen boys, and by implication as huntsmen. Several paintings show girls old enough to begin to learn the domestic arts, although there is an almost monumental picture of a preadolescent girl, dressed like a little housewife in ample skirts, holding a racquet and shuttlecock. The magic of this painting is in the stiffness of the feathers and the polished feel of the wood in the girl's

grasp. Her face is not up to the material reality of her garments and her playthings. Perhaps there was a problem of scale, but Chardin did not, in my view, master the portrait until his very late self-portraits in pastel, or the magnificent drawing of his second wife in 1775.

Her teacup survives the first Madame Chardin. It still emits steam, this time in the company of a jar of apricots, three wineglasses (two of them empty), some biscuits, an orange, and a packet of sugar wrapped in paper of a hue never seen outside a Chardin still life, neatly tied. The intimacy between upstairs and downstairs is reflected in the way elegant pieces of soft-paste porcelain, like Madame Chardin's cup, mingle with the heavily glazed utensils in the still lifes, and both fraternize with vegetables, fruit, fish, bread, and meat. Chardin remains within his own four walls as a painter but moves between parlor and kitchen—between the ladies taking tea, reading, examining embroidery, training a canary to sing, and the strapping women who do the work.

The kitchen women are the glory of his art. Nothing in the history of painting, except his own *Turnip Peeler* or *The Attentive Nurse*—in which a woman is preparing an egg for a convalescent—compares with *The Return from Market*, in which a servant is shown laying two immense rounds of crusty bread on a polished walnut buffet, still holding a gigot in a cloth sack, which hangs heavily in her right hand. She is pausing rather than resting, and she has the dignity and inwardness of one of Michelangelo's sibyls. Chardin has a sense for the particularity of her clothing, which would have been beneath Michelangelo: Her voluminous blue apron, her striped skirt and neckcloth, her flounced cap and pointed shoes correspond to the personality he teases out of utensils and furniture. But this time a fleeting expression, at once melancholy and pert, brings her face to life. The kitchen women have inner lives: The turnip peeler pauses to pursue a daydream, the scullery maid looks up from her drudgery, the attentive nurse is absorbed in something more vital than laying out an invalid's meal.

Chardin did four versions of *The Return from Market*, and he had

it engraved as well. The engraving displays a caption so incommensurate with the painting's depth of humanity that it is difficult to understand how Chardin could have let it stand: The servant is described as preoccupied because she has "borrowed" household funds to pay for her fancy clothes. It is a demeaning legend, but Chardin was something of a hustler, as an eighteenth-century artist in one of the lower categories was obliged to be, and the bourgeois purchasers of engravings found amusing the idea of little wickednesses in saucy serving girls. They are no worse than a cat he would place among the oysters, knowing how sentimental the French could be about a mischievous kitten: *Regardez le minou méchant!* He was obliged to paint to the market as well as to the soul, which accounts for the fact that he turned out *singeries*—pictures of monkeys painting, or writing, or carving statues, or playing music, which the French always found engaging (and which the organizers have left out of the Metropolitan show). There is a streak in Chardin of what we find objectionable in Norman Rockwell. For all that, no one touched him, not even Rembrandt, in presenting as the deepest things we know the surfaces of daily life. When I spend any time at all with Chardin, I think of what the shade of Achilles says when Odysseus seeks to console him for having died: It is better to be alive, even as a poor, landless underlaborer in the service of another man, than king over "all the perished dead."

August 7/14, 2000

Tilman Riemenschneider

An image, Albrecht Dürer said, is "no more responsible for superstitious abuse than a weapon is responsible for a murder." It is somewhat startling to find, in the controversy over the power of images in the early years of the Reformation in Germany, the familiar argumentation of the National Rifle Association. Admittedly, Dürer had the same vested interest as a purveyor of images that a manufacturer of handguns has in arguing that the point is not to control weapons but to reeducate their users. The analogy nevertheless stands as evidence for the felt danger of images in Dürer's world. Indeed, the image would be far more dangerous than a mere weapon, since it exposes worshippers to the danger of eternal punishment in case they find themselves, as often happened, worshipping the image instead of whatever the image represents. Better to rid the churches of images altogether than to trust the pious not to believe that Jesus or Mary, or a particularly well-disposed saint, was mysteriously present in their effigies. The power of the image was in effect the power of the being that occupied it, which struck the enemies of the image as idolatry, or the worship of finite things. This had the consequence of driving images underground, in the form of doll-sized objects of private adoration. Even today, after all, lovers kiss the snapshots of their beloveds, as though the relationship between the two were metaphysically intimate. Iconoclasm did not always entail that images (read: "idols") should be burned like heretics. They could be shrouded or stored in cellars or otherwise quarantined. But image control was the

order of the day under militant Lutheranism—not least of all because the church issued indulgences to those who prayed to particularly powerful images, like the Virgin of the Apocalypse or the Virgin of the Rosary. Protestants could do little better to register doctrinal difference than to purge their churches of likenesses. Catholicism retaliated by crowding its churches with images for the benefit of those who sought the concrete presence of the beings they worshipped. Aesthetic contemplation was not really a concept in the sixteenth century. Churches were not museums of fine art.

It is ironic that iconoclasm should have erupted with such virulence in the golden age of German sculpture, bringing it in effect to an end. The great achievement of the so-called limewood sculptors of the late Gothic period was the elaborate altarpiece, or retable, which served to render visible the object of devotions enacted on the altar just below. It was very much as if the saint conferred upon her celebrants the immense benefit of her virtual presence in the charged space where masses were performed. The architecture of the retable contributed to the awe in which the image was held. It was, for example, equipped with doors, which would be opened only on auspicious religious occasions but otherwise were kept closed. It had to have been a pretty powerful experience to behold one's special saint under candlelight, as the priests in elaborate robes intoned indispensable prayers in a language farmers and merchants no longer understood (conducting services in the vernacular belonged to the same agenda as iconoclasm). The space of the retable was a space within the space of the church, and when the doors stood open, an extraordinary bond united the persons within and without that encapsulated space. It would have been difficult to believe with Dürer that the images were merely neutral. Everything in the setting cried out against such a reduction.

The Franconian sculptor Tilman Riemenschneider was the great master of the pre-Reformation retable. There is an astonishingly complete altarpiece in the Jacobskirche in Rothenburg, executed around 1502, which must have seemed miraculous in its own right because of the skill with which it was carved. It is known as the Holy

Blood Altarpiece, containing what was believed to be Christ's very blood as a relic. My own view is that images were felt more or less to have the status of relics, and one's relationship to them was entirely parallel to that with such awesome things as pieces of the true cross, or drops of the Virgin's milk, or whatever. There is a large photograph of the Holy Blood Altarpiece in the exhibition devoted to Riemenschneider at New York's Metropolitan Museum of Art, and it is worth a moment's examination if one wishes to get a sense of the context for which so much of the artist's work was designed. The retable consists of three zones. In the lowest zone, which in effect is the altarpiece's predella, angels on either side of the crucified Christ display some of the emblems of his redemptive suffering—the whipping post on one side, the cross on the other. The topmost zone is a flamboyant superstructure, as intricate and lacelike as a Gothic spire, which gives the sense of being made of the thorned branches with which Christ was flogged and crowned. This shrine holds the relic that refers to and is explained through the suffering represented in the predella. The midzone shows Christ and his disciples taking their last meal together, the weight of the event inscribed in the seriousness of their expressions. The inner surfaces of the doors, visible only when they are opened, show scenes from the life of Christ, carved in an astonishingly low relief—Christ's fateful entry into Jerusalem on the altar's right, and on its left Christ in the Garden of Gethsemane, praying not to have to undergo the tortures shown in the predella or spill the blood believed actually present at the apex of the tower. The whole piece is, as one of the specialists writes in the catalog, "an intense reflection on the nature of representation."

Not long ago, a distinguished novelist volunteered, in a panel in which I participated, a comparison between literary and visual art. The difference, he said, is that because novels are made of language, they express thought, whereas pictures are just pictures. This is hardly a judgment that can survive the experience of a work like the Holy Blood Altarpiece, if it is even possible to think of it as a "reflection on the nature of representation." The truth, which would be

amazing if it were not so commonplace, is that visual artists express thoughts, and often very complex thoughts, by sensuous means so compelling that even the illiterate can grasp their meaning. In the eighteenth century, pictures and sculptures underwent transformation into aesthetic objects, to be addressed through a kind of disinterested contemplation. They were put on pedestals, so to speak, the way women once were, to be admired as decorative trophies. I have often thought that the aestheticization of images and of women was an ingenious response to the perceived danger of both. In any case, from my fellow symposiast's point of view, a visual artwork is simply something good to look at, perhaps an embodiment of beauty. But aestheticization was a defensive measure against the fear that images would penetrate consciousness and cast us into sin. Words, by contrast, were relatively harmless. "The whole direction of early Lutheran piety," Michael Baxandall writes, "was away from the image, indeed away from the altar, and towards the word and the pulpit."

Fortunately for us, Riemenschneider produced his great work before retables stopped being commissioned, leaving sculptors with no way to earn their livelihoods. Something like this happened, incidentally, in late medieval philosophy as well. It became more and more intricately architectonic—until, through Lutheranism, thinkers all at once lost interest in abstruse distinctions and ramified argumentation. "The wretched Luther has emptied the lecture halls," a sixteenth-century philosopher said. What philosophy and art would have been like had the Reformation never taken place is impossible to imagine.

There is no integral altarpiece in the Metropolitan exhibition, but there is a wall installation made up of six components—four figures from the predella and two carved door panels—from a magnificent retable, originally in the Church of Mary Magdalen in the town of Münnerstadt. The predella figures are the four evangelists, each holding the Gospel with which he is credited, and each represented in a posture of complete inwardness, as if reflecting on the meanings of the events he has narrated. They seem to represent four stages of writing. Matthew is looking upward, as if waiting for a revelation to transcribe in the book in his lap; Mark, with his lion, doglike on the floor beside

him, is intensely reading what he has written; Luke has closed his book and is reflecting on its incredible narrative; John appears to be interpreting a difficult passage, perhaps for himself, holding up the fingers of his right hand like a scholarly explainer. Or perhaps he is editing. The four figures together form a frieze of intense intellectual concentration. They originally populated the lower zone of the Münnerstadt retable.

The middle zone reveals the ascension of the Magdalen, accompanied by angels and wearing a penitential garment. The doors show scenes from the Magdalen's life when she was still a harlot, paying tribute to Jesus in ways that may have occurred to a woman of her calling—laving Christ's feet with her luxuriant tresses in the house of Simon, reaching out to touch the resurrected Christ with one hand and holding her jar of ointment with the other, as if to comfort him in the only way she knows. Christ repulses the gesture, telling her not to touch him—*Noli me tangere*. The garments of both figures—and Christ's banner as well—seem whipped by a strong wind, to my mind always the emblem of invisible powers. In Counter-Reformation Rome, the furled, blown garment expresses the situation of celestial beings—saints, martyrs, angels—caught up in a world of fierce invisible forces. In an early Annunciation, which Riemenschneider carved in alabaster, the angel's robe is agitated as if the angel had been blown into the Virgin's presence. Interrupted by this astonishing occurrence, the Virgin looks calmly up from her book, but in contrast with the angel, her robe falls in deep, gentle curves to the floor. They belong to different orders of being.

The components from the Münnerstadt altarpiece, like those from the Holy Blood Altarpiece in Rothenburg, are carved of limewood, and this raises a question to which no one, so far as I know, has found a compelling answer. Since it was the practice in Germany to cover sculpture with polychrome paint, the question is why Riemenschneider's figures are palpably carved wood, natural rather than painted and gilded. The wood is not raw, of course. It is stained and polished, but its wooden substance has something like the warmth

and smoothness of flesh, and we can imagine it reflecting candlelight like beautifully polished furniture. All this would be submerged under gesso if the figures were painted to look like, well, real people with pink faces and blond hair and rich garments. There is a paradox in the fact that they look more real, though visibly carved from wood, than had they been painted to look more realistic. Their unembellished woodenness did not in any case immunize viewers against the toxin that images were believed to carry. Fidelity to the medium, of course, was ideologized in modernist times, so that painting wooden sculpture was considered an aesthetic crime. But it is probably a mistake to project aesthetic theories very far back in time. Riemenschneider's contemporary Veit Stoss was in fact commissioned to paint the Münnerstadt altarpiece. But Stoss specified that one of his own altarpieces should not be painted, leaving us to ponder what the reasons could have been.

He was, the catalog speculates, "keenly aware that layers of ground and paint would conceal the fineness of carving." But who would be interested in fine carving except fellow members of the sculptors' guild? Those who knelt before the altar were put in the presence of a vision and were hardly interested, caught up as they were in prayer, in the craftsmanship of the figures. Much of the writing on Riemenschneider—about whom not a lot is known—uses concepts from modern art criticism, when the whole institutional structure of presenting art resembles nothing in the world of the limewood sculptors. Baxandall, whose scholarship is indispensable, finds that Riemenschneider's work, seen from a close view, is disappointing: "The figures are grotesquely proportioned with big heads and even larger noses" and "The more carvings by Riemenschneider one sees, the more repetitive and mechanical the cutting of such detail as eyes and hair can appear." But the images were not intended to be seen close up. Nor were they meant to be shown together, as in a retrospective exhibition, in which a modern critic might complain that his figures were much alike—that the artist was "repeating himself." People did not move from church to church, as they do in Chelsea from one gallery to another. Much of the critical literature, if less outspoken than Baxandall, is equally anachronistic. Which leaves in the dark the

fact that Riemenschneider and Stoss and so many of the limewood sculptors of Germany quite evidently cherished the fact that their great works were seen to be made of grained and knotted wood, minimally enhanced with stain.

The figures were for the most part meant to be seen from below—the curators have installed the carvings at the high angle from which they would have been seen by worshippers. The disproportion Baxandall deplores might, from that perspective, simply have disappeared. The heads of Greek sculptures were deliberately enlarged in order that they look normal when the statue is displayed on columns. This was one of the illusions that Plato held against the visual artists of his time. The largeness of heads in retables contributed to the illusion so central to religious experience in Franconian churches, which would differ completely from the experience of a scholar examining them objectively with magnifying glasses.

In any case, unless one is looking with a connoisseur's eye at the pieces installed in the exhibition, one will not have a sense, let alone a strong sense, that the work is repetitive. We may not be able to see the figures with the eye of faith, the way Riemenschneider's contemporaries did, but we cannot but respond to the intense feelings his figures express—cannot fail to note the way the calmness of the Virgin, for example, is made transparent by the visual excitement of the angel's garment. Many of the pieces, of course, refer to some lost altarpiece, but even without the context in which a figure's expression would be explained by showing its object, we get a pretty good sense of what Riemenschneider is attempting to tell us. We know, for example, through the effect the sober figure of Saint Matthew makes on us, what it would contribute as part of an altarpiece. Matthew has been distracted by something momentous. He was fiddling with his robe when the revelation came, and his hands seem arrested in whatever gesture he was performing. His eyes look steadily away, his expression is resolute, he is prepared for the terrible events that lie ahead. Connoisseurship is probably indispensable in deciding matters bearing on the physical statue, but it has little to do with the calling of

a saint. Riemenschneider was not carving for experts but for the most ordinary of persons. His means—and meanings—are almost transparent.

Matthew is as upright as a pillar. As such, the statue contrasts with the amazing image of Tobias and the Archangel Raphael carved by Veit Stoss, placed next to Matthew to show the strong differences between these two masters. The story is from the Old Testament: Tobias's father, Tobit, has gone blind and become poor. The devoted son sets out to collect money owed Tobit and meets a stranger, who instructs him to catch a fish, remove its gall, and use this to restore the father's sight. Raphael is measurably taller than Tobias in Stoss's piece, and characteristically, his garment seems blown about by the winds that proclaim his angelic identity. It is easy to suppose that he moves without touching the ground—every inch an archangel. Tobias is dressed like the Jack of Hearts, with a felt hat and what may be an ermine tippet. His feet seem to execute a dance step, and indeed his *contrapposto* posture is that of a dancer. But he also seems, in contrast with the effortlessness with which Raphael moves, to be feeling his way along the ground, unsure of his footing. In an odd way, Tobias seems, like a good son, to have taken on his father's blindness. He is clutching the angel's arm and being led. His head is tilted upward, and he has no expression to speak of.

The archangel wears a smile of cosmic superiority. There are no smiles as such on Riemenschneider's faces. Stoss belonged to the archetype of the rebellious artists, in trouble with the law, often on the lam. Riemenschneider was as upright as his Saint Matthew, which could be a moral self-portrait. He was a pillar of the community, a magistrate as well as the master of a busy workshop, Kantian in his devotion to duty (for reasons of political conviction, he too got into hot water). He gave his patrons images they understood, since the expressions they wear are like the expressions through which we all read one another's feelings. In this respect, there is little difference between their psychology and our own. The figures suffer and show tenderness, in just the way people everywhere do. The retables show ordinary humans caught up in superhuman happenings. Their readability has to have lent conviction to the images, and possibly it explains

something about the use of wood. This too may be a modern attitude projected back into an artistic period very different from ours, but we are made of the same emotional substance as those first affected by his figures, which they saw as made of the same emotional substance as themselves.

April 17, 2000

Damien Hirst

In memory of Saul Wineman

Damien Hirst is thirty-five years old, and since 1988, when he organized and starred in the legendary exhibition of young British artists titled "Freeze," he has been what one London critic felicitously called the "hooligan genius" of British art. The hooligan genius belongs to artistic mythology, but we have not had an example of one in the visual arts since perhaps Jackson Pollock, and Hirst's hooliganism is evidently of the same ruffian order we associate with the English soccer fan—he even composed an anthem for that brawling brotherhood in which the only identifiable word is "vindaloo." There is a photograph of him glowering in a meadow, wearing shorts, low boots, an open jacket; we cannot but wonder about the fate of the cow standing behind him, considering that Hirst has been responsible for having some of her sisters sliced into sections, immersed in formaldehyde, and distributed in no particular sequence in so many glass tanks. Such works, like the affecting lamb or the bisected pig in last year's "Sensation" show at the Brooklyn Museum of Art, have touched off a debate in ethics as to whether it is a better fate for an animal to wind up as a work of art when its destiny would otherwise be the dinner table—or, in the case of the magnificent tiger shark that was also on view in "Sensation," as dog food.

Whatever the outcome of these disputes, Hirst uses death as a way of expressing thoughts about death. "His most celebrated work," according to a press release, "has never shied away from the terrible beauty that lies in death and the inevitable decay contained in beauty";

Hirst himself, on a Web page, is quoted as saying, "I am aware of
mental contradictions in everything, like: I am going to die and I want
to live forever. I can't escape the fact and I can't let go of the desire."
The title of one of his most controversial, and somehow most sublime,
works—the tiger shark suspended in formaldehyde solution—is *The
Physical Impossibility of Death in the Mind of Someone Living*. "It is pos-
sible to avoid thinking of death," the novelist Leo Litwak recently
wrote me, "but that would require me to stop thinking." The work is
very frequently shocking, which is the hooligan side of his genius.
Shock is a means, however, of advancing the Heideggerian reflections
on death that have driven him from the beginning, very much in evi-
dence in the exhibition of Hirst's work now on display at New York's
Gagosian Gallery.

Hirst did a photograph in 1991 called *Self Portrait with Dead Head*,
which perhaps only a hooligan would have thought of. It shows
his vividly youthful face, grinning merrily at the viewer, while his
head is placed, literal cheek by literal jowl, with what appears to be
the decapitated head of what had been a much older man. Perhaps
any such head would be frightening, but this looks as if its owner had
been frightening while alive: It is like the convict's head in a particu-
larly scary film version of *Great Expectations*. The photograph could
scarcely be in worse taste: It violates our sense of the dignity owed the
dead, whatever they may have deserved from us when alive, and it
stirs some primordial, ill-understood sense of fittingness. Perhaps only
the very young would be sufficiently without squeamishness to pose
intimately with a cadaver. However, once one's disgust is overcome, as
much with the artist as with his subject, one realizes that he has cre-
ated an unforgettable image of life and death and an artistic path that
takes us through the body of his work from that moment on.

The theme of death, at least as expressed through animals and an-
imal parts, is muted in "Theories, Models, Methods, Approaches, As-
sumptions, Results, and Findings," as Hirst has titled the Gagosian
show. It is, however, obliquely implied in the title *Concentrating on a
Self Portrait as a Pharmacist*, this time a painting of—and I assume

by—the artist. It is a fine, expressionist picture that shows the skeptics not only that yes, Hirst can paint, but that even in an earlier period of art, when painting was art's primary vehicle, he would have been a marvelous artist. It is, however, not on the wall. It is on an easel, from which a white coat hangs down. Painting of this sort being so old-fashioned a medium, one infers that this is an artist's smock. In fact, it is a laboratory coat of the sort doctors and pharmacists wear. Easel, painting, and lab coat are enclosed in a glass booth, itself set into a large vitrine. Outside the booth, hence unreachable by the artist in the act of painting, is a taboret with brushes, rags, and tubes of paint.

Pharmacognosy—to use the old-fashioned word—has obsessed Hirst for nearly as long as death has, and in the present political pre-occupation with prescription drugs, the exhibition could hardly be more topical. In 1992 Hirst created an installation specifically titled *Pharmacy*—which, according to the label, contains "medicine cabinets, desk, apothecary bottles, fly zapper, foot stools, bowls, honey, glass. Overall dimensions 28'7" 22'7" (variable)." It is like a play drugstore for a privileged child. In "Sensation," there were several shallow vitrines arrayed like medicine cabinets, with vials and boxes aesthetically arrayed. These were used as decorative items in the instantly fashionable restaurant Pharmacy, which Hirst opened in London in 1997. The present show is like a museum of pharmaceutical displays. There is, for example, a wall cabinet containing "8000 individually hand crafted model pills"—though I am insufficiently drug literate to be able to identify any of them. The work is somewhat mysteriously—unless the pills modeled are stupifiants—called *The Void*. There are in addition two quite large wall cabinets with arrays of surgical instruments, anatomical models, skeletons, basins, and the like. One of them is called, somewhat irreverently, *Stripteaser*. Perhaps it refers to the skeletal condition in which we are stripped of our flesh by the various items of surgical cutlery (in another room, one finds a glass cabinet displaying several animal skeletons, titled *Something Solid Beneath the Surface of Several Things Wise and Wonderful*). There is an overall tone of nervous merriment, of giggling in the face of our mortality. I can imagine a hooligan joke about the stripteaser who peels the flesh off her bones and, now a skeleton, capers about the stage

grinning at the patrons, oblivious of the fact that there are no erotic skeletons. One of the works in the show consists of a skeleton on a cross of glass panels, above whose skull a pair of eyes (painted Ping-Pong balls) bobbles in a spirited danse macabre on what I guess are air jets. It is called *Death Is Irrelevant*.

The show brings together in a way both sides of Hirst's persona, concerned with death and with healing. I got an understanding of one genre of his paintings, for example, that, superficially at least, doesn't seem to have much to do with the preserved carcasses of animals. These are arrays of dots, regularly arranged—like pills—in neat rows and columns. They are painted with glossy househould enamel on canvas, and it feels as if Hirst uses the entire spectrum of colors made available by the manufacturer. There is, despite the orderliness of the matrix, no chromatic pattern that I could discern: It is as if the choice of colors were randomly determined, except that Hirst has said that no two hues in a given painting are identical. So there would be no way of projecting the pattern past the edges: There are no "repeats." The paintings have the all-over patterning of wallpaper (a similar thing used to be said of Mondrian). As art, they have the look of Minimalist paintings of a few decades ago, less austere than the dot paintings done by Robert Irwin but generated by comparable imperatives. A recently published dictionary of twentieth-century artists describes these works as "plumbing the repetitious possibilities of painting," as though they were merely formal exercises "produced in seemingly endless series by Hirst's assistants." I previously saw very little in these paintings, nor could I see any way of connecting them with the rest of his work, viewed as a collective meditation on death.

Recently, however, I began to pay attention to their titles. One of the paintings in "Sensation," for example, was called *Argininosuccinic Acid*. A chemical involved in the synthesis of arginine, argininosuccinic acid is one of several amino acids used to form proteins, fundamental components of all living cells. Several paintings in the show are named after cobras—*Naja Naja, Naja Naja Atra, Naja Melanoleuca, Naja Flava, Naja Haje*, and so on. *Naja Naja* is the asp, the venom of which is legendarily deadly. According to an ancient authority, the Egyptians employed a form of relatively humane execu-

tion by means of asp bites, and it must have been with *Naja Naja* that Cleopatra committed suicide. There are antivenins, made of venoms, however, and one wonders if Hirst has in mind the idea that certain toxins can generate their own cure. Digging around a bit, I encountered reference to the fact that he may actually believe that these paintings have specific pharmacological properties. I was unable to see any relationship between the (not well understood) chemistry of snake venom and the formal properties of the dot paintings—but in any case, the idea that painting is a form of pharmacology makes it a literal possibility that the artist can be a pharmacist. It is not necessary for viewers themselves to share this belief, but it strongly connects these otherwise incongruous paintings with the rest of the work. And it incidentally underscores the fact that formalism alone will not get you very far in art criticism.

The first thing one encounters upon entering the gallery is a colossal figure, twenty feet high and weighing six tons, in luridly painted bronze. It monumentalizes a toy, called Anatomy Man by its manufacturer and designed so that children can learn the shapes and placement in the body of the major organs. "I loved it that it was a toy," Hirst told an interviewer. "I wouldn't have done it with a teaching hospital one." The fact that the immense figure (titled *Hymn* [=Him]) is an enlarged educational toy underscores the element of play that I felt was in the 1992 *Pharmacy* and in *Death Is Irrelevant*. A work called *The History of Pain* is a high white box, with a number of knife blades sticking up, threatening a bleached beach ball suspended above them. It is, I suppose, an allegory of mind and world, the former rising and falling on a jet of air in the spirit of a striptease, as the viewers wait for the ball to fall onto the knives to be shredded. Its message—the ball as consciousness, the world as knife blades—may be somewhat obvious, but I find it difficult to think of another artist concerned to deal with the concept. It is this readiness to take on the questions of the ages that causes my overall admiration of the Young British Artists, even if they cross the line in sometimes trivial, sometimes juvenile ways.

There is nothing obvious, trivial, or juvenile about two of the

works, titled *Love Lost (Bright Fish)* and *Love Lost (Large River Fish)*. As with *Concentrating on a Self Portrait as a Pharmacist*—like most of the works in the show—these are installed in very large vitrines or aquatic tanks. Each of the *Love Lost* tanks contains the furniture of a gynecologist's examining room, with stirruped tables and surgical instruments. In one there is a computer, in the other, more humanly, a clothes stand. The furniture in both is submerged, and fish swim freely, as in aquariums. The works are inevitably mysterious, as there is no clear narrative that connects the examination equipment with the water and the fish, nor is there any available allegory one can easily seize. Any interpretation that occurs to me seems instantly superficial, so I think it best to let the mystery stand. There is, however, one truth worth considering, which is that both works are extremely beautiful, and while I do not know how to connect beauty with (what I suppose is) abortion, it seems to me that one possibility is that beauty heals, as the artist Robert Zakanich once said to me. There is something universally aesthetic in watching the movements of fish through water, like dancers through space. But in *Love Lost*, this beauty is somehow related to, well, lost love, embodied in the abortionist's setup, and the idea may be that the beauty heals the pain of loss, or that it can. It at any rate suggests a meditation on the pharmacology of beauty. What cannot avoid notice, however, is fish excrement drifting down, beginning to soil the immaculate equipment. And we know, unless steps are taken, that the water will grow murkier and murkier, and the fish will die, and beauty will vanish. Water is not formaldehyde. The beauty cannot be preserved. And the fragility of beauty is like the fragility of life.

The title of the show—"Theories, Models, Methods, Approaches, Assumptions, Results, and Findings"—is also the title of one of its works, which consists of two vitrines, each with noisy blowers and a small population of Ping-Pong balls. It seems a sullen, pointless work, and one cannot but wonder how it connects with the title, which could be a postmodern name for an anthology in the philosophy of science. The work is like one of those devices with which lotteries are decided, where each ball has a number. Here the balls are unmarked, rise and fall meaninglessly, without deciding anything. If I see it as

suggestive of anything, it is by way of a pessimistic answer to the meaning of life. Luckily, the desire to go on living does not depend on getting deep answers to our question of why.

In an interview conducted in 1996, Hirst was asked to make an Artist's Statement. His first answers were yob irreverences, not worth reprinting here. But then, abruptly, he tells the interviewer that he likes a piece by Bruce Naumann, of which he gives an exceptionally sensitive reading: "It's a neon sign that's a spiral that goes into nothing in the center and you have to tilt your head when you read it and it says 'The true artist helps the world by revealing mystic truths,' and you go 'Oh, yeah, great' and then you go 'Oh god' and there's nothing there."

Naumann did this work in 1967, as a sort of window or wall sign. I had always taken the work as a piece of Naumannian irony, but it is clear that this is not Hirst's attitude. It never occurred to me that part of the meaning of the work is that it gives no answer to the question of which *are* the mythic truths. If one were to see it in a show of Naumann's work, and look at the pieces it is surrounded by, one would have to say that Naumann is not a true artist by his own definition: His pieces are all more or less jokes, which makes this work a joke. I had not considered the spiraled words just ending in empty space to mean: There are no mythic truths, there is only nothing. As an artist's statement, "Oh god, there's nothing there" is pretty deep.

Whatever your cultural agenda, then, you owe it to yourself to pilgrim up, down, or over to Chelsea, to look at the spectacular exhibition of Hirst's art in the scarcely less spectacular setting of the remodeled Gagosian Gallery. It is a little early in the twenty-first century to speak of high-water marks, but it's difficult to believe that Gagosian's space—twenty-three thousand square feet, the size of a small museum—will soon be superseded. And if a body of work comes along that in ambition and achievement puts Hirst in the shade, we are in for a remarkable era. I cannot imagine what it would be like to afford, let alone live with, one of Hirst's pieces, but someone has to be paying for works of this sort, each of which requires a sub-

stantial capital investment in hardware. And I am again overwhelmed by the generosity of the gallery system, which opens its doors to the general public free of charge. Free admission to the other high arts is rare and uncharacteristic. The walls at Gagosian have even been decorated with a tasteful green graph-paper motif, to imply the atmosphere of a natural history museum that Hirst's pieces seem to create. The show really feels, however, like a toyland, a Halloween extravaganza with something for everyone. Take the kids.

November 20, 2000

Barbara Kruger

Barbara Kruger is the absolute artist of the age of mechanical reproduction in its late-capitalist phase. Her product is the barbed image, designed to exist in unlimited numbers on the vernacular surfaces of inexpensive everyday objects, like mouse pads and T-shirts, tote bags and coffee mugs, wristwatches and umbrellas, as well as posters, postcards, book jackets, magazine covers, and matchbooks. They are as much or even more at home in the museum gift shop as in the galleries upstairs, and since the objects there are purchased and carted away, they enter the stream of life and carry her messages into precincts far from the centers of high culture. Beyond that, she has evolved a format as instantaneously recognized as the great logos of commercial art, so that Andy Warhol, were he still around, could add Krugers to his repertoire of images everyone in the culture immediately identifies. Asked to complete "I shop, therefore . . ." for thousands of dollars on the way to becoming a game-show millionaire, it would be the rare contestant who would not sing out ". . . I am," based on one of Kruger's more familiar epigrams. I can think of no other artist, not even Warhol, who has had a comparable reception.

I need hardly tell my readers that the archetypal Kruger is a variation of the same formal means—usually a photograph in black and white, banal and anonymous, overlaid by a small number of red banners bearing white lettering, always in the same type font (Futura Bold Italic). The blazoned message carries the piece's barb, and it

evokes an unmistakable voice. The voice is that of a moral critic, icy, smart, sarcastic, somewhat contemptuous, telling us in effect not to be jerks. "Don't be a jerk" is, in fact, one of her best-known messages, but it in some way accompanies all her messages, in the way "I think," according to Kant, accompanies all our thoughts. There are works by famous artists that belong to common consciousness in this way—the *Mona Lisa* or *The Last Supper*, for example, or perhaps *Gold Marilyn Monroe*. But every Kruger is familiar through the way Krugers are put together, even if one has never seen that particular Kruger before. She found the format early and has never seen reason to modify it. It is clear that whatever her larger purpose, the Kruger format serves it perfectly.

Consider the cover image on the catalog that accompanies Kruger's retrospective exhibition at the Whitney Museum of American Art. The message, distributed across three red banners printed one above the other, is: Thinking/of/You. The black-and-white image on which the message is superposed is of two hands. An open safety pin is held between the thumb and forefinger of one hand, its point pressed into the tip of the other hand's middle finger. It has not penetrated the skin but is about to. What exactly is the relationship between the picture and the image? That I—who am thinking of You—am a thorn in the flesh, so to speak. "Thinking of you" is what we might write on a postcard, or perhaps on a florist's card, attached to a gift of roses. It implies an intimacy, even an I/You relationship. You are on my mind, somehow, and I want you to know that you are. But ask how you would interpret a card with just this image of pin and fingers, with "Thinking of You" inscribed underneath or on the other side. You would not say "How nice!" It may not be threatening in the way a dagger would be, but neither is it a caress. The effect is to put the recipient on edge. Text and image together give a pretty fair picture of the relationship between "I" and "You" if I am Barbara Kruger and You are anyone within range of her voice. It is the relationship of I getting under Your skin.

———

Thinking of You" is not an aphorism, but Kruger's messages often have an aphoristic ring, in the sense that aphorisms should be pointed, like open safety pins, and designed to lodge in the memory, which is the reason for their being pointed. Memory is reinforced by means of associated winces. The earliest and most celebrated compilation of aphorisms is attributed to the father of medicine, Hippocrates, and they were designed to stick in physicians' minds for bedside use. "Don't be a jerk" is a very valuable teaching, given our all-too-human propensities, and though no one can spell out all the ways there are of being a jerk, it is not inappropriate to ask, at any given moment, if one is guilty of the offense. Kruger's barbed messages differ in this respect from the "truisms" of Jenny Holzer, an artist with whom, since she too uses words in her art, it is natural to compare her. Truisms express something we already know. Truisms pass for wisdom. But aphorisms hurt. That is why Nietzsche's work bristles with aphorisms, each tipped with a tiny touch of acid.

In most cases, the You is female. Kruger's well-known poster for the 1989 march on Washington in support of abortion rights has "Your body/is a/battleground" pasted over a woman's face split in two. There is an internal connection between female addressees and the fact that the messages are on things like coffee mugs and shopping bags. With this in mind, let's look at "I shop therefore I am." The photograph here is an open hand. The red banner has the shape and proportion of a credit card, slightly enlarged, on which the words are printed in the routine white letters. The "card" is so placed that the person whose hand it is seems to be displaying it. Of course, this is spatially impossible. The red banners and the photographic image always belong to different realms. The banners are on the surface, the object photographed is in pictorial space. The hand cannot, so to speak, be inside and outside the picture at once, as it would have to be to touch its own surface. There are always clever possibilities for artists to set up dissonances between surface and space in order to convey something about pictorial metaphysics, about the relationship between surface, which is real, and pictorial space, which is illusory. But Kruger is not that kind of artist. Whoever the I to whom "I shop therefore I am" refers, she is made to identify herself through procla-

mation with the activity of shopping. One says "she" because shopping in our society is fairly gender-specific: "Men hate to shop" could be one of Holzer's truisms.

Everyone recognizes the allusion to Descartes's celebrated "I think, therefore I am," and it is worth dwelling on the difference. Descartes offers "I exist" as something that cannot be doubted. Even if I try to doubt it, doubt is a form of thought, and if I think, I exist. More important, since I cannot think of myself as not thinking (try!), thought is inseparable from my nature; it is what I am: *sum res cogitans*. There is a certain dignity in being an entity whose essence is thought, but something frivolous in being one whose essence is shopping. The latter can be seen as an identity that has been thrust upon women as part of the social construction of gender. Women have internalized a role, essential to the operations of society as a mechanism, of consumption. But if they have had implanted in their mind the somewhat embarrassing "I shop therefore I am," they will at least be in a position to reflect upon whether this is an identity with which they are happy. They can ask whether in running up and down the aisles at Wal-Mart, flinging shoes, lingerie, parkas, cosmetics, potato chips into their carts, they are not, as it were, being jerks.

I have riffed my way into the discourse of late-capitalist critique, which was Kruger's intellectual milieu in the eighties, when she saw the world from the perspectives of Theory—that amalgam of Frankfurt School politics, poststructuralist semiotics, and feminist deconstruction that defined the cultural outlook of her generation and that still frames most of the critical literature devoted to Kruger's achievement. "I shop therefore I am" was meant to bring to consciousness what, when one thought it through, was not simply a fairly innocent distraction but a kind of willing collaboration in a social system. The shopper is an agent of her own oppression. The work is a piece of consciousness-raising. So how appropriate that Kruger's "I shop therefore I am" should have found its subversive way onto shopping bags, as a constant reminder, the way Hippocrates' aphorisms were meant to be. The inscription condemns the object it ornaments and, in its sly way, gets under the skin of she who carries it!

From this perspective it is obvious that "I shop therefore I am" is far more effective on a shopping bag than on archival paper, framed on the museum wall. There is, however, a certain paradox inherent to the work of art in the age of mechanical reproduction. Walter Benjamin, who originated the idea, drew a sharp distinction between works of art emitting auras of high spirituality and proletarian images doing honest work in the world. I have always thought Benjamin had in mind the great *montageur* John Heartfield, whose biting montages waged guerrilla warfare against Nazism as covers on working-class magazines. They certainly would not have had the impact they had were they hung instead in aurified isolation in gallery spaces. Kruger is like a Heartfield who has read the famous essay in which the distinction is made, and a certain number of her images are by way of digs at the museum. She installed banners on the facade of the Parrish Art Museum in Southampton, New York, for example. One, placed over the door, reads, "You belong here." As you enter into "Your" space, you pass between two signs that read "Money" and "Taste."

Now, money and taste are very nice things to possess. But somehow one feels unsettled being characterized this way—as unsettled, say, as one would be if all at once identified as a being that shops. The acquisition of taste takes time; the objects on which taste is honed and exercised cost substantial amounts of money. Is this what you should have been doing with your time and money? In the lower gallery of the Wexner Center on the campus of Ohio State University, there is a large, permanently installed Kruger that shows someone, mouth agape, holding his hands to his face, rather like *The Scream* of Edvard Munch, with the banner asking "Why are you here?" Situationally the question addresses the hapless individual who has entered the museum without especially thinking a reason was needed for being there. Since most who enter the Wexner Center are students, the work gives a little multiple-choice quiz: "To kill time? To get 'cultured'? To widen your world? To think good thoughts? To improve your social life?" None of these seem quite proportionate to the exalted role—the "aura"—of the museumed objects. So the question really is, Why is the museum here? What's it for?

K ruger did one of her meaner pieces in 1985. Superimposed upon an image of a ventriloquist's dummy—reminiscent of the one in an early Hitchcock film—she has placed, on three banners, "When I hear the word/culture/I reach for my checkbook." As with "I shop therefore I am," this alludes to a well-known expression, "When I hear the word 'culture,' I reach for my revolver," often repeated by Goering and Goebbels. Kruger is attacking those whom she mocks with the inscriptions flanking the Parrish Museum portal, who write the checks to buy the works the museum houses. There is a tiny sentence in the lower right-hand corner: "We mouth your words." The patron is an empty-headed dummy, serving as a medium for the artist as ventriloquist. On behalf of the benefactor we might protest: Where would the museum be without those checks? And the answer will come back: Who needs the museum?

This brings us to the paradox. Kruger's work needs the museum gift shop in order to circulate through the population, getting under people's skin. The Whitney gift shop, for example, has a whole display of Kruger tchotchkes. But the objects are there only because the images have been authenticated by having been accepted into the museum as works of art in the classical, aurified way. It is because she is first an artist that she is able to be a provocateuse. In fact, there is also a reverse effect: Because the work has become so familiar, one encounters it in the museum with the sense that one is seeing the original of what is so widely reproduced. With qualifications, it is like encountering the *Mona Lisa*, having seen it only on postcards. And the question then is, To what degree can one be an artist in the age of mechanical reproduction if one is not an artist in the way that mechanical reproduction was supposed to supersede?

K ruger in any case became an artist in the former sense in part through having been inspired by Benjamin's thought. She had initially been an exceedingly successful graphic designer with gifts so transparent that she became chief designer for *Mademoiselle* at the age of twenty-two. She did not—she perhaps could not—see a way of translating graphic design into art in the early seventies, when she

made the decision to become an artist. To follow the path of art in those years was to encounter a sequence of forks; taking a wrong turn would lead the pilgrim into the brambles of nonart: It was art or decoration, art or literature, art or illustration, art or design, art or craft, art or whatever. These false roads gave critics their vocabulary: Bad art was decorative, literary, designy, illustrational, craft. At the same time, especially for women guided by an evolving feminist consciousness, there was a certain uneasiness in following the rather well-marked path of painting, which was paradigmatically the path of art.

Painting had begun to be regarded with a certain suspiciousness, as somehow too "masculine" and hence too oppressive. The problem was then to find a way to make art that was not painting. Kruger's first efforts, according to Kate Linker, who wrote a book about her, "reflect insecurity, unease, and (in her words) 'alienation' deriving from her background in another discipline." She began to make what one might characterize as distinctively feminine works—large woven hangings, "whimsical patterns of brightly patterned cloth laced with metallic yarns and rows of sequins, ribbons, and feathers." These would certainly have been seen as feminine: Men would hardly make use of ribbons! Toward the end of the decade, Kruger got caught up in Theory as a form of social critique, particularly a critique of signs and the ways signs define the forms of our lives and exert power through the way we represent ourselves. At some point in the early eighties, in what must have been a kind of revelation, Kruger saw a way of turning Theory into art, and graphic design into its vehicle. By 1981 she had found the format that has since become so much a part of contemporary culture. "But you know," Hilton Kramer recently wrote, "designing magazines is not the same thing as creating a work of art, no matter what the message of the moment may be." It is not the same thing, no. But that does not mean one cannot create works of art the way one designs magazines. That is a possibility that Postmodernism has made available to those able to use it. It is part of what we must now recognize as the Postmodernist revolution in art, that art can be made out of anything. There are no antecedent criteria for what a work of art must look like; artists can invent their own genres, and there are no prior constraints on what works of art are supposed

to do. Her graphic skills gave Kruger the means to be an artist and address her sisters on the issues that defined their lives.

So Kruger has worked both sides of the street, sending her barbs out in numbers great enough to affect the common consciousness and at the same time to get these very images accepted, usually in large format, as works of art in the more traditional sense. Lately, it seems to me, she has, somewhat contrary to the course she has followed so effectively, begun to make work that does not so readily lend itself to the means of mechanical reproduction and maximum distribution. She has been making large and ambitious installations, such as we now experience at the Whitney. For my part, I do not find these works compelling, and I should explain why. Much as Descartes's *cogito* works only with the first-person singular, the force of Kruger's accusatory messages depends upon the second-person singular. In "You belong here" on the Parrish Museum facade, the viewer reads this as "I belong here." In the Wexner Center installation, I am the one addressed with "Why are you here?" Both those works are site-specific: The "here" refers to the place where I find myself when I see them. This intimacy is absent from the installations at the Whitney. We do not feel ourselves addressed. So the work does not engage us. There are too many words, there is too much noise, the atmosphere is something like that of a somewhat static disco, and the messages are somehow too blunt. I prefer the work that insinuates its message as with the point of a pin, like an inoculation against jerkiness. It is an admirable thing to have used art to get us to shape up and do the right thing. I am uncertain the new work will have this salutary effect.

October 2, 2000

Yoko Ono

John Lennon once characterized his wife, Yoko Ono, as the world's "most famous unknown artist. Everybody knows her name, but nobody knows what she does." What she was famous for, of course, was him. The art for which she was unknown could not conceivably have made her famous—although even the most famous of artists would be obscure relative to the aura of celebrity surrounding the Beatle of Beatles and his bride. Yoko Ono had been an avantgarde artist in New York and Tokyo in the early 1960s, and part of an avant-garde art world itself very little known outside its own small membership. The most robust of her works were subtle and quiet to the point of near unnoticeability. One of her performances consisted, for example, of lighting a match and allowing it to burn away. One of her works, which she achieved in collaboration with the movement known as Fluxus, consisted of a small round mirror that came in an envelope on which *YOKO ono/self portrait* was printed. It belonged in Fluxus I—a box of works by various Fluxus artists, assembled by the leader and presiding spirit of the movement, George Maciunas. But the contents of Fluxus I were themselves of the same modest order as *Self Portrait*. We are not talking about anything on the scale, say, of *Les Demoiselles d'Avignon*. We are speaking of things one would not see as art unless one shared the values and ideologies of Fluxus.

Fluxus, in that phase of its history, was much concerned with overcoming the gap between art and life, which was in part inspired by

John Cage's decision to widen the range of sounds available for pur-
poses of musical composition. Cage's famous *4'33"* consisted of all the
noises that occurred through an interval in which a performer, sitting
at the piano, dropped his or her hands for precisely that length of
time. A typical Fluxus composition was arrived at by selecting a
time—3:15, say—from the railway timetable and considering all the
sounds in the railway station for three minutes and fifteen seconds as
the piece. As early as 1913, Marcel Duchamp made works of art out of
the most aesthetically undistinguished vernacular objects, like snow
shovels and grooming combs, and he was in particular eager to re-
move all reference to the artist's eye or hand from the work of art.
"The intention," he told Pierre Cabanne in 1968, "consisted above all
in forgetting the hand." So a cheap, mass-produced object like a
pocket mirror could be elevated to the rank of artwork and be given a
title. How little effort it takes to make a self-portrait! In *The Republic*
Socrates made the brilliant point that if what we wanted from art was
an image of visual reality, what was the objection to holding a mirror
up to whatever we wished to reproduce? "[You] will speedily produce
the sun and all the things in the sky, and the earth and yourself and
the other animals and implements and plants." And all this without
benefit of manual skill!

Fluxus made little impact on the larger art world of those years. I
encountered it for the first time in 1984, at an exhibition held at the
Whitney Museum of New York in which the the art made in New
York in the period between 1957 and 1964 was displayed. It was a
show mainly of Pop Art and Happenings, and there were some dis-
play cases of Fluxus art, many of them objects of dismaying simplicity
relative to what one expected of works of art in the early 1960s, exem-
plified by large heroic canvases with churned pigment and ample
brush sweeps. Maciunas spoke of Fluxus as "the fusion of Spike Jones,
vaudeville, gag, children's games and Duchamp," and the display
cases contained what looked like items from the joke shop, the chil-
dren's counter in the dime store, handbills, and the like. Ono's rela-
tionship to Fluxus is a matter of delicate art-historical analysis, but if
she fit in anywhere, it would have been in the world Maciunas created
around himself, where the artists and their audience consisted of

more or less the same people. It was a fragile underworld, easy not to know about. Ono's work from that era has the weight of winks and whispers.

So, it was as a largely unknown artist that Lennon first encountered her, at the Indica Gallery in London, in 1966. The point of intersection was a work titled *YES Painting*, which consists of a very tiny inscription of the single word "Yes," written in India ink on primed canvas, hung horizontally just beneath the gallery's ceiling. The viewer was required to mount a stepladder, painted white, and to look at the painting through a magnifying lens suspended from the frame. It was part of the work, as it was of much of Yoko Ono's art, then and afterward, that it required the participation of the viewer in order to be brought fully into being. Much of it, for example, had the form of instructions to the viewer, who helped realize the work by following the instructions, if only in imagination. The ladder/painting was a kind of tacit instruction, saying, in effect, like something in *Alice in Wonderland*, "Climb me." Somehow I love the fact that John Lennon was there at all, given what I imagine must have been the noisy public world of the Beatles, full of electric guitars and screaming young girls. Lennon climbed the ladder and read the word, which made a great impression on him. "So it was positive," he later said. "It's a great relief when you get up the ladder and you look through the spyglass and it doesn't say *no* or *fuck you*; it says *YES*." There was only the simple affirmative rather than the "negative . . . smash-the-piano-with-a-hammer, break-the-sculpture boring, negative crap. That 'YES' made me stay." It would be difficult to think of a work of art at once that minimal and that transformative.

"YES" is the name of a wonderful exhibition at the Japan Society, much of it given over to the works for which, other than to scholars of the avant-garde, Yoko Ono is almost entirely unknown. I refer to the work from the early sixties, a blend of Fluxus, Cage, Duchamp, and Zen, but with a poetry uniquely Ono's own. The most innovative of the early works are the *Instructions for Paintings*, which tell the viewer what to do in order for the work to exist. These have the form of brief

poems. Here, for example, is the instruction for a work called *Smoke Painting*:

> Light canvas or any finished painting
> with a cigarette at any time for any
> length of time.
> See the smoke movement.
> The painting ends when the whole
> canvas or painting is gone.

Here is another, called *Painting in Three Stanzas*:

> Let a vine grow.
> Water every day.
> The first stanza—till the vine spreads.
> The second stanza—till the vine withers.
> The third stanza—till the wall vanishes.

Now these are instructions for the execution of a work, not the work itself. They exist for the purpose of being followed, like orders. In formal fact, the instructions are very attractive, written out in gracious Japanese calligraphy by, as it happens, Yoko Ono's first husband, Ichiyanagi Toshi, an avant-garde composer. It is true that the conception was hers, but by means of whose handwriting the conception should be inscribed is entirely external. Nothing could be closer to Duchamp's idea of removing the artist's hand from the processes of art. Duchamp was interested in an entirely cerebral art—the object was merely a means. And so these attractive sheets of spidery writing are merely means: The work is the thought they convey. "Let people copy or photograph your paintings," Ono wrote in 1964. "Destroy the originals." So the above instructions, in numbers equal to the press run of *The Nation* plus however many pass-alongs or photocopies may be made of this review, are as much or as little of "the work" as what you would see on the walls of the gallery. The question is not how prettily they are presented or even in what language they are written. The question is how they are received and what the reader of them

does to make them true: The instructions must be followed for the work really to exist.

So how are we to comply? Well, we could trudge out to the hardware store, buy a shovel, pick up a vine somewhere, dig a hole, plant the vine, water it daily—and wait for the wall against which the vine spreads to vanish. Or we can imagine all this. The work exists in the mind of the artist and then in the mind of the viewer: The instructions mediate between the two. At the Indica Gallery, Ono exhibited *Painting to Hammer a Nail*. A small panel hung high on the wall, with a hammer hanging from its lower left corner. Beneath it was a chair, with—I believe—a small container of nails. If you wanted to comply with the implicit instructions, you took a nail, mounted the somewhat rickety chair, grasped the hammer, and drove the nail in. At the opening, Ono recalls, "A person came and asked if it was alright to hammer a nail in the painting. I said it was alright if he pays 5 shillings. Instead of paying the 5 shillings, he asked if it was alright to hammer an imaginary nail in. That was John Lennon. I thought, so I met a guy who plays the same game I played." Lennon said, "And that's when we really met. That's when we locked eyes and she got it and I got it and, as they say in all the interviews we do, the rest is history."

Jasper Johns once issued a set of instructions that became famous: "Take an object./Do something to it./Do something else to it." Ono's version would be, "Imagine an object./Imagine doing something to it./Imagine doing something else to it." Ono's enthusiasts like to say how far ahead of her time she was, based on some entirely superficial parallels between her *Instructions for Paintings* and certain works of Conceptual Art, which also consisted of words hung on the wall. Thus in 1967 Joseph Kosuth composed a work that reproduced the definition of the word "Idea" as it appears in a dictionary. The title of the work is *Art as Idea as Idea*. The work of art is the idea of idea (Spinoza—profoundly—defined the mind as *idea ideae*). For reasons entirely different from Ono's, Kosuth was bent on transforming art into thought.

Art historians are always eager to establish priority, usually by

finding resemblances that have little to do with one another. In truth, Ono was precisely of her own time. It was a time when the very idea of art was under re-examination by artists. Works of art can never have been more grossly material—heavy, oily, fat—than under the auspices of Abstract Expressionism. But the aesthetic experiments of Cage, of Fluxus, and of Yoko Ono were not, in my view, addressed to the overthrow of Abstract Expressionism. They were rather applications of a set of ideas about boundaries—between artworks and ordinary things, between music and noise, between dance and mere bodily movement, between score and performance, between action and imagining action, between artist and audience. If the impulse came from anywhere, it came from Zen. Cage was an adept of Zen, which he transmitted through his seminars in experimental composition at the New School. Dr. Suzuki, who taught his course in Zen at Columbia, was a cult figure for the art world of the fifties. Yoko Ono had absorbed Zen thought and practice in Japan. The aim of Zen instructions was to induce enlightenment in the mind of the auditor, to transform his or her vision of world and self. The aim of Ono's instructions was similarly to induce enlightenment in the mind of the viewer—but it would be enlightenment about the being of art as the reimagination of the imagined. In her fine catalog essay, Alexandra Munroe, director of the Japan Society Gallery, writes, "Asian art and thought were the preferred paradigm for much of the American avant-garde." Abstract Expressionism and the New York avant-garde exemplified by Cage, Fluxus, and Ono belong to disjointed histories that happened to intersect in Manhattan at the same moment.

At the time of their marriage, Ono said that she and John Lennon would make many performances together, and the fact that Lennon set foot in the Indica Gallery in the first place and engaged with Yoko Ono in that atmosphere implies that he found something in art that was lacking in the world of popular music, for all his great success. It is characteristic that for him, art meant performance—not painting on the side, which was to become an outlet for his fellow Beatle Paul McCartney (there is an exhibition of McCartney's paint-

ings making the rounds today). What Ono offered Lennon was a more fulfilling way of making art, and inevitably she was blamed for the dissolution of the band. What Lennon offered Ono was a way of using her art to change minds not just in terms of the nature of art and reality but also in terms of war and peace. In 1968 Yoko Ono declared that "the art circle from which I came is very dead, so I am very thrilled to be in communication with worldwide people." One of Yoko Ono's most inspired pieces was her *White Chess Set* of 1966 (a version of which, *Play It By Trust*, can be seen in the Japan Society lobby). Instead of two opposing sides, one black and one white, she painted everything—the board and the pieces—white. Since one cannot tell which pieces belong on which side, the game quickly falls apart. "The players lose track of their pieces as the game progresses; Ideally this leads to a shared understanding of their mutual concerns and a new relationship based on empathy rather than opposition. Peace is then attained on a small scale." But with Lennon, she and he could attempt to achieve peace on the largest scale—could use art to transform minds. In 1969, for example, they enacted their Bed-in for Peace. The tremendous widening of the concept of art earlier in the decade made it possible for being in bed together to be a work of art. The press was invited into their hotel bedrooms, gathered around the marital bed, to discuss a new philosophy in which, as in *White Chess Set*, love and togetherness replaced conflict and competition. In the same year the couple caused billboards to be erected in many languages in many cities, as a kind of Christmas greeting from John and Yoko. The message was WAR IS OVER! (in large letters), with, just beneath (in smaller letters), IF YOU WANT IT. There was no definite article: The sign was not declaring the end of the Vietnam War as such but the end of war as a human condition. All you have to do, as their anthem proclaimed, was GIVE PEACE A CHANCE. Get in bed; make love, not war.

There is a somewhat darker side to Ono's work than I have so far implied. In a curious way, her masterpiece is *Cut Piece*, a performance enacted by her on several occasions, including at Carnegie Recital Hall in 1965. Ono sits impassively on the stage, like a beautiful resigned martyr, while the audience is invited to come and cut away a

piece of her clothing. One by one, they mount the stage, as we see in a video at the Japan Society, and cut off part of what she is wearing. One of the cutters is a man, who cuts the shoulder straps on her undergarment. The artist raises her hands to protect her breasts but does nothing to stop the action. Ideally the cutting continues until she is stripped bare. I find it a very violent piece, reminding me somehow of Stanley Milgram's experiment in psychology, in which people are encouraged to administer what they believe are electrical shocks to the subjects (who pretend to be in agony). The audience has certainly overcome, a bit too gleefully, the gap between art and life—it is after all a flesh-and-blood woman they are stripping piecemeal with shears. It reveals something scary about us that we are prepared to participate in a work like that.

Another film, *Fly*, shows a housefly exploring the naked body of a young woman who lies immobile as the fly moves in and out of the crevices of her body, or moves its forelegs, surmounting one of her nipples. The soundtrack is uncanny, and we do not know if it is the voice of the fly, the suppressed voice of the woman, or the weeping voice of an outside witness to what feels like—what is—a sexual violation. It is like the voiced agony of a woman with her tongue cut out. The sounds are like no others I have heard. Yoko Ono is a highly trained musician who gave her first concert at four and who sang opera and lieder when she was young. But she is also a disciple of Cage and an avant-garde singer who uses verbal sobs, damped screams, and deflected pleas to convey the feeling of bodily invasion.

Yoko Ono is really one of the most original artists of the last half century. Her fame made her almost impossible to see. When she made the art for which her husband admired and loved her, it required a very developed avant-garde sensibility to see it as anything but ephemeral. The exhibition at the Japan Society makes it possible for those with patience and imagination to constitute her achievement in their minds, where it really belongs. It is an art as rewarding as it is demanding.

December 18, 2000

Sean Scully

A question of some moment in Renaissance thought was whether sculpture was inferior, equal, or superior to painting. The texts in which the issue was mooted were called *paragone*, in which the two arts were compared, usually to the detriment of sculpture. Sculpting was a dirty, noisy, earthy activity. The sculptor was an artisan—think of the fact that sentencing someone to "hard labor" has meant condemning him to break rocks. The painter, by contrast, was an artist, and the subtext of the *paragone* is the social ascent of the painter, from the status of artisan to that of humanist scholar—a poet, say, or a philosopher. Painters sit while sculptors stand. Painters in their studios are elegantly garbed while sculptors are covered head to foot with stone dust. Seated before the easel, exerting no greater physical effort than is required to hold a small brush, the painter can listen to poets reciting sonnets, or scholars reading aloud from the classics, or singers and musicians filling the space with sweet harmonies. The spirit of the *paragone* is nowhere better expressed than in Jan Vermeer's *The Art of Painting*, recently on loan to the National Gallery in Washington, D.C. An artist, shown from behind, is painting the Muse of History, using a female model. He is handsomely dressed in slashed velvet and wears a beret. The model, in a blue silk gown, is crowned with laurel, and she holds, together with a horn of polished brass, a copy of Thucydides. Light pours into the studio, illuminating a large ornamental map on the facing wall. Imagine what would happen to so rich a map—or to the opulent Oriental

hangings—if they were in a sculptor's studio instead! The painter's costume, incidentally, belongs to an earlier century. So Vermeer situates the painter at the intersection of historical time and geographical space, since the place where he is painting is shown on the map. He is clearly a person of refinement and learning.

The history of art is full of *paragone*-style disputations: between craft and art, for example, or figuration and abstraction. But *paragones* also appear when the structure of society begins to give way, making it possible for a previously disfranchised group to move upward, or when an enfranchised group finds its status challenged, as with men by women today. In the Renaissance, sculptors more or less accepted the arguments from the other side and aspired to find modes of expression that emulated the condition of painting, using, for example, panels with very low relief rather than freestanding figures. At a certain point, at least in the history of art, the terms of the contest are altered so profoundly that the roles are actually reversed. In the present art world, for example, painting is very much on the defensive. And if there is anything to such reports from the front as Susan Faludi's, men have lost any sense of place or point by comparison with women, whose consciousness has been raised and their various superiorities celebrated. So men are uncertain whether to become more like women, as sculptors sought to emulate painters, or to find some elusive masculine essence.

The two *paragones* are in fact connected. Painting was challenged in the seventies, when increasing numbers of women undertook to become artists, and feminist theory began to characterize painting as something by and for white males, at the same time deconstructing the institutional structures that artificially supported male privilege. "Time was," Kant writes, "when metaphysics was entitled the Queen of all the sciences . . . Now, however, the changed fashion of the time brings her only scorn; a matron outcast and forsaken." Until the seventies, painting had been Queen of all the arts for most of art's history. "No conflict in its history," Thomas McEvilly has written in *The Exile's Return*, "has been as severe as that of the last generation: painting's disgrace and exile, around 1965."

In my view, 1965 is a few years too early. Pop Art, which flour-

ished in that year, merely shifted the content of painting to vernacular subjects, without calling into question painting itself. Roy Lichtenstein tweaked the pretensions surrounding the Abstract Expressionist brushstroke—but he did so by painting pictures of brushstrokes. There were no female Pop artists. Feminist issues were at best marginal in the uprising of 1968. But Linda Nochlin's immensely influential "Why Have There Been No Great Women Artists?" was published in 1971, generating a powerful body of cultural criticism. The feminist critique of painting, moreover, was not merely an isolated engagement in sexual politics. It went with a leftish revulsion against the commodification of art. Artists sought ways to circumvent the institutional complex of the art world—galleries and collections and careers—and to make museums more socially responsive. Later in the decade, painting became further stigmatized, under the auspices of multiculturalism, as merely the way Western culture expressed itself artistically.

It took a certain courage to persist as a painter under this triple indictment. There was a brief, intense moment in the early eighties when it seemed that painting had made a comeback and a countercharge. Neo-Expressionist painting was ecstatically received as evidence that the history of art was back on track. That coincided with an acquisitive appetite for art, which enabled successful painters to live fairly princely lives and even to thumb their noses at their perceived oppressors. David Salle's humiliating images of women, for example, must be understood as being in the spirit of waving a sword at the enemy. Neo-Expressionism did not thrive for very long, though certain of its major representatives, like Eric Fischl, Julian Schnabel, and Salle himself, have continued to prosper. The resurgence of painting proved to be an interlude rather than a change in the direction of history, and it is my view that the objective configuration of the art world, which began in the seventies and has continued, with that one minor interruption, into the present moment, rules out entirely the very possibility of a comeback of painting, at least as Queen of the arts.

———

What I mean by "the objective configuration of the art world" is the way the latter became increasingly pluralistic in the seventies, as artists sought and found avenues of expression alternative to painting. They were assured that there is in the first place no special way works of art have to be, so one was free to make art out of anything and have it look whatever way one wished. Aesthetics itself was pluralized, so far as it continued to be relevant at all. And artworks were often pluralistic within themselves, as artists, casting aside the imperatives of purity that had defined high Modernism, combined media in often unprecedented ways, taking what they needed from wherever they might find it. Artists characterized themselves as making objects. Beyond question, an "object" might incorporate painting as much as videotape or stuffed animals. But that is hardly a comeback for the Queen of all the arts! Painting had become an option and a means.

Still, a pluralistic art world is a pluralistic art world. A lot of the arguments leveled at painting in the *paragone* of the seventies were really as weak as those to which the enemies of sculpture had recourse in the Renaissance. It was, for example, difficult to persist in indexing painting to gender when there were any number of women who were marvelous painters—Dorothea Rockburne, for example, or Jennifer Bartlett or Elizabeth Murray or Sylvia Plimack Mangold. Last month I saw a masterpiece by Sylvia Sleigh, *Invitation to a Voyage*, executed on fourteen panels, which translated into contemporary terms a set of ideas and feelings Watteau had exploited in *Pèlerinage à l'île de Cythère*. There has to be room for painting in the open disjunction of ways of making art. But even those we think of primarily as painters have in some ways been liberated by the pluralism of art: David Reed, for example, though primarily a painter, has found ways of intercombining his paintings with video or film and framing them in installations that function to direct the way viewers are to think about the paintings themselves. Inevitably, the structure of critical analysis will depend upon whether one is talking about his installations, in which paintings are components, or about the paintings those installations help one see. A correlative pluralism in art criticism, in other words, is required.

———

Sean Scully, whose name belongs on the shortest of short lists of the major painters of our time, nevertheless is of the present moment through the fact that he constructs his paintings as objects having a certain three-dimensional identity, with insets and superposed panels. He has even invented a form of three-dimensional paintings, which he refers to as Floating Paintings. Floating Paintings are on fabricated metal boxes, which hang at right angles to the wall, like the modules one associates with Minimalist sculpture—but painted with his signature stripes. Stripes even determine the motifs Scully selects for his beautiful photographs of barns or shacks or road signs, which are disclosed, so to speak, as ready-made Scullys through their bold and energetic stripedness. The stripes (or bars) with which he works are themselves, in a sense, cultural borrowings that Scully encountered on a trip to Morocco in 1969. He was intoxicated by the dyed strips of wool that became stripes when sewn together into blankets or tents.

Stripes, of course, have been used by painters for the past several decades. The French painter Daniel Buren, for example, uses stripes as a way of subverting art, robbing it of any visual interest or point of focus, repeating vertical stripes, evenly spaced and mechanically executed, in an array that can go on indefinitely. There is in Buren's work the sullen repetitiveness of reggae. This is in no sense meant as a criticism, given Buren's philosophy of art, but rather as an explanation of how his stripes are vehicles of political action. Scully's stripes, by contrast, are vibrant and painterly, and often differ in width, color, and even direction, as when he inserts a panel in which stripes have widths and hues different from those of the panel that surrounds them. He is in every sense a highly humanistic artist, who sees in abstraction as he practices it a form of religious metaphysics. It was consistent with this spirit that he should leave Britain for America to settle in New York, which he viewed as the promised land: He felt that the tradition of great painting was alive in the work of Mark Rothko and Willem de Kooning, much in the way classical learning had been kept alive in European monasteries—points of civilization and illumination within the surrounding cultural darkness.

There is a very intimate show of Scully's works on paper at the Metropolitan Museum of Art. Before giving oneself over to the amazingly nuanced watercolors and pastels, the prints and the photographs, one might pause at the entrance to contemplate two of his oil paintings, placed just outside the gallery. At the very least, they show the internal evolution of Scully's stripes. *Red on Cream*—painted in 1976, the year after he moved permanently to America—consists of narrow reddish stripes laid horizontally across a cream ground. *Molloy* was done eight years later. It would have been extremely difficult, despite the fact that both paintings are made entirely of stripes, to have predicted a work like *Molloy* on the basis of *Red on Cream*—or, for that matter, to retrodict from *Molloy* to the painting of 1976.

Superficially, *Red on Cream* appears to exude the spirit of Minimalism, which was very powerful at that time. *Molloy*, by contrast, could have been done by no one but Scully. It consists of three (or four) vertical panels. One panel contains two green horizontal bars—too wide to think of simply as stripes—which are either on an orange ground or separated by orange bars. The orange-green panel is superposed onto a squarish panel, consisting this time of vertical bars in red and black. There is another panel on the extreme right, also of vertical black and red bars. This panel has a deep relationship, in form and color, with the squarish panel, very much as if the red-black-red pattern of bars continues behind the orange-green panel, which disrupts the rhythm. The orange-green panel is an outsider and even perhaps a kind of virus. The upper and lower edges of the panels are not perfectly aligned, and there is no continuous surface to the work as a whole: Some of the panels are in front, some behind, which is in part what I meant in describing Scully's more recent works as objects (though certainly not as sculptures). I have read that *Molloy*'s red stripes are of "the kind used in *Maestà*." *Maestà*, by Duccio di Buoninsegna, is the supreme masterpiece of Sienese painting. It shows the Virgin enthroned, with the Christ Child on her lap, symmetrically flanked by groups of holy personages on either side. Whether there is in fact this affinity, the thought that there might be—that the orange-green panel stands to the red-black panels in the relationship in which the Madonna stands to her adorers—suggests that Scully has achieved

in *Molloy* the kind of near-religious feeling he believed that great painting was invented to express.

This is true of *Red on Cream* as well, although less obviously. Before he left London, Scully's paintings were grids or plaids that, however well received, did not convey, in his view, the spiritual qualities he came to New York to seek. For the first five or so years of his residence here, he worked with the kind of evenly spaced narrow stripes *Red on Cream* employs. Since these were perceived as Minimalist works of a very high order, they brought Scully considerable recognition. He did not see them as Minimalist at all, but rather as romantic and religious. I suppose, seeing the cream as light coming through the closely spaced bars, one could see a kind of allegory. But in beginning to study the painting itself, one recognizes that there is a quality of searching in the way the stripes inch across the canvas. The edges have a subtle tentativeness despite the way they are regimented. The wider kind of stripe in such paintings as *Molloy* makes retroactively clear that Scully's intentions were not Minimalist in the earlier painting, despite appearances. The bar-stripe, with its delicately fading and dilating edges, is unmistakably a declaration of affinity with Rothko, whose work Scully hugely admires (and whom he wrote about tellingly in London's *Times Literary Supplement*, on the 1998 Rothko retrospective at the Whitney).

Indeed, one can see Scully's work as carrying forward, almost alone, the concept of painting with which the New York School is rightly identified. I have often reflected on the fact that whatever unites them, the works of no two Abstract Expressionist painters look alike. Unlike the Impressionists, who always resembled one another, the Abstract Expressionists were never interestingly similar in style. They are so different, for example, that had Rothko never existed, we could not imagine a style like his on the basis of what the others had done. Scully had discovered a style of painting in which Abstract Expressionism continues to exist, but the architecture of his paintings belongs entirely to the present moment.

What is astonishing about the works on paper is the way Scully has

been able to adapt the spirit of his formal vocabulary to the quite different demands of other media—like watercolor, for example, or pastel. The bars and stripes and checkerboard squares of oil paintings have a layered quality—they are visibly built up, layer upon layer, with the submerged layers allowed to show through the final one. They imply wide brushes and great physical strength to move the nearly viscous pigment and to keep it within boundaries. Pastel involves rubbing friable chalk over toothed paper, which in its nature confers a certain sparkling luminosity to the forms, and it is responsive to differences in pressure. The principle of pastel, Scully once told me, is like that of putting on makeup. The watercolors demand an entirely different set of reflexes. To paint a bar in watercolor requires an ability to begin and end it without puddling, and to achieve the sparkling translucency of its washes without allowing it to pool.

A major exhibition of Scully's works on paper opened in January at the Albright-Knox gallery in Buffalo, in case the Metropolitan's "Sean Scully on Paper" should pique your appetite for more. And I have not even touched on the suite of photographs, or the exquisite illuminations for *Heart of Darkness*, or Joyce's *Pomes Penyeach*, included in the show.

Scully's historical importance lies in the way he has brought the great achievement of Abstract Expressionist painting into the contemporary moment—and in a way overcome the terms of the *paragone* that sent painting into exile. It goes without saying that historical importance is not the kind that Scully wishes his art to achieve. The *paragones* locate the work in the very history that his paintings strive, whatever their medium, to overcome, in favor of something exalted and elusive and universal. As in *The Art of Painting*, for example.

February 21, 2000

Paul McCarthy

J ean Clair, director of the Musée Picasso in Paris and widely respected both as scholar and art critic, has for some years been out of sympathy with contemporary art. When he and I shared a platform in the Netherlands a year ago, he spoke of a new aesthetic marked, in his view, by repulsion, abjection, horror, and disgust. I have been brooding on this ever since, and particularly on disgust as an aesthetic category. For disgust, in Jean Clair's view, is a common trait, a family resemblance of the art produced today not only in America and Western Europe but even in the countries of Central Europe recently thrown open to Western modernity. We do not have in English the convenient antonymy between *goût* (taste) and *dégoût* (disgust) that licenses his neat aphoristic representation of what has happened in art over the past some decades: *From taste . . . we have passed on to disgust.* But inasmuch as taste was the pivotal concept when aesthetics was first systematized in the eighteenth century, it would be a conceptual revolution if it had been replaced by disgust. I have never, I think, heard "disgusting!" used as an idiom of aesthetic approbation, but it would perhaps be enough if art were in general admired when commonly acknowledged to be disgusting. It is certainly the case that beauty has become a ground for critical suspicion, when its production was widely regarded as the point and purpose of art until well into the twentieth century.

Though "disgusting" has a fairly broad use as an all-around pejorative, it also refers to a specific feeling, noticed by Darwin in his mas-

terpiece, *The Expression of the Emotions in Man and Animals*, as excited by anything unusual in the appearance, odor, or nature of our food. It has little to do with literal taste. Most of us find the idea of eating cockroaches disgusting, but for just that reason few really know how cockroaches taste. The yogurt that sports a mantle of green fuzz—to cite an example recently mentioned in a *New Yorker* story—may be delicious and even salubrious if eaten, but it elicits shrieks of disgust when seen. A smear of soup in a man's beard looks disgusting, though there is of course nothing disgusting in the soup itself, to use one of Darwin's examples. There is nothing disgusting in the sight of a baby with food all over its face, though depending on circumstances we may find it disgusting that a grown man's face should be smeared with marinara sauce.

Like beauty, disgust is in the mind of the beholder, but it is one of the mechanisms of acculturation, and there is remarkably little variation in our schedules of what disgusts. So disgust is an objective component in the forms of life that people actually live. The baby is very quickly taught to wipe its face lest others find it disgusting, and we hardly can forbear reaching across the table to remove a spot of chocolate from someone's face—not for his or her sake but for our own. What he speaks of as "core disgust" has become a field of investigation for Jon Haidt, a psychologist at the University of Virginia. He and his associates set out to determine the kinds or domains of experience in which Americans experience disgust. Foods, body products, and sex, not unexpectedly, got high scores when people were queried on their most disgusting experiences. Subjects also registered disgust in situations in which the normal exterior envelope of the body is breached or altered. I was philosophically illuminated to learn that of fifty authenticated feral children, none evinced disgust at all. But I am also instructed by the fact that my cultural counterparts are disgusted by what disgusts me, more or less.

This overall consensus encourages me to speculate that most of us would unhesitatingly find the characteristic work of the artist Paul McCarthy, largely live and video performance, disgusting. There

may be—there doubtless is—more to McCarthy's art than this, but whatever further it is or does depends, it seems to me, on the fact that it elicits disgust. It may, for example, debunk a false idealism McCarthy regards as rampant in Hollywood films, advertising, and folklore, as one commentator writes. But it achieves this just so far as it is disgusting. It may relentlessly and rigorously probe the air-brushed innocence of family entertainment to reveal its seamy psychic underpinnings, to cite another critic. So it may show what really underlies it all, the way the worm-riddled backside of certain Gothic sculptures whose front sides were of attractive men and women were intended to underscore our common mortality. But that does not erase the fact that maggots count as disgusting. So possibly McCarthy is a kind of moralist, and his works are meant to awaken us to awful truths and their disgustingness as a means to edificatory ends. That still leaves intact the revulsion their contemplation evokes. Disgust is not something that can easily be disguised. Beautiful art, Kant wrote, can represent as "beautiful things which may be in nature ugly or displeasing." But the disgusting is the only "kind of ugliness which cannot be represented in accordance with its nature without destroying all aesthetic satisfaction."

"Nothing is so much set against the beautiful as disgust," Kant wrote in an earlier essay. So it is all the more striking that McCarthy's commentators attempt to find his work beautiful after all. "I wanted to think about the question of beauty in your work, an interviewer murmured, to move from the manifest to the latent." *The New York Times* speaks of the "unlikely beauty of the work," adding that it is "not standard beauty, obviously, but a beauty of commitment and absorption." I have to believe that McCarthy's perceptions can be very little different from the rest of ours. He has, indeed, almost perfect pitch for disgust elicitors, and accordingly making the art he does must be something of an ordeal. That may have the moral beauty that undergoing ordeals possesses, especially when undertaken for the larger welfare. But if it is that sort of ordeal, then it by default has to be disgusting. As the Gothic statuary demonstrates—or, for that matter, the history of showing the fleshly sufferings of Christ and the martyrs—artists down the ages have had recourse to some pretty dis-

gusting images for the ultimate benefit of their viewers. (Taking on the iconography of Disneyland, as he does, is hardly commensurate with overcoming Satan's power, but I'll give McCarthy the benefit of the doubt.)

Something over three decades of McCarthy's work is on view at New York's New Museum of Contemporary Art in SoHo, and since he is widely admired by the art establishment, here and abroad, there are prima facie reasons for those interested in contemporary art to experience it. The disgusting works have mainly to do with food, but—citing Haidt—disgust is, at its core, an oral defense. There is no actual gore, though McCarthy uses food to evoke the images of gore. Similarly, there are no actual envelope violations; no one is actually cut open. But again, various accessories, like dolls and sacks, are enlisted to convey the idea that the exterior envelope of the body is breached or violated. McCarthy makes liberal use of ketchup in his performances, and in interviews speaks of the disagreeable smell of ketchup in large quantities. That is part of what I have in mind in speaking of his art making in terms of ordeal. There may or may not be actual shit, but chocolate is what one might call the moral equivalent of feces, as you can verify through watching a few minutes of his *Santa Chocolate Shop*. Karen Finley used only chocolate to cover her body in the performance that landed her in hot water with the National Endowment for the Arts a few years ago—but everyone knew what she was getting at.

The use of foodstuffs distinguishes McCarthy's art from that of the so-called Vienna Actionists of the 1960s—Hermann Nitsch and Otto Mühl are perhaps the best known, though the actor Rudolf Schwarzkogler attained a happily unmerited notoriety through the rumor that he cut bits of his penis off in successive performances of *Penis Action*. The Actionists made use of real blood and excrement, and excited at least the illusion of humiliation through such happenings as that in which a broken egg was dripped into Mühl's mouth from the vagina of a menstruating woman. They were heavily into desecration. McCarthy is pretty cheery alongside these predecessors.

His work refers to nursery rhymes and children's stories, and he makes use of stuffed animals and dolls, often secondhand, and costumes as well as rubber masks from the joke shop. Some writers have described McCarthy as a shaman, but he rightly sees that as something of a stretch: "My work is more about being a clown than a shaman," he has said. As a clown, he fits into the soiled toy lands of his mise-en-scènes, which kick squalor up a couple of notches, as Emeril Lagasse likes to say when he gives the pepper mill a few extra turns.

The clown persona is central to what within the constraints of McCarthy's corpus might be regarded as his chef d'oeuvre, *Bossy Burger* (1991). But he worked his way up to the creation of this role through a sequence of performances. In these, he stuffed food in his pants, covered his head with ketchup, mimicked childbirth using ketchup-covered dolls as props. In one, or so I have read, he placed his penis inside a mustard-covered hot dog bun and then proceeded to fill his mouth to the point of gagging with ketchup-slathered franks. Throughout, food was placed in proximity to parts of the body with which food has no customary contact. But many human beings are reluctant to touch food that has merely been left untouched on the plates of strangers. Disgust is a defensive reflex, connected with fear, even if we know the food that evokes it is perfectly safe and edible. That is why there is so strong a contrast between beauty and disgust: Beauty attracts.

McCarthy got the idea of using food as the medium of his performances in the course of searching for a very basic kind of activity. Inevitably, he had to deal with disgust, which is inseparable from eating as symbolically charged conduct. It is understandable that he would stop performing for live audiences (as he did in 1983) and begin to devise a form of theater to put a distance between himself and his viewers. I would not care to perform *Bossy Burger* a second time, even if I had the stomach to perform it once. It is perhaps part of the magic of theater that disgust survives as an affect, even through the video screen. It doesn't help to know it is only ketchup.

———

The action of *Bossy Burger* transpires in what in fact was a studio set for a children's television program, and the set—a hamburger stand—is exhibited as an installation. It shows the damage inflicted on it by the performance, and looking in through the open wall—or the windows—we see an utterly nauseating interior, with dried splotches and piles of food pretty much everywhere. It has the look of California Grunge, as we encountered it in the work of Ed Kienholz. A double monitor outside the set shows, over and over, McCarthy's character, togged out in chef's uniform and toque—and wearing the Alfred E. Neuman mask that connotes imbecility—grinning his way through fifty-nine minutes of clownishly inept food preparation. Thus he pours far more ketchup into a sort of tortilla than it can possibly hold, folds it over with the ketchup squishing out, and moves on to the next demonstrations. These involve milk and some pretty ripe turkey parts. The character is undaunted as his face, garments, and hands quickly get covered with what we know is ketchup but looks like blood, so he quickly takes on the look of a mad butcher. He piles the seat of a chair with food. He makes cheerful noises as he bumbles about the kitchen or moves to other parts of the set, singing, "I love my work, I love my work." Everything bears the mark of his cheerful ineptitude. At one point he uses the swinging door to spank himself, but it is difficult to believe this constitutes self-administered punishment. He looks through an opening at the world outside. McCarthy says he envisioned this chef as a trapped person, but whether that is an external judgment or actually felt by the character is impossible to decide from the work itself. Viewers may find themselves wanting to laugh, but a certain kind of compassion takes over. Perhaps it is a test for tenderness. Whatever the case, even writing about *Bossy Burger* makes me feel queasy.

You won't get much relief by looking at *Family Tyranny*, in which the character uses mayonnaise and sings, "Daddy came home from work," as he prepares to do unspeakable things to his children. "They're only dolls" helps about as much as "It's only art" does, which underscores Kant's point about disgust. *Painter* mercifully turns to other substances in its slapstick comedy about the art world. McCarthy plays the role of art star, wearing a sort of hospital gown, a

blond wig, and huge rubber hands, and he has a kind of balloon by way of a nose. Everyone else in the action—his dealer and his collectors—wears the same kind of nose, which perhaps caricatures the hypertrophied sensitivity that exposure to art might be thought to bring. At one point, the Painter climbs onto a sort of pedestal as an art lover kneels to smell his ass. In another action, he chops away at one of his fingers with a cleaver, and crows OK! when it comes off. This belongs to the iconography of self-mutilation that has, since Van Gogh—and perhaps Schwarzkogler—become an ingredient in our myth of the true artist. The Painter's studio is filled with huge tubes of paint (one of them labeled SHIT), and he parodies the Abstract Expressionist address to painting by slapping pigment wildly here and there, rolling it onto a table, and then pressing his canvas down onto the paint while pushing it back and forth, all the while singing some version of "Pop Goes the Weasel." Paint, food, and blood serve throughout McCarthy's work as symbolic equivalents. I could not suppress the thought that *Painter* is a kind of self-portrait—there are photographs elsewhere in the show of an early performance in which McCarthy frantically whipped a paint-laden blanket against a wall and window until they were covered with pigment.

It will be apparent that I am a squeamish person, an occupational impediment for an art critic if Jean Clair is right about the new aesthetic (for my response to that contention, see www.toutfait.com/issues/issue_3/News/Danto/danto.html). I am not, however, disposed to prudery, though I have a strong memory of a certain visceral discomfort when I was first writing on Robert Mapplethorpe's photographs. McCarthy's *Spaghetti Man* I thought was pretty funny. It is a sculpture, 100 inches tall, of a kind of bunny wearing a plastic grin of self-approval. It could easily be on sale at F.A.O. Schwarz were it not that the bunny has a fifty-foot penis, which coils like a plastic hose on the floor beneath him. It is a kind of comment, but from an unusual direction, on Dr. Ruth's reassuring mantra for insecure males that Size Doesn't Matter. It really does matter from the perspective of masculine vanity, even if Spaghetti Man's organ would put too great a dis-

tance between himself and a partner for any show of tenderness during coitus. So its message may well be that we should be grateful for what we've got.

I don't have anything very good to say about *The Garden*, an installation of McCarthy's on view at Deitch Projects. The garden consists of fake trees and plants—it was a movie set—in which one sees— Eek!—two animatronic male figures, one doing the old in-and-out with a knothole in one of the trees, the other with a hole in the ground. Some ill-advised writers have compared the work to Duchamp's strangely magical last work, *Étant Donnés*, where one sees a pink female nude, legs spread, sharing a landscape with a waterfall and a gas lamp. The masturbations in *The Garden* are too robotic for mystery and the meaning of all that effort too jejune to justify the artistic effort. *Cultural Gothic*, a pendant to *The Garden*, is in the main body of the show at the New Museum. It is a life-size sculpture of a neatly dressed father and son engaged in a *rite de passage* in which the son is enjoying sex with a compliant goat. Whether the motor was in its dormant phase or the electricity not working—or the museum inhibited by some failure of nerve—there was no motion when I saw it. I thought that an improvement, but purists might think otherwise.

April 23, 2001

Sol LeWitt

In memory of Van Quine

About halfway through the installation of Sol LeWitt's art at New York's Whitney Museum of American Art, a small alcove gallery is given over entirely to *Autobiography*, a work from 1980. *Autobiography* consists, by my calculation, of 1,071 simple black-and-white photographs, arranged in 3-by-3 square grids. The pictures are of an almost striking banality, with a degree of photographic distinction near zero, and they show, for the most part, the most ordinary of objects: tools, balls of twine, shoes and articles of clothing, kitchen utensils, snapshots, books, houseplants. Except for the flat files and drafting instruments—triangles, T squares, templates, protractors, rulers, and the like—their counterparts would have been found in most households of the Western world at the time. The inventory defines domestic normality for persons of a certain class—not too wealthy, not too poor. More metaphysically, the objects participate in what Heidegger designates as *Zuhandenheit*—the Ready-to-Hand—the kinds of things one notices only when they are not ready to hand, their absence impeding the smooth flow of daily life. Their inventoried presence accordingly testifies to the orderliness of this household, in which everything is present and accounted for, and to the organizational disposition of Sol LeWitt, whose household it was.

The personality itself, of course, is not a further item in the inventory. We know from external sources that LeWitt was about to vacate his living space in 1980 and move to Spoleto, Italy, and that he wanted to photograph each object with which he lived. In a video interview,

Sol LeWitt: Four Decades, on continuous view outside the lobby gallery, the artist tells the exhibition's curator, Gary Garrels, that a far better picture of him can be gotten from the photographs of all the things he lived with than from an ordinary portrait. The question has been raised as to why he did not then title the work *Self-Portrait*. My sense is that it is because "autobiography" implies the concept of a life, and a life is something lived. The ordinariness of the objects inventoried further implies that there is nothing out of the ordinary in LeWitt's life, that it could be the autobiography of Whoever, Wherever. It may be remarked that there is no photograph in *Autobiography* of *Autobiography* itself—though it would be philosophically daring to have included the representation of the life as a further item in the life represented. I cannot forbear observing the philosophical significance of the fact that *Autobiography* fails to include a photograph of LeWitt himself. "When I enter most intimately into what I call myself," the philosopher David Hume wrote, "I always stumble on some particular perception or other . . . I never can catch myself at any time without a perception, and never can observe anything but the perception." There is no experience of the self, Hume concludes, and so the term is without meaning.

Still, not everyone would photograph each of his possessions, as if for a yard sale, and organize them into a set of 3-by-3 grids. Nor can the work be rid of one's own subjectivity by organizing its components meticulously. If anything, character and disposition are revealed through the order or absence of order in one's life. In a way, the LeWitt exhibition could itself be titled "Autobiography." It is difficult to believe that someone who took and arranged the photographs as compulsively as LeWitt appears to have done would leave the content and organization of a life's worth of his art to another. "If you require a monument," Sir Christopher Wren inscribed in St. Paul's Cathedral in London, "look around you."

The relevance of this to LeWitt's oeuvre, in whole and in part, lies in the philosophy he articulated in a crucial text, "Paragraphs on Conceptual Art," first published in *ArtForum* in 1967. In the late 1960s there would have been relatively little to appreciate in the work other than the way it exemplified the theory. In its own right it was what the

Italian critic Achille Bonito Oliva recently called "minimalial," even if it was not Minimalist in the strict ideological meaning of the term. It is true, however, that as LeWitt's art has evolved it has become decreasingly important to know much about that philosophy in order to respond to the work. Stand near the elevators at the Whitney and observe the expressions of sudden pleasure when the doors open and visitors see the marvelous wall painting *Loopy Doopy* behind the airy wooden structures in front of it. Few of those stepping out can be veterans of the theoretical debates to which "Paragraphs" belonged or know much of the subsequent history of Conceptualism as an artistic movement. For all its genesis in theory, LeWitt's work affords such instantaneous pleasure that it must appeal to an innate aesthetic sensibility that really does belong to Whoever, Wherever. This, together with the fecundity of his invention, is part of LeWitt's greatness as an artist. But even if the philosophy enters less and less into the content of what we experience, it belongs to the historical explanation of even the most recent, least apparently theoretical work.

"When an artist uses a conceptual form of art," LeWitt wrote, "it means that all of the planning and decisions are made beforehand and the execution is a perfunctory affair."

The implication is that the work of art is the transcription of an idea, in the medium its idea specifies. In 1967 it would have been LeWitt's practice to transcribe his own ideas; but later, when he began to do the wall drawings that were to become the genre most distinctive of his work, he more and more left the transcription of his ideas to what he terms "draftsmen." In a text from 1971 he wrote, "The artist conceives and plans the wall drawing. It is realized by draftsmen. (The artist can act as his own draftsman.) The plan, written, spoken or a drawing, is interpreted by the draftsman." It is fairly clear that between "artist" and "draftsman" there is a functional distinction involving different skills, and that it is in no sense necessary that a single individual incorporate both functions.

An example of a work for which the plan can be spoken is *Wall Drawing #51: All Architectural Points Connected by Straight Lines. Blue Snap Lines*. A "snap line" is a length of chalked cord tautly stretched along a flat surface. It is plucked, like a violin string, leaving a straight

line, the color of the chalk. The number of vectored lines will be a function of the number of "architectural points" the lines connect. *Wall Drawing #51* was done in 1970 and "installed" that year in the Museo di Torino in Turin, Italy. Its latest installation, done in 2000, can be seen on the extreme north section of the east wall of the fourth-floor gallery, where the viewer will initially register it as a network of pale blue straight lines connecting corners with corners. It may have been done at other times, on different walls, and one hopes it will go on being installed, transcribed by different draftsmen, when we are all long gone. The installations themselves can be painted over or destroyed in other ways, but the plan itself has only the reality of a concept. And it need never have existed in the form of a drawing. It would have been enough for it to be a plan, scribbled down as an instruction to the draftsman or communicated by phone or on a tape, and so need no more resemble the set of its embodiments than a set of scrubbed floors need resemble the injunction, "Scrub the floors!" Neither must the transcriptions resemble one another, as long as they comply with the plan. The distribution of "architectural points" will differ from actual wall to actual wall. I find it delicious that there are lines that connect the corners of the room with the corners of the alarm systems that happen to be placed in the wall chosen for the present installation of *#51*—and perhaps chosen to illustrate the point. In the catalog illustration of the same work, the lines densely converge on the electrical outlets near the floor. It looks like the maps of airline routes one sees on in-flight magazines, shown radiating out from hubs.

There is an unmistakable skill in using snap lines to make nice, clean vectors on the wall, and there is no reason to suppose that LeWitt himself has such skills. The aesthetic of *#51* is really inconsistent with casual, smudged marks, and part of the pleasure of the work derives from the impeccability of its execution. Compare it, though, with a 1972 work that shows a page from a publication about art, and indeed the art of certain of LeWitt's contemporaries—Marcel Duchamp, Robert Rauschenberg, Robert Morris, Jasper Johns, and several others. It addresses the topic of "human control," which of course plays a central role in LeWitt's philosophy. I don't know who the

author is. In any case, the plan of the work is in effect its title: *From the Word "Art": Blue Lines to Four Corners, Green Lines to Four Sides, and Red Lines Between the Words "Art" on the Printed Page*. My hunch is that the draftsman of this work was LeWitt himself, using colored ink and pencil, and perhaps one of the straightedges we see in *Autobiography*. But anyone possessing the minimal skills required to execute diagrams in high school geometry class could do this work. Who but LeWitt, however, could or would have formed the concept of connecting the word "art," as an isomorphic set of physical entities composed of ink molecules, with the perimeters of the physical surface on which they are deposited, as well as with one another? The work is witty, slyly deflationist of the concept of art as well as some of its theories, and exceedingly arch in the way it refers, as work, to the content of the text it unites with its page. The pleasures here, as with *#51*, are only marginally sensuous. They are largely conceptual pleasures and perhaps best appreciated by those who belonged in the same intellectual atmosphere to which the works themselves belong. (I have to say that I love these works!)

But let us return to LeWitt's credo and to the polemical atmosphere in which it was composed. What is actually implied by the severe disjunction between conception and draftsmanly enactment? First, it implies that art is a form of mental thought. "Mental thought" may seem redundant, but in the era in which "Paragraphs" was written, there was an overall philosophical tendency to deconstruct the idea that thinking is something that takes place exclusively in the mind. It was argued that painters, for example, or pianists, think with and through their hands and fingers, that a carpenter thinks with the saw and hammer, a dancer with his or her body, and that it is through the body that these people express themselves. Certainly, it might have been said, dancing does not transcribe through movements a terpsichorean plan in the dancer's mind! Certainly the clarinetist riffs in public space and does not mechanically perform a privately inscribed score! Indeed, when this position was being argued in such philosophical texts as Gilbert Ryle's magisterial *The Concept of Mind* (1949),

artists, especially those of the New York School, were expressing themselves in sweeping gestural movements on canvases laid on the floor or pinned to the wall of their studios. Painting was something that happened out there—not something that takes place in here. One begins with a mark, another mark, a third mark—a splash, a smudge, a drip—until the whole work energetically completes itself and the artist can then see what has been achieved. It was not something in which "all of the planning and decisions are made beforehand" with "the execution a perfunctory affair"! How could Pollock's *Autumn Light* have been planned? Or de Kooning's *Woman I*? In Abstract Expressionism, hand and eye were everything, and for those who can remember that era, the intellect could hardly have been more suspect. The painter's studio and the philosophy seminar room were at one in repudiating the "ghost in the machine."

LeWitt, by contrast, was an unabashed mentalist. "It is the objective of the artist who is concerned with conceptual art to make his work mentally interesting to the spectator." And, on a note that must have been infuriating to those who saw it as the aim of painting to express and arouse feelings of the most visceral order, LeWitt adds that conceptual artists would "usually want [the art] to become emotionally dry." It need not be boring—"It is only the expectation of an emotional kick, to which one conditioned to expressionist art is accustomed, that would deter the viewer from perceiving this art." *Wall Drawing #1*, first installed in the Paula Cooper Gallery in 1968, is not in the Whitney show, but you can see the plan for it in the catalog. It is a composition made up of four rectangular areas, overlaid by a network of vertical and horizontal lines, drawn with graphite sticks, which would have had the visual exhilaration of window screens were it not for the superimposed diagonal lines, drawn at forty-five-degree angles, forming an overlay of nested diamonds. *Wall Drawing #1: Drawing Series II 18 (A&B)*—to give it its full name—is, one might say, almost aggressively dry. But it would have had great contextual excitement in 1968. It is often said in retrospect that Abstract Expressionism as a movement was finished in 1962. But it still tended to define what one expected to experience in galleries in the later sixties. Pop Art used the brash, lurid colors of commercial logos clamoring

for the attention of consumers. So it would have been astonishing to enter an avant-garde space like Paula Cooper's and see something that is "perceived first as a light tonal mass . . . and then as a collection of lines." From the perspective of its historical moment, *Wall Drawing #1* has to have been seen as provocative—a feeling that has faded with the evolution of the art to which LeWitt has so greatly contributed: We are living in a conceptual art world. On the evidence of *Autobiography*, meanwhile, one cannot but feel that there is an aspect of LeWitt's personality present in the neatly drawn, evenly spaced, repeated uninflected lines. It is a disposition transformed into an aesthetic, to be found throughout his work—though it is by no means the whole of the LeWittian aesthetic, which has become increasingly sensuous (as in the marvelously interlaced red and purple of *Loopy Doopy*) and hardly calculated to give pleasure to those with what the great logician W.V.O. Quine—who died on Christmas Day at age ninety-two—once spoke of as a "taste for desert landscapes."

One cannot imagine *Loopy Doopy* as having been done by LeWitt in 1968. He has penetratingly observed that "the difference between the sixties and now is that those years were a time of very strong ideology, politically, aesthetically, and every other way. In order to break with the past and make new things, you had to begin with some kind of ideological framework." The work, one might say, has become decreasingly ideologized, and though the same distinction between plan and execution remains in place, there would be little inclination to consider the execution "perfunctory." LeWitt rarely serves as his own draftsman any longer, but he closely monitors those who carry out his plans.

Consider in this light LeWitt's sculptural—or, as he would say, "structural"—works. His 1964 *Standing Open Structure Black* is one of the defining sculptural works of the twentieth century: a simple wooden structure, painted black, with nearly square cross sections, ninety-six inches tall. It is like a three-dimensional diagram of a geometrical figure, since it consists only of edges and corners. It could have been selected as a furnishing for the house that Ludwig Wittgen-

stein built and designed for his sister in Vienna. Typically, LeWitt's structures are variations on cubes used as modules, painted black or white, and looking, I suppose, like skeletal models for pieces of architecture or perhaps for molecules. They do not always stand on the floor—sometimes they are hung from walls or even suspended from ceilings. They all give the sense of being reductions of complex objects to their elementary constituents. Speaking again of the sixties, LeWitt observes, "I could never have made a colored sculpture. It was something I just couldn't do . . . But now I say, so what? If it seems to promise some kind of interesting result, why not do it?"

Perhaps he is referring to such works as *Non-Geometric Form #8*— more engagingly titled *Splotch (color)*. It is a gaily painted, irregularly curved object, like a cartoon mountain range, which is in a side lobby on the ground floor at the Whitney, the walls of which are no less gaily decorated with bands and arcs. It is an example of what LeWitt's friend Lucy Lippard called Eccentric Abstraction, the greatest exponent of which was LeWitt's protégée, Eva Hesse, the young sculptor who died in 1970. For all the tragedy of Hesse's life, her work was full of mirth, and it is very much as though, in relinquishing ideology, LeWitt took her as his model. *Splotch*, *Splat*, and *Blob* are names that LeWitt uses. They belong to the lexicon of comic strips, in one of which *Loopy Doopy* could be the name of a character. This is a joyful show, full of fun and beauty, a gift to the world. The Whitney looks as if it had been expressly designed with LeWitt's ideological work in mind. The later work brightens the dour interior.

February 5, 2001

Renee Cox: *Yo Mama's Last Supper*

The almost exact coincidence in time between the destruction of the Buddha figures by the Taliban in Afghanistan and Mayor Rudolph Giuliani's renewed jihad against the Brooklyn Museum vividly underscores the problems that authorities seem to have in dealing with images. It hardly matters whether it is the most sophisticated city in the world or one of the world's most backward countries—authorities form Panels on Decency or mount Exhibitions of Degenerate Art or ship avant-garde painters off to rot in gulags or divert funds badly needed for the relief of famine to pound, with advanced weaponry, effigies into rubble. And let us not forget Plato's scheme for ridding the Just Society of mimetic art generally. As these examples suggest, iconoclasm cannot always be explained with reference to religious orthodoxy. William Randolph Hearst and Congressman George Dondero of Michigan did what they could on grounds of patriotism to cleanse America of any images that smacked of Modernism. "Art which does not beautify our country in plain simple terms that everyone can understand breeds dissatisfaction," Dondero proclaimed. "It is therefore opposed to our government and those who create and promote it are our enemies." Why should our taxes support imagery of which our officials disapprove? (The answer, of course, is that they were not elected to tell us what we could see—they were elected to secure our basic freedom to make up our *own* minds on matters of expression, artistic and otherwise.)

Renee Cox's suddenly famous photograph, which shows a naked

woman at a dinner party, has been stigmatized by Mayor Giuliani as indecent and anti-Catholic. It is in fact neither. The title, as everyone in the world now knows, is *Yo Mama's Last Supper*, but Yo Mama has been one of the ways Cox has referred to herself since the time when, enrolled in the Whitney Independent Study Program, she did a number of large nude photographs of herself pregnant and, later, with her son. The title in effect means "The Last Supper According to Renee Cox," and the art-historical reference is to the *Last Supper* according to Leonardo da Vinci. There are a great many pictures of Christ's last meal with his disciples, all of them by the nature of the case interpretations, since literal pictorial records are out of the question. Cox's interpretation enjoys the protections of the First Amendment, but one loses a great opportunity in thinking of her work—or anyone's work, for that matter—merely in terms of the artist's right to make it or the museum's right to display it. Cox is a serious artist, with serious things to say in her chosen medium. The First Amendment exists to protect the freedom of discourse, rightly perceived as central to the intellectual welfare of a free society. Art belongs to that discourse, and our taxes support museums in order to give citizens access to it. Mayors should be first in line to secure these rights and benefits rather than voice hooligan pronouncements against art for the evening news.

Yet the history of images is also the history of forbidding the making of images. This interdiction is wholesale at Exodus 20:4, where Jehovah prohibits any likeness of anything that is in heaven above, or that is in the earth beneath, or is in the water under the earth. There is an implied thesis in pictorial psychology in this commandment, which probably goes to the heart of the matter: People have a hard time not believing that there is an internal connection between pictures and their subjects. If you can place a picture of an antelope on your cave wall, you have made an antelope present in the cave. If you have a picture of a saint before you, the saint herself is right there, mystically present in her icon. So if you pray before the icon, your prayers are immediately heard by her whose image it is. It was this intimacy with holy beings that made icons so greatly cherished in early Christianity and that accordingly made them so vexed a political nuisance in the Byzantine Empire, which was torn asunder for more than a century

by controversy over what we might think of as pictorial metaphysics. The arguments pro and con had an intricacy and deviousness that help give the term "byzantine" its familiar meaning. But when the Iconoclasts were in power, it also meant an actual destruction of icons so thorough that very few of what must have been an almost countless number of them have survived.

D rawing is said to have been invented by a Corinthian girl, Dibutades, who traced the outline of her lover's shadow on the wall so that she would keep a trace of him with her when he left. Images in their nature have outlines, which is why Byzantine theorists regarded every likeness of God as false: God has no outlines, and so to picture God is to represent God as finite. The Byzantine practice of worshipping God through worshipping an icon of God is idolatry, which is the worship of finite things. And it was the intent of Exodus to forestall idol worship. The problem this presented to the established religion was that the church in fact exercised monopolistic control over images, and prohibition accordingly had deep economic consequences, given the appetite that was a defining trait of Byzantine culture. Supporters of icons had a clever answer. Toleration of images is one of the grounds on which Christianity distinguishes itself from Judaism and indeed Islam. The whole message of Christianity rests on the proposition that God decided to save humanity from sin by self-incarnation in human form. But human beings in our nature are finite. Since God is Jesus, in worshipping Jesus one is worshipping an infinite being in finite form. Indeed, we have Jesus' own testimony for the acceptability of images, since he himself conferred his image upon Saint Veronica, who offered him her veil to wipe his brow with as he struggled up the road to the cross: When she received it back, there was the image of Christ's face, like a photographic impression. This was considered a miracle, and Veronica's veil is one of the most important relics in the church's large inventory.

The identity of the persons of the Trinity is the most abstruse and contested teaching of the early church, but once the decision is made to take on human form, the question of gender immediately arises,

and this brings us to the Brooklyn case. Humans are sexually bimorphic, so the question cannot be avoided. Could God have chosen to be incarnate in a female body? To say that God could not have is inconsistent with God's power. My sense is that a male body would have recommended itself at that moment in history, in order to make sure that Jesus would have a respect and authority not ordinarily accorded females. But does this rule out that Jesus *could* be represented as female? That might have been difficult for worshippers to deal with during certain stages of iconography, though it should hardly be an insuperable problem, once we appreciate that pictures may be regarded as symbols rather than mere likenesses. Not even the first Christians had difficulties in accepting that Christ could be represented as a fish! The Greek word for fish, *ichthys*, acted as an acronym for "Jesus Christ God's Son Savior." One of the great theologians went so far as to play on the idea that through the sacrament of baptism, water is the medium in which we live, so that Christians, like Jesus, are fishlike in nature.

The masculine identity of Jesus is explicit in representations of the Christ child in Western art, over and over again shown with a penis, often pointed to in pictures, sometimes by the Christ child himself. The great art historian Leo Steinberg has made this the theme of a major contribution, *The Sexuality of Christ in Renaissance Art and in Modern Oblivion*. Any ambiguity on the matter raises difficulties of interpretation. When, for example, pilgrims carried lead badges showing Christ bearded and crucified but wearing a robe, these were found to be puzzling in Northern Europe, where only women wore such garments. Here is the reasoning that resolved the issue: On the evidence of dress, the figure had to be female. (Evidently clothing trumps beards, since there are bearded women.) A myth evolved that the bearded woman was Saint Wilgefortis, which derives from *virgo fortis*—strong virgin. Wilgefortis, a beautiful virgin, wanted to devote her life to Christ but was betrothed to the king of Sicily. She prayed that she be made ugly, and God answered by causing a beard to grow on her face. The king of Sicily, disgusted, canceled the wedding. Her father was so angry that he had his bearded daughter crucified. Thus grew up the cult of Saint Wilgefortis, and her worshippers, praying

before the figure of a bearded woman, were unbeknownst to themselves really praying to Christ.

An image of a crucified person wearing a dress could be, taken literally, Saint Wilgefortis, or symbolically it could be Jesus. The central figure in *Yo Mama's Last Supper*, since nude, is hardly ambiguous in point of gender. But it is ambiguous as to whether it is literal or symbolic representation. So let's begin to examine the work as art critics.

It is an exceptionally large photograph, in color, consisting of five panels, each thirty-one inches square. The female figure occupies the entire central panel. She is standing, arms outspread, palms upturned, behind a table set with some bowls of fruit and a wineglass. Because of the title and certain formal similarities to Leonardo's painting, one has to say that she occupies the place of Christ. I think that it is incidental to the meaning of the picture that Cox photographed herself as Jesus, since I don't think she is suggesting that she is Jesus, or that it is a self-portrait of Renee Cox as Jesus. Rather, she is working along lines associated with Cindy Sherman, who photographs herself but not as herself, with the difference that Sherman has never, so far as I know, shown her own nakedness. Renee Cox has used herself as model for Jesus, symbolically represented as a woman. This is interpretive conjecture: It is impossible to know from the picture alone whether Cox is saying that Jesus was in fact a woman or merely that he is being represented as a woman. The differences are immense, one being about theological, the other about representational, fact. Obviously the two can be connected. No one thinks that Jesus was actually a lamb, but he is often enough depicted as a lamb, and this is thought to be a symbolic way of presenting some deep truth about Jesus. One speaks about being washed in the blood of the lamb, but as Muriel Spark observes in a novel, blood is too sticky to wash with, so the image is poetic license.

In the "Sensation" show (at the same museum and which also drew the mayor's ire), the British artist Sam Taylor-Wood showed a Last Supper with a woman, nude from the waist up, as Jesus. She ti-

tled the work *Wrecked*. Taylor-Wood's picture is somewhat baroque and even Carravagesque, and in it Jesus looks haunted. Cox's picture is rather classical, with the disciples distributed in two groups of three on either side, and Jesus appears (I would say) magisterial. S/he is holding what I imagine is a shroud over his/her arms and passing behind the body, so as not to conceal her femininity. Taylor-Wood's picture raised no hackles at the time, but this may be explained through hackle fatigue—unless the fact that Jesus is black in Cox's image is the suppressed premise in the recent complaint.

Since Christ has been shown as a lamb in many wonderful paintings—and continues to be represented by a fish in various gift items and ornaments for automobiles—there is iconographic room for him to be shown in many different ways. Showing God as male is, as I say, a historical contingency. It could be a metaphor, through which one conveys Christ's absolute authority, males traditionally having that in patriarchal societies. But there is a more central consideration. Let us remember that the whole message of Christianity is that God took on a human form in order to redeem us through his suffering. There is a magnificent piece of criticism by Roger Fry of a *Madonna and Child* by Mantegna. "The wizened face, the creased and crumpled flesh of a new born babe . . . all the penalty, the humiliation, almost the squalor attendant upon being 'made flesh' are marked." In view of the profound suffering both women and blacks have undergone through history, it would be entirely suitable that Christ be represented as either of these, or both. It is true that in Cox's picture, Christ looks exalted and self-certain. It is a picture of someone defiant and prepared to face down her oppressors. But it is, on whatever symbolic level, after all a picture of God. Taylor-Wood's picture is of Jesus as human. But the important truth is that Jesus is supposed to have been both, and the issue of what gender the human is to be in a given representation is a matter of delicate interpretational negotiation.

These are the considerations on which I want to deny that the picture is either indecent or anti-Catholic. The mayor blurted out these epithets when he was shown a photograph of *Yo Mama's Last*

Supper in the *Daily News*. Giuliani can always be counted on to make entertaining noises in the presence of art. He might have said the same thing had an artist scanned a picture of a fish into Leonardo's painting. I appreciate the fact that the mayor has more pressing things to deal with than pondering the mysteries of Christ's body or the language of religious symbols, but if the so-called Decency Panel he has formed presses forward, I think he owes it to art and to his religion to ask that pictures that offend him be explained to him. I would be astonished if the panel he has appointed is interested in doing that on his behalf. If I were summoned as a witness, I would be eager to point out the complexities of interpretation involved with the art that comes before it, and that the panelists should consider the art the way it is considered by a critic, from the perspective of what view is being visually advanced. Seen that way, it becomes a matter of finding plausible critical hypotheses and then seeing whether they could not be true—giving the art the benefit of the doubt. I cannot imagine the panel having to meet very often once its meetings turned on such matters of interpretation. The issue finally becomes of a piece with conflicts in society at large, where we have learned to tolerate views whether we like them or not.

There is, to be sure, a distinction between protecting a right and supporting an art museum with our taxes. There are those who see free expression as a right but not necessarily a public right to art museums as institutions. That question reduces to one of why we should have art museums, paid for by our taxes. My view is that it would not be art if it did not advance views, whether the views are mine or agree with mine or not. So you can't have art museums without the question of freedom of expression arising. (Whether there should be museums at all is another question entirely, though fortunately it is not the mayoral panel's charge to answer it!)

So let's imagine that after all the explanations, an image really *is* anti-Catholic and indecent. Should our tax dollars support such art—or further, since any view can be expressed in art, are there other views we would not want expressed in our art museums? I say that if it can be expressed outside of art, there is room for it in the museum if expressed *as* art. Let us take a very controversial view—that abortion

is murder. That is part of the discourse on abortion, and it is certainly at the heart of the "pro-life" movement. A painting that shows an abortion clinic with the title *Massacre of the Innocents* has a right to be shown if the belief it expresses has a right to be voiced—as it of course has. It is offensive to pro-choice advocates, but hanging it in an art museum harms them less than having to face people shouting their position in front of clinics.

All this takes us a long way from Renee Cox's photograph, and it shows how irrelevant to the deep issues of expressive freedom a panel on decency really is. These days, "indecency" is a fairly marginal infraction, since questions of fittingness and suitability are almost impossible to arbitrate. If anything is unsuitable, I would suppose it is officials talking recklessly about art when they are representatives of a city in which interest in art is profound and serious talk about art is as expressive of the city's soul as talk about baseball. A city of great museums and universities, a beacon of high culture to the world at large, deserves decency in discourse about art on the mayor's part. I would not insist on a panel to keep the mayor in line.

May 28, 2001

William Kentridge

In a famous sequence of photographs, Henri Matisse documented, over the course of six months in 1935, twenty-two states of his evolving *Large Reclining Nude*. On impulse, I recently made photocopies of these and fastened them together as a kind of flip-book. This yielded a crude approximation to a cinematic experience in which the nude figure turned and twisted and fluttered her legs up and down, while parts of her body swelled and subsided. It was in fact quite sexy but did not seem quite to fit what Matisse spoke of, figuratively of course, as a motion picture film of the feeling of an artist. So I shifted into a sort of slow motion and register the following tentative observation: In the first state, recorded on May 3, Matisse's model is depicted in a fairly straightforward way, occupying roughly the lower half of the canvas. By September 6, her head has been disproportionately enlarged, and it has become a recognizable portrait of Lydia Delectorskaya, his *poseuse*. On October 30, the head has grown disproportionately small, the features are schematic, the torso has grown lank, and her bent arms fill the canvas from top to bottom. It really felt as if I had been able to track the artist's feelings toward the model, who becomes for him an individualized woman about midway through the painting's development. If so, the sequence does more than document the stages of a painting. It charts a transformation, from an external relationship between artist and model to an intimate relationship between man and woman. The motion picture film then yields something we could not easily get from the completed painting itself,

marvelous as that great work is, and it shows something about the limitations of painting as a medium. Who knows if Matisse did not begin photographing his painting because he sensed there might be a deeper story to tell than the history of how a painting changes.

The artist's emotional involvement with Lydia Delectorskaya has remained a Matisse family secret, but it is difficult to suppress the thought not only that a change of feeling toward her took place in the course of executing *Large Reclining Nude* but, more boldly, that Matisse used painting as a way of discovering what his feelings were. The South African artist William Kentridge speaks of drawing in almost these terms: "The activity of drawing is a way of trying to understand who we are or how we operate in the world. It is in the strangeness of the activity itself that can be detected judgment, ethics and morality . . . So drawing is a slow motion version of thought . . . The uncertain and imprecise way of constructing a drawing is sometimes a model of how to construct meaning." Note the cinematic metaphor through which Kentridge characterizes mental process and how, though his artistic ambitions otherwise resemble those of Matisse to no appreciable degree, he also sees drawing as an avenue to self-discovery.

South Africa was invited to exhibit in the Venice Biennale in 1993 in acknowledgment of the repeal of apartheid, and in 1995 the first Johannesburg Biennale was organized as a gesture that South Africa was now part of the international art community. Kentridge himself exhibited in the Fourth Istanbul Biennale, held that same year, and ever since he has been widely shown and highly admired for his animated films based on his drawings. But the drawings themselves have an independent authority, in large part, I believe, because of the palpable evidence they provide of their author's search for meaning and even for personal meaning. It may seem curious that in work with so marked a political intention as Kentridge's, there should be the same preoccupation with self-understanding that we find in Matisse, who seems almost flagrantly hedonistic as an artist. But upon reflection it is no less curious that someone who created for himself a world of *luxe, calme, et volupté*—to use an early title that Matisse appropriated from Baudelaire—should, at a somewhat advanced age, use painting as a method of self-analysis.

In point of style, Kentridge's work has a certain retrospective aura, as if it belonged more to the era of Matisse than to the contemporary world. The drawings and, indeed, the animated films for which they serve as material feel much in spirit as if their provenance were the art world of *Mitteleuropa* from the early part of the twentieth century. Kentridge himself has commented on this:

> Much of what was contemporary in Europe and America during the 1960s and 1970s seemed distant and incomprehensible to me . . . The impulses behind the work did not make the transcontinental jump to South Africa. The art that seemed most immediate and local dated from the early twentieth century, when there still seemed to be hope for political struggle rather than a world exhausted by war and failure. I remember thinking that one had to look backwards—even if quaintness was the price one paid.

It is perhaps testimony to the deep pluralism of the contemporary art world that the language of early Modernism should be accepted and even admired as a vehicle for expression and exploration today. Kentridge is rightly considered a very important artist, which explains why he is the subject of a major exhibition at New York's New Museum of Contemporary Art. (It will travel to the MCA in Chicago, the CAM in Houston, and the Los Angeles County Museum of Art, before its final venue in the South African National Gallery in Cape Town.)

Kentridge draws primarily in charcoal, a medium versatile enough to have been used in the achievement of the *demi-teinte* drawings prized by the Beaux Arts academies of the nineteenth century, as well as in the broad expressive drawings of German Expressionism. Kentridge appreciates charcoal (enhanced by a sparing use of pastel) for its softness and quickness on paper. But with its sensitivity to pressure, to revision and overdrawing, to erasure and smudging, it lends itself particularly well to the kind of probing exploration for which Kentridge prizes drawing as an activity. The result often stands as a kind

of palimpsest of the stages of its emergence as an image. There is, moreover, an internal connection between drawing in charcoal and the exceedingly primitive technique of animation Kentridge evolved. One can photograph a drawing, then modify the drawing, then photograph that—and continue this process until one has transcribed, through sequences of smudging, erasing, and overdrawing, a complete transition not just in the drawing, physically considered, but also in what the alterations in the drawing sequentially depict. In short, the photographs taken at various stages of a drawing's alteration literally become frames in a filmstrip that, when projected, show a change in the reality depicted. Animation enables Kentridge to get beyond the limits that Matisse circumvented by means of serial photography.

An example will make this clear. Consider a sequence of fourteen frames from Kentridge's 1991 film, *Sobriety, Obesity, & Growing Old*. Each of these is a photograph of the same drawing as it has undergone a series of changes. In the first frame, we see a factory building in a somewhat dated modernesque style of architecture, drawn in a correspondingly dated Modernist style that Kentridge has made his own. The factory, sharply highlighted, stands against the sky, alone in a barren landscape. In the next frame, the artist has begun to scribble a sort of dark mass, like a dust cloud, at the building's base. In the third frame, the artist has begun to erase, hence lighten, the top part of the cloud. This cloud grows larger and lighter through a number of frames. Meanwhile, he has begun to rub out the drawing of the building. The building grows fainter and fainter as the cloud engulfs it. Now the artist begins to erase the cloud so that there is a frame in which a ghostly *pentimento* of the building hovers over the thinning cloud. Finally, as the dust has settled, the artist has drawn the figure of a man standing in what remains of the cloud, his back to us, facing where the building used to be. In the final frame, the figure of the man is darkened. He stands alone before the traces on paper of an erased factory. As with Matisse's *Large Reclining Nude*, where there is only one canvas, the changes in which have been documented by his photographs, here there is only one drawing, systematically modified. But where *Large Reclining Nude* shows no signs of the changes Ma-

tisse made, the final photograph in Kentridge's sequence shows the stages it has gone through—the erasures, the scribbles, the darkening, the outlines of the factory that used to be there, the shape of the man who entered the picture only in the final stages of the drawing. It is like a face that bears the marks of its owner's experience. "What is interesting about doing the animated films," Kentridge told interviewers, "is that it's a way of holding on to all the moments and possibilities of the drawing." His drawings record the struggle to achieve them.

Put another way, the changes in *Large Reclining Nude* were not made for the sake of being photographed; the photographs merely document those changes. The changes in the drawing of the factory, by contrast, were narratively driven and made for the *sake* of the photographs, because it is through them, as a film sequence, that a story is told. It is the story of a world falling apart. The figure in the drawing is internally related to the factory. He was in fact the factory's owner, as we know from the film from which this sequence has been extracted. We have been shown the fact that his world has fallen apart, that he is left alone in the landscape in which his factory once stood. The figure is that of the industrialist Soho Eckstein, a character Kentridge invented—the star of his series of allegorical films, which he calls "Drawings for Projection," of which *Sobriety, Obesity, & Growing Old* is the fourth.

Soho is an overweight, balding, ruthless man, with a heavy cigar and an emblematic pinstriped suit and striped necktie. The suit-and-tie is his attribute—as much so as keys are the attribute of Saint Peter or a chalice of blood that of the bereaved Madonna in Christian iconography or a silk hat and moneybags the attributes of the Capitalist in left-wing iconography. Soho is never shown not wearing it, whether working or sleeping, or lying in a hospital bed, or in a symbolic pool of water embracing his alienated wife. In the first of the films, in which he is introduced—*Johannesburg, 2nd Greatest City after Paris*—Soho Eckstein is the embodiment of greed and rapacity. He has bought up half the city of Johannesburg and sits at his desk, running his vast network of enterprises, or at a table swilling down mountains of food with bottle upon bottle of wine. Outside, we see an

industrial wasteland, punctuated with pylons and floodlights, and traversed by the expropriated masses. In *Monument*, Soho addresses a crowd as a benefactor, at the dedication of a monument to the Working Man. In *Mine*—a wonderful pun, since the mine is mine—the film connects Soho with his mining enterprises. We see rows of miners blasting away in dark precincts, and we see Soho orchestrating their activity from a desk, on which are displayed pieces of African art as trophies. But things have begun to go very badly for Soho in *Sobriety, Obesity, & Growing Old*. His empire has collapsed. He is alone in a world for whose barrenness he is largely accountable.

But the loss is more personal by far than my narrative thus far would suggest. Soho's wife has been taken away from him by his alter ego, Felix Teitlebaum, a moony artist who looks like a somewhat leaner Soho with his clothes off. Aside from these differences, Felix and Soho look much alike, which suggests that together they constitute a self-portrait of the artist, since he resembles them both. And that is another illustration of how drawing leads to self-knowledge.

As in the final frame of the collapsing factory, we see Soho alone against an empty sky—a mere smudged blankness onto which the artist has superimposed the words, printed in block letters:

HER ABSENCE

FILLED

THE WORLD

And we find ourselves feeling sorry for poor Soho, a human being after all, with a broken heart.

Kentridge's commentators see the films as filled with references to the political drama of South Africa, and doubtless the artist's countrymen will be able to read these in terms far more local than are available to us who have not lived through the agonies of those struggles. At the same time, the films attain a level of allegory that makes them almost universal. Soho is an inspired invention, but he corresponds to the hard-nosed kind of industrialist commonplace in the representation of capitalism since at least the time of Marx and En-

gels. "I paint the capitalist and the landlord in no sense *couleur de rose*," Marx wrote in his preface to *Das Kapital*. But here individuals are dealt with only insofar as they are the personifications of economic categories, embodiments of particular class relations and class interests. Were it not for lettering in "Johannesburg," there would be no way of knowing that the masses represented in *Johannesburg, 2nd Greatest City after Paris* were African blacks. The image could have been by Käthe Kollwitz or some illustrator for *New Masses*. There is thus something generic in the relationship between Soho and the country he exploits, into which the particularities of apartheid have to be read. But similarly, it is by virtue of romantic allegory that Soho's guilt is internalized as insensitivity to his wife's emotional needs. And where in South African political reality does the sensitive and artistic figure of Felix Teitlebaum exactly fit? In *Sobriety, Obesity, & Growing Old*, the political becomes the personal. There is a wonderful image in that film in which the essential triangle of Soho, Mrs. Eckstein, and Felix is represented. Soho, holding a cigar that gives off the dense black smoke of one of his factory chimneys, is gazing into what I take to be a loudspeaker, while luscious Mrs. Eckstein lies beneath Felix, her eyes closed either in dream or rapture, while—in the animation—a kind of fish swims from Felix to her. It is exceedingly erotic, as the film itself at moments is, though it is difficult to know whether the love scenes are imagined by Soho or enacted by the couple, or, for that matter, imagined by them. In a way, Soho, Felix, and Mrs. Eckstein—Tycoon, Artist, and Wife—form as rich an allegorical triangle as Offissa Pupp, Ignatz, and Krazy Kat in George Herriman's inspired landscape. The films Kentridge made afterward are deeply introspective exercises in which both Soho and Felix undertake, in their different ways, to construct meanings for their lives. Mrs. Eckstein is not developed further.

I am very impressed by the way, as an artist, Kentridge seeks to reflect political problems through interpersonal relationships. In her instructive catalog essay, Lynne Cooke cites Kentridge's way of seeing his situation as an artist who is at once engaged and disengaged: "Aware of and drawing sustenance from the anomaly of my position."

At the edge of huge social upheavals, yet also removed from them. Not able to be part of these upheavals, nor to work as if they did not exist. That is the way I see his art—not part of the upheavals but to be understood through the fact that they exist and in some deflected way explain the art. In the end, if one thinks about it, this is the way artists have often dealt with political upheavals: at their edge, and in the framework of love stories. Think of Hemingway or Tolstoy or, if you like, Jane Austen or possibly Matisse.

The films are the heart of the exhibition, as they are the crown of Kentridge's oeuvre, and I would head for them immediately. After that you can work your way back through the gallery, in which some of the stills—the drawings he used for the films—are on display. On your way in, you will have passed a sort of animated *Shadow Procession*, in which silhouetted figures, which inevitably remind one of the disturbing cutouts of the brilliant Kara Walker, sweep past your vision. It is a little soon to pronounce the show unforgettable, but I have not been able to erase from my memory the song by Alfred Makgalemele that accompanies *Shadow Procession*, and my feeling is that certain of the images will be with me for a very long time.

July 16, 2001

Picasso Érotique

In his essay for the catalog that accompanies "Picasso Érotique," beautifully installed in the Montreal Museum of Fine Arts, Jean-Jacques Lebel reproduces an extraordinary drawing that is not included in the exhibition itself. On the right is a vagina, sparsely surrounded by pubic hairs. It dwarfs the homuncular male figure, moving open-eyed and stubble-cheeked into the dark night of death, emblematized by a sweep of black wash. The date of execution is inscribed in large and ornamental numerals: 25.7.72. It was perhaps the last of the goaty old master's drawings of a woman's *sexe*—he was to die, aged ninety-one, the following April. The figure, of course, is Picasso himself. In his middle seventies, after he was abandoned by his young and beautiful mistress, Françoise Gilot, he represented himself as some figure of contempt—an old man, a monkey, a clown, a grotesquely fat caricature of an infantile male personage, often an artist—juxtaposed with an inward-dwelling woman, a model, usually nude, indifferent to his presence. The male will often be shown draped and ornamented with the paraphernalia of worldly recognition—armor, for example, or robes too large by far for his shrunken physique. The woman needs no external mark of power. Her youth and nakedness, which at times are accentuated by a circlet of flowers worn in her hair, are emblem enough. In this small, scary masterpiece, Picasso is taking leave at once of life and of sex. *Eros c'est la vie* was the punning pronunciation of Rrose Sélavy, the pseudonym that his fellow eroticist, Marcel Duchamp, took for himself when he assumed his

periodic female identity. The same disproportion of this farewell drawing is embodied in Duchamp's monumental *Large Glass*, in which the Bride sits aloof and alone in an upper chamber while her various Bachelors are segregated in a limbo of desire below.

The disengaged vagina is a universal symbol. What Picasso has scrawled in the 1972 drawing could have been incised in plaster outside a doorway in India or brushed in red pigment on a wall in Rome at any moment of its history—or scribbled with ballpoint in lavatory booths or drawn with a pencil stub wherever lonesome men languish. On the other hand, it belongs to its meaning to be furtive and hidden. The female nude is omnipresent in Western art, but the representation of a woman with her genital orifice displayed is exceedingly rare. There are two celebrated exceptions. The first is the somewhat presumptuously titled *The Origin of the World* by Gustave Courbet, painted in 1866—roughly the moment when the term "pornography" entered the language. It shows a reclining woman, her legs spread apart, her garment lifted to the level of her breasts and her luxuriant pubic thatch exposed to the viewer. The woman's head, lower legs, and arms are cropped by the edges of the canvas, which was evidently kept covered by a green veil after the painting was done. It was commissioned by a Turkish diplomat, Khalil Bey, and was later acquired by the celebrated French psychoanalyst Jacques Lacan, who was, incidentally, Picasso's consultant on most medical questions. Lacan too kept it hidden—like the portrait of *La Belle Noiseuse* in Balzac's *Chef d'oeuvre inconnu*. It was concealed behind a painting by Lacan's brother-in-law, the Surrealist André Masson, and shown only to favored visitors. Courbet's painting became the property of the French state after Lacan died, and I first saw it at—naturally—the Brooklyn Museum. It was shown in the 1988 "Courbet Reconsidered" exhibition in the days predating Mayor Rudolph Giuliani, when it aroused neither outcry nor outrage but only a certain curiosity. Later it went on view at the Musée d'Orsay, surrounded with enough art history almost to neutralize it. I once discussed it in a lecture at Yale but was hesitant to show a slide—though I was told afterward that avant-garde feminists have adopted it as a symbol of female power. In certain African societies it is considered lethal to behold a woman's

genitals, which are kept safely out of view by means of the myth of their dangerousness.

The other example is Duchamp's mysterious *Étant donnés . . .* in the Philadelphia Museum of Art, where, peering through a peephole, one finds oneself looking at the shaven cleft, between her spread legs, of a woman lying on her back. Duchamp designed the installation in such a way that the hole through which we see her will not allow the viewer to see her head or even if she has a head. It was Duchamp's last work, done in secrecy during the final twenty years of his life, when the received opinion was that he had given up art for chess. There is a wall in "Picasso Érotique" with small apertures through which one can see backlit transparencies both of the Courbet and the Duchamp as Picasso's predecessors in the representation of a woman's open *sexe*. It is a distinguished but not a particularly extensive artistic genealogy, considering the wide distribution of this particular organ and the extraordinary interest it generates in most of our lives. A visitor from outer space could acquire a wide knowledge from the history of art of what human females look like undressed but have not a clue as to the vagina's existence or visual appearance.

There are two main aesthetic reasons for its absence from art. The first is enunciated by Freud: The genitals themselves, the sight of which is always exciting, are hardly ever regarded as beautiful. When a New York gallerist was shown some examples from a work by the French Surrealist Henri Maccheroni, titled *2000 photographies du sexe d'une femme*, she said she realized why, by contrast with breasts and buttocks, this particular attribute played no part in the stereotype of feminine beauty. The second reason is this: The difference between male and female nudes is that the male's genitals are visible unless they are covered but the female's are invisible unless uncovered, which requires that the woman assume an awkward posture in which they are displayed. There are two circumstances in which this routinely takes place. The first is the gynecological examination. The second is where they are flashed by sex workers for the enticement and arousal of clients. In a superb review of a book on a brothel in a recent issue of *The Nation*, Leah Platt quoted

the author's interview of a working woman on her job, performed behind a window before a paying male: "make eye contact, pout, wink, swivel your hips a little, put a stiletto-clad foot up on the window sill to reveal an eye-full of your two most marketable orifices, fondle your tits, smack your ass, stroke whatever pubic hair you haven't shaven off . . . until the customer comes, then move on to the next window." The segregation of the Bride from the Bachelors in Duchamp's *Large Glass* could be an allegory of this transaction.

In her legendary early film *Fuses*, the great performance artist Carolee Schneemann undertook to discover whether showing how sexual love looked corresponded to the pleasure of experiencing it, and this involved her in finding a way of exhibiting herself that was neither gynecological nor pornographic. I have never seen *Fuses*, but in her forthcoming book, *Imaging Her Erotics*, Schneemann describes how the film landed her in hot water with audiences from the art world, from which she had supposed she could count on a measure of support. Since there are a certain number of opened vaginas in "Picasso Érotique," the exhibition's organizers—Jean-Jacques Lebel and Jean Clair, director of the Musée National Picasso in Paris—prudently decided against seeking a New York venue for their show, thinking, with the European's affecting ignorance of North American geography, that New Yorkers need but slip across the border to see it. So unless you're prepared to take an hour's flight on Air Canada—or do the thing properly by postponing your trip to Barcelona until the show is installed in the Museo Picasso, near where it all began—you'll have to make do with consulting the catalog and writing a letter of indignation to Giuliani's Panel on Decency.

Just inside the entrance to "Picasso Érotique," the exhibition's designer has re-created an imagined bordello bedroom as one might have existed in the red-light district of Barcelona in the era of Picasso's youth. Projected on its wall is a clip from what I take to be a vintage film, in which a generously proportioned woman, sitting on the edge of the bed, lifts her breasts in the time-honored way and then stands, with her wrapper open, to give us a view of her nakedness. The action is pretty fast. We get a shot of a man administering cunnilingus while

a frustrated customer peers through a keyhole until he evidently can't hold himself in any longer and falls to the floor, clutching his front, like one of Duchamp's bachelors. It certainly beats an acousta-guide in setting the somewhat merry tone the early drawings and watercolors carry out. The pictures are really scraps, pages from a sketchbook, graphic souvenirs of the artist's erotic encounters in the kinds of bedrooms we have just seen, with the kinds of women we have just been shown. A lot of the pictures are on the border between cartoons and life drawings. There is a certain amount of cunnilingus, some lively sketches of an ecstatic woman in high stockings fingering herself, some scenes of women sitting around half dressed, a few quite tender scenes of lesbian caress, and a fairly ambitious painting of the artist himself, looking as innocent as a choirboy and wearing a striped jersey, being treated to fellatio. It is on loan from the Metropolitan Museum of Art, but I'll lay odds that though it was painted in 1903, in the middle of Picasso's extravagantly admired Blue Period, you won't see it proudly displayed there when the Montreal show is over.

The interest of these mostly ephemeral works lies as much in what they tell us about the male sexual imagination as about what Picasso saw. Men visited the brothels of the so-called *barrio chino*—the Chinese Quarter of old Barcelona—as they visit brothels everywhere: in part to see, in part to enact, what life otherwise allows them only to imagine. That is why the displayed vagina belongs so centrally to pornography—the much-debated male gaze is not readily gratified, due to its object's hiddenness. There are relatively few depictions in the early parts of the show of the way men and women in love express that condition sexually.

But there is a great deal of that in Picasso's art, beginning with when he fell profoundly in love with Fernande Olivier in 1904 and began to see life *en couleur de rose*: The so-called Rose Period is not merely a change of palette. Pictures titled *Le Baiser* (The Kiss) or *L'Étreinte* (The Embrace) outnumber by a significant factor those showing special couplings of the kind advertised in Pompei—though there is a gouache from 1917 that could easily have been copied from the kinds of souvenir postcards that are probably still hawked outside

the excavations. Its chief pictorial function is to display the man's enormous penis in a state of futile erection, since the couple has assumed a position too athletic for actual intercourse to take place: She is standing on her head, with one foot braced against his chin. In the main, except when he is being satirical, Picasso has no use for the caricaturely gross penis. He shows himself as normally proportioned in an awkward, scowling 1902 *Self Portrait With Nude*.

The kisses are intensely felt and at the same time comically shown: In a painting dated January 12, 1931, the couple dart their triangular tongues into each other's mouths; the woman's nose is draped affectionately over the man's, her eyes closed and his rolled upward. In *Figures at the Seashore*, it is impossible to determine to which of the two kissers the breasts belong, as if the difference between two individuals has been transcended, and they are one being, with tangled legs and arms. One cannot but think, in these wonderful middle-period works, of Aristophanes' vivid thesis in *The Symposium*, that each of us was once part of a single being, now split into two, each part seeking to be reunited with the other. So many of the *Baisers* and *Étreintes* are ingenious, imperfect reassemblages of bodily parts into helpless erotic wholes, destined to fall apart despite the great passion that brought them together. The overall mood is one of tenderness and comedy.

So I was not surprised to learn from the museum's publicist that there have been very few complaints about the show in Montreal, though attendance so far has greatly exceeded expectations. But there has been a spontaneous show of affection on the part of those who visit the show together. Basically the show is about love. She told me that she had been alerted by one of the guards that couples often begin to hold hands while looking at the work, to whisper in each other's ear, to embrace lightly, even to kiss. I found that a very touching discovery and really something of a vindication for mounting such a show. It is evidence that there is more to experiencing art than allowing one's eyes to be flooded with form. This is the power of erotic representation: We respond with affection. But sex has another strand as well, a raucousness and comedy that the ancients appreciated when they rocked with laughter at the sight of satyrs capering across the stage with leather phalluses. For all his tenderness, Picasso was a fierce satirist, aware that we can look pretty ridiculous in the grip of sexual

passion. There is a delicious suite of etchings done in 1968, showing the painter Raphael making endless love to his mistress, La Fornarina, never so overcome by passion that he has to put down his brushes and palette and use both arms. In all of these images, Picasso shows the couple's genitals fitted together like bolt and bolt hole, but each wears the calm smile of Hindu deities in cosmic fornication, as if butter would not melt in their mouths. Most of these etchings contain observers as well as the lovers themselves. The pope, for example, often drops into a picture to observe the action—and in some of them Michelangelo gets an eyeful while hiding under the bed.

Raphael, painter of sweet madonnas and charming infants, was not above doing a bit of pornography himself now and then. His notorious 1516 frescoes of the history of Venus, commissioned for Cardinal Bibbiena's bathroom in the Vatican, were whitewashed over in the nineteenth century as inconsistent with what was felt to be spiritually fitting for the artist of the *Acts of the Apostles*. The nineteenth century was a bad time for the erotica of the masters. Ruskin had no hesitation in ordering the destruction of Turner's horny drawings on the grounds that he was obviously insane when he drew them. But the depiction of sex was one of the main reasons that drawing was invented. Even the misogynous Degas executed a series of monoprints in the Maison Tellier, one of Paris's best-known brothels of the 1880s. They show the prostitutes lounging about, waiting for clients or engaged in lesbian sex with one another. Picasso owned some of these quite compassionate images, and as he approached the age of ninety, he devoted a rowdy suite of etchings to the somewhat implausible episode of Degas observing the whores. There are a good many exceedingly open, exceedingly juicy vaginas in these pictures, I would say lovingly drawn, in which it is indeterminate whether the women are mocking or tempting the voyeur. In one, Picasso shows lines of sight from Degas's eyes to the hairy juncture of vaginal lips spread open for his uncertain delectation.

There are no open vaginas in Picasso's own celebrated brothel scene, the famous *Demoiselles d'Avignon*, one of the canonical works of Modernism and by all accounts his masterpiece. It could in one way

almost be a Cubist paraphrase of one of Degas's monoprints, in which the women are gathered to greet the visitor, who they hope will select one of them for whatever he is into. Here are five women in all—three classical figures to the viewer's left, two masked women to the right, one of them, her back to us, squatting. The masks could be African, could be Oceanic, but hardly belong to any European tradition other than that of the ethnographic museum, where Picasso first saw them. Whatever they are up to, the women hardly look as if they are out to tempt us. If we did not know from scholarship that it was a brothel scene, it is hard to know how we would read the work. It is easy to sympathize with Alfred Barr, who acquired the painting for the Museum of Modern Art, when he described this as a purely formal figure composition, which as it develops becomes more and more dehumanized and abstract. Leo Steinberg quotes this in a great essay, together with a 1912 interpretation by the poet André Salmon, of Picasso's own inner circle: The women " 'are naked problems, white numbers on a blackboard.' Can we be looking at the same canvas?" Steinberg asks with incredulity. I shall always be grateful for this "Can we be looking at the same canvas?" It definitively erased from my aesthetic whatever inclination I had toward formalism in art. On the other hand, I am not ready to be included in the "us" to whom Steinberg says this picture looks like a tidal wave of female aggression. I cannot get female aggression to fit with the overall feeling toward women conveyed in this wonderful exhibition, not even in the period when Picasso was painting Salome dancing for the price of John the Baptist's head. *Demoiselles d'Avignon* is not in the show, and that's a good thing. Nobody really understands it; nobody is even able to say whether it is a success or a failure. It may not be white numbers on a blackboard, but it falls outside the range of the human—all too human—to which eroticism, as behavior and imagination, belongs.

September 3/10, 2001

Art and 9/11

Not long after the attack on the World Trade Center, when my wife and I sat dazed and weeping by the television screen, a call came through from a journalist wanting to know what the art world's response to all this was to be. We were amazed that any call could get through, since the phone lines were pretty much down. I had not been able to call any of our artist friends, but the last question I would have raised with them was how they were going to deal with the tragedy in their art! My sense was that every artist I knew was in the same state of grief and disbelief as we. Indeed, as I discovered in the days afterward, everyone I talked to wanted to express the same thoughts and feelings I needed to. Asked by a colleague how I felt, I said, Like everyone else. And my colleague responded, We all feel like everyone else. And it would have been inconsistent with that feeling to think much about art at all.

Still, it says something about the power of art that someone should have looked to the art world to do something. I remembered a somewhat corny lecture from an undergraduate art history course, in which the people of Paris cried out, Take up thy brush, David! when Marat—*l'ami du peuple*—was stabbed to death in his bathtub. However corny, it was not all that far from the truth, as I recently read in T. J. Clark's marvelous study *Farewell to an Idea*. Like most political events, the French Revolution was enacted through images—think of how important to radical Islam those posters of Osama bin Laden have all at once become. Marat was a cult figure for extreme Jacobin-

ism, and it is entirely credible that someone actually stood up on the
floor of the Convention and shouted to David, Give us back Marat
whole! This is what David might really have believed himself to have
done in his tremendous painting of the slain Marat, shown as if de-
scended from the cross. Pictures, in the people's eyes, are miracles,
Clark writes, where what everyone thought was lost, or maybe just
subject to time and fevers, comes back forever into the world. To
whatever degree this not uncommon view of the power of images co-
incided with David's own, no one could look to art to give us back the
World Trade Center whole. If someone did try to turn the event into
art, it would in any case not be by means of painting a picture of the
twin towers as they stood. A painting of the sky over Ground Zero is
hardly needed, since the reality of their goneness inflects the glamour
of everything that remains of the Manhattan skyline. But in any case,
contemporary art has pretty much abjured pictorial representation as
its main vehicle. Whom would the people summon to artistic action
today?

On a recent visit to the Maryland Institute College of Art, I saw an
especially moving installation in a faculty show by its graduate dean,
Leslie King-Hammond. It was moving because it was of a piece with
the hundreds of shrines that appeared spontaneously all over New
York—in front of firehouses, along the edges of apartment building
stairwells, surrounding monuments in parks and public places. In her
installation, King-Hammond had placed votive candles, photographs,
flowers, flags, and other ephemera. One of the things contemporary
art has made available to artists is the freedom to appropriate to their
own artistic ends the very things with which ordinary, artistically un-
trained persons express themselves, so they can now bring the powers
of life into art. So, much of contemporary art consists in selecting and
arranging the things that define ordinary life. The avant-gardes of the
1960s were eager to overcome the gap between art and life, or to abol-
ish the distinction between high and popular art. An agonized corre-
spondent asked in an e-mail what Beuys would do if he were alive
today. My sense is that he would do exactly what King-Hammond has
done. He would assemble candles, photographs, flags, and flowers. I
was told that when her piece was installed, people stood in front of it

and wept. How often does that happen in faculty shows, or in any show at all? It was as if the difference between what was in the art world and what was not had entirely dissolved. The art world could do nothing better than what the world itself did. In truth, I think, it could do nothing other than the world itself did. There was no room for anything else as art.

As it happens, I was to have traveled up to the Davis Museum at Wellesley College on September 11, for the opening of a remarkable installation by Joseph Bartscherer, which, by an uncanny suitability, was titled *Obituary*. The work is in the form of a kind of cemetery, in which copies of *The New York Times* are arrayed, like gravestones, in orderly rows. Only those copies of the newspaper are displayed that carry obituarial photographs on the front page. Bartscherer, a photographer himself, has been collecting and preserving these newspapers since January 1, 1990. The first he displays is from January 26, 1990, which incidentally showed a photograph of Ava Gardner, dead at sixty-seven. Bartscherer was interested, among other questions, in whose picture gets to appear on the front page when he or she dies, and where on the front page it is placed, and how it relates to the other photographs printed there. *The Times* attempts to preshape history through the placement and size of stories and pictures, and Bartscherer was in particular concerned to exhibit the way significant deaths are presented to readers of the paper. The shape of newspapers is an important part of visual culture, but Bartscherer was attempting to bring to consciousness the way we think of death as a part of public life. I had written an essay for the catalog, and the artist and I were to have held a public conversation on this topic and others, which, of course, never took place. Death was written all over the front page on September 12, but there were no obituarial photographs. There have in fact been five since September 11; the most recent picture is of Mike Mansfield.

Wellesley College is not an art school, and it took great courage on the part of the curator of *Obituary*, Lucy Flint-Gohlke, to have exhibited a work that was certain to raise the questions of why it was there, how it was art. Those would have been important questions for college students to have faced before September 11. Instead of the open-

ing, there was on that day a kind of vigil. Officials of the college spoke, and of course there were tears. For the moment, *Obituary* was transformed into a shrine, not for the celebrities whose pictures occasioned the work but for the ordinary people whose deaths defined what everyone felt that day and since. The work became one with the vernacular surfaces of New York City, initially appropriated to display pictures of the missing, together with descriptions of their identifying marks, in case anyone should know their whereabouts. As days passed, these became obituarial photographs and the focus of meditation and sorrow. For a few weeks, the tiled columns at the Times Square subway stop were transformed into a cenotaph, with photographs taped one above the other, on all four sides. Someone placed candles at the bases, along with flags and flowers. New Yorkers paused in their transit to and from the shuttle to read the descriptions of people they did not know but whose loss emblematized their own, even if none of their friends or family members were among the actual victims. The victim was collective, and it was us. *The Times* transformed itself into a hometown newspaper, publishing, day after day, obituaries of the ordinary people—the guy across the street, the girl in the building next door—who were killed. I thought of Colonel Rainborough's great speech in the debates in Cromwell's army council: "The poorest he that is in England hath a life to live, as the greatest he."

Of the many commentators I have read on the attacks, only the historian of science Lorraine Daston, in the *London Review of Books*, observed their highly symbolic quality. We might have seen this for ourselves, had we recalled the aborted hijacking of an Air France plane a few years ago, which it was the intention of the terrorists to explode in the air above Paris or crash into the Eiffel Tower. *Air de Paris* was one of Marcel Duchamp's more poetic ready-mades. The Eiffel Tower has a meaning the Tour Montparnasse lacks. To destroy the Eiffel Tower would be to wound the soul of France, detested by the Algerian pirates for its colonialist policies. Bin Laden taunted America for its inability to protect its largest buildings. He did not boast about our inability to protect the lives of so many of its ordinary citizens. My own sense is that the hijackers thought of the buildings

themselves as primary targets, then of the people. Had they attacked instead our nuclear facilities, as Daston notes, the damage would have been of an altogether other order. Al Qaeda is still thinking symbolically, warning Muslims to avoid high buildings and airplanes, and threatening heads of state responsible for Muslim deaths.

It is a perversion of Islamic ethics to write off the deaths of innocent civilians as mere "collateral damage," to use the idiom of our homemade terrorist, Timothy McVeigh, who borrowed it from the military lexicon. But had the target been nuclear facilities, human deaths would not be collateral but primary. As it was, for New Yorkers, the material destruction was collateral. The perceived target was life—our life, in both senses of the term: the fact that we live and the way we live. So when the avant-garde composer Karlheinz Stockhausen declared the attack a work of art, he was thinking as a terrorist, and his comment was rightly received with moral disgust. What terrorists saw as symbolic, New Yorkers saw as a war against a form of life. The tragedy of these crossed incongruent perceptions is that we are responding with conventional war—*à la guerre comme à la guerre*—when the true response is to continue to live the life the perpetrators loathe and to find effective ways to engage with terrorists without squandering the sympathy our losses earned us even in the Muslim world.

Since it is our form of life that has been the symbolic target, it is precisely appropriate that any artistic response should be the spontaneous mode of symbolic mourning that everyone understands—the vernacular display of candles, flags, flowers, and the images that, in their own poignant way, express the same aching hope and sorrow that David's painting of Marat did. I don't think the proposed memorial light show in lower Manhattan—to restore the vanished skyline with columns of light—is the right kind of response. It is wrong because it memorializes the structures without restoring the form of life they facilitated. When, one by one, the artists I know returned to their studios, what they returned to was the art they were engaged with before. In that sense, that is what, so far, the art world is doing about the

attacks. People have been killed, but forms of life—that through which their lives had meaning—survive. There have been newspaper pieces about what happens to cities when they undergo disasters. They live through it, and beyond. The lights go back on, the theaters and restaurants fill up, everything works again. As the architect Christopher Wren had inscribed on his tomb in St. Paul's in London: If you seek a monument, look around you.

In the art world, and perhaps elsewhere, the expression "September 10" has taken on an epithetic connotation. In a seminar with graduate art students at the Maryland Institute, one of them spoke of the work of a celebrated contemporary artist as "so September 10." That made me wonder whether September 11 marks the beginning of a new period in the history of contemporary art, and even more, whether it marks a change in American conduct. A good bit of what is universally regarded as the typical behavior of New Yorkers might seem September 10, by sharp contrast with what we saw in those extraordinary amateur videos, made by plain men and women who happened to be downtown with camcorders on the morning of the disaster. People were everywhere shown acting with dignity, generosity, bravery, goodness and, spectacularly, with heroism. It was to me a demonstration of something deep in the culture, which was there on September 10 and will be there as part of the American spirit for a very long time. September 11 was a demonstration of a moral reality, in much the same way that everyone feeling like everyone else was. But that did not prevent the huge endorsement of a war against terrorism that, to my perception, is war *sans phrase*—as if the life of the poorest he in Afghanistan were of no greater consequence than that of ordinary American lives in the symbolic calculus of the terrorists themselves.

In his chapter on David, T. J. Clark cites a passage from George Kubler on the abrupt change of content and expression that the history of art sometimes exhibits. The sudden transformation of Occidental art and architecture about 1910 is an example of a change that was as if instantaneous. I don't know whether art itself can have undergone an abrupt change of this order on September 11, since I am far from certain that, though we are told nothing will be the same again, the moral quality of life in the West was changed by the horrors

we have lived through. The point is that we have lived through them, evidently the same as we were, despite the demonstration of moral sublimity on September 11 and through the days that followed. Everyone still feels like everyone else. What the instantaneity of the impromptu shrines has taught us is that art, at some level, is an abiding integral component of the human spirit. I have always taken this on faith, but I am not grateful to the terrorism for having provided us with a modicum of empirical confirmation. Given the circumstances, I would be glad never to have known how true it proved to be.

November 12, 2001

Philip Guston

have always marveled at the way Abstract Expressionism was able to transform a disparate group of painters, none of whom had shown any particular promise of artistic greatness, into figures of stunning originality. It was as if the movement opened up possibilities for paint never before exploited, and the artists were lifted by what they discovered onto an entirely new plane of expression. It was a convulsive moment in the history of art, and by the time it was finished, not only was there a new pantheon of artistic heroes but also a reconfiguration of the entire complex of practices that defined painting. The Abstract Expressionist canvas had become what Robert Motherwell characterized as "plastic, mysterious, and sublime." There was even a new style of talking—impulsive, confessional, oracular, and grandiose—in which artists attempted to re-enact, on the verbal level, what was taking place on the surface of their canvases. Words like "The Absolute," not to mention "Nothingness," "Anxiety," "Dread," and "Despair," rose like speech balloons through the smoke-filled air of the Cedar Bar and the Artist's Club on Eighth Street.

As tight-knit as the movement was, Philip Guston was, even then, a figure apart. When he turned to abstraction in the early 1950s, he had achieved considerably greater recognition as an artist than any of his peers. He had won the Prix de Rome in 1948 and, four years earlier, the first prize in "Painting in the United States," an exhibit sponsored by the Carnegie Institute in Pittsburgh, for a painting called *Sentimental Moment*, a study of a young woman caught in an intro-

spective mood, holding a locket. That painting made him famous and was widely reproduced. And when Guston did go abstract, his distinctive abstract style differed from that of any of his peers more widely than any of them differed from one another. His way of laying down paint was not fluid and urgent, like Pollock. It was not slashed and brushy, like de Kooning, or sweeping and calligraphic, like Kline. It did not float translucently, like Rothko. Guston's strokes fell like short, clustered dabs of pigment into nests and networks of closely harmonized hues, which resembled passages in Impressionist landscapes. The question was even raised whether it was Expressionist at all—whether Guston had not originated instead a form of Abstract Impressionism. The distance between what Guston had been, and what he became through Abstract Expressionism, was thus shorter than that traversed by any of the others. There was a certain shimmering quality, a master's touch, that, if my memory serves me well, *Sentimental Moment* shared with his great abstractions of the early 1950s.

I have to confess that I had been profoundly affected by *Sentimental Moment* when I first came across it as a young man; for a time I kept a picture of it pinned to my wall like an icon, though I never saw the painting itself. So I was disappointed that it was not included in the retrospective exhibition of Guston's work at New York's Metropolitan Museum of Art, even if it is easy enough to understand why. It really was a sentimental painting, which does not quite go with the edgy image of Guston that the show seeks to project. And beyond that, a retrospective aspires to be a narrative rather than a chronicle of an artist's life, so far as this is attainable. With that narrative, considerations of whether a piece or even a body of work fits with the story one wants to tell govern one's choice of what to show. The great dramatic moment of Guston's career was his return to figuration in the late 1960s and the debacle exhibition at the Marlborough Gallery in 1970. But the figuration to which he returned was at least as dissonant with that of *Sentimental Moment* as with the vibrant abstractions. So *Sentimental Moment* was in effect twice repudiated by the artist himself. It would be difficult to imagine a more shocking juxtaposition than setting that soulful young woman, in her nuanced pink blouse, in

a roomful of the raucous cartoons through which Guston shocked the sensibilities of the art world in 1970.

Becoming an abstract painter was not, so far as I can tell, a momentous choice for Guston in the 1950s. He was part of a New York art world in which it was a natural next move for a gifted and ambitious artist. The particular style that suited Guston drew upon his personal interests in East Asian philosophy. Along with John Cage and the composer Morton Feldman (of whom there is a remarkable portrait in the Metropolitan show), he attended Dr. Suzuki's lectures on Zen Buddhism at Columbia, and he evolved his abstract forms out of the calligraphic doodles he made with quill pen and ink. "My greatest ideal is Chinese painting," he wrote in 1978, "especially Sung painting dating from the tenth or eleventh century." There is a Sung feeling in the quivering abstractions of the 1950s, as if of natural forms shrouded in mist. The decision to abandon abstraction in the late 1960s was of another order altogether, and it went completely against the grain of Guston's art world. Figuration was bad enough, but to paint in the coarse comic-strip style that Guston appropriated for his 1970 show was more than bedding down with the enemy. It was seen as a betrayal of the values of high art with which the New York School identified itself. It was an aesthetic scandal.

True, Abstract Expressionism was petering out as a movement. And there was an exciting alternative to it in Pop Art, which challenged the distinction between high and low art, borrowing its images from advertisements and the comics. But no one would have expected a prince of contemporary abstraction to cross over into a style that even the enthusiasts for Pop would have found raw and smeary, like something splashed on the side of a subway car. The images of Pop belonged to the vocabulary of commercial art. They were sharp and clear and attractive. Guston's belonged to the vocabulary of delinquency. They really were expressions of contempt and rebellion toward what his peers regarded as holy. "Abstract art," he wrote in a notebook at the time, "is an escape from the true feelings we have, from the 'raw' primitive feelings about the world—and us in it."

Guston's transit from abstraction to cartoon was cruelly portrayed by Hilton Kramer in a widely cited review as a passage from "mandarin" to "stumblebum." The term "mandarin" was intended to diminish what had set Guston apart as an abstractionist. The paintings were too dainty, too delicate, too light and airy by contrast with the heavy pigment of the true Expressionists to be considered authentic. The new paintings were then seen as an opportunistic bid for that missed authenticity. They were coarse, juvenile, and demotic.

I sometimes wonder if Guston himself did not see his previous achievements as "mandarin." The new work was deliberately bad painting, and to this day I am not sure that anyone understands what motivated him to abuse what passed for good taste, both in substance and in style, in what he had to have known would be perceived as an act of aesthetic aggression. Only someone able to paint as exquisitely as Guston could will to paint like a "stumblebum," which falls under a distinction of the kind Plato canvassed in *Lesser Hippias*. So it was a kind of reverse—or perverse—mandarinism. He once quoted a speech that Isaac Babel, one of the writers he admired most, gave to the Soviet Writers Union in 1934. Babel said: A very important privilege, comrades, has been taken away from you. That of writing badly. Guston added: Doesn't anyone want to paint badly? It was as if he were reclaiming a forfeited privilege in 1970. The freedom to throw aesthetics to the wind. The only painter to recognize this at the Marlborough opening was de Kooning. For the rest of the art world, it was, Guston said, "as though I had left the Church: I was excommunicated for a while."

In any case, it was not simply a matter of reclaiming the right to produce images. Nor was it, I think, an oblique way of protesting the Vietnam War, though he was troubled by "the brutality of the world" and though his images expressed a concern with political evil, particularly the broadly rendered Ku Klux Klan figures, tooting through empty urban streets like Mutt and Jeff in open jalopies, wearing patched hoods, carrying spiked two-by-fours. Guston had, in fact, painted Klan figures in the 1930s, when he was a teenage labor activist

involved in a strike. The Klan had been used by the police as strike-breakers, and they even removed Guston's paintings from a show he held in a bookstore. One of these paintings, *Drawing for Conspirators*, is in the Metropolitan show, and one can understand its presence there: It contributes to an image of a politically engaged artist, as does the scary painting of Richard Nixon with a swollen leg in a painting Guston did in 1975, *San Clemente*. That work goes with the brilliant series of Guston's Nixon caricatures that were assembled by Debra Bricker Balken in her book *Poor Richard* and exhibited at the David McKee Gallery in September of 2001. These demonstrate the way a great painter can create powerful images by "painting badly."

But the Klan figures of 1970 were allegorical self-portraits. "I perceive myself as being behind a hood . . . The idea of evil fascinated me, and rather like Isaac Babel, who had joined the Cossacks, lived with them, and written stories about them, I almost tried to imagine that I was living with the Klan. What would it be like to be evil? To plan and plot?" Kramer's review was illustrated with *The Studio*, in which a Klan figure is executing a self-portrait, holding a brush in one hand and a stogie in the other, looking at his picture of himself through eye slits in his hood. The room is lit with a bare bulb, a clock with one hand hangs on the wall. Like all the Klan paintings, it is an exercise in moral as well as artistic transvestism. Only a good man could wonder what it was like to be evil, just as only a good painter could paint badly on purpose. But there was something deeply satisfying in this new style, and Guston made it his own for the remainder of his life. It turned out to be the ideal means to paint what concerned him as a man. The great comic-strip artists had evolved a vocabulary for treating things everybody knew about in ways that everybody could understand.

Interestingly, something like the transit from mandarin to stumblebum was enacted by Andy Warhol a decade earlier. Warhol's early art, apart from his commercial work, at which he was singularly successful, embodied the aesthetics of swish valentines. He did cute tinted drawings of pussycats, cupids, flowers, and ladies' boots, with texts in a kind of ornamental handwriting. For private consumption, he did drawings of very pretty boys with good-looking cocks. And then, for

reasons that have never been explained, he began, in 1960, to make his own the kind of boilerplate advertising images that everyone in the culture is familiar with. They were vernacular, familiar, and anonymous, drawn from the back pages of blue-collar newspapers, the inside covers of sensationalist tabloids, pulp comics, fan magazines, junk mail, publicity glossies, and throwaway advertisements. In 1961, it would have been almost impossible to believe one was looking at art when one saw them. His first show was in April of that year, in the Fifty-seventh Street windows of Bonwit Teller. One of the works was called *Advertisement*, a montage of black-and-white newspaper ads: for hair tinting, for acquiring strong arms and broad shoulders, for nose reshaping, for prosthetic aids for rupture, and for ("No Finer Drink") Pepsi-Cola. Bonwit's window also included *Before and After*, advertising the nose you are ashamed of transformed into the nose of your dreams. The remaining paintings are of Superman, the Little King (on an easel), and Popeye. Displayed with the frocks the store was carrying that season, the images would have been thought clever background by such passersby as noticed them.

Abstract Expressionism revolutionized painting, but what Guston and Warhol did revolutionized art. Their transits were part of a migration of artists that began in the 1960s to cross the bridge that separated art and life. It is one thing to aspire to the sublime. It is another to bring into art the preoccupations of a man with ordinary appetites, who worries about love and eating too much, and how to give up smoking, and not just about being evil but being bad. I love Guston's *Painter's Table* of 1973. There is the ubiquitous bare lightbulb—the window with the green window shade tells us that it is night. Smoke rises from a lit cigarette at the edge of the table. One cannot tell if something is a dish with paint tubes or an ashtray with crushed-out butts. There are a few books and some old shoes, soles up. Are the old-fashioned flatirons improvised paperweights? There is a red painting on the table of a single eye in profile, surely the artist's own. Are the two spikes leftovers from the Ku Klux Klan paintings?

In a painting that one assumes is the head of Guston's wife with

big eyes, peers up over the edge of an ambiguous blue shape. Is it the edge of a table? Or a blanket? Or the sea? It carries the exceedingly sentimental title *Source*. The painting could be *Sentimental Moment* in the style of the 1970s, when Guston did a number of exceedingly intimate paintings, alluding to his marriage and to his concern over his wife's health. *Couple in Bed* is a marriage portrait with a sick wife. The artist brings his brushes into bed with him and sleeps with his shoes and wristwatch on. Nothing matches the tenderness of the final small paintings of domestic objects, through which he celebrates the intimacy of the household in a way that bears comparison with Chardin. An artist who leaves us with a painting of a thick salami and cheese sandwich on seeded rye as one of his last works cannot be reduced to a single narrative theme, political or poetic. It wouldn't have hurt to have had *Sentimental Moment* in the mixture. He was a sentimental man, somewhat given to self-pity, to worry and gluttony, plagued by weakness of will and the need for love, and his last great oeuvre, like Joyce's *Ulysses*, monumentalizes the wry comedy of everyday feelings.

December 29, 2003

Philip Guston: The Nixon Drawings

In 1878, Henry James reported in these pages the outcome of *Whistler v. Ruskin*, the buzz of the London art scene that year. Whistler, Ruskin had written, was "a coxcomb," demanding "200 guineas for flinging a pot of paint in the public's face." The painter sued for libel and was awarded nominal damages consisting of one farthing. The trial was a Gilbert & Sullivan farce brought to life, since the language of litigation in its nature is comically unsuited to aesthetic determination. Ruskin's critical and Whistler's artistic reputation were left largely unaltered by the verdict, but there is little question that it was an immense personal defeat for Ruskin. The vehemence of his critical prose registered the urgency he attributed to aesthetic matters—so to call his language into question was to call into question his vision of the world. Whistler probably *was* a coxcomb, whatever that Edwardian epithet means. But Ruskin was a figure of tragic stature, and the episode helped precipitate his final emotional breakdown.

The unhappy confrontation between Whistler and Ruskin is the subject of a brooding introspective aria in the second act of *Modern Painters*, the 1995 opera by David Lang and Manuela Hoelterhoff, based on Ruskin's life. It was an inspiration to see in Ruskin a subject suitable for operatic representation, and it recently occurred to me of how few art critics this might be true. Ruskin's tragedy was internally connected with his stature as a prophet of aesthetic redemption. If good art is as integral as he believed to a good society, art criticism is

an instrument of social change. Ruskin could hardly have agreed with James that it was at most an agreeable luxury—like printed talk. And Ruskin's assessment of it has continued to inflect the art criticism of writers who might not fully subscribe to his particular social vision. How are we to explain the often punitive edge of critical invective if critics supposed themselves engaged in mere agreeable discourse—like reviewing restaurants, say, or fashion shows? The lives of art critics may not be the stuff of grand opera, but face-offs between critics and artists have at times risen to operatic heights because the art under contest was viewed by both as possessed of the greatest moral weight.

I am thinking about opera just now because the art I want to discuss here—Philip Guston's seventy-five caricatures of Richard Nixon, loosely organized to tell a story—has its subject and something of its tone in common with the 1987 opera *Nixon in China*, by John Adams and Alice Goodman. If someone were inspired to compose an opera *Guston in Woodstock*—the upstate New York village to which Guston withdrew after a critical debacle in 1970—the climactic moment of it would be an agon between the artist and the Ruskinian critic Hilton Kramer. As described in the previous essay, Kramer was by no means alone in deploring the turn Guston's art had taken in a wildly controversial exhibition at the Marlborough Gallery. But the language of his review in *The New York Times*, of which he was then chief art critic, was worthy of Ruskin in acid indignation, and a librettist would have no difficulty in composing a fierce duet between the opposed protagonists. The contest, however, was far deeper than that which pitted Ruskin against Whistler. It was deeper not just because Guston was deeper as an artist and a man than Whistler ever aspired to be, but because nothing less than the future of art history was at stake. Kramer understood that the kind of art Guston was now making—to which the Nixon drawings belong—was radically inconsistent with the art to which he as a critic was dedicated in every fiber of his being. The contest was, in my view, a surface reflection of a deep turn in art history. Kramer saw in Guston the betrayer of a shared faith. What he could not acknowledge was that Guston was helping consolidate a new artistic order.

The review's headline, quoted now whenever Guston is written about, was "A Mandarin Pretending to be a Stumblebum." Not only are the words demeaning, but together they condense Guston's career into an unedifying tale of artistic opportunism. Guston had in fact been regarded as the most lyrical of the Abstract Expressionists, and in the spirit of full disclosure I admit to having adored Guston's abstractions at the time. I adore them still: I cannot look at one of those dense, shimmering works without feeling the exaltation of pure beauty. In the way they crowd the center of their canvases, they put me in mind of how Morandi's boxes and bottles endeavor to occupy one another's spaces in the middle of his compositions. The late critic David Sylvester, who admired them, wrote in 1963 that Guston is "committed to luxury. His paint is exceedingly rich, even luscious—in its texture, in its implications of high virtuosity." Sylvester compared them with Monet's late paintings of water lilies and described the paintings as intensely withdrawn and private. The 1970 paintings, by total contrast, were huge pictures of Ku Klux Klan figures in patched hoods, executed in a kind of classical comic-strip style that was being reinvented at the time by Robert Crumb in *Zap Comix*. It owed something to Krazy Kat, something to Mutt and Jeff, something to Moon Mullins. I greatly admire Guston's raw Klanscapes, but it would be an aesthetic category mistake to speak of adoring them. They were not designed to gratify the eye but to injure the viewer's sensibility. Kramer had no better way of characterizing him than as pretending to a naïveté Guston did not honestly possess. So he was a false lyricist now masquerading as an artistic lowlife—a mandarin pretending to be a stumblebum. Kramer probably did not write the headline, but I'll co-opt whoever did for my libretto. And I'll use Guston's own words from the time to give me my duet: "I got sick and tired of all that Purity! I wanted to tell stories."

Artistic purity was much in the air at the beginning of the 1960s. In his profoundly influential *Modernist Painting* of 1960, Clement Greenberg described Modernism as a set of purgations, in which each of the arts seeks to identify what is essential to its defining medium and eliminate everything else. "Thus would each art be rendered

'pure,' and in its 'purity' find the guarantee of its standards of quality as well as its independence." For Greenberg, illusion was an impurity in painting, which properly should be abstract. Using their own words, we can imagine another duet, early in *Guston in Woodstock*, between Greenberg and Guston. For Guston must have had Greenberg's thesis precisely in mind when, sitting on a panel that took place around that same time, he said, "There is something ridiculous and miserly in the myth we inherit from abstract art. That painting is autonomous, pure and for itself, therefore we habitually analyze its ingredients and define its limits. But painting is 'impure.' It is the adjustment of 'impurities' which forces its continuity. We are image-makers and image-ridden." The confrontation could hardly be more stark. But it sounds as if it refers to the dilemma that defined artistic consciousness from the onset of abstraction and became acute in America in the 1940s—whether to paint the figure or go abstract. There was certainly a dramatic moment in the lives of each of the Abstract Expressionists, with the exception perhaps of Motherwell, when they left the figure behind and discovered the style through which each became a master. Guston himself had gone through the crisis. But his painting of 1970 marked a crisis of an entirely different order. Guston did not merely do the figure, as de Kooning had done in 1953 with his famous Women. For de Kooning had discovered a way of having his cake and eating it too—painting the figure using the same gestures that were so effective in his great abstractions. But Guston did the figure in a way that repudiated his entire philosophy of painting. The shift was precisely as dramatic as that from mandarin to stumblebum. It really was like leaving the church. But the decision was not merely artistic. It was a moral decision that took an artistic form.

The question for Guston was how one could go on painting beautiful pictures when the world was falling apart. The pursuit of aesthetic purity was not an acceptable option. For Kramer, to abandon aesthetics was to forsake art. Obviously this was not Guston's view. He needed to find an art that was consistent with his moral disquiet.

"What kind of man am I, sitting at home, reading magazines, going into a frustrated fury about everything—and then going into my studio to adjust a red to a blue. I thought there must be some way I could do something about it. I knew ahead of me a road was waiting. A very crude, inchoate road. I wanted to be complete again, as I was when I was a kid."

I assume this soliloquy refers to the time of his retrospective exhibition at the Jewish Museum in 1966. The abstractions of those years, one can now see, had a crude, inchoate quality. But that was not the road Guston was seeking. "There is nothing to do now," he went on, "but to paint my life . . . Keep destroying any attempt to paint pictures, or think about art. If someone bursts out laughing in front of my painting, that is exactly what I want and expect."

Guston began to work in two ways in the months ahead. "I remember days of doing 'pure' drawings immediately followed by days of doing the other, drawings of objects . . . Books, shoes, buildings, hands—feeling a relief and strong need to cope with tangible things." It is this return to the commonplace objects of daily life, away from the exalted forms of Abstract Expressionism, that became the central truth of 1960s art—in Fluxus particularly, but also in Pop and even in Minimalism. The impulse came from Zen, which had become so strong a spiritual current in New York intellectual life. He was not pretending—he *became* a Zen stumblebum. The drawings were and are brilliant. This may have solved his artistic quandaries, but not his moral ones. For this he made use of the Klan. He was painting the evil in each of us in a style every one of us knew. When he was a mandarin in 1957, he did an exquisite abstraction called *The Mirror*. When he became a stumblebum in 1970, he painted the kind of moral mirror in which Hamlet meant to catch the conscience of the king.

The Nixon drawings belong to the last great phase of Guston's career, and they constitute a kind of comic intermezzo. All seventy-five of them were done in Woodstock in the late summer of 1971, and they appear to have been conceived as frames in a kind of comic-strip

book, narrating the self-mythologizing life of our scariest politician. Guston titled the book *Poor Richard* and made unsuccessful efforts to get it published. The book's version of Nixon's story was in any case overtaken by history. It was overtaken in the first instance by triumph—Nixon actually went to China in February 1972, whereas that event is treated with a fictive indefiniteness in *Poor Richard* (the drawings having been completed the previous year). And of course it was overtaken by Nixon's disgrace—by Watergate and resignation—in the years that immediately followed. So the drawings remained almost unknown to any but specialists in Guston's work until now, when, thanks to the initiative of Debra Bricker Balken, they have been reproduced in their entirety in the new book *Poor Richard* (University of Chicago), together with a spirited explanatory essay by her, telling how they came about. Moreover, the originals can be seen at the David McKee Gallery in New York, and enjoyed for their sharp humor and graphic brilliance. I can think of no historical parallel in which a great artist has shown himself to be a cartoonist of genius while engaging himself directly in the political reality of his moment—though Picasso used a comic-strip format in the two etchings of the *Dreams and Lies of Franco*.

Who knows what impact they might have had? Caricature has at times succeeded in putting certain public figures in a light so unflattering that their power has been damaged and even destroyed. It became almost impossible for the French to take Louis Philippe seriously once they saw him through Daumier's drawings as having the form of a pear—the term connotes stupidity. Thomas Nast found such damaging ways of drawing Boss Tweed and his corrupt Tammany cohorts that they were graphically and then politically discredited. Nixon's nose and stubbled jowls were a ready-made cartoon, with an irresistible resemblance to a cock and balls, which is the way Guston shows him. *Poor Richard* is perhaps too playful—too funny, really—to have inflamed public indignation beyond the point it had already reached at the time. But who can really say? What would we think had Daumier's lithographs remained hidden until today, and all we knew were his marvelous paintings of Don Quixote and peasant women in a railway wagon? Or if Thomas Nast did not have the out-

let of *Harper's Weekly*, and the fierce caricatures of Boss Tweed were discovered in an attic years after his death? The powers that images can release are unpredictable, which is why censorship exists. Even at their brilliant best, of course, there would have been a moral disproportion between the ludic preposterousness of Nixon and his cronies—Spiro Agnew, John Mitchell, and Henry Kissinger, as they are depicted in *Poor Richard*—and the actual evils of Vietnam and Cambodia. Still, Nixon's soiled image has been so cleaned and polished since his fall that the historically unaware might think him a candidate for Mount Rushmore. So Guston's drawings might after all do some real good in reminding us of the abject truth of a personage whose unique character so combined evil and absurdity.

Nixon is first shown as a college football player, with shoulder pads and a varsity letter. His features had not yet evolved into their genital configuration, though the nose shows phallic promise. He is given Little Orphan Annie eyes to emblematize his sham innocence. We next see the politically obligatory poverty of his childhood home— a log-cabin-style interior with wood stove and log pile, and a volume titled LINCOLN prominently displayed on a bare table. In the next frame Nixon is hitting the books hard, under a bare lightbulb (note the volume titled WILSON). Soon he is standing in his patched and ragged garments with his faithful dog Checkers (in an inspired touch, Guston shows the latter with checkerboard markings). Suddenly we are at Key Biscayne, Nixon's favorite hangout, soon to be kept company by Kissinger (always represented as a pair of walking horn-rimmed glasses); Agnew, in Hawaiian shirt and inseparable from his bag of golf clubs; and Mitchell, never without his pipe. This is the cast of characters. Pat—who plays an important role in *Nixon in China*—is not to be seen.

I'll let the rights to *Guston in Woodstock* go, well, for a song. But it has some wonderful theatrical possibilities I have not mentioned, like a scene at the Marlborough opening, where a chorus of Tenth Street painters sing, "This isn't painting, Phil." Guston and de Kooning throw their arms around each other, caroling together, "It's all about

freedom" (Chorus: "This isn't painting, Bill"). Then a scene back at Woodstock, where Guston and his neighbor, Philip Roth, entertain each other with their hilarious Nixon imitations (Roth's satire *Our Gang* was, like *Poor Richard*, an artistic product of those sessions). History gives us a better ending than Guston dared dream of: Nixon bidding farewell to his presidency as Kissinger's glasses mist with tears—and a pilgrim chorus of Neo-Expressionist painters singing Guston's triumph as the curtain falls.

October 1, 2001

Alberto Giacometti

The comprehensive exhibition of Alberto Giacometti's work on view at the Museum of Modern Art opened on the centenary of the artist's birth, to a world very different from that of 1965, when the museum was last given over to it. It hardly needs saying that downtown Manhattan would not have figured greatly in the consciousness of those who saw the earlier show—though interestingly enough it was on Giacometti's mind when he traveled to New York that year. He had been commissioned to design a piece for Chase Manhattan Plaza, and part of his reason for coming to New York was to get a sense of that site. The downtown area was undergoing its great development in the middle 1960s—the World Trade Center was finally approved then—and one can imagine, as a sort of *tableau vivant*, the celebrated sculptor and his friends standing like living statues in various different positions on the deserted plaza at night. On the night of this year's opening, Chase Manhattan Plaza was dense with smoke and deep in dust, and everyone who attended the show could think of little but the death and disaster New York had experienced a bare month earlier. But in some way the devastation made the city seem closer to the war-ruined world with which Giacometti's signature work is commonly associated than could possibly have been the case in 1965, when America seemed immune to attack, and war was something that took place far away and on someone else's territory.

The architect of Chase Manhattan's headquarters downtown, Gordon Bunshaft, had envisioned three colossal walking figures, high

enough to stand up to the looming office buildings with which the
space was surrounded. The prototype of figures walking might have
been Giacometti's *City Square* of 1948, in which four of his archetypi-
cally attenuated male figures are shown walking in various directions
in a space otherwise empty, save for a single standing woman. *City
Square* is frequently used to illustrate a thesis about European cities,
ruined and rubbled by World War II, or, alternatively, about the lone-
liness and alienation of modern urban existence. As such, it has be-
come a cliché of book-jacket illustration for texts of popular sociology
or existentialist philosophy, both of which helped create a cloud of
received interpretation, disseminated in courses of Art History 101
wherever it is taught, which still stands almost indissolubly between
Giacometti's work and its countless admirers. It is, to be sure, a very
poetic vision to imagine four or five Giacometti figures at ground
level, something like Rodin's *The Burghers of Calais*, but among which
the supposedly alienated office workers in the world capital of alien-
ation might hurry, in transit from impersonal offices, to sway in
crowded isolation on the subway cars that speed them to their anony-
mous habitats. Rodin's figures are life-size, but if Giacometti's thin
bronze figures were of that scale, they would vanish in the Lonely
Crowd. The poetry would evaporate except at night, as when the
artist and his friends moved about the plaza under artificial light.
That is doubtless why Bunshaft proposed that the figures be im-
mensely tall—but that would subvert the poetry as well and add to the
crowd's alleged demoralization. Giacometti himself, in all likelihood
leery of the by-then-inescapable interpretations that falsified or at least
distorted his work, at first proposed a kind of anthology of his pieces,
including *Monumental Head*; he finally decided on a single standing
woman on a scale uncharacteristically large for his work. Scale, how-
ever, was deeply limited by his remarkably intimate relationship with
his sculptures. To have had a work fabricated by others would have
been inconsistent with what at that point one might call his philoso-
phy of art. A Giacometti sixty-five feet tall would not really be a Gia-
cometti at all but an effigy of one—what he would have dismissed as
an object. The commission in any case was never executed, and the
artist died the following year.

It is not simply for reasons of scale, however, that Giacometti's sculpture was not truly suited to the public spaces of New York. *The Burghers of Calais*, which was commissioned by the city of Calais to commemorate a heroic episode in the Hundred Years' War, was intended to stand outside the cathedral, where the citizens could tell their children the story of how the town was saved by six of its most prominent citizens, who agreed to sacrifice themselves in order that the populace not starve. It was Rodin's own idea that it not be placed on a pedestal but on the same level as that occupied by the people of Calais themselves. The figures are not dwarfed by the surrounding architecture. They look like real human beings, with expressions of the sort that ordinary human beings can read as they read one another's. Giacometti's figures have an altogether different character. They are meant primarily to be seen, the way we see figures in paintings. Of course, as sculptures, they are three-dimensional by default. But they are not intended to be viewed from different angles or walked around, any more than the figures in a painting are. Giacometti, whom I knew somewhat when I was a student in Paris, once told me that he thought of himself primarily as a painter, and indeed that even in his sculptures he tried to represent the world in a purely visual way, which he clarified as follows: He wanted to show the world as it would be experienced by someone who had no hands and whose visual field was not inflected by other modalities of sense, such as touch.

This curious view is confirmed by Jean-Paul Sartre in a brilliant essay, published under a title he appropriated from Balzac—*La recherche de l'absolu*—in *Les Temps modernes*. Giacometti, he writes, is the first to sculpt a man as he is seen, that is to say, at a distance. He confers on his plaster personages an absolute distance, as a painter does with the inhabitants of a painting. One gets a feeling for Giacometti's unusual vision from the fact that he once made the attempt to sculpt a figure the way it would be seen at a distance, in the evening, on the Boulevard Saint-Michel. The MoMA catalog tells us that Giacometti "later commented that in those days he had not yet understood that such things could only be painted." Sculpture of

course necessarily exists in real space—but Giacometti's effort was to sculpt figures that incorporate a distance of their own. Sartre put it this way: "He creates a figure 'ten steps away,' 'twenty steps away,' and that remains the case no matter where you stand." In other words, if you were to stand ten steps away from one of the figures represented as ten steps away, then real distance and represented distance would be identical. But if you were fifty steps away, the object would still be represented as ten steps away, and the distance between you and the sculpture would differ from the distance in the sculpture, which would, in Sartre's terms, be absolute. That may indeed be possible only in painting, but it was what Giacometti was after as a sculptor.

Sartre says something even more striking about Giacometti's figures. "The moment I see them, they appear in my field of vision the way an idea appears in my mind." This is a way of explaining the somewhat ghostly feeling of his figures, as if they were persons whose bodies had been all but erased. Giacometti was legendary for destroying his work—his studio floor would be found littered with broken plaster in the morning, after undoing a night's work. I think this was the result of an impossible effort to eliminate whatever gave them the solidity that belonged to their material condition as sculpture. The almost unreal thinness of his figures gave rise to the belief, entirely false, that they were inspired by the starved inmates of concentration camps. That is not really the kind of artist he was. He was pursuing a way of creating the human body as if it were almost purely a soul. Sartre writes of how these fine and liberated natures rise into heaven—"they dance, they are dance, they are made of the same rarefied matter as those glorious bodies we have been promised." This is a far cry from the ragged stick figures of Buchenwald!

Sartre's essay served as the catalog text for Giacometti's 1948 exhibition at the Pierre Matisse Gallery in New York, which gave him his sudden great reputation in world art. Perhaps because of Sartre's own philosophical fame as an existentialist, Giacometti was himself perceived as an existentialist by association. Sartre used a vivid, at times a perversely incendiary, vocabulary, and though such terms as

"dread," "anxiety," "nihilation," "shame," and "anguish" are readily redeemed for quite ordinary terms in philosophical discourse, once Giacometti was identified as an existentialist, it was all but impossible not to see his men, his women, and his groups of figures as inflected with the dark drama of death and danger, and as "plagued by such a strong sense of estrangement from both nature and society," to cite an influential textbook. That has made his work seem somehow anchored in a post–World War II mood, which it in fact has very little to do with at all. The art comes, really, from sources within Giacometti's own artistic personality. Giacometti was an exceedingly social person and in no sense estranged from people. He spent his evenings in cafés, in animated discussion. In the mid-1960s, he was working on a portfolio of lithographs called *Paris sans fin—Paris Without End*. The famous *City Square* is meant to be seen as people encountering people. I have the most powerful memory of the first time I saw his wife, Annette, come into the studio. She was very pretty, wearing a sweater and skirt. Giacometti's face lit up with the most intense look of love I have ever observed. Here comes Annette! he cried, with joy.

But there is a respect in which deep resonances exist between Sartre's philosophy and Giacometti's great work of the late 1940s and early '50s, which perhaps explains why Sartre, who was after all not that deeply involved with the visual arts, should have devoted two essays to him. Bear with me as I attempt to say a few words about Sartre's philosophy. In *La recherche de l'absolu*, he speaks of Giacometti's work as midway between being and nothingness—between *l'être et le néant*—which was the title of Sartre's early masterpiece. Being and nothingness refer to Sartre's two main categories. Material objects have being. Consciousness is not a material object, and hence is, in a sense, a kind of nothingness, and we, as conscious beings, are a kind of nothingness as well. Sartre characterizes human beings as a futile passion—we have an unfulfillable yearning to possess the solidity of material things and the immateriality of pure consciousness. But it is in our difference from things that our inalienable metaphysical freedom is grounded. Sartre speaks of the effort to escape into the condition of mere things as bad faith. As I'll try to show, Giacometti's attitude toward his art has in fact something of the distinction be-

tween being and nothingness Sartre ascribed to his sculpture. But Sartre discovered it there—it was not something Giacometti derived from Sartre's version of existentialism.

The American artist Mercedes Matter records that in reaction to what critics and writers said about the metaphysical content of his work, Giacometti said, "It's a monstrous misunderstanding. To me it's nothing of the sort. It's a purely optical exercise. I try to represent a head as I see it." I can somewhat vouch for this. Giacometti was passionate about philosophical conversation but mainly about the phenomenology of perception. We used to discuss Bertrand Russell's idea that physical objects are logical constructions out of sense data. He was very friendly with Maurice Merleau-Ponty, who must have explained to him his theories about sense experience—about how the field of perception is everywhere inflected by all of our sense modalities working together in synthesis, of how the world discloses itself to consciousness and how philosophers must learn from artists—from Balzac, Proust, Valéry, or Cézanne—rather than from science. Still, even if not an existentialist, he was not an ordinary man, plodding along doing optical exercises like an experimental psychologist. He was an emotionally complex person, with a history of traumas, intensely preoccupied with dreams and with death. These feelings are conspicuously enough embodied in the work for viewers to sense that they are in the presence of meanings at once personal and of great human moment.

Consider *The Palace at Four A.M.*, an object, as he was to call it, made in 1932, when he was part of the Surrealist movement in Paris. It is a kind of symbolic self-portrait—a realization of personal relationships and feelings. The impression it gives of a rickety wooden cage is reinforced by the presence of a skeletal bird—a sort of pterodactyl—fluttering in what may be a sort of tower. In a cage within a cage is a spinal column, carved in wood, which the artist identified as a woman with whom he had had an intense, somewhat claustrophobic relationship. There is a more obviously female figure, standing before what may be three doors, in a long skirt. This he interpreted as

his mother. Finally there is a suspended object—a sphere in an elongated spoonlike receptacle, with which he identified himself. Mother, child, love, and death—and the bird that perhaps expresses escape—enact one of the defining dramas of human existence.

It was a cleft ball, suspended in a cage, designed to swing over a crescent-shaped object, one edge of which fit the cleft, in a back-and-forth motion that insinuated sexual intercourse, that first brought Giacometti to the attention of the Surrealists when it was shown in a gallery window. They discovered in him an artist who, without benefit of indoctrination, had spontaneously hit upon exactly the kind of art in which they believed. It was an art that externalized the hidden truths of psychic reality in strange and wonderful objects—a reality that dreams disclosed. Giacometti wrote, "For many years I have executed only sculptures that have presented themselves to my mind entirely completed." Since already complete, as it were, it would have been quite irrelevant who executed them. So it would have been quite beside the point had Giacometti consigned *The Palace at 4 A.M.* to a woodworker for fabrication. A few years later, he had, according to Mercedes Matter, a revelation about the difference between an object and a work of art:

> An object is perfect in itself; a work of art can never be perfect since it represents a particular vision, only one view of reality, while so many others are equally valid. But if a bottle breaks, it is nothing at all; whereas a work of art broken, damaged, so long as it still projects the vision it represents, continues to exist. An object does not represent a vision, it is merely a thing in itself . . . My work was not a creation, it was no different from that of a carpenter making a table . . . It was necessary to return to the sources and to start all over again.

The distinction between objects and works of art sounds very much like Sartre's distinction between beings-in-themselves—material objects—and conscious beings, or beings-for-themselves. What he meant by a work of art was something as close as philosophically possible to a human being.

Whatever their status, the works Giacometti made while he was a Surrealist project the obsessions and preoccupations that define the sources of his art, and MoMA has done a great service in giving so much of this exhibition over to his Surrealist output. His makeup was that of a true visionary—a Surrealist by nature more than affiliation, given to almost paranormal and near-hallucinatory experiences. What made him turn away from Surrealism is a matter for psychobiographical speculation, but he felt an evident need to turn to reality, and he began by making heads. For this he was literally expelled from the movement by the imperious André Breton, who said, dismissively, that "everyone knows what a head looks like." But Giacometti was interested in something far deeper than what heads look like. He was, rather, concerned with the way a head looks when its owner is looking at an object. "One day when I was drawing a young girl I suddenly noticed that the only thing that was alive was her gaze," he said in 1951. "The rest of her head meant no more to me than the skull of a dead man. One does want to sculpt a living person, but what makes him alive is without a doubt his gaze. Not the imitation of eyes, but really and truly a gaze."

One feels that this is what he sought for the rest of his life, in his paintings and drawings, and in his sculpture. Not how things appear but the way they show themselves as conscious of the world. His tireless effort was to bring clay to life. Nothing but life was art in his view. If all he had succeeded in making was objects, he would have failed. That would have been the deep reason the project for Chase Manhattan Plaza never came to anything. The reason is internally connected with what made him among the greatest of artists.

December 3, 2001

Norman Rockwell

When the archforger Hans van Meegeren undertook to hoodwink the experts by painting what they accepted as a theretofore unknown Vermeer, his motives were more devious than those of the ordinary counterfeiter. For he believed himself to be an underappreciated painter and Vermeer's equal. The moment his *Christ at Emmaus* was purchased by the state on the authority of the leading Vermeer specialists, van Meegeren meant to reveal that it was he who had painted this masterpiece. And since the experts believed the painting was by Vermeer, they were obliged in consistency to acknowledge van Meegeren as Vermeer's peer. Much the same form of proof was used by Alan Turing to argue that computers possess intelligence. If a computer printed out a set of answers to a literary quiz that were just like those a human being would have given, then one would have in consistency to attribute intelligence to the machine, since human beings possess it by default. And, with qualifications, something like this form of argument has been invoked by enthusiasts for the art of Norman Rockwell to validate their admiration. Suppose it can be shown that Rockwell employed the pictorial strategies also found in the Dutch genre painters of the seventeenth century. Or that the smiling veteran, seated at the counter in Rockwell's *After the Prom*, plays the role of an internal observer, in much the way that a lordling does when he looks up the skirt of a woman on a swing in Fragonard's *The Swing*. Or that the wall before which the little black schoolgirl is being escorted by burly federal marshals in Rockwell's 1964 *The*

Problem We All Live With looks like a Twombly. Since there are these affinities, and since Twombly is in MoMA, Fragonard in the Wallace Collection, and Jan Steen in the National Gallery, what save prejudice explains the absence of Rockwell from those validating walls?

No such arguments are needed to prove that Vermeer was a great artist—we learn the meaning of "great artist" through his work. Similarly, we have no need of indirect proof that human beings possess intelligence, for what would intelligence mean if human beings lacked it? No one had to prove the artistic merit of Dutch genre painting—or Fragonard—by appealing to the work of other artists, and in the case of Twombly there are no other artists whose work shows that his must be accepted if theirs is. So why does a case have to be made for Rockwell? Why is there a special problem with him? What makes his work so controversial? In a way, if he weren't as good as he was, the question would hardly arise. No one has undertaken to establish the artistic merit of the large number of Rockwell's contemporaries whose primary venues were the covers of magazines in the golden age of magazine illustration. Almost from the beginning, Rockwell stood out as someone with exceptional gifts. There is no lobby for James Montgomery Flagg or J. C. Leyendecker or N. C. Wyeth or Peter Arno or the legions of other cover artists whose work caught the public's eye on the nation's newsstands. So why not accept him for the wonder he was? None of the artists whose affinity to him has been enlisted in his support had what he had.

"Loving Rockwell is shunning complexity," the critic of *The Village Voice* declares, who goes on to concede that "many of Rockwell's illustrations can turn you into a quivering ball of mush." Of how many painters in the history of art is something like that true? It seems to me the pictorial psychology of paintings that can have that effect transcends present knowledge. It implies skills of a kind the painters of the Counter-Reformation would have given their eyeteeth to command. Painting is not simply what takes place on the canvas. It is what goes on between the canvas and the viewer. Rockwell was one of the supreme masters of that space, an eroticist of human feeling, a rhetorician of visual persuasion. Small wonder every advertising director in the country was eager to sign him up!

"The emotions," Aristotle writes in Book II of *Rhetoric*, "are all those feelings that so change men as to affect their judgments and that are also attended by pain or pleasure." The ancient rhetoricians made it the object of their study to manipulate the emotions of their auditors, and rhetoric was widely regarded as practical knowledge of a very valuable order. It was something politicians had to possess, since they needed to inspire confidence in themselves and distrust of their opponents and hatred of the common enemy. And it was what lawyers needed to know in order to sway jurors, not merely by argument but by coloration and emphasis. The Sophists, who advertised themselves as able to teach how to make the better appear worse and the worse appear better, were regarded as exceedingly dangerous by Socrates, and we have a number of dialogues in which Plato depicts him wrestling with the leading rhetoricians of the day—Protagoras, Gorgias, Thrasymachus, Callicles, and others—in an effort to immunize his fellow Athenians against their wiles. For somewhat parallel reasons, Socrates regarded artists as dangerous, and he famously undertook to exclude them from the ideal Republic. To be sure, he had poets primarily in mind. The visual arts aroused his suspicions as well, but chiefly in the respect that sculpture was capable of causing illusions, or false beliefs, of a somewhat restricted sort. It is a conjecture on my part that classical artists did not represent figures as themselves expressing feelings, like suffering or ecstatic transport. So artists did not evoke in their viewers feelings like anger or pity—the cases Aristotle particularly addresses in connection with tragedy—which became central in late Christian art, where the aim was to cause viewers to bond, through the feelings art aroused, with the individuals depicted—Jesus, the Madonna, or the martyrs. And perhaps it was in order to achieve this that realism made such remarkable progress in the West, especially in the use of facial expression and body language. To be able to control feeling through images was one of the church's most powerful weapons, which was in part one of the reasons iconoclasm—the destruction of images—was in turn a weapon for the church's opponents.

———

Learning how to represent feelings was one of the subdisciplines of narrative painting. One of the contributing factors in Mona Lisa's enigmatic smile is the fact that there are no surrounding incidents that explain or are explained by it, and one has to speculate that its causes are interior to the woman shown. The enigma would disappear had Leonardo put her in the same space with a child or a kitten, or placed a letter in her hands. The art historian Edgar Wind once showed how the same facial expression conveys ecstasy if displayed by a bacchante, or extreme grief if displayed by a woman at the foot of a cross. But there is a great difference between representing emotions and eliciting emotions in the viewer. I'm not sure, for example, that the issue comes up in Vasari, as if the purpose of painting for him were entirely cognitive, a matter of visual knowledge, successful if the artist provokes an illusion. I am sure, to take a case I discussed recently, Jacques-Louis David's depiction of the slain Marat, that it was not intended merely to show how Marat looked after he was stabbed—it was intended to arouse anger and compassion in its viewers. And I feel as well that Picasso's Blue Period images are to be explained through obvious rhetorical intentions. It would, on the other hand, be incredible to learn that Cézanne expected to arouse feelings in those who viewed his cardplayers or his portrait of his wife. And in the main, feelings rarely come into play in Modernist art. The complexities are formal, and art appreciation in recent decades has largely been a matter of formal discernment.

It is entirely possible to analyze Rockwell's art in such formalistic terms, but his effort was nearly always to organize the elements of his compositions to engage the feelings of his readers in pleasurable ways, and if one is numb to the intended feelings, the formalities hold little interest. I use the term *reader* rather than *viewer*, since Rockwell's means were narrative, and because a certain form of literacy was presupposed. Usually, one was qualified to read the pictures through having lived the same form of life the personages depicted are shown to be living, so that part of the pleasure came from understanding the meaning of what they are doing without having to have it explained. The title of the exhibition of Rockwell's work on view at the Guggenheim Museum is "Pictures for the American People," and it might be

an interesting exercise to imagine having to explain what was going on in the picture to a foreigner. What is a prom? What is a diner? Who is Santa Claus? What are Sunday clothes? To be an American is to recognize instances of these with the same immediacy as that which Warhol counted on in showing us Marilyn, Elvis, Liz, Jackie, Brillo, or Campbell's. Rockwell not only showed us people in situations with which everyone was familiar, he also showed them as having the feelings that go with being in those situations. But more takes place in the typical reader than recognition. The reader is moved or touched by the feelings they display. And probably one is moved by the fact that one is moved, momentarily flooded with a feeling of warmth. One's heart, as the *Voice* critic puts it, say, has been wrung. We can criticize Rockwell for causing feelings—or for the feelings he causes—but it is there that what makes him distinctive as an artist must be found.

Consider *After the Prom* (1957). A young couple sit at a counter, which they share with a man in a leather work jacket and a sort of aviator's cap. He is probably a veteran, in any case middle-aged, and someone who knows life. The couple are in prom clothes: a white gown, a blue hair ribbon for her, a rented white dinner jacket and bow tie for him. She is showing her corsage to the counterman, while the boy, holding her pink sweater and white gloves, looks on with pride. The body of the counterman is composed in such a way as to express a visible and exaggerated Wow. The vet smiles over his coffee cup. The couple embody an innocence that contrasts with the counterman's feigned but well-intentioned wonder. It contrasts as well with the somewhat down-at-the-heels decor of the diner—there are cigarette butts on the scuffed floor—and in some way redeems it. The couple have brought the freshness of this moment of their lives into the stale air of ordinary life. And everyone except the couple feels philosophical—the vet, the counterman, and the reader. Everyone is touched. The world is a greasy spoon, beauty falls from the air, but there are moments of grace. The couple are bathed in the halo of their own innocence.

The figure of innocence is a central device in Rockwell's best paintings. There is, for example, the little boy and the elderly woman in *Saying Grace*, who enact a moment of prayer in another greasy

spoon, oblivious of the pair of workmen with whom they must share a table. The workmen are outside the circle of innocence, but they are moved by those it encloses. They have not been so hardened by life that they cannot be touched by the act of simple faith, and that is true of us, who probably are more like them than like the boy and grandmother, who have the attributes of travelers: There is a valise and an umbrella. The woman has come to fetch the boy in the gray manufacturing town we see through the window of the restaurant. Some tale of sadness hangs in the atmosphere. But they have a faith the rest of the eaters do not have, which gives them a strength the rest of us have to get along without. The world that Rockwell shows is always pretty shabby. Like the diner in *After the Prom*, there are butts on the floor of the restaurant. In *Walking to Church*, a family, dressed in their Sunday best, walk past the Silver Slipper Grill in a run-down section of the city. There is rubbish in the street, a picture hangs crooked in the restaurant window. The building needs paint. The innocence of the family, carrying prayer books, shields them from the squalor with which they are surrounded. We, who are touched by them, are not shielded. Still, the fact that we are touched by the contrast shows that there is some goodness in us after all. And this is what Rockwell wants to tell us. The world is decaying around us. Life's not a picnic. We do what we can. But we have been reassured. The tug on the heart proves that we still have one. Rockwell was not much of a churchgoer. Sunday was a workday, like every other. He is not addressing us as if we were persons who pray. He is addressing us as persons for whom prayer is not really part of our lives at all. And he is assuring us that we have good hearts even so. I say "us" because we—the art critic of the *Voice* no less than you and I—are still moved when we look at his paintings.

Rockwell often said that he was really an illustrator rather than an artist. By this he meant in part that art had taken a direction in the twentieth century away from representational art, so that he was, in effect, beached by history. History was Cubism, Futurism, Surrealism, Abstract Expressionism. And what was he painting? Babysitters, newlyweds, middle-aged papas and mamas, skinny adolescents, pic-

turesque geezers, mutts, cleaning women, friendly cops, family doctors, Santa Claus. Real artists were out there making art history. He sat home all day making pictures. Picasso and Braque compared themselves to aviators and mountaineers. He would have liked to have compared himself to Rembrandt, Dürer, Van Gogh. Reproductions of their self-portraits are tacked to his canvas in his wry *Triple Self-Portrait* of 1960. But he knew ambitious artists were not going to inspire themselves with copies of *Triple Self-Portrait* fixed to their canvases. "Like Norman Rockwell" had become a term of derision. What he overlooked in this sour self-appraisal was that he was not just a painter of recognizable things. Norman Rockwells were themselves recognizable things. They were part of the world. They were not just illustrations of reality. They were part of the reality of his times. Anybody in America could pick them out like stop signs or American flags. The only other artist of whom something like this is true is Andy Warhol.

Rockwell's failures are his paintings that are just illustrations of reality, such as his painting of men walking on the moon, or that are merely ancillary to an implied text, such as his pictures of Daniel Boone and Ichabod Crane. Often these have odd proportions by comparison to the proportions of a standard magazine page. They are vertical or horizontal panels. The failures lack what I would call internality. They exclude the viewer from the reality they depict, by contrast with the *Saturday Evening Post* covers, where one feels oneself addressed as part of the reality. We belong to the form of life the picture shows. The picture is about us. Their familiarity entails that we are, even today, the same people as the ones he shows. The fact that we are still moved by so many of them means that the American personality has changed very little since the magazines that bore those images were fresh from the press. This is still the way Americans see themselves, and since how we see ourselves is part of who we are, there is a measure of truth in these pictures. This is what President Bush was referring to when he claimed to be amazed by the fact that Americans are hated in so many parts of the world. Even Rockwell knew it was not the whole truth when he painted those stirring images of the struggle for civil rights in the South for *Look* magazine.

Could those who expressed hatred for Ruby Bridges, the little black girl in the affecting vulnerability of her white frock, on her way to school, be the same Americans as those who saw themselves in the *Saturday Evening Post* covers? Could those who scribbled obscenities, who threw tomatoes, who jeered at innocence be the same people who smiled at innocence when those who displayed it were "like us"? That's the question the exhibition leaves us with. Do the tender feelings Rockwell's images instill define the default state of the American persona? Or does their existence define a moral myth? Who exactly are we?

January 7/14, 2002

Surrealism and Eroticism

The legendary Surrealist exhibitions of the late 1930s and early 1940s were Surrealist in spirit and secondarily Surrealist in content. In 1942, for example, an exhibition called "The First Papers of Surrealism" was installed at the Whitelaw Reid mansion on Madison Avenue in New York, and those who attended it were far more likely to remember the show itself than any of the works on display. It was designed by Marcel Duchamp, using one mile of string to weave a sort of spider's web from floor to walls to ceiling, which visitors had to climb through to look at the art hung on temporary display panels. Moreover, they had to put up with a crowd of schoolchildren boisterously playing ball or skipping rope or chasing one another through the show. The children were instructed to say that Mr. Duchamp said it was OK for them to play there, if anyone raised the question. It was an ideal way to subvert any propensity to seek a rich aesthetic experience in contemplating the art, and by indirection to demonstrate that it was not the point of Surrealist art to be an object of aesthetic contemplation in the first place. Duchamp disdained aesthetic response—"That retinal shudder!" he dismissed it in a late interview.

Duchamp had also installed the legendary International Exposition of Surrealism at the Galerie Beaux-Arts in Paris four years earlier. There he arranged to have the ceiling hung with twelve hundred coal sacks that, though empty, showered residual coal dust on the throngs below, who were supplied with flashlights to see the paintings

hung in shadows. Upon entering the show, visitors encountered *Rainy Taxi* by Salvador Dalí—an ancient taxicab on which water poured down from the ceiling. The driver and passenger were both man-nequins, the former equipped with a shark's head and wearing gog-gles, the latter a frump covered with escargots, and both placed on a bed of lettuce.

These exhibitions achieved the same shock of incongruity that was intended to characterize what one might think of as Surrealist experi-ence in general, as expressed in one of their favorite paradigms from a text by Isidore Ducasse, aka le Comte de Lautréamont: "The chance meeting on a dissecting table of a sewing machine and an umbrella." There is a 1920 photograph by Man Ray of a mysterious object wrapped in a heavy blanket and bound with rope. It was used as the fron-tispiece of the first issue of a magazine, *La Révolution surréaliste*, the readers of which would immediately have inferred from its title— "The Enigma of Isidore Ducasse"—that the wrapped object must be a sewing machine. Visitors to non-Surrealist exhibitions of Surrealist art—such as "Surrealism: Desire Unbound," on view at New York's Metropolitan Museum of Art—might be let in on the secret by a wall label reading "sewing machine, wood, fabric, card." But without know-ing the identity of Ducasse or the text alluded to, the point of the work would be lost on them.

Surrealism was essentially a literary movement, whose primary products were books, magazines, poems, letters, and manifestos. These in fact form a considerable part of "Desire Unbound," which, together with the many aging snapshots of groups of smiling Surreal-ists, could with equal suitability have made up a show at the Morgan Library or some comparable venue. Art itself was largely peripheral to the movement, serving, like Man Ray's photograph, to illustrate the essentially philosophical ideas of the writers, who were chiefly poets and what one might term aesthetic ideologists, tirelessly taken up with defining what we might term "Surrealist correctness." At least in the early stages of the movement, one of their questions was whether painting was even a Surrealist possibility. Ironically, the writers have

become the subject of scholarly specialization, while Surrealism itself is widely identified with a body of paintings, preeminently those of Dalí—desert landscapes in acute perspective, on the floor of which various objects, often teeming with ants, cast sharp shadows. It was Dalí who designed the dream sequence in Alfred Hitchcock's film *Spellbound*, and it is his idiom that has been universally appropriated for the representation of dreams.

It is with reference to dreams that Surrealism was initially formulated in André Breton's *First Surrealist Manifesto* of 1924. What excited Breton about dreams was the fact that what happens in them defies reason and certainly common sense. But for just the reason that dreams cannot be captured in the discourse we use in our waking lives, they were, until Freud, relegated to parentheses that we felt no need to incorporate into the narrative of our lives. Breton was convinced that this was, in effect, throwing away something of inestimable value, and in the *Manifesto* he described a method of writing that makes the dream accessible to our waking consciousness. This, in effect, is a kind of automatic writing, writing that as far as possible is uncontrolled by our critical faculties. The resulting pages will be impossible to appreciate in the ways ordinary writing is appreciated. "Poetically speaking," Breton says, "they are especially endowed with a high degree of immediate absurdity." Nevertheless, what we have done has somehow brought the dream before our conscious minds, and what we have is at once reality and dream, hence a kind of "absolute reality." Surrealism is then the method through which this absolute or "sur-" reality is made available to us as a resource to be used. Here is Breton's definition:

> SURREALISM, noun, masc. Pure psychic automatism by which it is intended to express, *either verbally or in writing*, the true function of thought. Thought dictated in the absence of all control exerted by reason, and outside all aesthetic or moral preoccupations.

I have italicized "either verbally or in writing" to emphasize that Breton does not mention either singing or playing, or drawing or

painting. There is little if any Surrealist music, though one might think that jazz would exemplify psychic automatism to perfection. Breton thought Surrealist music was impossible, probably because music lacks the dimension of realism that is a precondition for surrealism—an objection that would be overcome in the case of opera, and indeed my musical informant, Lydia Goehr, has told me of a Surrealist opera, *Julietta*, by a Czech composer. Painting, on the other hand, met the criterion of realism, but as far as the Surrealists were concerned, it lacked the spontaneity of writing or speech. Dalí painted like an old master, using perspective and chiaroscuro, building up glazes, creating illusions. There is no way it could have been done automatically or without rational control. So by definition, his painting cannot be Surrealist. It would be like transcribing a dream in rhymed verse. The most that can be said is that he illustrates strange conjunctions and encounters, directed, as it were, by a strong artistic will.

One might say that the visual arts were admitted to Surrealism only when artists found ways of working more fluidly. Max Ernst's marvelous collage narratives, in which he clipped and pasted images from old engravings, recommended themselves to the Surrealists. Miró, who actually used writing in his paintings together with images, was also accepted. When Breton encountered the sculpture of Giacometti, it was as though he at last found someone who seemed to dream while awake, in the medium of clay and plaster.

In truth, it was mainly the painter Matta who found a way of drawing automatically and hence surrealistically. And Matta taught the New York painters—especially Pollock and Motherwell—how to do this. Psychic automatism evolved spectacularly into what we now think of as Abstract Expressionism, and it was through the chance encounter of Right Bank poets and rednecks like Pollock on the dissecting table of Manhattan that American artists were able to produce work that Motherwell describes as "plastic, mysterious, and sublime"—adding that "no Parisian is a sublime painter, nor a monumental one, not even Miró." But Abstract Expressionism was never "Surrealist" in the sense in which Dalí's images were. It was as though

there were two dimensions to Surrealism—psychic automatism and absurdity. The latter does not figure in Breton's definition, but it certainly figures in what we might call Surrealist sensibility.

I learned a certain amount about what it would have been like to be a Surrealist from Robert Motherwell, who as a young artist in New York in the early 1940s became a kind of guide to Breton and a cadre of other Surrealists, then in exile in New York, where they endeavored so far as possible to re-create the form of life they'd lived in Paris. Twice a week they would gather for lunch at Larre's, an inexpensive French bistro on West Fifty-fifth Street, and proceed afterward to Third Avenue, at that time lined with all sorts of secondhand stores and antiques shops. The activity for the afternoon was to decide which of the objects on display were Surrealist and which were not. It was a fairly serious matter to be wrong about this. Matta would have been disgraced when he misidentified as Surrealist a certain gargoyle head—until Duchamp intervened, saying that maybe he had a point. Duchamp, listed as Generateur-Arbitre (producer and arbitrator) in the catalog for the 1938 exhibition, was not officially a Surrealist, but Breton regarded him as having perfect pitch when it came to what possessed surreality and what did not.

A famous such object was a curious wooden spoon Breton and Giacometti had found at the flea market in Paris. A little shoe was carved just under the spoon's handle. It struck Breton that the whole spoon could be seen as itself a shoe, with the little shoe as its heel. He then imagined the possibility that its heel was another shoe, with a heel of its own, which itself was a shoe . . . and that this could go on to infinity. The spoon he saw as an example of "convulsive beauty" in the sense that it revealed through its structure a state of mind, which consisted in a desire for love. There is a photograph, again by Man Ray, of this found object with the descriptive title "From the height of a little slipper making a body with it . . ." which was published in Breton's book *L'Amour fou*. There would be no way of telling from the photograph—or from the spoon itself—that it had convulsive beauty or the evasive property of surreality. And I am uncertain whether it has either of these intrinsically, or only for the individual to whom it reveals, the way a verbal lapse does in Freud's *The Psychopathology of*

Everyday Life, a state of mind that would otherwise have remained unconscious. At the very least, some fairly elaborate chain of interpretation—as again in the *The Psychopathology of Everyday Life*—has to be supplied. Surrealism was a taxing and fully absorbing form of mental activity.

In his *First Surrealist Manifesto*, Breton mentions having become aware of a certain "bizarre sentence" that came to him "bearing no trace of the events with which I was involved at the time." He was unable to remember the exact wording, but it generated the writing he subsequently identified as Surrealist. The little spoon, as it happens, helped unpack a different such phrase, one that had been obsessively running through his mind—"Cendrier-Cendrillon"—which means "Ashtray-Cinderella." Breton refused to learn English, not so much, I believe, out of the vanity that is threatened when we lose the fluency of our native tongue but because we dream in our own language. The terms "ashtray" and "Cinderella" have no obvious connection, but "cendrier" and "Cendrillon" have a common root—the French word for cinders or ashes, which enables them to be conjoined in free association. Breton went so far as to ask Giacometti to make an ashtray in the form of Cinderella's slipper. But he remained baffled by "Cendrier-Cendrillon," and somehow the slipper spoon helped clarify the emotional state that expressed itself through the conjunction. But you have to read *L'Amour fou* to find out how.

L'Amour fou brings us to "Desire Unbound"—since unbound desire is exactly what *L'Amour fou* is. Desire—and in particular erotic desire—is the theme of the Metropolitan exhibition. With qualifications, everything in the show possesses surreality—or convulsive beauty—providing we understand how to unlock it. The most helpful thing to understand is that aesthetics was never a central Surrealist preoccupation, so looking for an aesthetic experience here will not get you to first base. You have to look at the exhibits the way those displaced Surrealists looked at the objects on view in shop windows sixty years ago, trying to decide which were the Surrealist objects. Motherwell told me that his problem in playing that game lay in the fact that he

had been brought up to look at antiques aesthetically. His mother was an antiques collector. But he got a kind of *education surréaliste* in those afternoons spent peering through dusty shop windows, tutored by Breton and Duchamp. With a sigh of what I felt was despair, he said on one occasion that the whole world was beginning to look surrealistic to him. But that, as he of course knew very deeply, was a metaphorical truth. The world seemed pretty crazy when the International Exposition of Surrealism took place in Paris in 1938. France was falling apart, German planes were bombing Barcelona, Germany was poised for conquest. The Surrealists were not aiming for the kind of experience that could be had from reading the headlines.

But neither did they think that the creation of the surrealistic was their unique contribution to art. The surrealistic existed *avant la lettre*. The Surrealists found it present throughout the history of art—in Hieronymus Bosch and in Hans Baldung Grien for obvious reasons, in Seurat's *La Grande Jatte* for less obvious ones. The first gallery in the show is given over to Giorgio de Chirico, whom the Surrealists took as a predecessor, and the second one to Dada, many of whose members, especially Max Ernst and Marcel Duchamp, were to make substantial contributions to Surrealism when it emerged as a movement in the 1920s. But the first object one encounters in entering the show—*Venus aux tiroirs, 1936*, a plaster Venus in whose torso Dalí had placed a number of small drawers, as in a jewelry case, each with a fur-covered knob—is self-consciously Surrealist. Fur seemed by itself to confer surreality when adjoined to any object, the use of which seemed to rule out fur as a material—like a teacup, for example. No survey of Surrealism would be complete without Meret Oppenheim's 1936 fur-lined teacup, which somehow is like a dream object rendered concrete. One can see why. The last thing one expects, lifting a teacup to take a sip, would be the feeling of fur on one's lips. It happens only in dreams, where it would seem to disguise an obvious reference and a no-less-obvious repressed wish. Oppenheim had a genius for finding ways to express genital references through everyday objects, and much of Surrealism was taken up with such disclosures. There is a photograph by Man Ray of an unidentified woman, her head thrown back so that we see the lines of her jaw from below. But then, with the

irresistibility of an optical illusion, the neck convulses into the shaft of a thick penis, with the jaw becoming the glans—and the image looks like a huge penis coming out of a woman's shoulders. Surrealist objects are displacements of the objects of desire with which the world around and within us abounds—though a lot of good it does us so far as the gratification of desire is concerned. Perhaps that is why it seems to constitute the constant preoccupation of mental life, which surfaces distortedly in our dream life.

The great emblem of unfulfilled and perhaps unfulfillable desire is Duchamp's 1915 masterpiece *The Bride Stripped Bare by Her Bachelors, Even*, usually referred to as *The Large Glass*. A display case here holds notations and sketches for the work, and there is a painting of the bride in Duchamp's Cubist manner. The stripping has gone so far that the flesh has been taken away, and what we see looks like her reproductive system, including a schematized uterus. She is suspended in an upper chamber, separated by a glass shelf from her "bachelors"—a chorus of "malic forms" in the lower chamber. The two chambers are united and separated by an erotic desire that leaves everyone at once unsatisfied and inseparable. Duchamp, as is well-known, took a female identity for himself as Rrose Sélavy—*Eros, c'est la vie*—and was photographed wearing a woman's hat, makeup, and furs by—who else?—Man Ray. In one of his most famous works—a postcard of the *Mona Lisa* on which he drew a mustache and goatee—Duchamp sought a reverse transgendrification. Magritte showed the female torso as a ready-made pun on a male face, with the nipples as goggle eyes and the pubis as beard. In Surrealist thought, male and female are often transcriptions of each other, as in the myth of Aristophanes that once upon a time we were a single being, male and female at once, and that ever since we have longed, in futility, for our other half. In Surrealism, though, the split was not clean—each of us bears something that belongs to our sexually opposite number.

The Surrealists did have robust love lives, and the heart of the show—no pun intended—exhibits the cat's cradle of their relationships: Gala with Paul Eluard, Man Ray, and finally Dalí; Max Ernst

with Leonora Carrington and Dorothea Tanning; Eluard with Nusch; Man Ray with Meret Oppenheim and Lee Miller; Louis Aragon with Elsa Triolet; Breton with Nadja and Jacqueline Lamba. And there were plenty of secondary loves as well. Many of the women were artists in their own right, and it is a merit of the show that a lot of their work is shown. I'll end with one of my favorite lines from a Surrealist poet, Robert Desnos, bound to two women—Yvonne George and Youki Foujita—by *l'amour fou: J'ai tant rêvé de toi que tu perds ta réalité* (I have dreamt of you so much that you have lost your reality). The line is logically equivalent to: "I have dreamt of you so much that you have gained surreality." The beauty of the objects of Surrealist desire became convulsive through dreams. May this become true for us all!

March 11, 2002

Artemisia Gentileschi

In the vestibule of the superb exhibition of Orazio and Artemisia Gentileschi at New York's Metropolitan Museum of Art, the organizers have installed a large colored photograph of the ceiling decoration done in 1611 for the Casino of the Muses in the Palazzo Pallavicini-Rospigliosi in Rome. It shows a number of musicians—the Muses themselves—performing on a balcony around the room, and it is painted in the confectionary colors of some improbable Italian dessert—candied fruit in sculpted whipped cream. A handsome girl, elegantly dressed and holding a large fan, gazes out over the balustrade. It is said to be Artemisia Gentileschi herself, posing for Orazio, her father, who painted all the other figures as well, making music or standing about enjoying it. Artemisia would have been eighteen at the time and was already an accomplished painter. The illusional architecture was then painted by Orazio's associate, Agostino Tassi, a master of perspective, who had been engaged to teach that art to Artemisia. The whole scene, of an almost edible beauty, is an image of life at its sweetest—music, indolence, and the pleasures of an attractive company.

The following year, Orazio, Artemisia, and Agostino Tassi were to be caught up in scandal. Orazio brought suit against Tassi for having violently deflowered his gifted daughter, and Tassi denounced Artemisia as having had no virginity to lose at the time the two of them became lovers. The sensational record of the trial, which became the buzz of Rome, has inspired novels, a film, and a recent play. And

Artemisia—characterized by the art historians Rudolf and Margot Wittkower as "a lascivious and precocious girl, [who] later had a distinguished and highly honorable career as an artist"—has become a feminist heroine. The degree to which her sexual trauma inflected her subsequent art remains a topic of debate. It has, for example, become something of an interpretive commonplace to read her gory depictions of Judith cutting off the head of Holofernes as an act of revenge for having been raped.

The ceiling decoration, which serves as a kind of prelude to the exhibition, could not contrast more vividly with the dark violence typical of the Gentileschis' paintings. Father and daughter were both much under the influence of Caravaggio, and indeed it is as prominent *caravaggisti* that they were largely remembered in histories of the Italian Baroque before Artemisia was rescued by feminist art historians with a natural interest in forgotten and neglected woman painters. In Caravaggio, an uncanny light picks out scenes of violent conduct that would otherwise have transpired in a world of utter darkness. It is as though we see as with the all-seeing eyes of God the terrifying deeds that those who perform them might believe are hidden— murder and robbery, violation and revenge, torture and defilement. The consolation of Caravaggio's paintings is the assurance that every sin is known and registered. The soft bright world of the Casino of the Muses belongs to the taste of a gentler age than the Baroque, in which the Gentileschis, father and daughter alike, earned their fame for paintings of extreme drama in which, if anything, they went beyond Caravaggio in the ferocity of their protagonists. And they selected their subjects precisely as occasions for demonstrating their unflinchingness.

The Baroque in Italy saw a coarsening of culture, in which painters were enlisted to depict the spilt blood and broken bodies of the great heroes and heroines of the Christian faith undergoing their martyrdom. Blood was the emblem of redemptive suffering. Almost the first work one sees by Orazio is an immense altarpiece showing the circumcision of Christ, in which God sheds the first blood of his human incarnation. Painting was the arm of Catholic revival against the threat of Protestantism, and the wounds and visible agonies of holy

beings were designed to awaken sympathy in viewers. A splash or spurt of blood was as commonplace in Baroque painting as automobiles exploding in flames are in action movies. Artemisia was a painter of her time.

A gostino Tassi's injury to her was not so much the violence of his attack as the fact that he robbed her of her virginity and falsely promised marriage. It is after all not the standard response of raped women to want to marry their ravishers, but there is evidence of continuing affection on both sides after the incident, and Orazio emphasized in his petition of 1612 that his daughter had been known in the flesh many a time by Tassi. Artemisia, whose description of her forced seduction is recorded in some detail—the judge asked how she knew that she was bleeding from it, for example, and not menstruating. When she underwent torture, by an instrument involving rings tightened around her fingers by means of string, she called out to her betrayer, "This is the ring you gave me, and these are your promises!" She was a spirited woman, and it is worth comparing her version of Judith with Caravaggio's. Caravaggio's Judith is a young girl, with her hair braided in rings over either ear. She handles the sword to kill Holofernes, the general who had conquered her people, awkwardly, as something foreign to her, and she performs the action with a becoming squeamishness, as if repelled by the sight of blood, which spurts out in red jets. Caravaggio has composed the scene within a canvas far wider than it is high, in order to put as much distance between Judith and the victim as possible. Her servant is a crone, to show off Judith's innocence and inexperience. Artemisia's Judith is a *femme forte*. She handles the sword with the confidence and power of a fishwife dealing with a particularly large tuna, while her maidservant holds Holofernes down with both her arms. And the canvas is higher than wide, so that the full weight of the two women presses down. And the blood is there because—well, that's the way decapitations were represented in Roman painting circa 1613.

———

If any of Artemisia's paintings refer to unwanted sexual attentions, it would be her first known work, the amazing *Susanna and the Elders*, the story of which even refers to a trial and a vindication. But the painting antedates the trial of Tassi by two years, according to the experts. Artemisia was seventeen when she painted it, and it would compel our astonished admiration even if there were not the subsequent whiff of scandal. Pure, beautiful Susanna sits naked in her husband's garden, waiting for her maidens to bring a basin of water and some oil, when the horny elders, who have no business there, attempt to blackmail her. Either she yields to their lust, or they will say that they saw her in the arms of a man. But the wily Daniel establishes her innocence by examining the elders separately and showing that their stories do not jibe. It was a fairly popular subject, and it is not difficult to see why. The viewer is given an eyeful of Susanna's nakedness, with the excuse that the story after all is from the Bible—and there is the added benefit that one can condemn the prurience of the elders while enjoying Susanna's discomfiture, unable to cover herself with the towel that the artist always makes just too skimpy for purposes of modesty.

The question remains of why this particular subject would have recommended itself to Artemisia. My own thesis, probably not entirely original, is that it was important to potential patrons to know that a painting that dealt with embattled sexual innocence was by a woman, who presumably knew the problem from within. *Susanna and the Elders* was the ideal subject for showing that, all the more so when there was the added possibility that it was the artist's own nakedness that one was seeing—that the artist painted her own breasts, ruled out in the case of Rembrandt or Ludovico Caracci or Lucas Cranach or Veronese or Tintoretto or the many Old Masters who found the subject irresistible.

Artemisia belongs to this great company by virtue of her artistic achievements, but it was her gender that defined her artistic identity, in this case as in others. Being a woman actually helped in Artemisia's art world. One of the most interesting things I learned from the show's excellent catalog was the fact that in 1636, when she was established and illustrious, Artemisia received payment for three quite dif-

ferent paintings (all untraced today)—a Bathsheba, a Susanna, and a
Lucretia—from Prince Karl von Liechtenstein, an avid collector who
obviously associated these alluring female subjects with the famous
female painter. There is an engraving, based on a self-portrait by
Artemisia, in which she is identified as "Artemisia Gentileschi, Most
Famous Roman Woman [*romana famosissima*], Painter of the Acade-
mia Desiosa." In the self-portrait, Artemisia showed herself in an op-
ulent low-cut dress, in lace collar and jewels, wearing an expression of
almost aristocratic disdain and a wild, disheveled coiffure. She did not
hesitate to bestow her own strong features on her passionate and
heroic Judiths, her Lucretias, her Esthers. It was an age of great col-
lections. It would be altogether desirable, in showing visitors through
one's gallery, to be able to say, before a painting of this or that famous
woman, that she had been painted by a woman no less famous—the
great Artemisia Gentileschi—and to display the engraving as evi-
dence that she had given to that brave and forceful figure her own
mouth and eyes.

Of course, Artemisia was not famous at all in 1610, when she
painted her *Susanna*. But the painting has a certain gestural
authenticity that makes it feel like a personal allegory of a young
woman's ordeal. The elders are shown leaning over the wall against
which Susanna's back is almost literally pressed. It is as if her oppres-
sors are crowded into Susanna's space, where they press down upon
her like a dense cloud. They have already penetrated her person in a
symbolic way by being much closer to her than decency allows, far
closer than voyeurs, and are already touching her hair. Susanna is
twisting her body to escape their touch and has raised her arms to
shield herself from her tormentors—though we viewers get to see one
of her breasts. There is a marvelous expression of anguish and disgust
on her face. Her gestures are entirely convincing, and one cannot but
infer that Artemisia knows from her own experience the way a girl
would respond to unwelcome approaches.

A diary by Fernande Olivier, who was to become Picasso's mis-
tress, has recently been published. She was a beautiful girl, and others
could not keep their hands to themselves when around her. Fernande

at first welcomed the attention as evidence of her attractiveness. But she had constantly to defend herself against sexual molestation. I don't think a male artist would know how to enact the bodily gestures that expressed this the way someone who had to deal with it all the time would do. And it would not have occurred to a male artist to ask a model to pose that way. Whether anyone had gotten as close to her as Tassi was to do, Artemisia conveys through her Susanna the bodily truth of what one might call the proto-rape that Fernande (who was brutally raped by her husband) describes so graphically. There is a question in connoisseurship as to whether Orazio had a hand in Artemisia's *Susanna*, but if my interpretation is sound, it was essentially her painting. You can check his picture of the same subject in the Met show for purposes of comparison. It is a fine painting, but it lacks the internal fire that came naturally to his daughter in dealing with the subject.

But for the legal wit of her attorney, Susanna, like Lucretia, would have been the victim of her virtue. Susanna placed virtue above life, since she knew she would be punished with death as an adulteress, which the elders would say she was if she refused them her body. And Lucretia, raped by Tarquin, had to erase the stain with her own blood—which is more or less the equation implied in cleansing sin with Christ's blood in the Christian theory of redemption. The attractiveness of Lucretia as a topos for painters is that, as with Susanna, it gives them a moral opportunity to display a woman's breasts in a narratively compelling way. She is almost invariably shown with a dagger pointed at her bared bosom. Artemisia seems to me to have posed for her Lucretia, executed 1623–25. I base this on the fact that she is shown with the knife in her left hand, which would be puzzling until we take into account the fact that it is probably a mirror image of Artemisia holding a knife in her right hand. But I don't think we are to read it as a self-portrait—a portrait of herself as Lucretia.

There is a difference between using oneself as a model and painting oneself as the personage for whom the model stands. We may be seeing Artemisia's flesh in her paintings of Lucretia or Susanna or Cleopatra, but I don't see her portraying herself *as* Lucretia or Su-

sanna or even Cleopatra, whose self-administered death by means of an asp allows the same natural way to show bared breasts. I feel the same way about Artemisia's depiction of Danaë in a marvelous painting she did in 1612, the very year of the trial. Titian had painted a *Rape of Danaë* and so, for that matter, had Orazio. The story was well-known. Danaë's father was told that his daughter would give birth to his slayer, and he prudently locked her up in a tower. What he had not counted on was Zeus, who was stricken with Danaë's beauty and metamorphosed himself into a shower of gold, impregnating her. The child turned out to be Perseus, who indeed killed his grandfather. Danaë is always shown nude, though there is reason to wonder why, if Zeus could get through stone walls, a nightgown would be much of an obstacle. In any case, Artemisia's Danaë is clearly enjoying the experience. It is raining gold coins in her chamber, and she is in some sort of sexual transport, clutching the coins in her hands—though whether because of sexual or monetary greed is difficult to say. It is a nice piece of ambiguity for a young artist to have negotiated and not far from seventeenth-century reality. But I cannot see the painting as a self-portrait of Artemisia as Danaë.

I would, on the other hand, accept the possibility that the painting of Clio in the exhibition is Artemisia as the Muse of History, because fame was so integral to her artistic persona. Or that her *Allegory of Painting* is to be read as at least a symbolic self-portrait, since it would show her as one with the attributes of her art (it would be difficult to see it as a literal self-portrait, since the figure is heavily foreshortened). There are four Judiths (excluding those painted by Orazio) in the show, and I would willingly accept a conjecture that Artemisia identified with her, not on the grounds of paying Tassi back for having raped her but because Judith was a paradigm of a woman who used her femininity to achieve real goals. For one thing, Judith is described as being beautifully dressed, with jewels and a hairdo to enhance her desirability. Holofernes invited her and her maidservant into his tent, where he drank himself into a stupor. When Judith displayed his severed head, she so raised the morale of the Israelites that they overcame their enemy. Artemisia was a proud woman, as she had every right to be, as a recognized wonder of the age. Her letters are full of grumbles,

since she was the head of a household, in need of cash since she had a daughter to marry off and no husband to turn to; the man she married after the trial had disappeared, and she did not know if he was even alive. But she had patrons in high places, her prices were respectable, and she corresponded with Galileo. And being known as a woman was internally related to her success.

We must all be grateful to the Met for having put this show together, even if it has a particular relevance to specialists, still sorting out the attributions of the works. There will always be a nagging question of what was done by Orazio and what by Artemisia. This is by no means mere pedantry, since a lot of our readings depend on being clear on authorship, and even on getting the dates right (the Wittkowers thought Artemisia fifteen at the time of the trial). But I am even more grateful to the feminist art historians who pulled Artemisia out of obscurity and who did so much of the research needed to set the story straight. Too many great artists have been forgotten to get indignant because she was, or to explain it as the result of her being a woman. Think of Vermeer, Caravaggio, Piero della Francesca, just for starters. There is a fringe benefit to this: Thinking hard about Artemisia helps us begin to appreciate the great painters of the Italian Baroque, her father included, who, like her, have been too opulent, too operatically passionate, too vehemently theatrical to appeal to our minimalist tastes. It helps to see her work through gendered readings, so long as we recognize that this does not entail seeing her as a victim.

April 8, 2002

Gerhard Richter

It seems scarcely to have required a great philosophical mind to come up with the observation that each of us is the child of our times, but that thought must have been received as thrillingly novel when Hegel wrote it in 1821. For it implied that human nature is not a timeless essence but penetrated through and through by our historical situation. Philosophers, he went on to say, grasp their times in thought, and he might as a corollary have said that artists grasp their times in images. For Hegel was the father of art history as the discipline through which we become conscious of the way art expresses the uniqueness of the time in which it is made. It is rare, however, that grasping his or her own historical moment becomes an artist's subject. It was particularly rare in American art of the second half of the twentieth century, for though the art inevitably belonged to its historical moment, that was seldom what it set out to represent. It strikes me, for example, that Andy Warhol was exceptional in seeking to make the reality of his era conscious of itself through his art.

German artists of the same period, by contrast, seem to have treated the historical situation of art in Germany as their primary preoccupation. How to be an artist in postwar Germany was part of the burden of being a German artist in that time, and this had no analogy in artistic self-consciousness anywhere else in the West. Especially those in the first generation after Nazism had to find ways of reconnecting with Modernism while still remaining German. And beyond that they had to deal with the harsh and total political divisions of the

cold war, which cut their country in two like a mortal wound. Gerhard Richter was a product of these various tensions. But like Warhol, whom he resembles in profound ways, he evolved a kind of self-protective cool that enabled him and his viewers to experience historical reality as if at a distance. There is something unsettlingly mysterious about his art. Looking at any significant portion of it is like experiencing late Roman history through some Stoic sensibility. One often has to look outside his images to realize the violence to which they refer.

Richter grew up in East Germany, where he completed the traditional curriculum at the Dresden Academy of Art, executing a mural for a hygiene museum in 1956 as a kind of senior thesis. Since the institution was dedicated to health, it was perhaps politically innocuous that the imagery Richter employed owed considerably more to the joy-through-health style of representing the human figure at play, which continued to exemplify Hitler's aesthetic well after Nazism's collapse, than to the celebration of proletarian industriousness mandated by Socialist Realism under Stalin. This implies that East German artistic culture had not been Sovietized at this early date. The real style wars were taking place in West Germany and surfaced especially in the ephocal first Documenta exhibition of 1955. Documenta, which usually takes place every five years in Kassel, is a major site for experiencing contemporary art on the international circuit today. But at its inception, it carried an immense political significance for German art. It explicitly marked the official acceptance by Germany of the kind of art that had been stigmatized as degenerate by the Nazis and was thus a bid by Germany for reacceptance into the culture it had set out to destroy. The content of Documenta 1—Modernism of the twentieth century before fascism—could not possibly carry the same meaning were it shown today in the modern art galleries of a fortunate museum. But Modernism, and particularly abstraction, had become a crux for West German artists at the time of Documenta 1, as if figuration as such were politically dangerous. It was not until Richter received permission to visit Documenta 2 in 1959, where he first encountered the art of the New York School—Abstract Expressionism—that some internal pressure began to build in him to engage

in the most advanced artistic dialogues of the time. The fact that he fled East Germany in 1961 exemplifies the way an artistic decision entailed a political choice in the German Democratic Republic.

It was always a momentous choice when an artist decided to go abstract—or to return to the figure after having been an abstractionist, the way the California painter Richard Diebenkorn was to do. But to identify oneself with Art Informel—the European counterpart of the loosely painted abstractions of the New York School—as many German artists did, was to make a political declaration as well as to take an artistic stand. Richter was to move back and forth between realism and abstraction, but these were not and, at least in his early years in the West, could not have been politically innocent decisions. Neither was the choice to go on painting when painting as such, indifferently as to any distinction between abstraction and realism, became a political matter in the 1970s. If ignorant of the political background of such choices, visitors to the magnificent Museum of Modern Art retrospective of Richter's work since 1962—the year after his momentous move from East to West—are certain to be baffled by the fact that he seems to vacillate between realism and abstraction, or even between various styles of abstraction, often at the same time. These vacillations seemed to me so extreme when I first saw a retrospective of Richter's work in Chicago in 1987, that it looked like I was seeing some kind of group show. "How can you say any style is better than another?" Warhol asked with his characteristic faux innocence in a 1963 interview. "You ought to be able to be an Abstract Expressionist next week, or a Pop artist, or a realist, without feeling that you have given up something." For most artists in America, it is important that they be stylistically identifiable, as if their style is their brand. To change styles too often inevitably would have been read as a lack of conviction. But what the show at MoMA somehow makes clear is that there finally is a single personal signature in Richter's work, whatever his subject, and whether the work is abstract or representational. It comes, it seems to me, from the protective cool to which I referred—a certain internal distance between the artist and his work, as well as between the work and the world, when the work itself is about reality. It is not irony. It is not exactly detachment. It expresses the spirit of an artist who has

found a kind of above-the-battle tranquility that comes when one has decided that one can paint anything one wants to in any way one likes without feeling that something has been given up. That cool is invariant to all the paintings, whatever their content. As a viewer one has to realize that abstraction is the content of one genre of his painting, while the content of the other genres of his painting is, well, not abstraction. They consist of pictures of the world. So in a sense the show has an almost amazing consistency from beginning to end. It is as though what Richter conveys is a content that belongs to the mood or tone, and that comes through the way the quality of a great voice does, whatever its owner sings.

Before talking about individual works, let me register another peculiarity of Richter's work. He paints photographs. A lot of artists use photography as an aid. A portraitist, for example, will take Polaroids of her subject to use as references. The photographs are like auxiliary memories. With Richter, by contrast, it is as if photographs are his reality. He is not indifferent to what a photograph is of, but the subject of the photograph will often not be something that he has experienced independently. In 1964 Richter began to arrange photographs on panels—snapshots, often banal, clippings from newspapers and magazines, even some pornographic pictures. These panels became a work in their own right, to which Richter gave the title *Atlas*. *Atlas* has been exhibited at various intervals, most recently in 1995 at the Dia Center for the Arts in New York, at which venue there were already six hundred panels and something like five thousand photographs. These photographs are Richter's reality as an artist. When I think of *Atlas*, I think of the human condition as described by Plato in the famous passage in *The Republic* where Socrates says that the world is a cave, on the wall of which shadows are cast. They are cast by real objects to which we have no immediate access and about which, save for the interventions of philosophy, we would have no inkling. But there is an obvious sense in which most of what we know about we never experience as such. Think of what the experience of the World Trade Center attack was for most of us on September 11 and after-

ward. We were held transfixed by the images of broken walls and
burning towers, to use Yeats's language, and fleeing, frightened
people.

The first work in the exhibition is titled *Table*, done in 1962.
Richter considers it the first work in his catalogue raisonné, which
means that he assigns it a significance considerably beyond whatever
merits it may possess as a painting. It means in particular that nothing
he did before it is part of his acknowledged oeuvre. Barnett Newman
felt that way about a 1948 work he named *Onement*. He considered it,
to vary a sentimental commonplace, the first work of the rest of his
artistic life. Next to *Table*, one notices two photographs of a modern
extension table, clipped from an Italian magazine, on which Richter
puddled a brushful of gray glaze. *Table* itself is an enlarged and sim-
plified painting of the table in the photographs, over which Richter
has painted an energetic swirl of gray paint. It is easy to see why it is so
emblematic a work in his artistic scheme. Whatever the merits of the
depicted table may have been as an object of furniture design, such ta-
bles were commonplace articles of furniture in middle-class domestic
interiors in the late fifties. In 1962 it was becoming an artistic option to
do paintings of ordinary, everyday objects. We were in the early days
of the Pop movement. The overlaid brushy smear, meanwhile, has ex-
actly the gestural urgency of Art Informel. So *Table* is at the intersec-
tion of two major art movements of the sixties: It is representational
and abstract at once. Warhol in that period was painting comic-strip
figures like Dick Tracy—but was dripping wet paint over his images,
not yet able to relinquish the talismanic drip of Abstract Expression-
ism. Indeed, in 1960 he painted a Coca-Cola bottle with Abstract Ex-
pressionist mannerisms—a work I consider *Table*'s unknown artistic
sibling. Richter gave up Art Informel in 1962, just as Warhol dropped
Abstract Expressionist brushiness in favor of the uninflected sharp-
ness and clarity of his Pop images. By 1963 Richter had begun paint-
ing the blurred but precise images that became his trademark. Richter's
marvelously exact *Administrative Building* of 1964 captures the dispir-
iting official architecture of German postwar reconstruction, espe-
cially in the industrial Rhineland. And his wonderful *Kitchen Chair* of
1965 is a prime example of Capitalist Realism, the version of Pop de-

veloped by Richter and his colleague, Sigmar Polke, in the mid-sixties. Richter and Warhol had fascinatingly parallel careers.

The deep interpretative question in Richter's art concerns less the fact that he worked with photographs than why he selected the photographs he did for *Atlas*, and what governed his decision to translate certain of them into paintings. There are, for example, photographs of American airplanes—Mustang Squadrons, Bombers, and Phantom Interceptor planes in ghostly gray-in-gray formations. Richter was an adolescent in 1945 and lived with his family within earshot of Dresden at the time of the massive firebombings of that year. The photograph from which *Bombers* was made had to have been taken as a documentary image by some official Air Force photographer, whether over Dresden or some other city. The cool of that photograph, compounded by the cool with which that image is painted—even to the hit plane near the bottom of the image and what must be the smoke trailing from another—cannot but seem as in a kind of existential contrast with the panic of someone on the ground under those explosives falling in slow fatal series from open bays. But what were Richter's feelings? What was he saying in these images?

And what of the 1965 painting of the family snapshot of the SS officer—Richter's Uncle Rudi—proudly smiling for the camera, which must have been taken more than twenty years earlier, shortly before its subject was killed in action? Tables and chairs are tables and chairs. But warplanes and officers emblematize war, suffering, and violent death. And this was not simply the history of the mid-twentieth century. This was the artist's life, something he lived through. We each must deal with these questions as we can, I think. The evasiveness of the artist, in the fascinating interview with Robert Storr—who curated this show and wrote the catalog—is a kind of shrug in the face of the unanswerability of the question. What we can say is that photographs have their acknowledged forensic dimension; they imply that their subjects were there, constituted reality, and that the artist himself is no more responsible than we are, either for the reality or the photography. The reality and the records are what others have done. He

has only made the art. And the blurredness with which the artist has instilled his images is a way of saying that it was twenty years ago— that it is not now. Some other horrors are now.

The flat, impassive transcriptions of Richter's paintings are correlative with the frequent violence implied by what they depict. That makes the parallels with Warhol particularly vivid. It is easy to repress, in view of the glamour and celebrity associated with Warhol's life and work, the series of disasters he depicted—plane crashes, automobile accidents, suicides, poisonings, and the shattering images of electric chairs, let alone Jackie (*The Week That Was*), which memorializes Kennedy's funeral. Or the startlingly anticelebratory *Thirteen Most Wanted Men* that he executed for the New York State Pavilion at the 1964 World's Fair. Compare these with Richter's 1966 *Eight Student Nurses*, in which the bland, smiling, youthful faces look as if taken from the class book of a nursing school—but which we know were of victims of a senseless crime. Warhol's works, like Richter's, are photography-based. The pictures came from vernacular picture media—the front page of the *Daily News*, or the most-wanted pictures on posters offering rewards, which are perhaps still tacked up in post offices. These were transferred to stencils and silk-screened, and have a double graininess—the graininess of newspaper reproduction and of the silk-screen process itself. And like Richter's blurring, this serves to distance the reality by several stages—as if it is only through distancing that we can deal with horror. I tend to think that part of what made us all feel as if we were actually part of the World Trade Center disaster was the clarity of the television images and the brightness of the day that came into our living rooms.

Whatever our attitude toward the prison deaths of the Baader-Meinhof gang members in 1977, I think everyone must feel that if Richter is capable of a masterpiece, it is his *October 18, 1977* suite of thirteen paintings, done in 1988 and based on aspects of that reality. These deaths define a moral allegory in which the state, as the guarantor of law and order, and the revolution, as enacted by utopian and idealist youths, stand in stark opposition, and in which both sides are responsible for crimes that are the dark obverses of their values. But how fragile and pathetic these enemies of the state look in paintings

that make the photographs from which they were taken more affecting than they would seem as parts, say, of *Atlas*. Who knows whether Richter chose the images because they were affecting, or made them so, or if we make them so because of the hopelessness of a reality that has the quality of the last act of an opera, in which the chorus punctuates the tragedy in music? There are three paintings, in graded sizes, of the same image of Ulrike Meinhof, who was hanged—or hanged herself—in her cell. The paintings do not resolve the question of whether she was killed or committed suicide. They simply register the finality of her death—Dead. Dead. Dead. (*Tote. Tote. Tote.*)—in a repetition of an image, vanishing toward a point, of a thin dead young woman, her stretched neck circled by the rope or by the burn left by the rope. That is what art does, or part of what it does. It transforms violence into myth and deals with death by beauty. There was a lot of political anger when these paintings were shown in 1988, but there was no anger in the gallery on the occasions when I have visited it in the past several weeks.

By comparison with the ferocity of human engagements in the real world, the art wars of the mid-twentieth century seem pretty thin and petty. But it says something about human passion that the distinction between figuration and abstraction was so vehement that, in my memory, people would have been glad to hang or shoot one another, or burn their stylistic opponents at the stake, as if it were a religious controversy and salvation were at risk. It perhaps says something deep about the spirit of our present times that the decisions whether to paint abstractly or realistically can be as lightly made as whether to paint a landscape or still life—or a figure study—was for a traditional artist. Or for a young contemporary artist to decide whether to do some piece of conceptual art or a performance. Four decades of art history have borne us into calm aesthetic waters. But this narrative does not convey the almost palpable sense in which Richter has grasped his times through his art. One almost feels that he became a painter in order to engage not just with how to be an artist but how, as an artist, to deal with the terribleness of history.

May 13, 2002

Barnett Newman and the Heroic Sublime

Henry James could not resist giving the hero of his 1877 novel *The American* the allegorical name "Newman," but he went out of his way to describe him as a muscular Christian, to deflect the suggestion that Newman might be Jewish, as the name might otherwise imply. He is, as an American, a New Man, who has come to the Old World on a cultural pilgrimage in 1868, having made his fortune manufacturing washtubs, and James has a bit of fun at his hero's expense by inflicting him with an aesthetic headache in the Louvre, where his story begins. "I know very little about pictures or how they are painted," Newman concedes, and as evidence, James has him ordering, as if buying shirts, half a dozen copies of assorted Old Masters from a pretty young copyist who thinks he is crazy, since, as she puts it, "I paint like a cat."

By a delicious historical coincidence, another New Man, this time unequivocally Jewish—the Abstract Expressionist Barnett Newman—visits the Louvre for the first time in 1968, exactly a century later. By contrast with his fellow noble savage, this Newman has had the benefit of reading Clement Greenberg and working through Surrealism. So he is able to tell his somewhat patronizing guide, the French critic Pierre Schneider, to see Uccello's *The Battle of San Romano* as a modern painting, a flat painting, and to explain why Mantegna's *Saint Sebastian* bleeds no more than a piece of wood despite being pierced with arrows. He sees Géricault's *Raft of the Medusa* as tipped up like one of Cézanne's tables. "It has the kind of modern

space you wouldn't expect with that kind of rhetoric." And in general the new New Man is able to show European aesthetes a thing or two about how to talk about the Old Masters, and incidentally how to look at his own work, which so many of his contemporaries found intractable. In Rembrandt, for example, Newman sees "all that brown, with a streak of light coming down the middle . . . as in my own painting."

"All that brown, with a streak of light coming down the middle" could be taken as a description of the first of Newman's paintings with which the artist felt he could identify himself, done exactly two decades earlier than the Louvre visit and retroactively titled by him *Onement 1*. Most would have described it as a messy brown painting with an uneven red stripe down the middle, and nobody but Newman himself would have tolerated a comparison with Rembrandt. But Newman told Pierre Schneider, "I feel related to this, to the past. If I am talking to anyone, I am talking to Michelangelo. The great guys are concerned with the same problems."

We must not allow it to go unnoticed that Newman counted himself as among the great guys, though it is something of a hoot to imagine trying to convince Henry James, were he resurrected, that the works that make up the wonderful Newman exhibition at the Philadelphia Museum of Art are concerned with the same issues as the Louvre masterworks that gave his protagonist Newman a headache and eyestrain. Even critics otherwise sympathetic to advanced painting in the 1950s were made apoplectic by Newman's huge, minimally inflected canvases—fields of monochromatic paint with a vertical stripe or two—and they have provoked vandalism from the time of his first solo show at the Betty Parsons Gallery in 1950. As we shall see, Newman thought he had resolved the problems that concerned the great guys who preceded him. They had been struggling to make beautiful pictures, whereas he considered himself as having transcended beauty and picturing alike. His achievement was to capture the sublime in painting.

Newman regarded *Onement 1* as marking a breakthrough for his work, and a new beginning. The installation in Philadelphia dramatizes this by framing the piece by means of a doorway leading from

one gallery into another. While standing in a gallery hung with pictures done by Newman before the breakthrough, one glimpses a new order of painting in the room beyond. Like all the great first generation of Abstract Expressionists, Newman seems to have passed abruptly from mediocrity to mastery with the invention of a new style—like the flung paint of Pollock, the heavy brushstrokes of de Kooning, Kline's timberlike black sweeps against white, Rothko's translucent rectangles of floating color. The pre-*Onement* paintings may seem somehow to point toward it, in the sense that there is in most of them a bandlike element that aspires, one might say, to become the commanding vertical streak. But in them, the streak (or band, or bar) shares space with other elements, splotches and squiggles and smears that are tentative and uninspired. The vertical streak alone survives a kind of Darwinian struggle for existence, to become the exclusive and definitive element in Newman's vision, from *Onement 1* onward. The basic format of Newman's work for the remainder of his career is that of one or more vertical bands, which run from the top to the bottom of the panel, in colors that contrast with a more or less undifferentiated surrounding field. Sometimes the bands will be of differing widths in the same painting, and sometimes, again, they will differ from one another in hue. But there will no longer be the variety of forms he used in the pre-*Onement* period of his work. It is as if he understood that with *Onement 1* he had entered a newfound land rich enough in expressive possibilities that he need seek for nothing further by way of elementary forms. *Onement 1* is planted like a flag at the threshold, and when one crosses over it, one is in a very different world from that marked by the uncertain pictures that preceded it.

I have followed Newman in respecting a distinction between pictures and paintings. *Onement 1* was a painting, whereas what he had done before were merely pictures. How are we to understand the difference? My own sense is that a picture creates an illusory space, within which various objects are represented. The viewer, as it were, looks through the surface of a picture, as if through a window, into a virtual space, in which various objects are deployed and composed: the Virgin

and Child surrounded by saints in an adoration; stripes surrounded by squiggles in an abstraction. In the Renaissance, a picture was regarded as transparent, so to speak, the way the front of the stage is, through which we see men and women caught up in actions that we know are not occurring in the space we ourselves occupy. In a painting, by contrast, the surface is opaque, like a wall. We are not supposed to see through it. We stand in a real relationship with it, rather than in an illusory relationship with what it represents. I expect that this is the distinction Newman is eager to make. His paintings are objects in their own right. A picture represents something other than itself; a painting presents itself. A picture mediates between a viewer and an object in pictorial space; a painting is an object to which the viewer relates without mediation. An early work that externally resembles *Onement 1* is *Moment*, done in 1946. A widish yellow stripe bisects a brownish space. Newman said of it, "The streak was always going through an atmosphere; I was trying to create a world *around* it." The streak in *Onement 1* is not in an atmosphere of its own, namely, pictorial space. It is on the surface and in the same space as we are. Painting and viewer coexist in the same reality.

At the same time, a painting is not just so much pigment laid across a surface. It has, or we might say it embodies, a meaning. Newman did not give *Onement 1* a title when it was first exhibited, but it is reasonable to suppose that the meaning the work embodied was somehow connected with this strange and exalted term. In general, the suffix "-ment" is attached to a verb like "atone" or "endow" or "command," where it designates a state—the state of atoning, for example—or a product. So what does "onement" mean? My own sense is that it means the condition of being one, as in the incantation "God is one." It refers, one might say, to the oneness of God. And this might help us better understand the difference between a picture and a painting. Since Newman thinks of himself and Michelangelo as concerned with the same kinds of problems, consider the Sistine ceiling, where Michelangelo produces a number of pictures of God. Great as these are, they are constrained by the limitation that pictures can show only what is visible, and decisions have to be made regarding what God looks like. How would one picture the fact that God is one?

Since *Onement 1* is not a picture, it does not inherit the limitations inherent in picturing. The catalog text says that *Onement 1* represents nothing but itself and that it is about itself as a painting. I can't believe, though, that what Newman regarded in such momentous terms was simply a painting about painting. It is about something that can be said but cannot be shown, at least not pictorially. Abstract painting is not without content. Rather, it enables the presentation of content without pictorial limits. That is why, from the beginning, abstraction was believed by its inventors to be invested with a spiritual reality. It was as though Newman had hit upon a way of being a painter without violating the Second Commandment, which prohibits images.

Kant wrote in the *Critique of Judgment* that "perhaps the most sublime passage in Jewish Law is the commandment Thou shalt not make unto thee any graven image, or any likeness of anything that is in heaven or on earth, or under the earth," etc. This commandment alone can explain the enthusiasm that the Jewish people felt for their religion when compared with that of other peoples, or can explain the pride that Islam inspires. But this in effect prohibited Jews from being artists, since, until Modernism, there was no way of being a painter without making pictures and hence violating the prohibition against images! Paintings that are not pictures would have been a contradiction in terms. But this in effect ruled out the possibility of making paintings that were sublime, an aesthetic category to which Kant dedicated a fascinating and extended analysis. And while one cannot be certain how important the possibility of Jewish art was to Newman, there can be little question not only that the sublime figured centrally in his conception of his art but that it also was part of what made the difference in his mind between American and European art. Indeed, sublimity figured prominently in the way the Abstract Expressionists conceived of their difference from European artists. In the same year that Newman broke through with *Onement 1*, he published an important article, "The Sublime Is Now," in the avant-garde magazine *Tiger's Eye*. And my sense is that in his view, there could not be a sublime picture—that sublimity became available to visual artists only when they stopped making pictures and started making paintings.

Peter Schjeldahl recently dismissed the sublime as a hopelessly

jumbled philosophical notion that has had more than two centuries to start meaning something cogent and has not succeeded yet. But the term had definite cogency in the eighteenth century, when philosophers of art were seeking an aesthetics of nature that went beyond the concept of beauty. Beauty for them meant taste and form, whereas the sublime concerned feeling and formlessness. Kant wrote that "nature excites the ideas of the sublime in its chaos or in its wildest and most irregular disorder and desolation, provided size and might are perceived," and he cited, as illustrations,

> Bold overhanging and as it were threatening rocks; clouds piled up in the sky, moving with lightning flashes and thunder peals; volcanoes in all their violence of destruction; hurricanes with their track of devastation; the boundless ocean in a state of tumult; the lofty waterfall of a mighty river, these exhibit our faculty of resistance as insignificantly small in comparison with their might.

Since Kant was constrained to think of art in terms of pictures as mimetic representations, there was no way painting could be sublime. It could consist only in pictures of sublime natural things, like waterfalls or volcanoes. While these might indeed be sublime, pictures of them could at most be beautiful. Kant does consider architecture capable of producing the feeling of sublimity. He cites Saint Peter's Basilica as a case in point because it makes us feel small and insignificant relative to its scale.

What recommended the sublime to Newman is that it meant a liberation from beauty and hence a liberation from an essentially European aesthetic in favor of an American one. The European artist, Newman wrote,

> has been continually involved in the moral struggle between notions of beauty and the desire for the sublime . . . The impulse of modern art was this desire to destroy beauty. Mean-

while, I believe that here in America, some of us, free from the
weight of European culture, are finding the answer, by denying
that art has any concern with the problem of beauty and where
to find it. The question that now arises is how can we be creat-
ing an art that is sublime?

There can be little doubt that in Newman's sense of his own
achievement, he had solved this problem with *Onement 1*. It is cer-
tainly not a beautiful painting, and one would miss its point entirely if
one supposed that sooner or later, through close looking, the painting
would disclose its beauty as a reward. There was a standing argu-
ment, often enlisted in defense of Modernism, that the reason we were
unable to see modern art as beautiful was because it was difficult.
Roger Fry had written, early in the twentieth century, that "every new
work of creative design is ugly until it becomes beautiful; that we usu-
ally apply the word beautiful to those works of art in which familiar-
ity has enabled us to grasp the unity easily, and that we find ugly those
works in which we still perceive only by an effort." Newman's re-
sponse to this would have been that he had achieved a liberation from
what feminism would later call the beauty trap. He had achieved
something grander and more exalted, a new art for new men and
women.

Newman used the term "sublime" in the title of his *Vir Heroicus
Sublimis* (1950–51). It is a tremendous canvas, nearly eight feet high
and eighteen feet wide, a vast cascade of red paint punctuated by five
vertical stripes of varying widths, set at varying intervals. Newman
discussed this work (which the critic for *The New Republic* called asi-
nine) in an interview with the British art critic David Sylvester in
1965.

One thing that I am involved in about painting is that the
painting should give a man a sense of place: that he knows he's
there, so he's aware of himself. In that sense he related to me
when I made the painting because in that sense I was there.
Standing in front of my paintings you had a sense of your own
scale. The onlooker in front of my painting knows that he's

there. To me, the sense of place not only has a mystery but has that sense of metaphysical fact.

Newman studied philosophy at City College, and Kant sprang to his lips almost as a reflex when he discussed art. But it is difficult not to invoke the central idea of Martin Heidegger's philosophy in connection with his comment to Sylvester. Heidegger speaks of human beings as *Dasein*, as "being there," and it is part of the intended experience of Newman's paintings that our thereness is implied by the scale of the paintings themselves. In his 1950 exhibition at the Betty Parsons Gallery, he put up a notice that while there is a tendency to look at large paintings from a distance, these works were intended to be seen from close up. One should feel oneself there, in relationship to the work, like someone standing by a waterfall. The title of the painting meant, he told Sylvester, "that man can be or is sublime in his relation to his sense of being aware." The paintings, one might say, are about us as self-aware beings.

A high point of the Philadelphia show is Newman's *The Stations of the Cross*, a series of fourteen paintings that is certainly one of the masterpieces of twentieth-century art. As a spiritual testament, it bears comparison with the Rothko Chapel in Houston. I have the most vivid recollection of being quite overcome when I first experienced *The Stations of the Cross* in the Guggenheim Museum in 1966. Newman used as subtitle the Hebrew words *Lema Sabachthani*—Christ's human cry on the cross. The means could not be more simple: black and white paint on raw canvas, which he used as a third color. The fourteen paintings do not map onto corresponding points on the road to Calvary. But Newman seems to use black to represent a profound change of state.

The first several paintings have black as well as white stripes (or "zips," as he came to call them, referring perhaps to the sound that masking tape makes when it is pulled away). Black entirely disappears in the *Ninth Station*, in which a stripe of white paint runs up the left edge, and two thin parallel white stripes are placed near the right edge. The rest is raw canvas. The *Tenth* and *Eleventh* stations resemble it, through the fact that they too are composed of white stripes

placed on raw canvas. Then, all at once, *Twelfth Station* is dramatically black, as is the *Thirteenth Station*. And then, in the *Fourteenth Station*, black again abruptly disappears. There is a strip of raw canvas at the left, and the rest is white, as if Christ yielded up the ghost as Saint Matthew narrates it. The work demonstrates how it is possible for essentially abstract paintings to create a religious narrative.

No one today, I suppose, would hold painting in the same exalted state that seemed possible in the 1950s. Newman became a hero to the younger generation of the 1960s, when the history of art that he climaxed gave way to a very different era. He triumphed over his savage critics, as great artists always do, and all who are interested in the spiritual ambitions of painting at its most sublime owe themselves a trip to Philadelphia to see one of the last of the great guys in this thoughtful and inspired exhibition, the first to be devoted to his work in more than thirty years.

June 17, 2002

Joan Mitchell

n *Empire Falls*, Richard Russo's neo-Dickensian novel of a dying mill town in central Maine, the high school art teacher is portrayed as something of a soul killer. Indifferent if not hostile to signs of true creativity in her students, she encourages them to admire, for bad aesthetic reasons, what the author regards as bad art. Her favorite painter, for example, specializes in old rowboats and the rocky Maine shoreline, and on his local-access show, *Painting for Relaxation*, he executes a painting in exactly one hour, start to finish. Entirely aware of her teacher's impaired taste, the best student in the class still cannot but admire the TV painter's way of attacking the canvas: It is as though his arm, wrist, hand, fingers, and brush are an extension of his eye, or perhaps his will. It comes as something of a surprise that teacher and student have this admiration in common with Joan Mitchell (1926–92), one of the great if underappreciated Abstract Expressionist painters of the New York School, whose luminous achievement is honored with a celebratory exhibition at New York's Whitney Museum of American Art. Every morning, according to Kenneth Tyler, in whose graphics workshop in Mount Kisco Mitchell frequently worked on prints when she was in this country, she would watch a public television show whose host was a landscape painter with a Southern drawl; in each episode a painting would be created, from primed canvas, to the emergence of a mountain scene or a seascape. Tyler says that Mitchell adored that show, and she'd be in a good mood when she came down to the studio from the apartment, just after a shower.

Mitchell must have found especially appealing the swift, sure, dancelike way the TV painter dashed his brush across the canvas, just as so-called action painters were supposed to do, but left, at the same time, a recognizable image behind. Despite her abstractionist credentials, she saw herself as a landscape artist—"What's so interesting about a square, circle, and triangle?" And just as the TV painter was able to create an outdoor scene within the windowless space of a television studio, she evoked trees, bridges, or beaches in a downtown Manhattan studio that looked out on a brick wall. "I carry my landscapes around with me," she told Irving Sandler when he interviewed her for "Mitchell Paints a Picture," one of a famous series that appeared on and off in *ArtNews* in the 1950s. She seems to have been remarkably tolerant for someone as strongly opinionated as she typically was. "There is no one way to paint," she said to Sandler. "There is no single answer." She characterized herself as something of a conservative.

The picture that Mitchell painted for Sandler's 1957 article referred to a remembered moment in East Hampton some years earlier, when a legendarily undisciplined poodle she owned went swimming. She called the picture *George Went Swimming at Barnes Hole, but It Got Too Cold*, and it typifies her extraordinary work of the middle 1950s, when she seemed to paint only masterpieces. The implied narrative of the title refers to the course the painting took, rather than an actual change of temperature on that memorable day. The yellows, which emblematized the warm light of a summer afternoon, gave way, for reasons internal to the painting, to areas of white and hence, wittily, to winter. It is hardly the kind of landscape a TV painter would have ended his hour with. There is a thick tangle of heavy, largely horizontal brushstrokes about a third of the way up the canvas—black-blues, ochres, paler greens, and a surprising passage of cadmium red. A patch of grays and pale blues in the upper right corner feels like winter sky, while a spread of strongly swept blues and purples at the bottom of the canvas must be a reminiscence of water. The feeling of cold is mostly achieved through white and whitish

spaces, climbing like broken ice from bottom to top, punctuated by slashes and lashes of fluid pigment that the clever student in Empire Falls High School would recognize as the artist's attack. The painting manages to meld ferocity and tranquility into a single stunning image that is Mitchell at the height of her powers.

The first painting of Mitchell's that I recall seeing had an immense impact on me. Since I followed the Abstract Expressionist scene, I may have seen her work earlier without, so to speak, encountering it. What I knew absolutely was that this was a great painting, that I would wish to have painted it more than any other, and that it was entirely beyond me. By contrast with this artist, everyone I knew of was comparatively tentative and fearful, as the young student in *Empire Falls* felt her work to be. It was somewhat chastening, in those sexist days, to realize that it had been painted by a woman. Possibly it could only have been painted by a woman, but in any case a stereotype had been shattered. The painting was called *Hemlock*, and it hung by itself in the first room of the Martha Jackson Gallery. It seemed to me that Abstract Expression had found a new direction and that its methods could now be used almost like poetry, to capture and communicate real experience. In the interview with Sandler, Mitchell said, "The painting has to work, but it has to say something more than that the painting works." It had been enough, in those days, that a painting should work. There was little beyond that, one could say. But with *Hemlock*, as with so many of the pieces Mitchell did around the same time, it went beyond what Duchamp dismissed as that "retinal shudder": She brought the world as she lived it into her art, and as advanced as her work of the 1950s was, experiencing it was like experiencing nature in an intense, revelatory moment. No one else I knew of had managed that.

Hemlock is a tree composed as an ascending set of horizontal sweeps of green and black against a white winter sky. The bands seem hung like branches on a trunk, explicit in certain passages, whited out but implied in others, and it feels constructed, like a complex Chinese character that could have been an ideogram for hemlock, built stroke by parallel stroke up the left side of the canvas. But it is not static. Some of the branches seem to be whipped into movement, on the can-

vas's right side, as if they were feeling their way into emptiness at the edge of a cliff, like a heroic oak tree once painted by the Norwegian artist Dahl, which his nation adopted as the symbol of its toughness in an adverse world. Whipped loops of black paint animate the air, and cascades of drips rain down. The whole image has the quality of a great drawing, except, of course, that the white is not the background of white paper but is itself painted in such a way as to interanimate the thrashing branches and the vividness of the void. Only de Kooning could have come close to *Hemlock*. Kline was never able to solve the problem of adding color to his black-and-white canvases without diluting them.

Mitchell was as much one with the art world of her time as the tree in *Hemlock* is with the paint it is made of. Had that world perdured, she would have been one of the most celebrated artists of our time. The fact that she has instead been neglected lies, I think, not in the circumstances of her gender—as Jane Livingston, the curator, to whom we must all be grateful for this wonderful show, alleges in her catalog essay—but in the fact that she painted for the rest of her life as if she were drawing sustenance from an art world that had in truth vanished. She was like a fragment of a planet that had broken off and followed an independent orbit after the planet itself had crumbled to bits.

The direction of art changed radically and irrevocably a very few years after my encounter with *Hemlock*. In 1961, Allan Kaprow, chief author if not the inventor of "Happenings," installed *Yard* in the courtyard of Martha Jackson's new gallery. It consisted in a disordered heap of used automobile tires. Kaprow, who wrote his master's thesis (studying with the art critic Meyer Schapiro at Columbia) on Mondrian, worked with John Cage at the New School for Social Research in the years Mitchell was establishing her name (1956–58). He shortly gave up painting for assemblage and made chance and indeterminacy the principles of his work. Kaprow's epochal *Eighteen Happenings in Six Parts* took place at the Reuben Gallery in 1959. *Hemlock* and *Yard* reflect different moments of the pervasive influence of Zen on New

York art in the 1950s. *Hemlock* belongs to the impulse of haiku and Zen watercolors. The pile of tires belongs to what I was later to call the transfiguration of the commonplace. Its impact on me, though I hardly recognized its meaning in 1961, was largely philosophical. It consisted in the question that now seems to me to have defined the 1960s, namely, Why was a pile of worthless rubber tires a work of art and not simply a pile of worthless rubber tires? Clement Greenberg was to call this "novelty art." Mitchell, open as she may have been about painting, dismissed what was happening as "pop, slop, and plop." It was not a transient phenomenon but a revolution in the production of art that remains with us forty years later.

Mitchell began to work in Paris intermittently in the 1950s, but she carried her inner landscapes with her as well, for a while at least, as her unmistakable style. In a sense, she was a New York School painter working in the fifteenth arrondissement, and though she gave her pictures French titles in the 1960s, one does not feel that they had as yet any French references. *Grandes Carrières* is a densely crowded thicket of pigment in the middle of a horizontal canvas, which could have an autumnal reference, with red and brown branches, and could even be read as a wildly brushed still life poised before a window, though the title means "large quarries." Abstract Expressionism was a world movement, but it assumed different identities from nation to nation: French Abstract Expressionism was unmistakably School of Paris through its irrepressible tastefulness, and Japanese Abstract Expressionism had a reckless scariness that New York was not ready for. The beautiful *Untitled* (1963), with its airy lightness, its lyrical scaffold of olive-green strokes and touches, continues to have a New York feeling. But with *Blue Tree*, and particularly *Calvi*, both done in 1964, Mitchell begins to respond to European, one even feels to Mediterranean, motifs. *Calvi* is a green, thick island of paint, almost scrubbed into or onto an otherwise nearly empty expanse sparsely enlivened by running calligraphic strokes. And then, perhaps in *My Landscape II*, 1967, and especially in *Low Water*, 1969, some deep change, inner or outer, has taken place, and she becomes a different painter from what she'd been, one about whom I have mixed feelings. She has become somehow more European.

—————

In 1988—I had by then begun to write this column—I traveled down to the Corcoran Gallery of Art in Washington to see a retrospective show of Joan Mitchell's work. I had been caught up in the way the art world had gone in the early 1960s and had more or less lost touch with Mitchell's work. But since it was something like having been in love to have been affected once by her paintings, I wanted to know what the artist had been doing over the intervening years. She was sixty-two years old, and she'd had a long, tempestuous relationship with the French-Canadian artist Jean-Paul Riopelle, whose memorial show (he died this year) at the Montreal Museum of Fine Arts ends the same day as Mitchell's. She had come into money and purchased a property in Vetheuil, on the banks of the Seine north of Paris, where Monet had painted before he moved to Giverny in 1881, after the death of his wife, Camille. In fact, Mitchell lived at 12 rue Claude Monet, and I wondered to what degree she had internalized the spirit of the site, or had, in her own way, taken on something of Monet's aura. A Dutch museum director recently complained to me that Mitchell had tried too hard to be like Monet. He compared her unfavorably with Ellsworth Kelly, who had gone to Paris and encountered Matisse, and then turned what he admired into something altogether American. But the relationship between Monet and Abstract Expressionism is more complex than that. Through Abstract Expressionism, Monet belonged to the spirit of American art.

Many of the great pieces from the 1950s were on view at the Corcoran, including *Hemlock*, which seems by general consensus to be her chef d'oeuvre. But in the main, I was disappointed in the show, and I felt confirmed in my somewhat sour negativity by the fact that Livingston, who installed it, felt much the same way. "I was disturbed," she writes, "by what I thought was an uneven show. It was far too big, with too much emphasis on recent work. I learned that the artist herself had a hand in its selection, and as is not unusual in such circumstances, she simply could not edit out the works that had most recently come out of the studio." I had a somewhat different explanation. I thought the exhibition showed what happens when an artist, whose

greatness owed so much to the discoveries of the movement she be-
longed with, outlives the movement. Individual achievement depends
upon the criticism and applause of those who share one's language
and values as an artist. It was an immense privilege to belong to a
movement like Abstract Expressionism. Everyone who was part of it
was greater through that fact than he or she would have been alone.

In any case, I did not write about the show. The happy ending to
this is that Livingston has now used her great curatorial intuitions to
put together the kind of show the artist herself would have been inca-
pable of. It is chronological but somehow orchestrated, and marked
by a kind of phrasing, so that one is able to live Mitchell's life through
her paintings. The issue of reference is less important than the recog-
nition that the work is referential. No one can tell from the painting
where George went swimming nearly half a century ago on Long Is-
land, or which particular hemlock, now grown venerable and great,
captured the artist's memory until it was delivered magnificently into
art. But there is, in addition to reference, the mood and feeling that
make the transformation of it into art memorable and urgent. More is
happening in *Calvi* than fixing something visually compelling. One is
not surprised to read that when she painted it, Mitchell was going
through a serious emotional crisis. When the Japanese Abstract Ex-
pressionist Jiro Yoshihara did a memorial painting for Martha Jack-
son, who died in 1969, he was asked why it consisted of a simple
white-on-black circle. He gave a Zen answer: "Since I did not have
time, this was the best way I could do at the moment." That is how I
feel about *Calvi*.

The show is so intense that when one turns a corner and comes
upon *Clearing*, 1973, it really feels like a clearing. It is restful and
calm, despite or perhaps because of the wavy black uneven oblongs in
two of its three panels, but mainly because of its beautiful lavender
rings, which to me felt like dreamy echoes of Yoshihara's image.
There is something Japanese about it, with its loose arabesques and
drips coming down like the rain in a print by Hiroshige. No one
would know that *La Vie en Rose* was painted in 1979 to mark the end

of Mitchell's long relationship with Jean-Paul Riopelle. Mitchell, in a
film I saw recently, put it this way: He ran off "with the dogsitter."
The work expresses sadness, even grief, but also relief and a kind of
resignation. Her polyptychs are extraordinarily personal, despite their
scale and ambition, and often they are salutes to her peers. *Wet Orange*
feels like a belle epoque interior and pays tribute to the oranges and
blues Bonnard and Vuillard made their own. *No Birds* makes a wry
reference to Van Gogh's late painting of crows in a golden two-panel
cornfield, except—no birds. Instead the sky is clouded with blackish
sweeps of dark menace, and one does not have to be told that the artist
was going through terrible pain. I leave *La Grande Vallée* for you to
put in your own words.

There has not been this much wonderful painting on view all at
once for a very long time, and fascinating as art has been since the
time when painting was the great bearer of its history, one cannot but
be nostalgic walking these galleries, tracing this life through woods,
clearings, fields, vales, masses of flowers, wet skies.

September 16, 2002

The Art of 9/11: One Year Later

Recall that after Schubert's death, his brother cut some of Schubert's scores into small pieces, and gave each piece, consisting of a few bars, to his favorite pupils. And this act, as a sign of piety, is just as understandable as the different one of keeping the scores untouched, accessible to no one. And if Schubert's brother had burned the scores, that too would be understandable as an act of piety.
 —Ludwig Wittgenstein

Announcements have begun to come in of exhibitions of art dedicated to the memory of 9/11. One of them, called "Elegy," had a September 3 opening at the Viridian Gallery in Chelsea, and its card in particular caught my eye. It displays a photograph by someone named N'Cognita, which embodies a mood of elegy with a remarkable specificity. It is a view down an unmistakable but anonymous New York street, taken in sharp perspective, with the buildings, most of their details obliterated, silhouetted darkly against an orange and lavender sky. They are vintage tenements, of the kind we all know, with heavy cornices and water towers, and the melancholy of the image is heightened by the absence of towers at the end of the street.

"We" refers, of course, to New Yorkers, for whom the view of emptiness at the ends of streets and avenues has been the nagging reminder of what we had more or less taken for granted as always there. No one loved the towers as much as everyone misses them—but it was

not so much the erasure of the landmarks that tore at the heart as it was the inerasable memory of how they fell. That memory, however, belonged to the whole world, to viewers everywhere, who kept seeing, over and over, as in a nightmare, the planes, the black smoke, the flames, the falling bodies, unforgettable against the brilliant blue Manhattan sky. But it is the rubbed-out skyline, framed by the distinctive New York buildings, that is the constant reminder for those who lived the experience by being in New York when it happened and whose visual habits keep it vivid through being thwarted. I was recently in Berlin, and I was struck by how my friends there keep seeing the absence of the Wall, drawing my attention to blanknesses that I, as an outsider, would otherwise never see as such. Those blanknesses now define the soul of Berlin, as these define that of New York.

I somewhat resist the idea of the anniversary, but at the same time acknowledge a deep wisdom in the way an anniversary marks a symbolic ending. The art that belonged to the experience of September 11 now constitutes a body of work that differs from the art that will undertake to memorialize it. The difference in part is this: One need not have shared the experience to memorialize it. The Vietnam Veterans Memorial was designed by Maya Lin with supreme memorialist intuition, though she had no experience of the Vietnam conflict, having been too young when it tore the nation to bits, nor had she lost anyone who meant something to her in the war. But the art I have in mind could have come only from having experienced the event. Jan Scruggs, the infantryman who made it his mission to bring a Vietnam memorial into being, titled his book *To Heal a Nation*. That is what memorials should do, hateful as the events memorialized may be. That is the function of elegies as well. They use art as a means of transforming pain into beauty.

That already began, on September 11 itself, with the moving, extemporaneous shrines that appeared spontaneously all over New York, and became inseparable from the experience, so much so that, appropriate as they were at the time, it would be a bad idea to re-create one as a memorial, say in a vitrine. There is nothing about Maya Lin's masterpiece that itself belongs to the event, the way, say, a helicopter would, or a mortar that had actually been used there—

though the artist Robert Irwin once told me that sometimes a cannon on a lawn can be exactly the right solution, and I think I understand why. It is the grass that makes it right, which builds an image of peace into the emblem of war: "Green grows the grass on the infantry / at Malplaquet and Waterloo." I thought that artists could have done nothing better than the anonymous shrine makers, who knew intuitively that the shrines should consist in flags, flowers, candles, scraps of poetry or prayer, and photographs. But I have since thought about some of the things artists in fact did at the time, which came from the same impulse as the shrines—and this work has a certain interest through the ways it, like the shrines, caught something of the experience it responded to.

An artist I am close to wrote me, some weeks after the event, "I am fine, though it is hard to think about what kind of work to make at this point, other than decorative, escapist, or abstract. I suppose I'll explore one or all of these things." The work for which she is deservedly famous is so different from what it now occurred to her to explore, that it seemed clear to me that she was seeking something with the symbolic weight that the shrines had had, as signs and acts of what Wittgenstein speaks of as piety. A very deep piece of art history remains to be written about what New York artists did in those months when we thought or talked about nothing else, and the enormity of our shared experience flooded consciousness fully.

I single out "New York artists" mainly because I have the sense that the intensity of the experience depended very greatly upon whether one was here or elsewhere. A former student, at the time teaching in California, told me that he felt "impotent" in being away. He realized that so far as helping clear the rubble, search for bodies, bring in the supplies, he would have been redundant. The city had all the help it needed. But he felt, having lived and studied here for several years, that he had been injured in a way someone who was not a New Yorker had not been—and he felt the need to be here to share the grief. Not being here was internal to his impotence, if that makes sense, not that it would have made the slightest practical difference

whether he were here or not. And I think being here meant that this grief was palpable, that it was like something one breathed. One mark of that feeling was the way everyone became very considerate of everyone else, as if each of us was due a measure of moral sympathy. The kind of art that began to be made was another mark, special to the feeling.

Lucio Pozzi, a performance artist who really cannot properly be described quite that narrowly, tells how a European friend, who managed to get a call through, said, "At this point one cannot carry on making art." Pozzi answered, "Today I have painted a little watercolor, and I shall paint another one tomorrow." He had painted a copy in watercolor of a watercolor of his own, from a photograph of it in one of his catalogs. It is of yellow fields. He did this three times. On the following day, he stood outside his downtown studio and photographed the smoke as it lay in the street where his studio is located. He took several shots quite rapidly, just seconds apart, and turned the images into Xeroxes, which he stapled together into pamphlets, to be mailed to friends. Someone might have thought the pictures so alike that they could have been the same shot, reproduced ten or twelve times. I have seen such sets of images used in psychological experiments, mainly to demonstrate how pigeons, whose visual acuity is far sharper than ours, are able to distinguish between pictures that humans tell apart only with great difficulty. In my view, the images did two things: They showed what everyone downtown would have recognized as how their streets looked, and they did this with the zero degree of art. The other thing was to show how it felt to be there, engulfed in a cloud of sadness that would not lift.

I was struck by the fact that as with the photographs, Pozzi's watercolors looked alike. If I were to curate a show about how New York artists responded to 9/11, I would certainly include his series of photographs, and all three copies of the watercolor. And I would include several watercolors by Audrey Flack, who felt the despair of impotence my student spoke of and went out to Montauk to paint the sunlight on fishing boats. Audrey does monumental sculptures. I have greatly admired her immense figures of powerful females, for the feminist symbolism, of course, but also for their masterful execution.

She had been at work on a new colossus, intended to stand in the water off Queens. It was to have been of Queen Catherine of Braganza, after whom the borough of Queens was named. It was a brilliant concept, brilliantly executed, and Audrey modeled two airplanes, one for each of Catherine's pockets, standing for the borough's two airports. The reason the work was never completed belongs to the unedifying story of racial politics, but I mention her colossi here for the vivid contrast they point to between her sculptural ambitions and the water-and-sunlight aquarelles that met her needs after the terrible event. They are not in the least monumental. They are daringly ordinary, like skillful enough paintings by a conventional watercolorist, with nothing on her mind except to register how the world looked. The real world needed to be affirmed, and these are perfect examples for the art history of 9/11.

Had Queen Catherine stood, like the Statue of Liberty, when 9/11 took place, the two airplanes would certainly have been read as portents. But I cannot imagine airplanes in my 9/11 show. Tom Kotek, a graduate student in fine arts at Hunter College, told me how he and some fellow students visited an art school somewhere in New England not long after the event. They saw a work consisting of some cardboard towers and a toy plastic airplane. Wittgenstein tells of ways of expressing grief symbolically that we all understand and accept, even if it would not have occurred to us to do things that way. But there are certainly ways that would strike us as wrong or odd. Kotek and his friends thought that the installation they saw was not at all like something they would have made, having been in New York when it happened and still tasting the grief. In fact, none of them had yet done anything they would consider 9/11 art and weren't sure they would. There was nothing exactly wrong about the little plastic-and-paper crash site. It was the kind of thing that might naturally have occurred to artists who had not been in New York and were given an assignment. But genuine 9/11 art, as my examples suggest, had to find ways of embodying the feeling rather than depicting the event, and is inevitably oblique. An artist I spoke to who happened to have been in Australia on 9/11 showed a drawing she had done of the Sydney Opera House. Her thought was that the terrorists would have taken

out the most important building in whatever city they struck. So
the Sydney Opera House symbolized the World Trade Center towers,
like a substitution in the language of a dream. But I cannot imagine a
9/11 New York artist drawing the great opera house as a way of con-
veying what it felt like to have lived through the event.

I have been gathering ideas for my imagined 9/11 show and asking
artists whether they have done anything in particular that might be
included if I were to have gone forward with it. Here are a few more
examples of what I consider true 9/11 art.

I spoke with Robert Zakanitch a week or so after 9/11, and he told
me he was painting lace. Zakanitch had made his first reputation as an
Abstract Expressionist, but like so many, including Audrey Flack, felt
that he wanted to produce something more meaningful, having to do
with life. He became part of a movement in the late 1970s called Pat-
tern and Decoration—"P and D"—which attracted a number of
artists disaffected with mainstream art. A few years ago, he created an
ensemble of huge paintings called *Big Bungalow Suite*. The title refers
to the wallpaper and slipcover designs of his *Mitteleuropa* grand-
mother's house in New Jersey, where his family worked in factories.
He associated that profusion of decorative motifs with the comforting
femininity present in what was a sanctuary for him. Lace made a lot
of sense, given this background, even if he might have painted lace if
9/11 had not happened. But it had a particular meaning for him be-
cause 9/11 *had* happened.

The sculptor Ursula von Rydingsvard was born to peasant parents
in a labor camp in Germany, and her work is an effort to create a
world she never really knew. Her immense wooden sculptures refer
to a primitive form of life in primordial worlds. One of her main
forms is that of the bowl—she did a huge bowl for her last show at the
Neuberger Museum, in Purchase, New York, which was eighteen feet
across. The bowls are made of milled cedar beams, stacked, glued,
and shaped with power tools. They feel as if they were made with gi-
ants in mind. Interestingly, von Rydingsvard sometimes carves lace.
But her first work after 9/11 was a crisscross, fencelike structure that

she titled *mama, build me a fence!* A fence, like lace, is, as Wittgenstein would say, understandable.

The idea of an edge or a boundary also suggested itself to Mary Miss, whose studio is situated just north of Ground Zero. Miss is sometimes referred to as a "land artist," and her work is public through and through. Her most recent installation is a kind of "acupunctural" transformation of the Union Square subway station: Various points and fixtures throughout the space have been neatly painted a uniform red. She and her assistants conceived the idea of a "moving perimeter" around Ground Zero, which would in the course of the work take on the form of a wreath—and indeed the title of the piece is *A Wreath for Ground Zero*. It would have the form of a figure eight, with reference to the two linked areas where the towers stood, or of the infinity sign, symbolizing the "endless knot" of mourners. The "wreath" would allow visual access to the site as the rebuilding took place, and it would also "make a place for the flowers, flags, candles and notes that have appeared throughout the city." Miss's idea got the backing of various public arts agencies but inevitably ran into resistance with the bureaucracy and business interests of the city. One bureaucrat rudely asked who the hell she thought she was, coming forward like that when there were so many who had just as great a right as she. Her response was that everyone should be called to come forward with their ideas. Nothing immediate came of her project, but on her Web page she has issued a call for ideas, in a way modeled on the shrines that appeared everywhere, for memorial sites throughout the city, recognizing that New York as a whole was and is a mourning site. We should all be memorial artists.

I would certainly want to include in my exhibition an example of a post-9/11 shrine (attributing it, perhaps, to N'Onymous). But I might also include some art that somehow belongs to the experience, but only, in a way, after the fact. Let me explain. There is an artist-in-residence program sponsored by the Lower Manhattan Cultural Council, which had used the ninety-second floor in Tower One as studio space. The artists, whose work had been destroyed (and one of

whom was killed), were given a chance to show their work at a special exhibition given by the New Museum of Contemporary Art after 9/11. I had the sense that many of them were in a way continuing what they had been doing during their residency, which is certainly the sort of thing many New York artists did, however deeply affected they were by the circumstances. A lot of the best artists I know would either have continued along their trajectories or simply stopped working. As part of his residency in 1999, however, Stephen Vitiello, impressed by the silence within the tower in contrast to the vitality of the city outside, placed two contact microphones against the glass to record external sounds. He called these "World Trade Center Recordings," and one of them, *Winds After Hurricane Floyd, 1999–2001*, was included in the Whitney Biennial of 2002. It became a very affecting work, in part because of the metaphor that powerful and destructive winds generate, in part because of the fact that no such sounds will ever again be made. And in part because the sounds are the noises of a building far more vulnerable than it looked, or than the interior silences due to the thick glass walls would have led one to suppose. Like all the 9/11 art in my imagined exhibition, it tells us something profound about art, and about ourselves.

I have not made an especially systematic effort to track down further examples of 9/11 art. I really lack the curatorial impulse. And it would be a very strange exhibition were it all brought together, since the work would have very little in common other than the experience that occasioned it. I don't think 9/11 art will stop being made just because the anniversary is at hand. Who knows when an experience will need to be expressed in art? But because of the conditions on its authenticity, it will differ from memorial art, which must be public and take on the responsibility of putting the event at a distance, and must negotiate the controversies such memorials generate. The 9/11 art was private and personal, and dealt with the mitigation of grief.

September 23, 2002

Reflections on Robert Mangold's
Curled Figure and Column Paintings

once saw a film in which Henri Matisse was shown in his garden, drawing some large, deeply lobed leaves. The drawings were made swiftly and simply, and the effect was that of watching someone with the command over his hand that a great skater has over her body, executing some intricate figure in a single graceful sweep. The film then repeated the episode in slow-motion photography, and what at normal speed looked unhesitating and confident was revealed as a sequence of separate hesitations and decisions, too rapid to be registered by either consciousness or perception. The drawings themselves showed nothing of this history of trials and probings—they looked as graceful and certain as the gesture of making them when normally perceived. Were it not for the slowed camera, we would have no knowledge of how many tiny decisions—how many tiny *actions*—were performed in what outwardly appeared to be a single flowing act of drawing. And the latter, like consciousness itself, which does not, as William James famously declared, "appear to itself chopped into bits," in fact has the discontinuity of a bird's existence: "an alternation of flights and perches."

The stunning scrolling curves that Robert Mangold designates "curled figures" exist on a heroic scale by comparison with Matisse's leaves, which were drawn on a pad of paper he could easily hold with one hand while he drew with the other. Mangold's curled figures, by contrast, span large, multipaneled canvases and seem to imply the coordination of the artist's whole body in a feat of strength and virtuos-

ity, executing what appears at a normal distance from the canvas to be a perfect arabesque in a single draftsmanly act. The curled figures are compound spirals, which we read as unwinding from left to right, and we naturally infer that they must have been drawn from left to right as well, since we write in the same direction that we read. I want to describe the spirals somewhat closely, and in relationship to the space in which they are sited, since the points through which they unfurl have been plotted with the precision of a master shot in billiards. That alone should make us suspect of our first impression that they were drawn with a single flourish.

In *Curled Figure XXII*, the figure occupies four square panels. There are (so far) two versions of this work, which vary only in background color, orange in one version and a warm gray green in the other. I am mainly concerned with the figure itself and its relationship to the edges of the space it so gracefully fills. The figure resembles what is known as an Euler spiral, named after the Swiss mathematician who first studied it in 1744. It is an involuted curve—a curve traced as if by a point at the end of thread kept taut as it is unwound. It is important to realize that Mangold drew these figures without mechanical aids, in a procedure that depends entirely upon the coordination of hand and eye. But the relationship of the curve to the space, and especially to the edges, is so carefully thought out that it would be something of a miracle if the figure were drawn, say, with Matisse's élan. The spiral begins at a point midway across the left panel and about a third of the way up from the bottom edge. As it unwinds, it touches the edges of that panel at three points—bottom edge, left edge, and top edge—before describing a serpentine path across the two middle panels, finally curling to a point midway across the right-hand panel and about a third of the way down from the top edge, after touching the edges of that panel at three corresponding points— top edge, right edge, bottom edge. The six points at which the curve touches—or nearly touches—the edges of the panels define the relationship between curve and its containing space, and the exactitude of its unwinding from point to point is integral to our experience of the work.

When we move closer to the canvas, however, we realize that, far

from having been drawn with a single winding and rewinding ges-
ture, the drawing of the spiral shows the same history of "flights and
perches" that Matisse's drawing does when it is viewed in slow mo-
tion. What at normal viewing distance is a perfect spiral is at close dis-
tance a path marked by little decisions and revisions, changes in
direction and velocity, almost as if it were a drawing by Rembrandt
where the search for the edge were as important as the edge itself, or
where it is impossible to identify what belongs to the boundary from
the search for where it is located. The comparison is overstated. To
study a drawing by Rembrandt is always to be conscious of the way a
figure emerges through the search for it. In Mangold's drawing, we
become conscious of the search at a near distance, but it vanishes from
consciousness as we stand far enough away from the canvas to see the
whole curve evenly unwinding from left to right, filling the entire ex-
panse of the canvas, touching the edges at precisely the six points. Far
and near are, as it were, like the two speeds at which we see the act of
drawing in the film of Matisse. From a far distance, the whole figure
has the inevitability of something made flawless and predictable by
practice and disciplined reflexes. From a near distance, we see the
"flights and perches" the trained hand makes as it feels its way from
point to point. The concept of a spiral has no room, so to speak, for the
imprecision and hesitation of the human hand. But it belongs to these
works that the figures be understood as having been *drawn* by hand.

It is Mangold's intention that these works exist on the boundary
between drawing and painting, which means that the curled figure
somehow retains its identity as something hand drawn. This, I think,
is the function of those signs of seeking—the intermittencies of
searching—as the pencil feels its way toward the exact gradients of
the curve. Only when the form has been found—when the drawing is
done and the figure has been executed to the eye's satisfaction—does
the painting begin. The color is laid down in a thin coat by means of a
small roller and carried to the edges of the figure. It is crucial that it be
a thin coat, in order not to obliterate the history of the drawing. One
can see the marks of the search through the paint, as in a palimpsest.
Or one can if one stands close to the surface. From a distance one sees
just the handsome curve in a field of color, much in the way, when one

sees Matisse drawing at normal speed, one sees the crayon execute an outline without any sign of hesitation. It is as if each of the curled figures is seen as a drawing at close range but a painting at normal viewing distance. The use of the roller enables the artist to deposit the color without calling attention to the act of painting. The entire achievement is an exercise in veiled bravura.

Euler could not have studied the spiral that bears his name without the previous invention of analytical geometry, which means that the curve is the graph of an algebraic equation. It is a fair conjecture, I think, that Mangold did not compute the loci of the points that define his curve, any more than spiders do in the webs that display curves very like Euler's spiral or, for the matter, than the chambered nautilus, the coils of whose shell exemplify it perfectly. The spiral is found in certain flowers, but it is probably because of its presence in spiderwebs that it came to be called a clothoidal curve, after Clotho, one of the three Fates of ancient mythology. It is Clotho who spins the thread of our life to a certain length, determined by her sister Lachesis, at which point it is cut by the third Fate, Atropos. A spiral is thought of as a curve that unwinds around a point while moving farther and farther away until, as in Euler's spiral, it winds back around a second point. And to make a final reference, the curled figures are scrolls—written texts that are wound and rewound about spindles, with only part of the text exposed at any given time. The curled figures, for me, are visual metaphors for narratives—the left-hand spiral the beginning, the right-hand spiral the ending. Once one starts looking for them, clothoidal spirals are everywhere. They are optimal for constructing curves in highways. They reappear as S curves in Rococo ornamentation, along with the C curves of *Curled Figure XIV*. What I always admire in Mangold's paintings is the way one starts with trying to get the geometry right but then finds oneself thinking about the relationship of the hand to the forms, and then goes on to pick up human associations the more we think about them. Drawing, spinning, winding, rolling, and reading are cognate activities that imply beginnings and endings and actual durations. The "curled figures" thus are not simply forms that we take in all at once. We read them like texts.

The contrast between the essentially horizontal *Curled Figure* and

the narrow and starkly vertical *Column Paintings* could not be more vivid. The use of the word "column" has an art-historical reference, primarily through their images, to the *Endless Column* of Brancusi, which has, as form, no internally determined terminus. That is what endlessness means, after all—the figures, made up of regularly repeated pulses, can be indefinitely protracted in either direction. It is an endless *column*, however, through its vertical orientation: The pulses ascend skyward. Freestanding columns—Trajan's Column, for example, the Vendôme Column, or the Wellington Monument—carry the eye irresistibly upward.

Endlessness evokes infinity, and by a natural association the first of the *Column Paintings* has two of the familiar double-looped infinity symbols atop one another as in a mathematical totem pole. The curves touch or nearly touch the edges of the space at ten contact points. Notwithstanding the imperatives of composition, however, endlessness is not something that can be contained in a finite space, so however well the doubled infinite symbol is suited to its space, the image is cut off at the upper and lower edges, since it could go on and on in both vertical directions. It does not belong to the nature of an endlessly repeated image to relate internally to the edges of a space at all. The linear representation of heartbeat in an electrocardiogram has no internal relationship to the edges of the monitor, which merely shows a segment of the heart's pulsations. Brancusi's endless columns do in fact terminate, but their ending where they do is a matter of external and arbitrary decision.

The point is made visible in the other two *Column Paintings* here on view. *Column Painting #2* has two sine waves, one the trigonometric mirror image of the other, which intersect along a vertical axis (one is solid and the other hollow). They execute a kind of dance, and though Mangold had characteristically fitted them to the edges of the space, they could go on crossing one another's path to any distance. And similarly with *Column Painting #3*, in which the waves have different amplitudes. One of them owns the lateral edges, the other owns the center, and they relate like male and female dancers, the latter whirling around the former. But the dance can continue indefinitely. Mangold has made the *Column Paintings* about twice the height of a

normal human, so eye level falls about midway between top and bottom. This gives them a certain human scale as objects, but the images imply an eternal ascent.

The only painting culture I can think of that uses the vertical format is the Chinese, with its wall scrolls of landscapes and clouds, cascades and abysses, confined within narrow spaces. I am suddenly interested in discovering where in that space the Chinese master of the tall landscape begins what I imagine as the downward journey of his brush. Chinese writing goes from top to bottom, and one imagines that Chinese painting must go that way as well. In the *Column Paintings*, the curves seem to rise rather than descend—their direction is up, implying, for what it is worth, something about the differences between spirit and matter.

A while ago, I asked Mangold whether 9/11 had had any impact on his art. I had been collecting examples of artists whose work showed the effect of that experience. Mangold felt that while he of course had been affected, he doubted whether his work had, or even whether his work could be. Yet I cannot help but wonder if these are less column paintings than *tower* paintings—whether they are not really New York paintings, slim, elegant, and vertical, and animated by imagery that implies no limit, even if it can be cut off by the Fates.

December 2003

The Park Avenue Cubists

The Grey Art Gallery, which occupies the former site of the Museum of Living Art in the main building of New York University on Washington Square, is celebrating its legendary predecessor with an exhibition of work by the so-called Park Avenue Cubists, who embody the spirit of Modernism for which the earlier museum stood. The very conception of a "museum for living art" must have sounded discordant in 1927, when the institution was founded by Albert Eugene Gallatin, himself one of the "indivisible four" Park Avenue Cubists, as they were called, somewhat resentfully, by fellow members of the American Abstract Artists. There had of course been galleries given over to modern and contemporary art, but the concept of a museum implied that its holdings belonged to the past. Gallatin's collection of "living art" was selected to express the same present to which his museum belonged, and those with an appetite for modernity could for the first time in New York experience the advanced art of their time in a museum setting: Picasso's *Three Musicians*, Mondrian's *Composition in Blue and Yellow*, as well as work by Arp, Léger, Miró, Braque, and other Modernists, and ultimately the work of the Park Avenue Cubists themselves. Their paintings were executed to be perceived as living art, and it is that dimension of their self-aware contemporaneity that still conveys a certain excitement. Part of what defines modern art is the fact that it was created for persons who conceived of themselves as modern, the art contributing to that identity through the fact of its difference from the art of the past.

The NYU art historian Robert Rosenblum visited the Gallatin Collection when he was a boy, and I find his recollection particularly affecting. "Here was the future in flat planes and clean colors, with lucid arcs and angles replacing old-fashioned realist imagery, and all laws of gravity repealed in favor of the aerial freedom appropriate to the new century of speed and flight." What is moving about the art of the Park Avenue Cubists is that it belonged to the dark reality of the Depression by expressing the same bright dream of the future that the 1939 New York World's Fair conveyed. The design language of the World's Fair was "modernistic," to use a term of the time, and though there was no gallery of Modernist art in the visionary city erected in Flushing Meadows, the fair's famous emblem—the Trylon and Perisphere—monumentalized forms from the vocabulary of Modernistic painting. The World's Fair complex of buildings and avenues was intended to be the future made present, and its visitors left their bleak world behind when they passed through its gates. It was a future in which everything, even domestic appliances, looked as if it were in a state of infinite velocity. Very little "living art" actually figured in the fair's iconography, though one of its most popular emblems was a sculpture by Joseph Renier called *Speed*, representing a kind of aerodynamic horse with the streamlined look of a Futurist radiator ornament on a colossal scale. The paintings of the Park Avenue Cubists by rights belonged on the walls of the Home of Tomorrow, even if they were still lifes. They embody the fair's optimism, which is why they still manage to lift the spirits, though they belong to what the historian Reinhart Koselleck calls a *vergangene Zukunft*—a future that belongs to the past.

In their own time they were felt to belong to a past that *was* past. Their work was criticized as "derivative." So much of contemporary art since the 1960s has been taken up with the appropriation of past forms that we are far less concerned with repetition than the 1930s or '40s were, when the Park Avenue Cubists had to defend their originality. One of their number, George L. K. Morris, argued wittily enough that it is "as though a Sixteenth Century critic, after examining a fresco of Raphael, could think of nothing to say but that he detected the influence of Perugino." But obviously something more was

at issue than influence. Cubism was really more like a language than a style, and from the moment that it began to shard forms into arrangements of "lucid arcs and angles," it became one of the chief dialects of modern art, and it means Modernism whenever one sees it. Even so, it underwent stylistic changes. A 1908 review described Braque as having "reduced everything, sites and figures and houses, to geometrical schemata—to cubes." But early Cubist colors were drab and neutral—ochers and grays—by contrast with the pure, slangy colors of Park Avenue Cubism. And its forms look like slabs of clay by contrast with the latter's urbanity, which reflected the svelte architectures of Manhattan. Duchamp got into hot water with his fellow Cubists in 1913 when he tried to depict movement in *Nude Descending a Staircase*, probably because their rivals, the Futurists, made movement and speed the substance of their contribution. But Futurism was in effect Cubism with whiz lines and nested angles or curves to show "speed and flight." Morris's paintings feel as if he was trying to depict the images left on the retina by the way the eye performs saccades from point to point of the visual field. The wheel segments in his 1935 *New England Church* imply that one is riding past a church that one has to synthesize in order to recover its identity. The rest of the painting shows syncopated glimpses of a church through fragments of its architectural parts, distributed across the canvas. Instead of reconstructing the visual world, as the classical Cubists did, he is trying to show the process through which we construct the world visually and cinematically. His paintings, like those of his wife, Suzy Frelinghuysen, are like colorful diagrams of vigorous eye movements. What could have been more "living"?

In his catalog essay for the 1939 exhibition of the American Abstract Artists—an organization that he helped found—Morris wrote that "it is on its quality that an abstract work must stand, yet people persist in looking for everything except quality." The paintings on view at the Grey Gallery look better than they could have when they were first shown, just because so much of the ideology that defined the atmosphere of their art world has vanished, and we are able to look at the work without the prejudices that impeded its reception in its own era. Before World War II, for example, it was an a priori attitude that

simply by virtue of being American, their painting would have to be inferior. It was widely accepted that European painting in its nature was superior to anything American painters were capable of, almost as if just being an American meant that one was culturally disabled. Alfred Barr, the celebrated director of the Museum of Modern Art, which opened two years after the Museum of Living Art, was candid in saying that he had no interest in American art. The Park Avenue Cubists were disappointed that only one American—Alexander Calder—was included in MoMA's 1936 exhibition "Cubism and Abstract Art." The official reason was that it was the responsibility of the Whitney to show American art, but when the Whitney had mounted a show of abstract work by Americans in 1935, Morris complained that it was simply halfhearted: The art selected might well have confirmed the prejudice that Americans were just not up to the level of European Modernists. Robert Motherwell was still bitter about this years later. In an interview with Paul Cummings in 1971, he said, "The position in the 1930s and 1940s was that if you were a modern artist and any good, you were by definition a European . . . It was like wine. If wine is any good, it's French. Or if cooking is any good, it's French. It's inconceivable that an American can make a masterpiece." Against this wall of Eurocentrism, it meant much to American artists that the Museum of Living Art showed their work alongside the Europeans'.

There was, moreover, an overall prejudice against abstract art as such in the thirties. This came from three directions: regionalism, Socialist Realism, and the art establishment. The regionalists declared abstraction to be European and accordingly irrelevant to American life. Artists like Thomas Hart Benton or Grant Wood took it as their duty, so to speak, to paint America first. Socialist Realism was the pictorial language of class struggle. Artists should see themselves as "cultural workers" and make art with which working people could identify. They should be represented in overalls and cloth caps, creating surplus value by manipulating heavy machinery or driving tractors. Abstract art, if not unpatriotic, was counterrevolutionary. So the Park Avenue Cubists found themselves the target of artistic imperatives to paint America—since they were Americans—or to join forces

with the working class if their art was to have any relevance. Finally, the art establishment itself was hostile to abstraction, which it saw as decorative at its best. Despite being eulogized in her recent obituaries as a staunch supporter of avant-garde art, the newspaper critic Emily Genauer was an unrelenting opponent of abstraction. Writing for the *World-Telegram*, she dismissed the paintings of Mondrian and Moholy-Nagy as "so many simple commonplace patterns for bathroom tiles."

A gainst the background of the fierce polemics of 1930s art discourse, one can sense the defiance in the very wording of the title given to the organization the Park Avenue Cubists helped found to promote the art in which they believed—"American Abstract Artists." And one can see why Morris felt it important to distribute a questionnaire to those who visited its first exhibition in 1936, to see what "the people" actually thought about abstraction. He took great satisfaction in the results, which showed, in the words he quotes from *The New York Times*, that "in view of the fact that the official spokesmen for art have consistently preached against abstract art as 'un-American' the results of this inquiry show that the American public is far more interested, and would like to see more of it, than any one had hitherto suspected." But *Times* critic Edward Allen Jewell remained unrelentingly hostile to abstraction throughout his tenure.

Beyond that, calling them "Park Avenue Cubists" must have been an expression of *ressentiment*, even among their allies in the American Abstract Artists: It was a way of writing them off because of their wealth and social standing. They all had impressive pedigrees. Gallatin's great-grandfather was the United States treasurer under Jefferson and Madison, as well as an ambassador to France and England—and he founded New York University because, according to the show's curator, Debra Bricker Balken, he believed Columbia to be too Calvinist. Morris was descended from one of the signatories of the Declaration of Independence and was the first art critic for *Partisan Review*, which he supported financially when its editors broke with the John Reed Society and began turning it into America's lead-

ing intellectual and literary journal. Frelinghuysen came from a patri-
cian Dutch family in New Jersey—her grandfather had been secre-
tary of state under Chester Arthur—and she enjoyed successful
careers both as an opera singer and a painter. She sang the role of Ari-
adne in *Ariadne auf Naxos* to rave reviews and was selected by a jury
that included Marcel Duchamp, Max Ernst, and André Breton for in-
clusion in "31 Women" at Peggy Guggenheim's Art of This Century
gallery in 1943. Charles Shaw was a socialite and a man-about-town.
Clearly they were a classy bunch. Morris designed a Modernistic
house for himself and Frelinghuysen to paint in when they left their
penthouse for the summer. They traveled back and forth to Europe,
and of course Gallatin collected modern art. Even if it weren't the De-
pression, their charmed lives would have made it easy for their work
to be dismissed as elitist—still a powerful epithet in critical politics.

These were the things that stood in the way of appreciating the art
of the Park Avenue Cubists in their time. Most of the ideology that
bedeviled them has lost its power to intimidate. The School of Paris
declined precipitously after World War II, so being American stopped
being a cultural stigma. New York really did become the capital of
world art. Abstraction has become a genre, like portraiture and land-
scape, as can be seen in the oeuvre of Gerhard Richter, and the conflict
between it and "the figure" has become irrelevant, since painters of all
persuasions have drawn closer to one another under the radical charge
that painting as such is dead. Artists in Eastern Europe who were
tyrannized by the imperatives of Socialist Realism have all become
Postmodernists in the 1980s and have found their way into the inter-
national art world. There is always a certain *ressentiment* against priv-
ilege, but it is hard to think of a group of artists quite as elite as
Gallatin, Morris, Frelinghuysen, and Shaw when they were in their
prime.

What chiefly stands between us and their work today is something
they could not have defended themselves against, since it lay in their
actual future, namely, the emergence of the New York School, with its
daunting artistic achievements. I have the most vivid recollection of
seeing an exhibition of abstract painting at the Museum of Modern
Art in the 1950s and wondering why I should take seriously the

brightly painted pictures of circles and bars and squiggles when, moving dutifully along the wall of a gallery, I came suddenly upon Jackson Pollock's painting *The She-Wolf* and was knocked off my horse. I saw immediately that abstraction was capable of an undreamt-of greatness that nothing I had ever seen in the exhibitions of American Abstract Artists at the Riverside Museum so much as hinted at. In the light of Rothko, Kline, Newman, de Kooning, and Pollock, it would have been easy to concur with the judgment stated by Robert Lubar, one of the authors of the Grey Gallery catalog, that the Park Avenue Cubists are "little more than a quaint reminder of tentative and failed initiatives in the struggle to transplant the lessons of European modernism to American soil." If there is a criticism to be made of the Park Avenue Cubists, it is that they seemed content, to use Morris's phrases, to work at solidly grounding "the traditions of the future" and "the endless problems of form in design." They lacked the larger visions of their tremendous successors.

Notwithstanding all that, the work today looks marvelous—"delicious" is really the word—when we see it hung together where the masterpieces assembled by Albert Gallatin were once shown, and the show is an absolute treat in these bleak times. This is the first time in more than sixty years that all four artists have been shown just with one another, and I was impressed with the amount of pleasure the work evoked in the dense crowd that showed up at the opening. The jazzy, shaped canvases of Charles Shaw show that Manhattan and Cubism were made for each other. Gallatin, who took up painting at the age of fifty-five, turns out to have been the strongest of the four. But they are all worth thinking about. Now that history has wiped the ideological fingerprints from our glasses, we can enjoy the art as it could never have been enjoyed before. It restores, to be sure, a piece of American art history. But Gallatin's intention was that the art in his space should be living art—and what Debra Bricker Balken and the Grey Art Gallery have done is to bring the art back to life. That should be the goal of all art museums everywhere.

May 3, 2003

Leonardo's Drawings

In 1906 the French savant Pierre Duhem published a three-volume work on Leonardo as scientist under the innocuous title *Études sur Léonard de Vinci*. It was the work's subtitle that struck a note of novelty: *Ceux qu'il a lus et ceux qui l'ont lu* (Those he read and those who read him). Leonardo, then as now, was celebrated as an artist, an inventor, an engineer, a universal wizard, and, to appropriate the title of the current exhibition at the Metropolitan Museum of Art, a master draftsman. One would take it for granted that he was literate, but how interesting could it be to know what his reading list was, or on whose list of required reading his writings appeared? Duhem's book, however, was really a profound contribution to the history of science. It analyzed Leonardo's debts to medieval scientists like John Buridan, Albert of Saxony, and Nicolas Oresme, and then went on to the scientific impact of Leonardo's writings on subsequent investigators. It was no part of Duhem's intention to diminish Leonardo's originality as a scientist but rather to redeem the Middle Ages as a chapter in the history of scientific thought. It had been a historical commonplace to view the long interval between Archimedes and Galileo as a period of unrelieved ignorance and superstition. Duhem, a distinguished physicist and a great philosopher of science, was also a believing Catholic, and it was his aim to prove that Catholicism had played an importantly supportive role in the development of knowledge. He showed that Leonardo was carrying forward programs of research in mathematics, mechanics, and biological science that had a long and remark-

able medieval development. And he demonstrated that Leonardo, far from jotting down his observations on whatever came along, had a systematic scientific agenda that bears comparison with that of such later thinkers as Descartes, and that his various treatises contributed to research carried on well after his death.

The rebirth implied by the concept of the Renaissance had reference to classical learning. It was more or less self-promotion that demanded an interval of darkness between the fall of Rome and the rebirth of its culture in Tuscany. What Duhem established was that Leonardo mediated between the great investigators of the medieval period and those who were to come after him. And to a very large extent, one can construct a Duhemian picture of Leonardo's place in the history of art—a parallel narrative that shows that even where Leonardo was most original, he was also in effect in conversation with his predecessors, and his successors in conversation with him. Like Duhem's, this would not have the aim of diminishing his achievement as an artist but, since art comes from art as much as science comes from science, explaining it historically. Indeed, the Met's exhibition has exactly this format. One could almost paraphrase Duhem's subtitle: *Ceux qu'il a vus, et ceux qui l'ont vu.* The show begins with those whom Leonardo learned from and ends with those who learned from him.

There is little doubt that it is valuable to situate Leonardo in the history of art in this way. Consider the article on Leonardo in the celebrated eleventh edition of the *Encyclopædia Britannica*, by then–Slade Professor of Fine Arts at Cambridge, Sidney Colvin. "By his own instincts he was an exclusive student of nature . . . He was the first painter to recognize the play of light and shade as among the most significant and attractive of the world's appearances." But just as many of Leonardo's observations were intended to confirm ideas he acquired from Albert of Saxony and others, the "play of light and shade" that he made his own was taught him by Andrea del Verrocchio, to whom he was apprenticed. So it is entirely appropriate that the exhibition begin with a drawing of Verrocchio's, which shows that sfumato—a technique for depicting the way light and dark softly and almost indiscernibly grade into each other, convey the roundedness of a form—

was already a matter of studio practice when Leonardo was in his teens. It was thus not something he learned by studying nature but that he acquired from his master. It could be true that the way it was used by Leonardo stamped him as a pupil of Verrocchio. But sfumato was not a workshop mannerism—it was a discovery, like perspective. It was a way of showing the shape in three dimensions of volumes through light and shadow, just as perspective is a way of showing how objects recede in space. The decision to present things in these terms was one of the marks of the Renaissance. To show things the way the eye sees them defined the artistic culture in which Leonardo worked. But it is not a matter of culture that the eye sees the world the way it does. That, as we say, is hardwired. Because it was a cultural agenda to "conquer appearance," the history of art in the Renaissance is like the history of science when viewed as a progress. "In early modern Europe," the philosophical historian of science Thomas Kuhn wrote, "painting was regarded as the cumulative discipline." That medieval art did not conform to this agenda was counted by Renaissance writers like Vasari as palpable evidence that it belonged to the Dark Ages.

Instructive as it is to weaken the myth that Leonardo was the first artist to see nature as it looks, a certain price is paid. It is, we might say, unfair at once to Verrocchio and to us to see his magnificent drawing as a paradigm from which Leonardo learned the art of chiaroscuro. Verrocchio's drawing is of a young woman, shown at bust length, facing to the left. It is, to use an unfashionable word, a beautiful drawing of a beautiful woman, so much so that it is hard to tear one's eyes away from it and from her. The drawing is done in charcoal or in black chalk, and with a tenderness that matches the tenderness that it shows. The word "sfumato" derives from the word for smoke, and the areas of gray look as if they were breathed onto the woman's cheek and neck. There is a firmness in the drawing of the underlip and in tracing the curve of the chin until it fades into shadow. There is a delicacy and certitude in forming the curls that define the ornamental hairdo and the diaphanousness of the woman's garment. It would be worth dwelling on Verrocchio's famous draw-

ing, even had the Met borrowed it from Christ Church, Oxford, and displayed it in a gallery by itself, just to provide pleasure to its viewers without using it to teach anything whatsoever.

But it could also be used to teach a stronger and more difficult lesson by displaying it alongside what the catalog describes as Leonardo's "hauntingly beautiful" drawing of the head of the Virgin, which is also in the present show. Next to Leonardo's drawing, Verrocchio's looks almost abstract and schematic. Still, there is nothing that belongs to the progressive history of Renaissance drawing that Leonardo did not find in Verrocchio, though one might say that in it he has perfected the art of sfumato. On the other hand, there is something magical in the way Leonardo evoked the Virgin's head out of marks and smudges. And beyond that, Leonardo has imbued her with an expression of love and meditation. She is looking at something and is feeling something powerful about what she sees. Her smile is gentle. My sense is that those who look at her for very long will insensibly reproduce her expression on their own faces. Verrocchio's work could be used to teach the meaning of what great drawing is. Leonardo's could teach the meaning of great art. How he does it defies analysis, but it goes beyond being a master draftsman.

As it happens, we know a great deal about what the Virgin is looking at, since the head is a preparatory study for one of Leonardo's most mysterious paintings—the *Virgin and Child with Saint Anne*, in the Louvre. The Virgin is sitting on Saint Anne's knee, and the Child, holding a lamb, looks back over his shoulder at her from between her knees. Saint Anne looks at the Virgin looking at the Child; the Virgin holds the Child as the Child holds the lamb. The scene is set in a strange rocky landscape. The arrangement of the figures is like a mystical knot. I can appreciate that the Louvre would be unwilling to lend the painting under any circumstances, but it would be worth having a reproduction of it near the drawing, so that we could see what the object and meaning of the Virgin's look is. In another of the sketches for the *Virgin and Child with Saint Anne*, on loan from the British Museum, the figures are clotted together in a tangle of lines and washes. Saint Anne is an older woman, and the Virgin looks at her. They are given a sort of frame, to give Leonardo a sense of how they might fill

a panel later on. It is a dense, vigorous drawing, but it is also a path not taken—something we would not know from the drawing seen on its own.

Many of the drawings in the show refer to known works, and viewers might achieve a deeper understanding of Leonardo's creative processes by seeing the drawings as stages in a process and not simply on their own terms. There is, for example, an exceedingly energetic study for the Uffizi's *Adoration of the Magi*, a work so strange that it could be the transcription of a dream. The painting, in yellow ocher and brown ink, is so close to a drawing in its own right that scholars have wondered whether it is finished or not. In it, the Virgin and Child are in space of their own, surrounded by a crowd of adorers, astounded by the wonder of the event. The Child reaches out to accept a gift from a kneeling magus with one hand, while his other hand is raised as if he were making a talmudic point. In the piazza behind the company, horsemen rear wildly in front of a visionary ruin with a double staircase. Things are a great deal more confused in the drawing we are shown at the Met, where adorers invade the Virgin's space. In the painting, the architecture has been clarified. One still has to interpret what connection there is between the horsemen and the holy pair. No one in the history of art drew horses with the truth and passion of Leonardo. They gallop through the entire show, and one cannot help but wonder what Eadweard Muybridge thought he could discover by his battery of cameras set up to photograph a horse at gallop that he could not better learn from Leonardo's drawings. Horses do not pause in midcharge to pose for an artist. In some way Leonardo had stored a complete knowledge of how horses look from every angle and in every gait, with or without riders, and could transcribe that knowledge as easily as we write our names.

Horses figure centrally in two works we cannot, alas, compare with their preparatory drawings in the show, since they were never completed: Leonardo's career was punctuated with aborted masterpieces. One was the great equestrian monument to Francesco Sforza, commissioned by his son Ludovico. Leonardo worked on this colossal

sculpture on and off for about sixteen years. A contemporary writer described it as "the most gigantic, stupendous and glorious work ever made by the hands of man." By contrast with Verrocchio's famous equestrian statue of Colleoni in Venice, Leonardo was to have depicted Francesco on a rearing horse. It was to have stood, even without its rider, over thirty-one feet from the ground. Something like seventy tons of bronze was set aside for casting it, but it was never cast. The bronze was melted down for cannons, and the clay model for the "Sforza Horse" was used for target practice by Gascon bowmen after the French stormed the city of Milan and Ludovico was forced to flee. We have only the drawings left and some uncertainty whether they were done for the Sforza monument, *The Adoration of the Magi*, or *The Battle of Anghiari*.

When the French occupied Milan, Leonardo slipped back to Florence by way of Venice, where he paused to advise the Venetians on fortifications. His counsel to artists was to "flee before the storm." In Florence he was given an extraordinary commission, to paint a colossal fresco in the Great Council Hall of the Palazzo della Signoria. The subject selected was a battle scene, showing a victory of Florence over Milan. Michelangelo was commissioned to do a facing mural. Neither work was completed, but Leonardo's was a spectacular failure: Because of his impetuosity, the plaster did not dry and the pigment ran to form an incoherent muddle—something, one imagines, like the painting Balzac describes in his *Chef d'oeuvre inconnu*. It is a sad truth that Leonardo's genius outran his patience: He was not a perfectionist, as the material history of the *Last Supper*, already a preservationist's nightmare in his lifetime, shows. But the drawings for *The Battle of Anghiari* are among his great achievements, and for me they are the glory of the show.

Here is Leonardo's description of what he aimed at in the great fresco:

> First you will have the smoke of the artillery, mixed in the air
> with the dust raised by the movements of horses and troops . . .
> This mixture of air, smoke, and dust will be lighter on the op-
> posite side; and as the combatants advance into this vortex, they

will become less and less visible, and there will be less differ-
ence between their lit and shaded parts . . . The musketeers, as
well as their neighbors, will be reddish. And this redness will
diminish in proportion to the distance from its cause . . . You
will have different sorts of weapons between the feet of the
combatants, such as splintered shields, spears, broken swords,
etc. You will have dead bodies, some half covered with dust . . .

From this account, the work sounds like a monumental drawing in
red and black chalk, which lends itself, through smudging, to the at-
mospheric effects of mingled battle smoke and dust, and visual correl-
atives of clashing bodies, of shouts and screams, swords clanging
against swords, the cries of horses and exploding ordnance. The actual
cartoon—the full-scale working drawing Leonardo was to have
found means to transfer to the wall—was lost or destroyed in his life-
time (the same is true of Michelangelo's cartoon for his companion
fresco, *The Battle of Cascina*). It is one of the insoluble puzzles of art
history to reconstruct what the work would have looked like as a
whole.

Leonardo is said to have painted a central episode of *The Battle of
Anghiari*, of which a copy was made, and this is exhibited in the pres-
ent show. The copy has a certain interest in that Rubens is associated
with it. This is a matter for experts in connoisseurship to determine. It
is entirely credible that Rubens, in his own depictions of battles and
hunting scenes, was inspired by Leonardo's example—that Rubens
should be included in a Duhemian narrative of those whose work
owes something to Leonardo's example. But there is not the slightest
chance, based on Leonardo's words and the preparatory drawings in
the show, that *The Battle of Anghiari* would have looked like this. It al-
most looks like a "cartoon"—not in the sense of a working drawing
but of lampoon—by Leonardo of a group of grimacing warriors en-
gaged in mounted combat. But the small preparatory drawings them-
selves are astonishing. They represent, as the titles given them in the
catalog state, a "skirmish between horsemen and foot soldiers," "foot
soldiers wielding long weapons," and a "fight for the standard at the
bridge." These are in brown ink and black chalk and are about six

inches long and between four and six inches high. Men and horses hurl themselves at one another under clouds of dust. Weapons fly through the air. Bodies and heads emerge out of urgent tangles of ink. A man's arm holds some sort of hammer, a horse rears, a figure lies on the ground. It is inconceivable that in the final result, every contour would be carefully traced as in the almost hateful copy. There is not a single other case in which drawing and work are so incommensurable. The sole value of the copy lies in the way it makes this incommensurability palpable.

That is the one dissonance in an exhibition the like of which has never been attempted. This is the largest collection of Leonardo's drawings ever to have been shown together. I spoke briefly with designer Milton Glaser at the press opening, standing in awe in front of a depiction of mortar fire. Milton told me that he had never expected to see a show like this in his lifetime. We are all in debt to the audacity of its organizers and sponsors. However much or little any of us knows about Leonardo, we cannot but be overwhelmed by the unfurling from sheet to sheet of his graphic imagination, whether he is studying the fall of draperies or registering the grotesqueness or beauty of the human face or simply the way the body is twisted in the show of love or anger. Reviewers have suggested that by contrast with Verrocchio, there is something cold and indifferent in Leonardo's personality. But that assessment is impossible to sustain the moment one sees the drawings in which the Virgin holds the Child, who hugs a cat, or in which the Child awkwardly attempts to feed his mother with something he has taken out of a bowl with his pudgy fist. There is a drawing by Verrocchio of a horse literally made out of numbers, which show the proportions from point to point. Leonardo did not need diagrams to help him draw horses with truth and passion. When he drew a horse, he was a horse, drawing its form from what it felt like to be one.

April 7, 2003

Matthew Barney's *Cremaster* Cycle

For Art Winslow

Matthew Barney's *Cremaster* cycle consists of five thematically interrelated films, much as Wagner's *Ring* cycle is made up of four distinct but narratively interlinked operas. But Barney has also designed a number of sculptural objects for the work's elaborate mise-en-scène, and it is these that make up the bulk of the exhibition to which the Guggenheim Museum in New York has been given over nearly in its entirety. Moreover, the museum is internally related to the work, not only because a substantial sequence in one of the films uses its interior space as a setting but also because a symbolic correspondence is supposed to exist between the five films and the five ascending curves of the museum's helical architecture. The objects displayed on each of the museum's ramps were in effect props in the corresponding film. Not only do these objects derive their meaning from the films, but the order in which they are experienced, as one ascends from ramp to ramp, reflects the overall narrative of the work.

Wagner designed the Festspielhaus in Bayreuth as the canonical theater for presenting his oeuvre, and it is widely appreciated that seeing the *Ring* cycle performed in Bayreuth is a unique and indispensable part of experiencing it. The Guggenheim was of course designed by Frank Lloyd Wright, but Barney has exploited and modified its architecture for the key episode of the work as a whole. So unlike the Festspielhaus, which is not part of the *Ring*'s narrative, the Guggenheim really is part of *Cremaster*'s. This has given Barney's many European enthusiasts a special reason to make a pilgrimage to New York,

even if they may already have seen the exhibition in Cologne or Paris, for only here will they have been able to experience the Guggenheim as a work of installation art that belongs to the *Cremaster* endeavor. This makes it, by general consent, far and away the most impressive of the three venues. The question for Barney's admirers, expressed by one of my Northern European correspondents, is whether Matthew Barney is the Picasso of our time, or the Leonardo.

I think it enough that he should be the Matthew Barney of the present age, using artistic resources that would have been unavailable to his predecessors, as well as a conception of visual art that is entirely of our time. *Cremaster* is a contemporary *Gesamtkunstwerk* that uses performance art, music, film, dance, installation, sculpture, and photography. Barney himself is the work's author and dramaturge, as well as an actor in possession of the exceptional athletic powers his successive roles demand. And his art embodies preoccupations that are distinctive to our era. In *Cremaster*, these have largely to do with issues of what one might call the metaphysics of gender, and the use of the term "cremaster" implies as much. The term has existed in English since the seventeenth century, almost exclusively as part of the descriptive anatomy of the male reproductive system: It refers in its primary sense to the muscle of the spermatic cord by which the testes are suspended in the scrotum. But Barney has given it a somewhat allegorical spin, in much the way, I suppose, that Descartes did with the pineal gland, which, because it is situated between the hemispheres of the brain, impressed him as being the seat of the soul. No one to this day quite understands the pineal gland's function, but the cremaster is associated with the descent of the testes into the scrotum in the seventh month after conception, at which point the gender of the fetus is definitively male.

There is a point in embryonic development when matters are less clear-cut. Two genital swellings known as labioscrota separate, in the female to become the labia majora, and in the male unite to form the scrotum. But in the labioscrotal phase of our development, we are male and female at once, so to speak, and this condition of gender indeterminacy speaks with particular eloquence to a generation that, especially under the influence of feminist theory, postulates a condition

beyond the male-female disjunction. After sexual differentiation is established, the chief function of the cremaster is to raise the testes when the scrotum is chilled.

Why Barney should have singled out this particular muscle, rather than the spermatic cord or, for that matter, the testes themselves, is doubtless connected with the poetics of ascent and descent, which figure as metaphorical actions in the four *Cremaster* films in which Barney himself performs. He does not appear in *Cremaster 1*, in which two Goodyear blimps may be taken as symbolic embodiments of the genital swellings of the labioscrotal moment of our sexual development. In *Cremaster 3*, the character played by Barney climbs up and down an elevator shaft in the Chrysler Building; in *Cremaster 5*, he climbs around the proscenium arch in the opera house in Budapest; and in *Cremaster 4*, the character burrows through an underground channel fraught with symbolic meaning.

The spiraling interior architecture of Frank Lloyd Wright's Guggenheim lends itself to ascent and descent, and becomes a second site for the character's upward itinerary in *Cremaster 3*. Because of its role in the *Cremaster* cycle, the building overcomes the commonplace distinction between exhibiting space and exhibited content. But neither it nor the profusion of objects and images that make up the show as a whole can be grasped as art without reference to the films that are *Cremaster*'s core. The Guggenheim accordingly holds daily screenings of its various parts in its Peter Lewis Auditorium, and on each Friday, those with the required stamina can see the work in its entirety. It is a remarkable experience, and a remarkable if not altogether successful work. I have to say that I lost patience with *Cremaster 3*, the last installment of the cycle to have been made and three grueling hours long. But I am haunted by certain of its sequences, even if I remain unclear what the point is of the ordeal that it, and the cycle as a whole, depict.

The films in the cycle, as a useful handout claims, "represent a condition of pure potentiality," by which I imagine is meant the labioscrotal phase of genital development, before we are definitively male or

female. In fact, *Cremaster 1* glorifies feminity. It has two protago-
nists—a female performer and then a chorus of females who dance, so
to speak, as one. The action is dreamlike, and it reminded me, as do
many of the *Cremaster* sequences, of the Surrealist films of Maya
Deren. The female heroine is situated under a table, laden with
grapes, in the cabin of the blimp, seemingly guarded by women of an
almost forbidding beauty, wearing smart military uniforms. She suc-
ceeds, after some effort, in making an opening in the cloth above her
head, through which she pulls down clusters of the perhaps forbidden
fruit. The performer's name is Marti Domination, a real personage, I
discovered through the Internet, where she is identified as belonging
to The House of Domination. And though Marti Domination looks
thoroughly feminine, in a white intimate garment, high heels, and an
extravagant coiffure, the Web page leaves the matter of her actual
gender somewhat ambiguous. My sense is that Marti Domination por-
trays a woman, whatever the reality, and that the aura of sexual inde-
terminacy accounts in part for her having been cast in the role.

The action of *Cremaster 1* is split in two: As Marti Domination
arranges the grapes in logographic patterns on the floor, the chorus
executes isomorphic Busby Berkeley–like patterns in a football
stadium on the ground below: The gridiron is covered in blue Astro-
turf. Their movements are cadenced to swelling cascades of deliber-
ately gorgeous music, as in a musical from the 1930s. There is an
exalting moment when one of the chorines—Marti Domination her-
self—runs across the field with two balloons shaped like the Goodyear
blimps. Not much else happens. The action goes back and forth be-
tween grapes and girls, cabin and football field, and then comes to an
end. The entire review flirts outrageously with kitsch, which gives it,
one might say, its authenticity.

I f *Cremaster 1* is an ode to a certain idealized femininity—to beauty,
music, dancing, fantastic gowns, and pumps by Manolo Blahnik—
Cremaster 2 is a stylized ballad to violent masculinity. The hero is Gary
Gilmore, portrayed by Barney wearing a full beard. Again, the ac-
tion is dreamlike. The robbery and murder in the gas station (the

Goodyear logo can be glimpsed through its window as the attendant, shot through the back of the head, bleeds to death on the floor) mainly unfurl in silence. The execution of Gilmore, wearing convict stripes, is symbolically enacted as a rodeo act—he dies subduing a bucking bull—and his afterlife is fantasized as a Texas two-step, danced by a cowboy and cowgirl. These images are poetic and powerful, as is the mysterious flashback scene near the end of the film, in which Gilmore's grandmother, as an Edwardian belle with an impossibly narrow waist, speaks in a vast exhibition hall of that era with Harry Houdini. In a brilliant piece of casting, Houdini is played by Norman Mailer, the author, not incidentally, of *The Executioner's Song*. Mailer-Houdini delivers a speech—a rare occurrence in the cycle—poetically describing his escape from the submerged box in which he has been chained. He tells how he becomes one with the lock, how "a real transformation takes place." Escape through transformation is somehow the motif of the entire work, though the nature of our captive condition naturally remains somewhat indeterminate.

Cremaster 2 is, in my view, the most fully realized of the five segments of the cycle. But I have to say that I found *Cremaster 3* a mess. Calvin Tomkins wrote in *The New Yorker* that "a film like this may be one that only a Dick Cheney could walk out on without a frisson of self-doubt," but that walking out should have occurred to him at all speaks volumes about the film's shortcomings. Nothing but a cold sense of duty was able to keep me in my seat. The film exemplifies the flaw of hubris it is intended to portray, but one cannot really believe that it is any the less a flaw if it was made intentionally boring and preposterous. It is not my responsibility to moralize, but my conjecture is that Barney has attained the kind of artistic eminence that makes those who work with him reluctant to be critical. If this should be true, then it is a good thing that *Cremaster 4* and *5* were made before hubris on this scale kicked in. *Cremaster 3* is not redeemed by its unquestioned high points, any more than *4* and *5* are seriously compromised by their ennuis. It is a piece of bad art by a good and unquestionably important artist.

Disregarding *Cremaster 3*'s mythological prelude, the action of what one might consider its first act is split, somewhat like that of *Cre-*

master 1, between two planes. On the upper plane—the suspended elevator cabin, the Cloud Club bar, and indeed the glorious roof of the Chrysler Building—the performance is enacted by a single character identified as the Entered Apprentice, played by Barney himself. On the lower plane—the Chrysler Building's elevator lobby—the performance is by a chorus of five 1967 Chrysler Crown Imperials, engaged in demolishing what I surmise is a vintage black Chrysler. The demolition derby goes on interminably as, with screeching tires, the five Imperials crash into their victim, go into reverse, and crash again, and again, and again, finally dragging or pushing the shattered heap from their midst. The prolonged mayhem alternates with the action on the higher plane, where the Entered Apprentice muddles through the process of mixing mortar, using the elegant Art Deco interior of one of the Chrysler Building's elevators as a vessel.

There is something wanton and willful about the way both enactments take place. I somehow feel that Barney, who seems to lack a real sense of humor, intended all this as some kind of comedy. As the Entered Apprentice, he is dressed in vintage 1930s working clothes, including a fedora, and wearing a small mustache. Perhaps he is supposed to be suggesting the ineptitude of the Chaplin character in *Modern Times*. The slapstick routine with the bartender in the Cloud Club, who improvises a stepstool to fetch a glass, only to bring a whole cupboard of glassware crashing on top of him as he falls to the floor, is roughly as funny as the automobile massacre in the lobby below. The entire sequence is malevolently inane.

The Guggenheim Museum is introduced as a symbolic setting in *Cremaster 3*, where the Entered Apprentice makes his graded way upward through a sequence of degrees based on the rites of the Masonic Order. There is a genuine piece of wit in associating the Solomon R. Guggenheim Museum with the legendary Temple of Solomon, which is an important mythic site on which Masonic rites and beliefs are based. My grandfather and father were dedicated Masons, so Masonic appurtenances—the compass and square, the trowel and the apron, not to mention references to initiations and sworn secrecies—inflected

the atmosphere of my childhood. Masonry really was their religion, but I could never bring myself to follow them, since even as a youth my temperament was too positivistic to believe in occult teaching of any sort. I nevertheless picked up a certain amount of Masonic lore, which helped somewhat to clarify what takes place at successive stages of the Guggenheim's involuted ramp, as imaginatively transformed by Barney.

"Entered Apprentice" is a term in Masonic nomenclature, referring to the lowest degree in the Order. The highest standard degree is that of Master Mason. Masonic myth traces the origins of the fraternity to the Phoenician masons who worked on Solomon's Temple, as the Hebrews lacked the knowledge necessary to realize the king's architectural vision. The Master Mason was named Hiram Abiff, who possessed not merely the practical knowledge of shaping matter into usable forms but also the greatest Masonic secret of all, the "ineffable name" of God. I know by hearsay of a ritual enactment in which various Hebrew ruffians try to wrest the knowledge, and hence the power, from Hiram Abiff, who was finally killed—or sacrificed—only to be resurrected by King Solomon himself, using the Masonic Grip.

Barney has cast the sculptor Richard Serra to play the part of the Master Mason, or Architect, whom the Entered Apprentice finally murders. The main action of the Guggenheim interlude, however, requires the Entered Apprentice to pass a series of tests, which must be done in the time it takes for melted Vaseline to spiral its way to the museum's lobby. The molten Vaseline is flung against the parapet by the Architect, which reenacts one of Serra's most famous sculptures and indeed one of the signature works of the late 1960s. In 1969, Serra flung molten lead into the angle where wall and floor met in Leo Castelli's warehouse, using the architecture as a kind of ready-made mold. In a photograph of the time, Serra looks like a warrior hero, using the ladle as a weapon, and there is little question but that his act was perceived at the time as inaugurating a new moment in the history of sculpture. It is difficult not to see the demotion of lead to Vaseline as an emblematic degradation of that heroic moment to the present moment of postmodern art. The fact that the Entered Apprentice is him-

self killed in *Cremaster 3* is nevertheless a declaration that an artist of our day will achieve the status attained by Serra: Every member of the Masonic Order impersonates Hiram Abiff when initiated as a Master Mason. I have, meanwhile, nothing to say about the significance that Vaseline evidently has in Matthew Barney's vocabulary of symbols. Its cultural meaning is that of a lubricant, which can perhaps be connected to the two phallic columns erected by Hiram Abiff in the courtyard of the Temple. Someone once told me that in the night table next to his bed, all that was found after Auden's death were a large, economy-size jar of Vaseline and two pairs of castanets.

I must leave readers to their own resources in dealing with *Cremaster 4* and *5*. I think they are both quite magical. Barney is at his best in the role of The Candidate—a dandified tap dancer, half man and half sheep, with red spit curls—in *Cremaster 4*, which takes place on the Isle of Man. The "Three Faeries"—personages of genuine sexual ambiguity who serve as benign intercessors—are among Barney's most compelling inventions. In both these films, I thought of *The Magic Flute*—especially so in *Cremaster 5*, in which Ursula Andress plays the role of the Queen of Chain, in the sequence that takes place in the Hungarian State Opera House in Budapest. As everyone knows, the narrative of Mozart's masterpiece is also based on Masonic ritual. One cannot, meanwhile, praise too highly the musical scores for the whole cycle, composed by Jonathan Bepler.

Since objects and images relating to the different parts of the *Cremaster* cycle are arrayed on successive stages of the Guggenheim, the intention is that we shall imagine a mapping through which the exhibition replicates the cycle in another modality—in space, so to speak, in contrast with time. But the experience is totally different, and unless one has internalized the films and something of the ideas that animate them, what one encounters as one ascends or descends the ramp is more or less just art stuff. It does not on its own make an enchanting show. But the cycle has moments of great enchantment. It is an uncertain achievement, but one with which everyone interested in contemporary art must deal.

May 5, 2003

Christian Schad and the *Sachlichkeit* of Sex

From the mid- to the late 1920s, the German painter Christian Schad produced a group of paintings like little else in modern art. Possessing the translucent clarity of Renaissance portraits, they project a nighttown vision of *Mitteleuropa* worldlings bathed in a mood of obsessive eroticism. The oeuvre of a great many artists contains an X portfolio, so to speak, of erotic images. But I can think of no painter of Schad's stature whose work, in the few years in which he touched greatness, was so totally given over to erotomania that everything associated with the personages he portrays—a flower, an accessory, a human companion—seems to signal preferences in some exotic code of sexual specialization.

Some ten years earlier, as a member of the Dada movement, Schad attracted a certain notice through a body of work that could not contrast more vividly with the extraordinary paintings of the 1920s. It consisted of small experimental photograms in which bits of fabric and scraps of paper were arranged in abstract compositions on photosensitive paper that was then exposed to light. Through one of the vagaries of art history, the Museum of Modern Art acquired several of the "Schadographs," as Schad's photograms were dubbed by the Dadaist poet Tristan Tzara, and the artist's reputation has rested almost entirely on these early avant-garde efforts. The paintings, meanwhile, have until now remained almost totally unknown. This gives a particular excitement to the exhibition "Christian Schad and the Neue Sachlichkeit," at the Neue Galerie in New York City, where they are being shown for the first time in America.

Neue Sachlichkeit means "new objectivity," and it designates an art movement that took place mainly in Germany and Italy in the mid-1920s. The term entered the discourse of art writing in 1925, in connection with a famous exhibition organized in Mannheim, Germany, by Gustav Hartlaub, a curator of some note. The title was originally to have been "Post Expressionism." *Sachlichkeit*, or objectivity, contrasts fairly exactly with "subjectivity," which everyone would have associated with Expressionism, an art of inner feeling. German Expressionism was one of the great Modernist movements, and Schad himself belonged to it before he converted to Dada. The term "objectivity" suggests that the artists involved were bent on representing things as they really appear, but there is more—and less—to the movement than that. Schad's paintings, for example, seem to be objective transcriptions of actual persons in real settings—bedrooms and cafés. They have an almost clinically photographic truth, which can easily mislead us into thinking that that is all they are.

In fact, the heavy spice of sexual obsession in Schad's paintings is almost like the aura of religious devotion that Renaissance painters used to transform their models into saints and martyrs, rather than an atmosphere that he actually encountered in the cabaret precincts of Berlin and Vienna. The people he portrayed, often from memory, were vehicles for metaphoric transformation. "My pictures are never illustrative," he wrote in a caption for his 1927 masterpiece, *Self-Portrait with Model*. "If anything, they are symbolic." That symbolism gives these works the uncanniness of things dreamt. There are three mysteries connected with these extraordinary works: how anyone who made the photograms could have made them; why, after the brief period in which he achieved greatness in the late 1920s, Schad did nothing of significance for the remainder of his long life; and, finally and most important, the mystery of these amazing pictures themselves. To explain that, we need to relate them somewhat to the Schadographs, which belong to an earlier moment of Schad's life.

As a young man, Schad left Germany for Switzerland in 1915, ostensibly for reasons of health but mainly in order not to be called up as part of Germany's war effort. There he fell in with the Zurich Dadaists. Little of his art from the Dada years survives, apart from the

Schadographs, some woodcut prints, and a few posters, but Dada art was in its nature fairly ephemeral and deliberately minor, which has in part to do with the movement's refusal to make aesthetically ingratiating art. Dada's aim was indeed the suppression of beauty, since beauty was among the values venerated by the class responsible for the so-called Great War. Why should we make beauty for a society capable of that? The repudiation of beauty was thus a form of moral protest, not unlike the decision by the women in Aristophanes' *Lysistrata* to politicize sex by withholding it until their men stopped making war. So while the cannons pounded and millions of young men died elsewhere in Europe, Dada indulged in willful buffoonery. By turning themselves into artist-clowns, they rejected the role of artist-heroes, refusing to be complicit in the value scheme of the war-makers. I regard this as having had the incidental consequence of a major philosophical contribution—perhaps the main philosophical contribution made by art in the twentieth century. Dada demonstrated that something can be art without being beautiful, a notion that would at the turn of the century have been considered philosophically incoherent. And it had the consequence of politicizing beauty, which made Dada the forerunner of the antiaesthetic tendency of so much of contemporary art, with its implied edge of political critique. The Schadographs are almost paradigms of antiaestheticism, whatever further interest they may have for the history of photography or, for that matter, of abstraction.

The contempt that Zurich Dada displayed toward the society that had produced the wholesale slaughter of the Great War continued after the Armistice, as members of the movement sought to involve themselves in a form of art that might help effect political change. Dada also challenged the tendency of German culture to elevate the artist—The Artist—to the status of a quasidivine hero, and perhaps it was this cultural disposition that explains why Dada was essentially a German phenomenon, even though not all its members were German nationals. Posters in the First International Dada Exhibition in Berlin (1920) proclaim the death of art, but what they meant was that art as it had been exalted by German culture was dead.

The most distinctive art form of Berlin Dada was photomontage,

which became in their hands a vehicle of social and political critique well into the Nazi era. But initially, I think, photomontage was a corollary to Dada's antiaestheticism. Its critical subtext was that art can be made with scissors and paste, using newspaper and magazine boilerplate as its material. Its spirit could not have been more different from the earlier collage work of Picasso and Braque in Paris. It was sarcastic rather than witty. Berlin Dada made art out of images that had no redeeming aesthetic value—just what its society deserved.

Schad, by contrast, underwent a certain *crise de conscience* when he came down, so to speak, from the magic mountain of the Dadaist interlude in Switzerland and encountered the reality of the human suffering left in the war's wake. This was translated into a change in style: The jokiness of Dada seemed no longer a suitable option. Even though Dada's vision was never less than moralistic, its antiaestheticism appears to have struck Schad as having outlived its occasion. He was not part of Berlin Dada. Like several of its members, he found his way to a certain kind of realism but in a spirit entirely his own. And he pursued beauty as well, almost as if, since banishing beauty was a way of hurting the society that made the war, creating beauty was a way of healing it.

One reason for realism was as old as Shakespeare's *Hamlet*: to use art as a mirror "to show . . . the very age and body of the time his form and pressure," and in which society would see its moral face reflected. In order for that to happen, viewers must not merely recognize what they see but also see themselves reflected in it. And for some painters, this was to be the role for art in the disarray of postwar Germany.

Consider the painter George Grosz. Grosz participated in the International Dada Exhibition in Berlin in 1920 but felt the need to do something more than express his overall disgust with Germany by way of pranks. He wanted Germans to feel disgust with themselves, and so he set out to show them to themselves in an exaggerated mirror, as a means to their moral self-transformation. Grosz explicitly invoked Hamlet's metaphor: The artist, he said, "holds up a mirror to

his contemporaries' mugs. I drew and painted out of a spirit of contradiction, trying in my works to convince the world that it was ugly, sick, and mendacious." His work really did show his sick society to itself. There is little question that our picture of Weimar society is the one that Grosz has left us: porcine men, rolls of neck fat beneath their tight bowlers, flouncy whores in skimpy dresses hanging on their arms, walking past emaciated veterans on crutches begging for *Groschen*.

It has evidently not been difficult for art scholars to see Schad's work in terms of Grosz's model. The article on him in Grove's *Dictionary of Art* reads as follows: "Unlike . . . Grosz, Schad did not employ caricature. Instead he criticized the structures of society by coolly and uncompromisingly depicting every detail of his subjects and their surroundings and by revealing the distance and emptiness between them." The article goes on to interpret various paintings by Schad along these lines, as depictions of a decadent and dissolute society. The portrait of the Count St. Genois d'Anneaucourt, for example, is described this way: "Two prostitutes in transparent dresses vie for the count's attention, while he turns his back to them and stares rigidly out of the picture." Or again, "The exposing, ugly portrait of Countess Triglion is another critical comment on the moral decay behind the bourgeois facade."

But did Schad in fact depict the details of the world of his subjects? Did women in fact wear transparent gowns as they are shown in the painting of Count St. Genois d'Anneaucourt? That is to suppose that the New Objectivity was objective in a literal photographic sense. Schad wrote: "Count St. Genois was the sort of person who can only live in a city, with all its freedoms and social constraints. So I painted him in a dinner jacket against the skyline of Montmartre, between an older, and rather masculine woman and a well-known transvestite from the Eldorado in Berlin—the latter are both wearing see-through dresses." The dinner jacket is symbolic rather than illustrative, to use his distinction, as are the skyline and the dresses. It is as if he painted the count in a world that suited his fantasy, like a gift from the artist. But surely the see-through gowns and Montmartre itself were the

stuff through which Schad gave objective embodiment to dreams. The painting is not a condemnation of society, except perhaps of the way society falls short of our fantasies. Schad's realism had nothing in common with George Grosz's, which really was polemical in spirit. It was hardly a mirror at all, unless a magic mirror in which we don't see ourselves as we are but as we wish in our secret heart to be. The paintings are a form of wish fulfillment, as Freud tells us that our dreams are.

Let's look at Schad's great 1927 *Self-Portrait With Model*. An oil painting on wooden panel, this picture has the inner light of a Flemish masterpiece from the time of Jan van Eyck. Nothing about the picture, other than its title, tells us that it is of an artist and a model: It could, for all the internal evidence one might cite, be a pair of lovers or, for that matter, a prostitute and a client. There are no attributes of the artist's studio—no easel or palette—except the large window and a single enlarged narcissus, which is there not as a decorative touch but as a symbolic emblem. The two figures are narcissists. They do not look at each other, but within. Their expressions evoke an extreme self-preoccupation. The most striking attribute in the painting is the artist's transparent shirt, fastened with an ornamental tie with tassels. It would be what we call an intimate garment, if men wore intimate garments. It reveals his chest hair and the hair under his arm, but also his fleshy, almost feminine nipples. Schad tells us he really painted himself in a see-through shirt in order to show his naked body without showing himself naked. It makes for a more interesting picture. But it is unclear that it was a garment he actually possessed: It is "a shirt of the kind woven in ancient times on the Island of Kos."

Painting a transparent garment like that is an act of virtuosity, almost an advertisement for his virtuosity as an artist. But it is not the picture's only boast. The woman's face is marked with a scar—a *sfregio*, Schad tells us, having learned the world in Naples, where he lived after the war and where he married an Italian woman. A *sfregio* "was always inflicted by a jealous husband or lover, and displayed with great pride by a woman as a visible sign of the passion she inspired." So like the shirt, the scar is a boast. The narcissus is thus symbolic of how each of the lovers love themselves. They are proud of their

beauty and of their sexual power. Schad has neatly lettered his signature on the crumpled bedsheet. The cityscape silhouetted through the curtain represents "a vague longing for Paris," the city of erotic fulfillment. The model's hand, according to his caption, belonged to a woman who ran a shooting gallery at an amusement park in Vienna. The painting is an assemblage of disparate realities fused into a symbolic whole. It was not posed for and painted from life.

So what does objectivity mean in Schad's case? I again turn to Shakespeare for guidance. In characterizing the imagination in *A Midsummer Night's Dream*, Theseus describes its power as, among other things, giving "to airy nothing a local habitation and a name." Schad paints, as if it were an objective reality, a sexualized fantasy that is symbolically equivalent to that reality. He showed himself and the "model" as narcissists, in order to bring out what one might call a truth of character. This is the way it is with us, he is saying; there is narcissism in each of us. We only have eyes for ourselves. For a moment we escaped from our narcissism in the act of love—but this is the moment *après*. Now we wish we were somewhere else—in Paris, for example.

The two girls, in the most explicitly erotic of the paintings in the show, are each pleasuring themselves rather than each other. One is nude, the other wears a lacy slip with one strap down, revealing a breast. Neither is an object for the other's eyes. What could they be thinking about? What is the content of their respective fantasies? Whatever it is, what more vivid way can we express the truth that we all live in our heads than by autoerotic performances in one another's company? How better to express our apartness? That is the objective truth about human beings. The Count St. Genois d'Anneaucourt stands with his hands in the pockets of his tuxedo. He is interested neither in the man who looks like a woman nor in the woman who looks like a man, each of whom eyes the other, wishing he/she had something the other one has. The transparency of the garments means that we can see through to this truth.

Schad's distinction between illustrative and symbolic is nowhere

better displayed than in two portraits he did of his girlfriend, Maika. Maika looks more erotic when we see her dressed than undressed, and on an imagined rooftop with the longed-for Montmartre behind her than in a real hotel room in Paris. The beautiful half-length nude, by contrast with the model in the self-portrait, was actually painted in Paris, in a hot hotel room on the Boulevard Raspail, and really is "illustrative"—that is how this lovely girl looked, with her skin "like mother-of-pearl." But the painting of Maika on the roof is "symbolic." Schad has inscribed his signature on the skin of her left arm, which is one of the few art-historical references I have discerned in Schad's work. Raphael painted his signature on a band his girlfriend, known as La Fornarina, wears on that same arm. La Fornarina points to Raphael's name with a certain pride—he is the one who did the painting that shows her beauty, and he is the one to whom she belongs in life. Maika does not perform this gesture. She is her own woman. But the two flowers, the one that she wears on her bosom and one that sticks out on her other side, could hardly be more explicitly sexual. And the landscape behind her is Montmartre, not visible from the Boulevard Raspail. Even if she and Schad are in Paris, it is the Paris of our dreams that matters, not the real city. One can be in Paris and still long to be in Paris.

At this point I cannot resist citing the scholar in the Grove Dictionary, who possesses whatever eye it is that corresponds to a tin ear in music. She is describing what Schad tells us is the skyline in Montmartre in the portrait of Count St. Genois: "Through the window of the almost airless space one can see the grey houses of a working-class district: the contrast between the group and the background hints at the class divisions and inequalities in society." No: The contrast is between things as they are and things as they are imagined. Consider the woman in *Lotte*. It is "a portrait of the little milliner in the hat shop on the ground floor of the building that also contained the Pension Schlesinger, where I lived until I found a studio." He has imagined her as a demimondaine, wearing a blouse that came from the same imaginary boutique in which he found the green shirt in his self-portrait, and shown in complete self-possession seated in a café. The power of Schad's paintings is the power of fantasy. We return to them

compulsively. If they stop compelling us, something within us will have died. This leaves the mystery of why these paintings came to an end. What was it that died in Schad, since he went on living for nearly half a century more?

June 9, 2003

Kazimir Malevich

If the idea of monochrome painting occurred to anyone before the twentieth century, it would have been understood as a picture of a monochrome reality and probably taken as a joke. Hegel likened the Absolute in Schelling to a dark night in which all cows are black, so a clever student in Jena might have had the bright idea of painting an all-black picture titled *Absolute with Cows*—witty or profound depending upon one's metaphysics. In 1882 the Exposition des Arts Incohérents in Paris featured a black painting by the poet Paul Bilhaud titled *Combat de nègres dans une cave pendant la nuit*, which was appropriated in 1887 by the French humorist Alphonse Allais in an album of monochrome pictures of various colors, with uniformly ornamental frames, each bearing a comical title. Allais called his all-red painting *Tomato Harvest by Apoplectic Cardinals on the Shore of the Red Sea*.

Only in the most external and superficial respect does Kazimir Malevich's 1915 black square painted on a white ground belong to this history. For one thing, *Black Square* is not a picture; it does not, in other words, depict a black square outside the frame. One of its immense contributions to the concept of visual art lies in the fact that it liberated the concept of painting from that of picturing and thus opened up a new era in the history of art. "All paintings are pictures" would have been a strong candidate for a necessary truth until Malevich proved it false. But it was not a difference that met the eye. Had Bilhaud's all-black painting of 1882 been square, it might have looked exactly like Malevich's *Black Square*.

Black Square's radical difference from everything before it does not end there. Malevich's disciple, El Lissitzky, declared in 1922 that *Black Square* was "opposed to everything that was understood by 'pictures' or 'paintings' or 'art.' Its creator intended to reduce all forms, all painting, to zero." I think by its opposition to painting, El Lissitzky is saying that the fact that the square is painted is incidental to the work's meaning. Malevich himself said later, "It is not painting; it is something else." And so far as its opposition to art goes, well, you don't have to study art to be able to paint a black square. Anybody could do it. So though it was almost certainly Malevich's most important work, and inaugurated a new era in the history of art, it hardly seems appropriate to call it his masterpiece, just because the factors that make for something being a masterpiece don't really apply to it. It would be curious to think of it exhibited alongside *Mona Lisa* in a show called "Two Masterpieces." We marvel at its originality, not its painterly brilliance.

The idea behind what Malevich called Suprematism is that you cannot carry things beyond *Black Square*. It is as far as you can go: You have reached a point of absolute zero. Which isn't to say that *Black Square* is empty—there is, after all, a difference between not being a picture and being a picture of nothing! Calling an empty rectangle a picture of nothing would be a Lewis Carroll–like joke, whereas everything connected with *Black Square* underscores its seriousness.

Consider, for example, the way Malevich first showed it in the 1915 show "0.10. The Last Futurist Exhibition of Paintings," to which he contributed thirty-nine Suprematist works. An installation photograph shows *Black Square* mounted in an upper corner of the gallery, diagonally connecting two walls. This was evidently the position occupied by an icon in Russia: not hung on a wall or propped on a shelf, but in an upper corner. I think the reason would be as follows: Icons were never considered mere pictures of saints, the Madonna, or Jesus himself, so they did not aspire to create an illusion, as in Renaissance art. They were not, as Alberti said, a kind of window, through which one would believe one was seeing an external reality. What one believed instead was that holy beings would actually make themselves present in their images. Theoreticians spoke of the mystical presence

of the saint in the icon. And its placement near the ceiling was an obvious metaphorical entry point for beings that existed on a higher plane. A picture could be a decoration, but icons were fraught with magic. Through icons, the holy being was in our very presence, where it could be prayed to or honored. Trivially, a square is a square, not a picture of one. Malevich created reality rather than merely depicting it. And that in a sense is what the figure in an icon was believed to be—a reality rather than a picture.

After Malevich's death, when he lay in state, a black square hung above his head. There was a black square on his tomb. As a kind of icon, it carried a religious power. In 1920 he wrote, "I had an idea that were humanity to draw an image of the Divinity after its own image, perhaps the black square is the image of God as the essence of his perfection on a new path for today's fresh beginning." He clearly identified himself with the black square: It served him as a kind of signature, appearing in the lower right-hand corner of his last painting, a self-portrait. In any case, it was not a proto-Dadaist hoot.

The original *Black Square* is perhaps the pièce de résistance in an elegant exhibition at the Guggenheim Museum given over entirely to Malevich's Suprematist phase. It is the first time it has been allowed to travel, and one can see why. It's in terrible shape, so blemished by cracks and fissures that one would give it a pass at a yard sale. Its ravaged condition conveys a sense of touching vulnerability, like a martyr's relic. In fact, Malevich painted at least four *Black Square*s and it occurs as a motif throughout his oeuvre, making its first appearance in 1913, in a small pencil study for the decor of the Futurist opera *Victory Over the Sun*, two years before he invented—or discovered—Suprematism.

There are several of these studies in the Guggenheim show, in deference to Malevich's belief that they are proto-Suprematist works, though at the time he considered himself a Cubo-Futurist. After Cubo-Futurism, he went through a related style, making what he described as "alogical" or "transrational" works, hardly a year before the great breakthrough that *Black Square* represents. I wish I knew more

about the moment when Malevich decided to paint a large black square and realized that he had hit upon something that changed the meaning of art forever, not merely purging it of any pictorial elements but stultifying the impulse to see it as a picture of unrelieved blackness. Given the momentousness he ascribed to Suprematism, one can appreciate that Malevich looked for intimations of it in his earlier work, much in the way scholars pore over Pollock's pre-1945 work in search of the drip.

Victory Over the Sun was a collaborative effort by three avant-garde figures, all friends—the composer Matiushin, the poet Kruchenykh, and Malevich himself. It was given only two performances, at Luna Park in St. Petersburg. There were two acts. In Act I, the sun is captured and locked up in a concrete box. In Act II, the Strong Men of the Future produce a new social order, no longer dependent on the primitive source of light that had been worshipped for centuries. Music, words, and of course the sets and costumes were radical and cutting-edge: The music was dissonant, the lyrics were basic sounds in an experimental discourse called Zaum. Only fragments of the music and language survive, but Malevich's sketches for the costumes exist (you can see them on the Internet), and there are, as well, his set designs. The set that he later singled out as *Black Square*'s first appearance in his work is, according to the Guggenheim catalog, for Act II, Scene 5. Indeed, it shows a square divided by a diagonal into two areas, one black, the other light.

The truth is that the drawing in question has the look of something seen through a square opening in some sort of optical instrument, like a segment of the sun against a dark sky. It really looks like a picture.

Here is a better way to look at the question. In one of Malevich's studies for the opera's decor, there is a black square and a number of black rectangles—a large vertical one, and then two sets of three black rectangles at various angles to one another on either side of it. But in the same drawing there are a number of other components— some large letters, some numerals, a foot, a hand holding what looks

like a bomb, a cigarette with smoke—and a number of mere marks—circles, waves, hooks, indications of the edges of overlapping planes. It is an example of an "alogical" or "transrational" drawing, a drawing whose various components (some abstract, others representational) don't cohere as a composition. The alogical drawings have something of the disorder of dreams, as Freud attempted to characterize them when he suggested that we approach them like rebus puzzles—concatenations of pictures that seem to have no rational connection with one another.

Now imagine laying a piece of transparent paper over Malevich's drawing and simply tracing the black geometrical components, disregarding all the rest. The result will look like a Suprematist drawing of 1915, consisting of a number of free-floating rectangles together with a square. It is as though Malevich's drawing had a Suprematist drawing inscribed within itself. But this would have been invisible until Suprematism was invented two years later. Suprematism consists in getting rid of all the objects other than the geometrical ones. When that has been done, one is left with a nonobjectivist work, and Suprematism is virtually synonymous with what came to be called Non-Objective art.

The term was first used by Rodchenko in connection with his *Black on Black Painting* (1918), but Malevich made the concept his own and published a book, *The Non-Objective World*, in 1927. It is worth mentioning that the Guggenheim Museum was originally called the Museum of Non-Objective Painting when it was located on East Fifty-fourth Street in Manhattan, and one really felt as if one were entering a nonobjective world when one visited it. Most of the paintings consisted of shapes floating in empty space, many of them by Rudolph Bauer, the lover of the director, the Baroness Hilla Rebay, who used to sit at the reception desk, eagerly discussing the philosophy of nonobjectivity with anyone interested. There were a lot of Kandinskys and perhaps some Mirós and Mondrians. I don't know if there was anything by Malevich, but there were some at the Museum of Modern Art, including the famous *White on White*. It was a great place to take someone one felt moony about, and hold hands on the round gray velvet settees.

Very little of Malevich's Cubo-Futurist work of 1914, with which the Guggenheim show begins, or the alogical drawings and paintings of the following year, is especially rewarding unless you think of Suprematism as struggling to emerge from the early avant-garde clutter. But when one enters the gallery of 1915 masterpieces, there is a sense of liberation that must, one is certain, recapture Malevich's own feeling when he broke free and entered what he regarded as unoccupied territory. The paintings convey a feeling of utter glee. One feels as if one were witnessing the beginning of a new era, where the history of art has been left behind forever. The Russian avant-garde was obsessed with the idea of the fourth dimension, which its members read about in the mystical writings of Pyotr Demianovich Ouspensky. The fourth dimension was not an extra parameter in some dry equations but rather a living reality that one could hope to enter, like a new world. Ouspensky, a Theosophist, believed that artists were uniquely capable of making the fourth dimension vivid for individuals who are otherwise locked in their three-dimensional perception of the world. That is what the great Suprematist paintings convey—the optimism and generosity that defined the art of the Russian avant-garde at the dawn of Modernism, when it saw its mission as bringing art into life and contributing, through art, to the creation of a new social reality, a vision initially embraced by the Russian Revolution before the perversions of Stalinism.

The smooth geometries and whitish spaces of Suprematist painting, using brilliant colors and jaunty compositions, were a vocabulary of hope and idealism. They could symbolize all the bright modernities for which the art stood—syncopated rhythms; the fourth dimension as a field of infinite explorations; the radical redesign of contemporary clothing, housing, and cities—and above all, they could express speed and flight. "I have torn through the blue lampshade of color limitations," Malevich wrote in 1919, "and come into the white. After me, comrade aviators sail into the chasm—I have set up the semaphores of Suprematism!"

All the Suprematist compositions lift the spirit. Let's just consider

Airplane Flying. It is, of course, not a picture, so don't bother to look for the airplane. What it captures, rather, is the feeling of flight. The flight begins at the bottom right corner, with a tilted black square. Along the diagonal that its angle defines are two black rectangles, one larger than the other, with two thin whiz lines on either side, marked by thin black rectangles. At the upper edge of the largest black rectangle, direction changes—we get a flight of yellow rectangles, heading for the upper right corner, crossing a long, nearly horizontal thin red rectangle as it goes. "My new painting does not belong to the earth exclusively," Malevich said in 1916. "The earth has been abandoned like a house eaten up with worms. And in fact in man and his consciousness there lies the aspiration toward space, the inclination to 'reject the earthly globe.'"

This is how the future used to look. Then came the Depression, Stalinism, fascism, the two world wars, the cold war. The poor mangled *Black Square* shows how that once-bright future looks now. It is like the ashes of hope and in its way a memorial to Malevich himself, as the future collapsed around him. He died a poor man, disgraced and erased from the history of art according to the Soviet Union.

August 18/25, 2003

Max Beckmann

In Plato's *Republic*, Socrates illustrates his theory of the parts of the soul with the story of Leontius, who saw some corpses rotting outside the walls of Athens and was torn between revulsion and the desire to gaze at them. Leontius covered his eyes, but the desire was overpowering. "Look for yourselves, you evil things," he scolded his eyes, "get your fill of the beautiful sight!" This was an early example of what the ancients called *akrasia*, or weakness of will, where we find ourselves doing what we know we shouldn't. But the example illuminates an uncomfortable truth in the psychology of moral perception: Human beings derive pleasure from seeing what disgusts them; hence there is a pornography of torn and bloodied bodies, as well as of buff and sexy ones. This explains why viewers, rather than being simply revolted by depictions of martyrdoms and crucifixions, are instead drawn to them—a truth that underscores the Counter-Reformation's belief that the church might strengthen people's faith by increasing the luridness with which Christ's tormented flesh was represented. It explains an aspect of the power of images. It also helps explain why art that undertakes to show the horrifying truth of war is so often counterproductive. It serves to attract viewers precisely by repelling them.

Consider Max Beckmann's *The Way Home*, the first plate in *Hell* (1919), a portfolio of ten large black-and-white lithographs that can be seen in New York at the extraordinary exhibition of his work at MoMA-Queens. Two figures face each other beneath a street lamp, one the artist himself in suit and bowler, the other a grossly disfigured

veteran, wearing the familiar brimless cap of the German enlisted man at the time of World War I. Half his face has been blown off, he is noseless and almost eyeless, and the stump of an arm protrudes, like a stick, from his sleeve, which Beckmann grips with one hand while he points "the way home" with the other. A shadowy pair of crippled veterans are farther up the street, behind a woman, from whose boots and jutting hips one infers that the street is her milieu. It is not entirely clear that the soldier can see which way the finger points. But Beckmann can see: Like Leontius, he cannot take his eyes off the veteran's ghastly, skull-like head. And neither can we.

There is visual evidence that Beckmann actually saw such a head when he was a medical orderly in Flanders in 1915. A drypoint, *The Grenade*, shows wounded soldiers in the foreground, one of whom has lost part of his face. We can see the teeth through the hole. The scene of the explosion is imagined: Several panicked figures flee the bursting shell. But the cheekless man must have been drawn from life; Beckmann made many sketches of the maimed and dead, and throughout his work he called upon his knowledge of what human beings actually look like, dead or barely alive, on the field of battle. But his time as a field medic did more than provide opportunities for life (or death) studies. Beckmann, who lived in an apartment above the morgue and once dreamed that dead bodies invaded his room, was left with traumatic memories that he struggled in vain to master and that ultimately led, in 1915, to a severe breakdown. Counting on art to help him through his ordeal, he managed to visit the Musée des Beaux Arts in Brussels, where he came to admire the so-called Flemish primitives, including especially Rogier van der Weyden. They were to help frame his vision of reality when he returned to his career as a painter after the war, but looking at art did him little good in keeping despair at bay.

Beckmann started to paint again while still in uniform, during his slow recovery behind the lines in Germany. In a haunting self-portrait as a medical orderly, which is not, unfortunately, in the MoMA show, he appears in his green uniform, with the Red Cross in-

signia attached to his collar, presumably in the act of painting the picture of himself that we see. It's as if he were bringing himself back to life by painting: He shows himself closely studying his still-frightened expression, getting outside himself, as it were, away from the images that trouble his dreams. Beckmann's output of self-portraits is matched only by Rembrandt's, but this is one of the few in which he actually depicts himself as an artist, perhaps because painting, just after his time in the field hospital, was his particular "way home." Typically, Beckmann shows himself as part of the life he depicts. In his 1918 artistic statement, "A Confession," he wrote, "I need to be with people. In the city. That is just where we belong these days. We must be part of the misery that is coming."

The shattering truth was that, as the title of his portfolio implies, life in postwar Germany had itself become hell, the fabric of civilian life having been torn to shreds. A lot of the painting made by German artists who did military service was angry and accusatory. The Dadaist George Grosz had also undergone a severe breakdown and even tried to drown himself in a latrine in order not to be sent back to the trenches. Otto Dix, a machine gunner throughout the war, published his brutal *War Portfolio* afterward. Gruesomely wounded veterans stumble through their postwar pictures. Max Ernst, another Dadaist who had served as an artilleryman, later wrote, "A horrible futile war had robbed us of five years of our existence. We had the collapse into ridicule and shame of everything represented to us as just, true, and beautiful. My works of that period were not meant to attract, but to make people scream." It was an art of shock and disillusionment, a mirror of what Germany had done to itself.

Beckmann's initial impulse, by contrast, appears to have been to use his art to help heal German society. In a letter to his wife in 1915, he had written, "What would we poor mortals do if we didn't continually equip ourselves with ideas about God and country, love and art, in an attempt to hide that sinister black hole?" He rarely painted the war as he knew it, at least as such, but his medical observations gave him a vocabulary for dealing with damaged bodies in scenes of biblical enactment, especially so in his exceedingly ambitious if somewhat embarrassing *Descent from the Cross* of 1917. A patron, with whom he

had been looking at a Gothic woodcarving of a Pietà, challenged the artist to make a modern painting as powerful. The immense, awkward *Descent from the Cross* is unmistakably a modern work, with art-historical allusions to Rogier and Matthias Grünewald, and with irresistible metaphorical associations for a shattered nation hoping for resurrection. Beckmann brought the knowledge he had acquired in observing dead bodies to his depiction of Christ's body, which is very much that of a cadaver. It could not easily fit into a coffin without breaking its arms, which, because of rigor mortis, are stiffly extended from the time on the cross. Christ's drawn, emaciated body is lacerated and bruised, and the soles of his feet are turned upward in pronate position, showing the nail holes.

The Descent from the Cross is an ugly painting, and it is difficult to know what consolation it or its pendants—*Christ and the Woman Taken in Adultery* or *Adam and Eve* of that same year—might have brought to viewers. The figures are as dispiriting as the landscape is bleak: A jeering figure, pointing at the adulteress, is straight out of Bosch, while Adam and Eve look as if they had spent their lives in, respectively, a coal mine and a beer house, rather than in the Garden of Eden. Beckmann's Gothic borrowings enabled him to show human beings as morally disfigured as the world the war had left them with.

Berlin after the war was an exceptionally violent city, torn by revolution and beset by crime—a site of cold, hunger, epidemic disease, demoralization, and radical disorder, of rape, torture, murder. These are the subjects of *Hell*, which shows how cruelly men and women can treat one another when the social structures that underwrite daily life unravel. Beckmann prefaces his portfolio with a portrait of himself as a circus barker, beneath which he wrote the following sardonic caption:

Honored ladies and gentlemen of the public, pray step up. We can offer you the pleasant prospect of ten minutes or so in which you will not be bored. Full satisfaction guaranteed or your money back.

It is difficult to resist the thought that Beckmann's model for *Hell* was Goya's suite of etchings, *Los Caprichos*, which also has a self-portrait at the beginning, and the slogan "The sleep of Reason produces monsters." Goya's images are moral allegories, which refer partly to the *comédie humaine* and partly to the inhumanities of politics and religion in the Spain of his time. So far as I know, Goya does not show himself as part of that world. But Beckmann is outside the world of hell as barker, and inside it as witness and commentator. *Hell* is like *Los Caprichos* fused with *The Disasters of War*, comic and gruesome at once.

Plate 6 of *Hell* is titled *The Night*, which Beckmann worked up into one of his most famous paintings, bearing the same title. It depicts a scene of brutality that could as easily have taken place during the Thirty Years' War, which had been a high point, until the twentieth century, of the suffering war can inflict on human beings, with the difference that *The Night*'s agony takes place after hostilities have ceased. Vicious intruders terrorize a household. The woman of the house is shown from behind, tied by her wrists to a window frame. Her legs are spread, her buttocks are exposed, her corset has been opened, and her garments lie torn about her. A lit candle sits on the floor behind her, and it seems clear that she has been raped and tortured. Her husband is now being tortured on the dinner table: A man is tightening an improvised noose around his neck; another, with a bandaged head, smokes a pipe while twisting the householder's arm. The victim's left leg sticks rigidly out, the sole of his foot is blackened. A third hoodlum is holding the comically angelic, fair-haired daughter, wrapped in a red curtain, under his arm; she gazes tearfully at her mother's face, which we cannot see. A dog howls from beneath the tablecloth. Beckmann employs a kind of soft Cubism to evoke the spaces in this nightmare scene and to insinuate, perhaps, the shattering of a world. It is often classed as an allegorical painting, scholars poring over it to find local allusions, but I think it was just current events, like so much else in *Hell*.

Martyrdom (Plate 3) is a portrait of Rosa Luxemburg, her arms outstretched as if crucified, her eyes rolled upward in death, as stiff as a Romanesque Jesus. Her body is being pulled from an automobile by a

grinning banker in tailcoat and checked trousers, while coarse militia-men beat her with rifle butts. *The Last Ones* (Plate 9) shows a firefight of bitter-end Spartacists, one of whom grimaces with pain as his guts spill out like curly worms while figures fall this way or that, as in a comic drawing of slapstick performers. A starving family sits before empty dishes, a porcine man carries a skeletal corpse, gasbags ha-rangue the crowds, suave dancers two-step to string players, and drunks sing a patriotic song to the wheezing of an accordion. In the last plate, *The Family*, a young boy gleefully plays soldier, with toy grenades and helmet. His severe-looking grandmother protects to-morrow's grenadier, as Beckmann, pointing with one hand, as he did in the first plate, holds his head in the other hand. Nothing has been learned.

In *The Night*, Beckmann discovered his artistic vocation. He was never quite so topical or political again. The thought that *The Night* is allegorical is a retrospective judgment, since his most distinctive work is increasingly allegorical and symbolic. He portrayed himself as a clown the following year, wearing the same clown's traditional col-lar of points he wore in the frontispiece to *Hell*. He is holding a slap-stick and a mask in his left hand while extending his right hand in pronate position, as if displaying stigmata. A horn is in his lap. Later he did two paintings, which seem pendants, *Carnival* and *The Dream*. Each is filled with symbols: musical instruments, masks, clown para-phernalia, candles. In *The Dream*, a mustached man with bandaged, perhaps amputated hands climbs a ladder, carrying a large fish—a symbol that often recurs. An organ-grinder, perhaps blind, blows a horn, and a clown (judging by his collar) pulls himself along on cutoff crutches, as his legs have been amputated at the knee. A blond girl displays a palm, as if soliciting coins for the organ-grinder, while holding a Punchinello doll with the other. A girl in carnival costume lies on the floor, her skirts flying, playing a kind of viola. A mandolin lies beside her. The interpretation of dreams is always intricate, and so far as I have been able to read in the Beckmann literature, we are more or less on our own to say what it all means, here and elsewhere,

in these strong, handsomely painted, unsettling works, including the nine triptychs upon which Beckmann's greatest reputation rests. He painted magnificently in the thirty years that remained to him, but it is impossible, because of the complexity of the individual works, to discuss in suitable detail the remarkable art he left us, so much of which is shown in what is, after all, a retrospective exhibition.

I shall, however, offer an interpretive conjecture regarding *Departure*, the great triptych Beckmann finished in 1935, with which visitors to MoMA have been long familiar. The central panel shows four figures in a boat: a mother and child, a king fishing with a net, and a mysterious personage wearing a strange headdress. There is a Fisher King in Arthurian legend, a maimed figure who lives in a bleak castle set in a wasteland, and I believe him to be the subject of this work. The Grail quester, Perceval, witnesses a strange procession in the Fisher King's castle: Young people carry a bleeding lance and a golden chalice that the knight later realizes was the Holy Grail, which could have healed the Fisher King—if only Perceval had asked what it was—while restoring the wasteland to fertility. The left panel shows, among others, a brutally wounded figure, with bleeding arm stumps tied together above his head. The right panel shows a blindfolded figure carrying a fish, and a couple bound together, one upside down. A passing musician beats a drum. Germany had been a wasteland in 1918; it was about to be a wasteland again. Two years after finishing *Departure*, Beckmann had the supreme honor of having his work displayed in the notorious "Degenerate Art" exhibition in Munich. The day after it opened, he and his wife left Germany forever, spending the war years in Amsterdam before coming to America. His art is the mythography of wounds.

September 15, 2003

Whitney Biennial 2004

Several of the recent Whitney Biennials have aspired to something more than a display of "the latest in American Art," to cite the phrase used to advertise the current show. They have advanced various theses on the state of American art, and of the American soul, so to speak, so far as that can be inferred from changes in artistic practice during the previous two-year period. This can really be the only justification these days for restricting a show to American artists. For there is otherwise not a lot today to distinguish between the art made by Americans and the art made by anyone anywhere else. The art world has been globalized like the rest of life, and the kinds of things one sees at the great international exhibitions seldom divide along national lines. This year, the opening of the Whitney Biennial coincided with the so-called Armory Show, installed on two long West Side piers—a kind of mall where upscale galleries from various countries displayed the artists they represent. The artists came from Germany, Scandinavia, China, South Africa, Latin America, and elsewhere, as well as from the United States, but their work was on view primarily for purposes of acquisition. The Biennial seeks, by contrast, to spotlight talent, especially the sort of talent that has yet to achieve recognition, and so only a few of the artists in Biennial 2004 were in the Armory Show. The Biennial artists of today are the Armory Show artists of tomorrow. The current Biennial, however, sees itself as "reflecting what may be seen as a reinvigoration of contemporary American art at a moment of profound change in our cultural

landscape," according to the museum's press release—and for that one must confine oneself to American artists, who in every other respect are part of the global scene and whose work fits seamlessly into art fairs like the Armory Show as well as into biennials in Venice and Istanbul, Johannesburg and Havana, São Paulo, Sydney, Shanghai, and beyond.

Let me briefly review some recent Whitney Biennials. The 1993 Biennial is the paradigmatic case of a show that engaged the moral consciousness of its visitors by emphasizing art that challenged it. The show offered a scathing depiction of American society, singling out for attack the injustices of class, race, and gender. The most memorable display was the already famous tape of Rodney King being beaten by members of the LAPD, and the spirit of the show was embodied in the controversial admission tags designed by Daniel Martinez, which bore all or part of the message, "I can't imagine ever wanting to be white."

Since the brave though flawed 1993 show, the Whitney has advanced its arguments less stridently. The 1995 Biennial was noted for a heavy representation of works exploring sexuality and the body, implying, again, that these reflected preoccupations in American society as a whole. The 1997 Biennial was far less monolithic and far more cosmopolitan than its two predecessors and conveyed no message about America that I recall. The defining work of the 2000 Biennial was a somewhat heavy-handed installation by Hans Haacke that assailed Rudolph Giuliani for attacking the Brooklyn Museum and compared him to Hitler. But the revelatory piece in the show was by Thornton Dial, a widely respected African-American "outsider artist" from Alabama, who was represented by part of a large multimedia work called *The Death of Princess Di*. What was interesting was less the fact that an outsider artist was included in the show than that no one would have known that *The Death of Princess Di* was by an outsider artist. It was perfectly imaginable that the same work could have been executed by an MFA candidate from Yale or RISD—not because it was so polished but because a lot of contemporary art had the raw, obsessive quality of outsider art. Since art schools no longer teach skills and MFA candidates have the option of making art any way

they choose, the boundary between the self-taught and the highly taught artist has all but evaporated. And so there was little reason for the show's curators to call attention to the fact that Dial was an outsider. The 2002 Biennial, for its part, was largely composed of little-known artists, selected because they were engaged in one or another quest for spiritual meaning, which reflected the mood of the nation after 9/11. Taken together, Whitney Biennials have not merely shown the latest in American art but also provided a register of changes in American attitudes over the past decade, as seen through our art.

The curators of the 2004 Biennial do have a thesis about at least the younger generation of American artists—namely, that they are in some respect interested in artists of earlier generations. This could imply a general thesis about American culture today, though the curators make no effort to draw this out. But it did lead them to design a show that they regard as intergenerational. "What conversation did you have about your conception of the Biennial before you began traveling around the country to visit artists' studios?" Tim Griffin, editor in chief of *ArtForum*, asked the show's three curators—Shamim Momin, Chrissie Iles, and Debora Singer—in a recent interview. "One thing we discussed from the beginning," Momin replied, "was that we wanted an intergenerational exhibition." The press release makes this intention explicit: "The exhibition [aims] to present prominent artistic trends in new intergenerational work," it states, stressing that "the intergenerational premise of the show is evident throughout."

Is this such a revelatory or even novel premise? The Armory Show displays artists from different generations as a matter of course. After all, earlier artists like Warhol and Mapplethorpe are greatly in demand. And most past Biennials showed work by artists of different generations as well, without this having been highlighted as a theme. What makes the "intergenerational" aspects of the 2004 Biennial special?

I suppose the argument here is that there is some kind of an internal relationship between the generations shown. "We all noted that younger artists are very interested in the work of older artists from the

'60s and the '70s. There is also renewed interest in the '80s," says Chrissie Iles. The intergenerational character of the show could be achieved by showing, alongside the younger artists, the older artists in whom they have an interest. And indeed this Biennial includes 1960s and '70s luminaries like David Hockney, Robert Mangold, Mel Bochner, and Yayoi Kusama, along with 1980s stars such as Robert Longo, Jack Goldstein, Richard Prince, and Mary Kelly. But the work of these veteran artists is not represented, as it would have been in past Biennials, to show what they have recently been up to, but rather to illustrate the ostensible interests of the younger generation, the real subject of the show.

The approach might truly be intergenerational if these interests were somehow manifest in their work. I can see how there is what curators like to call an "affinity" between Hockney as a portraitist and Elizabeth Peyton, whose work so far consists exclusively of portraits of pretty boys and girls. The drawings by Sam Durant (born 1960) of Black Panther demonstrations and protests at Columbia in 1968 can be explained through nostalgia for 1960s radicalism—but that is not the kind of intergenerationalism at issue. I'm not suggesting there is no evidence in the work of such artists of what their elders have done, but it does not exactly hit you in the eye. The work shows all kinds of interest on their part, save for the kind of interest the concept of intergenerationality would lead one to expect.

Griffin asks some hard questions in his *ArtForum* interview. "Is it somewhat unique that a younger generation interested in art, culture, and politics would turn to previous decades instead of dealing directly with the here and now?" And: "Given this kind of looking back, what would you say this show is articulating about today?" The curators answered, "It's specific threads coming together as a response to a moment in contemporary society marked by turbulent international politics and an economic downturn. But one critical aspect of that pervasive intensity, even anxiety, felt in the work is that there is a sense of the necessity of renewal and purpose in the work right now." Hence, I guess, looking back.

———

This is the kind of talk by art experts that makes ordinary people feel as if they know nothing about art. And there is scant evidence that this is what the art is about. Debora Singer concedes that "there isn't so much work within the exhibition with direct political commentary, but, especially among younger artists, you see different rhetorical strategies—more masked and coded. Things are not so issue-based on the surface." Momin states that "the engagement is weirdly distant and yet simultaneously more immediate." I don't believe this for a minute, and the older artists they are said to admire don't take up politics in their work, even in a coded fashion. This isn't an intergenerational show at all. Still, the premise did give the curators a reason to include some wonderful work by older artists.

Jack Goldstein's film *Under Water Sea Fantasy*, which he began working on in 1983 and finished just before his suicide last year, is six and a half minutes of pure beauty. Richard Hertz recently published transcripts of Goldstein's unhappy recollections of his life in the art world of the 1980s, along with interviews with many who knew him, in a sobering book, *Jack Goldstein and the CalArts Mafia*. The film is a visual poem of fire, water, sea life, and light, and I sat through it three times, trying to reconcile its vision with the whining self-pity that comes through in Hertz's text and marveling at the disconnect between artists' lives and their works. I have twice written about Robert Mangold's brilliant *Column Paintings*, in which two or more sine curves enact a dance that integrates into their movement the edges of the sharply vertical panels in which the action takes place. Mel Bochner's new works, which I like to refer to as "thesaurus paintings," consist in synonyms of the word that gives them their title, like *Nothing*, *Mistake*, *Meaningless*, and others, all of which appear to belong to a philosophical, not to say metaphysical, vocabulary, whereas their vernacular synonyms can get pretty down and dirty. The words, separated by commas, are painted in neat capital letters, each in a different color, in rows across black canvas, which progressively empty the initial word of its portent while saying the same thing in more down-to-earth terms. In the painting called *Nothing*, the word NOTHING gives way to NEGATION, NONEXISTENCE, NOT-BEING, and NONE—and the vocabulary gets slangier and more vulgar—ZIP,

ZILCH, NIX, SQUAT, DIDDLYSHIT, GOOSE EGG, BUBKES—
ending with PFFFT. The terminal comma hints that the list can go
on. *Nothing* should be made into posters for your favorite existen-
tialist's study, and *Meaningless* would be just the thing for a logical
positivist. Nobody—NO-BODY—in any generation is in Bochner's
league when it comes to playing what logicians call use against men-
tion in logical tableaux.

It's not easy to generalize about the younger artists, in large part
because it's not easy to discern what they are getting at as individuals.
I often accept invitations as visiting critic to one or another graduate
school of art, mainly in order to find out what those about to enter the
art world are thinking about. This varies from year to year, but it also
varies from student to student. The students know a lot about what is
going on in the art world, visiting shows, reading the art magazines,
listening to talks by the artists who get invited to address them.
Mainly they have their own ideas and are finding ways to express
them in visual terms. They read a lot but often selectively—their bib-
liographies are defined by what they are looking for. Their knowledge
tends to be extremely esoteric, making it difficult to know what
thoughts are embodied in their work—much less to address their
work critically—unless you spend some time with them and learn
what they are trying to do. They're informed about the art of others,
but they're less inclined to appropriation than to allusion, as in litera-
ture, where part of understanding the text consists in understanding
what the allusions mean. There is a lot of "intertextuality," as a liter-
ary critic would say, but not all of it is "dialogue" and not much of it is
significantly "intergenerational." That means that viewing the work
of young artists is like trying to project some hypothesis as to what it's
about: One must infer the best explanation of what one is looking at
and then do one's best to confirm it by looking closely. No one should
be required to read an exhibition catalog, but clearly written wall
texts, decoding and unmasking, are these days as indispensable as sub-
titles for films in languages one does not understand. And, contrary to
Singer, the meaning of the work in the current Biennial is usually
harder to pin down than "issues of civil activism or issues of sexuality
or critiques of mainstream American cultural conservatism." To be se-

riously interested in such issues is inconsistent with concealing them by way of Aesopian strategies. If the work is so transgressive, it's been masked so successfully that the Biennial has received high praise from critics who attacked previous Biennials for being mired in politics rather than aesthetics.

Although a handsome production, the Biennial catalog is a glaring example of the inflation that has overtaken that genre of publication. It is more a souvenir of the occasion than anything of great use to the viewer, and the editors have chosen to include in it an anthology of writings by Borges, Anaïs Nin, Samuel Delany, and others who may have inspired the curators but are of little use to anyone else. With the accompanying box of ephemeral works by the exhibitors, it must have been extremely costly to produce for something of so little utility. Ideally, catalogs should aspire to the utility of guidebooks—something one can carry through the show, giving visitors what they need to know, with small illustrations for identification and mnemonic purposes. At the Armory Show there is always somebody watching the shop at each of the galleries, someone who can answer questions and talk with you about the work if things aren't too busy. The art at the Biennial is generally less familiar and often more difficult than what you would have seen on the piers. The 2004 Biennial is more opaque than its recent predecessors, and that opacity is reflected in the thought behind the catalog. The art is pretty interesting, though usually for reasons other than those the curators would have us believe.

May 17, 2004

John Currin

ew of the good things that reward the rising—or risen—young
artist have not fallen to John Currin in recent days. He is the
subject of a widely celebrated mid-career retrospective at the
Whitney Museum of American Art. Ecstatic "I told you so" reviews
appeared in *The New York Times* and in *The New Yorker*, the latter accompanied by a portrait of the artist by Richard Avedon. According to
a headline in *The Times*, he has "startled" the art world by switching
dealers, from Andrea Rosen to Gagosian, one of the toniest galleries in
the hierarchy. In 2002 a 1995 painting of the sort that once provoked
critical rants went for $427,000 at Sotheby's; on the private resale market, his prices have shot up to $600,000. And he has achieved all this as
much in spite of his work as because of it. Over the past decade, Currin's paintings of startlingly busty young women in miniskirts and
tight blouses have aroused the ire of a dour and censorious art establishment, which had marginalized painting as a medium, vilified
the "male gaze," and monitored political incorrectness with a near-
Victorian zealousness. His earlier detractors have now joined the chorus of his admirers. But what particularly impresses me is that he has
evolved from the role of Bad Boy of the art world into what very few
contemporary painters have the gift, let alone the taste, to aspire to—a
master of high Mannerist aesthetics. At a time when most of his contemporaries would cite Warhol, Duchamp, and Nauman among their
influences, Currin invokes Bruegel, Cranach, and Parmigianino.

"Mannerist" has typically been used as a pejorative, ever since

Mannerism was accepted as a genuine art-historical period of the sixteenth century, covering the art and architecture produced mainly in Italy from the High Renaissance till the advent of the Baroque. It is, according to *The Grove Dictionary of Art*, "the most willful and perverse of stylistic periods." What I find astounding is that in little more than a decade, Currin should have outgrown the aggressive thrift-shop style of his early portraits to become a virtuoso of a style and manner that would have been admired in Ferrara or Parma in the 1550s—and that Mannerism, with its artifice and virtuosity, should of all things define one of the brightest art stars of the early twenty-first century!

Being photographed by Avedon is one of the ordeals of celebrity, but the portrait by Todd Eberle, which *The Times*, in announcing his ascension to the Gagosian Gallery, reprinted from *Vanity Fair*, is a wonderful study of the Mannerist in his studio, rather than a mere demonstration, as in Avedon's case, of the photographer's will to power. It was taken in 2000, and as it is almost a key to reading Currin's pictures, the artist must have had a say in how he was to be shown. He stands between two easels, on one of which is a painting—the haunting *Sno-Bo* of 1999—and on the other is a mirror, which shows the artist from behind. The facial resemblance between Currin, with his boyish good looks and longish hair, and the delectable young woman in the painting is remarkable. It confirms his claim, often made in interviews, that he uses his own face as a model. That does not mean that the painting is a Self-Portrait of the Artist as a Young Woman—but his placement between mirror and painting is certainly an allegory of painting as he conceives it. On the ledge of the easel that holds the mirror, Currin has placed the open-toed red platform shoe with rope soles and long laces that Sno-Bo is wearing in the painting—and the puddle of reddish pigment on the glass palette is meant to tell us that he has been at work. The floor is strewn with the carefully placed magazines that Currin uses for models when he does not resort to his own features—*Cosmopolitan*, a girlie magazine, and two others I am unable to identify. Like everything in the photograph, they serve as signs. Currin's pants are smeared with white paint, which could be explained with reference to the fat snowflakes in the

painting. But Currin cannot be a sloppy painter, and the snowflakes are carefully dotted across the surface.

We know, moreover, that he wore paint-smeared pants on his first date with the artist Rachel Feinstein, whom he was to marry. "Whatever I wore," he said in an interview, "I am sure it was calculated . . . As the pretext of meeting her was that I was going to paint her, then that was the message." Everything in the photograph—like everything in the paintings—is calculated. Standing in the studio, Currin points, like a figure in an allegory by Bronzino, to a clue. In this case, the clue is his wedding band. The photograph tells a story. The painting is to be explained with reference to his marriage.

Let's leave the photograph, which you can find on the Internet, and pay attention to the painting, which I adore. *Sno-Bo* is a pendant to Currin's *Hobo*, the difference being mainly that in *Sno-Bo*, the charming vagrant stands daydreaming in the snow, her left foot resting on what would be a fork in a branch, except that it belongs to a shepherd's crook, which Sno-Bo uses as a staff to help her over her life's path. Her left elbow rests on her raised knee. Like her counterpart in *Hobo*, Sno-Bo is carrying a sack with what we presume are her worldly belongings. She is bent forward and to one side, so that her defenseless breasts hang softly down, above her vulnerable little belly. Despite the snow, she does not seem to suffer from the cold. She wears a bright smile, and her pensive eyes sparkle. She is clothed in the sheerest of pink intimate garments, something ordinarily to be worn in warm bedrooms. A tiny kerchief is tucked into a gold chain about her waist. Her sister figure Hobo also has a gold chain, with jewels, a blue ribbon tied gaily to her wrist, and her purse hangs from the fork in her walking stick. She wears a sheer sleeved blouse and panties so transparent that her pubic hair can plainly be seen.

The two figures are exceedingly mysterious. "I was interested in the silvers, the silvery-ness, and the see-through clothes," Currin says. "That was the big joke: It's a homeless person with beautiful see-through lingerie and bedecked in jewels." *Hobo* and *Sno-Bo* could be panels—say, summer and winter—in a Mannerist boudoir, the way

Boucher's paintings of the seasons decorate Madame Pompadour's boudoir, now in the Frick. They are erotic paintings that imply larger meanings. The women are protected by their beauty against the harshness of the world. The images imply the world's harshness by indirection. As paintings they have the power to hold us in front of them, contemplating meanings too fragile and remote for application to life, like the kinds of visions a wizard in Shakespeare is capable of summoning into momentary being for someone's entertainment—interludes in life. There are certain things that belong to art alone.

One of Currin's earlier paintings is called *The Wizard*. A man with cartoon features, looking something like a ventriloquist's dummy with thick lips and false eyelashes, palpates a young woman's immense breasts, wearing what look like tight black rubber gloves. His eyes are closed; her eyes are either downcast or gaze downward at her extraordinary bosom. It is difficult to tell whether the man is kneeling or the woman herself is gigantesque. There is a lingering question as to what exactly explains the title of the work, but I can think of a way of reading the work that does. If he is a wizard, then he has worked his magic on the woman, making her dream of large breasts come true. It may seem presumptuous, if not offensive to certain sensibilities, to suggest that it is her dream, not the Wizard's. Yet the picture is part of a body of works that project a world where women are proud of such breasts, measure them, and admire other women who have them. After *The Wizard*, men all but disappear from this world.

The Wizard was painted in 1994. Within just a few years, Currin began showing the paintings that won him notoriety. *The Bra Shop* and *Jaunty and Mame*, both of 1997, show women with breasts like beach balls, which stretch their sweaters or blouses past the point of safety. The women measure one another's bosoms or purchase the heavy-duty bras their amplitude demands. They look demurely pleased with the bodies nature bestowed upon them, but their faces are coarse and silly. It is a Mannerist touch that the paired females evoke a Visitation, a painting where two women—actually Mary and Elizabeth, the mother of John the Baptist—are shown meeting. It is easy to see how these paintings gave Currin a sexist reputation and seemed in general misogynistic and mean-spirited. They are aggres-

sive paintings, and women often felt infuriated upon seeing them.
Perhaps they were intended polemically, as a defense through offense
against the charge that painting as such is sexist and the province of
machismo. They certainly could not be simple fantasies of a male
fetishistically fixated on big boobs. Currin could not have been turned
on by the women in his paintings. He is someone with a singularly re-
fined sensibility, as is clear from his more recent work. But I am
struck by the fact that his critics and commentators alike have used
these grotesqueries, rather than the silvery Mannerist paintings, to de-
fine his project as an artist. That blurs the amazing shift in direction
that his work took around 1999. The earlier work required a suppres-
sion of the painterly impulses that have emerged. To use a distinction
framed by Hilton Kramer in deprecating Philip Guston, it is far easier
for a mandarin to become a stumblebum than the other way around.
Anyone can go to seed, but one cannot become a Mannerist as a mat-
ter of stylistic decision. One has to allow talents to show that have
been held in check all along.

The catalog places an exquisite portrait that Currin painted of his
wife in 2002 as a marker, dividing the plates into two sets that could
for the most part have been done by two different artists, so far at least
as painterly touch and pictorial manner are concerned. It is called
Rachel in Fur, and it has an almost porcelain translucency. Rachel
looks calmly out from behind huge hexagonal sunglasses, her pale lips
composed in a quiet smile. The fur looks deep, opulent, and luxuri-
ous: One sees its warmth and softness. The proportions of the face
have an ethereal oddness—the forehead is high and wide, the chin is
small, and the neck has been borrowed from Parmigianino. The
plates that follow, though for the most part they reproduce paintings
done slightly earlier, use another species of woman altogether, Man-
nerist creatures all, sprung from painting rather than copied from life,
undeniably erotic, but made of something beyond flesh, and looking,
as painting, more as if their habitat were the *Wunderkammer*—the
cabinet of wonders where sixteenth-century princes displayed strange,
rare, and beautiful objects—than the museum of fine arts. They em-
body the aesthetics of miniatures, executed with the finest brushes on
the smoothest surfaces.

A case in point is the astonishing *Pink Tree* of 1999. Two golden nude women are painted against a pair of bare trees whose branches have been sawed short, as if pollarded. The background itself is black, as in a painting by Cranach of goddesses, and the blackness transforms the flesh into something effulgent with its own light, like a celestial substance. The Mannerist body was typically elongated, with unusually small heads. Currin's women have these elongated figures, but he has given them disproportionately large heads on thin necks. They have luminous blond coiffures and strange yet perfect features. The woman on the right is smiling and has an ampler body than her partner. The two women touch, and there is in effect a choreography of hand gestures, but what is going on between them is anybody's guess. It could be a lady and her handmaiden or confidante—Phaedra and her attendant, say. (If it were a real Mannerist work, it might be Electra and Clytemnestra.) Who would have expected to see artifice like this in an age like ours? Such painting implies a court, the murmur of poetry, the sound of lutes, the discourse of fine ladies and chivalric suitors.

Stamford After-Brunch, probably Currin's masterpiece, brings us abruptly back to where we live. Three spoiled young women sit in their snug suburban living room, merrily clinking martini glasses and smoking big cigars. A wintry landscape, seen through the window, underscores the security of their lives. They have wonderful animated expressions, as if they have been sharing gossip or revealing naughty secrets. There is something comically wrong in the drawing of the figure to the right—the chief conspirator, one feels. Her butt goes back and back, straight out of the picture. It could make an erudite allusion to a Venus Callipygus—Venus with enlarged buttocks. Or it could mean something else. "The distortions of my figures do not originate from illustration. They come from my first drawing attempts whose inherent flaws and rhythms I try not to correct," Currin once explained. "My main concern is shaped from, partly, an abstract point of view while keeping it believable and keeping the graphic rhythm. I also find it intriguing and humorous." I don't think the bosoms are

believable in the controversial paintings of 1997, nor are they flaws in draftsmanship. They were willed. But here, the elongated butt serves as counterweight to the girl's large head, enabling her to bend forward, toward her pals, without falling over, though it could, if intentional, make a moral comment. With her cigar, martini glass, and head cloth covering her rollers, one supposes the young lady thinks she is pretty hot stuff. That tail carries away part of her sophistication while it enables her to keep her balance.

Currin is often compared to Norman Rockwell by critics who consider this the supreme put-down. I to the contrary think it shows how good Rockwell really was. But there is an edge to such paintings as *Stamford After-Brunch* that would be entirely foreign to Rockwell. This is nowhere more evident than in the strange *Thanksgiving* of 2003. Three festively dressed women are gathered around a table like a coven of witches, with some pieces of fruit, a few roses in a glass pitcher, and an immense uncooked turkey. The turkey appears to be thawing—it sits in a puddle of pink juice. One of the women offers a spoonful of this exudate to another, whose mouth is wide open, as if about to receive the sacrament. The scene is set in a dark and opulent room, with columns, beams, and an unlit chandelier. The two younger women are sisters, so to speak, of Parmigianino's *The Madonna of the Long Neck*. The older woman has exactly the coiffure of the heroine in Caravaggio's *Judith Beheading Holofernes*, which may be a clue to its meaning. The painting cries out for the kind of interpretation that Erwin Panofsky once gave of Bronzino's *Venus, Cupid, Folly, and Time*. It is an optimistic work in the sense that the artist evidently believes there exists an audience out there of the kind Bronzino could count on to enjoy unriddling allegories while admiring the craft. I find this confidence in the collaborative intelligence of the art world inspiring, if utopian.

February 2, 2004

Dieter Roth

Three years ago I saw a work by the late Swiss-German artist Dieter Roth that so captivated me that I am determined to write a book just to be able to reproduce it on the jacket. It consists of twenty sausages in assorted sizes, hanging, as in a German butcher shop, in two rows, and is titled *Georg Wilhelm Friedrich Hegel: Works in Twenty Volumes*. Roth had removed the labels from the individual volumes in a matched set of Hegel's *Werke* and pasted them onto corresponding *Würste*. Much as I admire Hegel's *Lectures on Aesthetics*, it was delicious to see its two volumes chopped into bits, stuffed into casings, and displayed as what Roth called *"Literaturwurst."* It was a witty critique of metaphysics that might have caused even those of my professors who were logical positivists to break into thin, sarcastic smiles.

The only piece by Roth I recall having previously encountered was a cheese book—part of a Fluxus collection that had been acquired by the Getty Foundation from the estate of Jean Brown, an avid enthusiast. A Getty official ushered me into a roomful of largely unclassifiable objects randomly placed on steel shelving. It is a tribute to Roth that his is the only piece I remember. He had flattened a lump of blue cheese in a plastic folder, clasped in a simple cheap binder. I regret never having seen Roth's legendary 1970 exhibition at the Eugenia Butler Gallery in Los Angeles, which consisted of thirty-seven suitcases in assorted shapes stuffed with various cheeses and called *Staple Cheese*—a play on "steeplechase" to which Roth added "(A Race)" in

case someone missed the point. In the nature of things, the art was at-
tacked by flies and maggots, and the stench is reported to have been
unendurable. I only read about it in *ArtForum*, after Roth's death in
1998.

None of these avant-garde creations prepared me for the impres-
siveness of Roth's oeuvre as a whole, on view at MoMA-Queens and
P.S. 1. If I'd been asked to imagine what an exhibition of Roth's work
would look like, I would have supposed something like that room at
the Getty—a jumble of eccentric odds and ends, very few of which
would have been seen as works of art before 1960. To my surprise and
delight, the author of the cheese book turns out to have been one of
the masters of twentieth-century art.

Specialists have employed a German term—*entgrenzen*—to de-
scribe Roth's procedure as an artist. It means, roughly, to overcome
boundaries. Roth's personality was such that if he encountered a
boundary, he would find ways of eliminating it. Fortunately, he came
of age in the 1960s, when the spirit of *Entgrenzung* flourished as never
before. Later in the decade, *Entgrenzung* would spread from art to
politics, with the rise of movements challenging boundaries of race,
gender, and sexuality. But its initial impulses were artistic and can be
traced to Marcel Duchamp, whose "ready-mades" blurred the bound-
ary between works of art and commonplace objects like snow shovels,
bottle racks, metal grooming combs, and urinals. The next important
figure in the history of *Entgrenzung* was John Cage, whose project was
erasing the boundary between music, as traditionally defined, and the
racket of ordinary life: sirens, coughs, static, whispers, farts. Cage's
composition students at the New School—the cadre of the Fluxus
movement, led by Cage's visionary protégé George Maciunas—went a
step further, seeking to erase the boundary between life and art. By
the end of that revolutionary decade, there were few if any boundaries
left to overcome in art, or for that matter in life.

I have tended to regard boundary erasure in art as largely a Man-
hattan contribution—downtown through Cage and uptown through
Dr. Suzuki's seminar in Zen at Columbia—but I now see that it was
part of the spirit of the times. Roth was a gifted designer with ad-
vanced tastes, dedicated at first to Constructivist graphics and concrete

poetry, but he had a need for something even more radical, which he found in the work of Jean Tinguely, a fellow Swiss. It has been said that the decade was dramatically inaugurated when, at the opening of Tinguely's exhibition at MoMA in 1960, his construction, *Hommage à New York*, self-destructed in the museum's garden with a lot of smoke and clatter. Roth met Tinguely later that year in Basel. "Everything was so rusty and broken and made so much noise," he said of Tinguely's work, likening it to "a paradise that I'd lost."

It's tempting to see Roth's mature work as an effort to re-create that lost infantile paradise by way of detritus, noises, and noxious smells. "Paradise Regained" would have been a fitting title for the Roth retrospective in Queens. What one feels is that he turned his entire life into art and created, through his unmatched ludic power, a world of amazing compilations that, like a natural wonder, takes one's breath away.

L ike his peers in Fluxus (a term coined by Maciunas), Roth was reacting against the repressive aesthetics of Modernism, a project that received its clearest formulation in Clement Greenberg's 1960 essay "Modernist Painting." Greenberg's view was that each art is defined through the medium specific to its practices, and that under Modernism each art is obliged to purge itself of everything alien to its essence. In painting, this meant the elimination of illusion, since the painted surface is essentially flat. The ultimate aim was to achieve purity. In a sense, Roth's Constructivist works were thoroughly Modernist in impulse, exhibiting the clarity of pure design. What Tinguely opened for him was a paradise of impurity, a world of infinite mess— just what he needed to break out of the ascetic order of Modernism.

In 1967 Roth began to craft what he called "Islands," made out of kitchen scraps, which he nailed to panels painted blue. He was living in Reykjavík at the time, and his inspiration was evidently the Westman Islands off the southern coast of Iceland. Just a few years earlier, the world's newest island, Surtsey, had emerged abruptly in the Westman configuration and become a kind of natural laboratory, in which the coming of life could be observed taking place. Roth doused the

food scraps with sour milk or yogurt and poured plaster over the whole. In no time at all, mold formed, decay set in, and the insects that Roth called his "collaborators" arrived. One might say that "Islands" embodied the spirit of Fluxus in visibly decaying into pools and puddles of slime. And for some years thereafter, Roth experimented with use of food as his medium, making prints out of squashed bananas and exploiting milk, sausage, cheese (of course), and above all chocolate, counting in each case on the processes of rot and decay to help life turn into art—and vice versa.

With his renunciation of beauty as an aesthetic goal, Roth exemplifies what I call the Intractable Avant-Garde. It was one of the marks of Modernist aesthetics to believe that however difficult, however ugly, a work of art will in the end come to be seen as beautiful. The Intractable Avant-Garde rejects this consoling wisdom. Roth once said that the moment something threatens to become beautiful, he stops. He was after a different aesthetic altogether in *Staple Cheese (A Race)*. Or take his *Tibidabo—24 Hours of Dog Barking*, a recording of a dog pound on Monte Tibidabo in Barcelona. It's hard to imagine anything more obnoxious than the uninterrupted barking of dogs, and sustained exposure does not make it more beautiful. What, then, is the work about? In my view it is about freedom and the cruelty of keeping dogs penned up.

Decay appears to be a major theme in Roth's work, but he professed to have little interest in it, except insofar as it enabled him to render "the processes of change visible." Consider, for instance, his innovative use of chocolate. Other artists have been interested in chocolate as a subject. Joseph Beuys's first multiple was a block of chocolate evoking the privations of World War II, when chocolate carried the meaning of warmth and subsistence: The U.S. Army D ration was a block of chocolate much like his. In her 1992 work *Gnaw*, Janine Antoni used chocolate as a visual metaphor for love. For Roth, by contrast, chocolate was both a subject and a medium in its own right. It connoted mess, and he was not indifferent to its resemblance to excrement (another of his materials), much in the way that Karen Finley smeared herself with chocolate as an emblem of female degradation. His signature work is a bust of himself cast in chocolate. Sometimes

he mixed the chocolate with birdseed, so that it might enter the food chain when pecked to nothingness. More spectacularly, he built towers of these chocolate busts, placing five of them at the corners and center of a pane of glass, laying another pane on top of these, placing five more busts on this, until a tower of chocolate heads would reach a certain height. The work is titled *Self Tower* (*Selbstturm*). In one of the inner galleries of the MoMA show, the sweet smell of chocolate forms an olfactory aura around a *Self Tower* built for the occasion. (There is also a tower of self-portraits as lions, also in chocolate.) Inevitably, the weight of the upper shelves pressing down would crush the heads on lower shelves. The glass itself might shatter. "Fluctuations in room temperature, insect activity, and changes in humidity expose the sculptures to a steady process of decay," the catalog states. "The ravages of time should not be arrested. The towers are left to deteriorate at the artist's own wish."

Readers might jump to the conclusion that the exhibit is a depressing affair, a riot of disgusting sensations, not for the faint of heart. In fact, the show is absolutely exhilarating, so full of exuberance, antic invention, and the joy of unhampered creativity that it lifts the spirit like little else in recent memory. The first work one encounters at MoMA is a late tapestry portrait of Roth, seated in his studio. He's wearing a cloth cap and jacket and what looks like a neckpiece in the form of a lobster, and seems engaged in a piece of embroidery himself, spread across his knees. He's surrounded by the jumble of his studio, which increasingly became the motif of his art. The critic Alfred MacAdam said that Roth's work reminded him of Courbet's masterpiece, *The Artist's Studio*, in which the artist portrays himself seated at the easel while a model looks over his shoulders and all his subjects surround him.

Large Tapestry, a collaboration between Roth and the weaver Ingrid Wiener, is a brilliant example of the principle of overcoming the gap between life and art. Tapestry is inherently a collaborative enterprise. As a general rule, the weaver is seated before an upright frame, strung with the vertical warp threads. The artist first prepares a so-called cartoon—a drawing the size of the intended work. This is placed behind the warp, and the artisan, who sees through the warp

threads, reproduces the cartoon by means of the colored woof threads. Instead of drawing a cartoon for *Large Tapestry*, Roth sat behind the threads, in effect turning himself into the cartoon.

Wiener worked on *Large Tapestry* from 1984 to 1986. Needless to say, Roth could not have sat still for two years. This left a great deal up to Wiener, who had to keep changing the tapestry to reflect the changes in her subject. Roth compared her work to that of Homer's Penelope, who unwove the day's work every night. Roth and Wiener did not so much unweave the tapestry as unweave and reweave life, accommodating the changes in the work.

As Roth's life and art became increasingly intertwined, the studio became medium and subject. Behind the *Large Tapestry*, one sees some of his late work, which, whether standing on the floor as sculpture or hanging on the wall as painting, are composites of paint boxes, brushes, cans, bottles, pictures, scraps of writing, drawings, crayons, pencils, frames, a toy ukulele, drafting tools, rulers, smears and slathers of pigment. They are made of what they are about, with little reference to the world outside the studio. It is difficult to think of another oeuvre centered quite so solipsistically on the materials and processes of its own production. *Cellar Duet*, for example, is an assemblage of tapes, with music by Roth and his son Björn, together with keyboards, players, recorders, amplifiers, toys, wires, again painted into a messy unity with artists' materials and whatever odds and ends lay ready to hand. In their clotted heterogeneity, these resemble Robert Rauschenberg's work of the 1950s, but obviously the impulses differ.

At P.S. 1 there is an even more startling example of Roth's transformation of life into art. His studio floor, one of the five large sculptures on display, has been turned on edge and placed against the wall. It becomes, in effect, an immense mural, self-mapping Roth's working space, the varying density of the drips and splatters documenting where the activity of painting was at its most and least intense. In *Solo Scenes*—an installation of 131 stacked video monitors—we see the artist at work, asleep, on the john—a fly's-eye view of Roth padding

back and forth, drawing, shaping, going about his life over a period of six months. Another work consists of eight projectors continuously showing slides of houses in Reykjavík, thirty thousand in all, each with a different building. Image rapidly succeeds image, the carousels clacking away, and though one could, in a sense, see the whole of Reykjavík if one remained in the room long enough, it would be a curiously empty and even dispiriting experience. The capital is shown without inhabitants, and it is ambiguous as to whether its meaning is that the populace turned its collective back on Roth or Roth simply excluded them from his vision. It is in any case a detached portrait of a city, one building at a time, made by someone who shows no sign of being part of the place—though one of the houses must be where he himself worked and lived and raised his children with a woman he loved.

P.S. 1 is also exhibiting what must be Roth's masterpiece—his *Garden Sculpture*, on which he worked off and on from 1968 until 1996. It is a kind of *folie*, which may have begun as a platform, a place to sit outdoors beneath the stars, to which disparate parts were added— ladders, wheels, windowpanes, lengths of dressed lumber, a whirligig, video monitors, potted plants—in a whole of rickety monumentality. It comes with its own workshop, including power tools and rows of electrical cords, as if Roth had become obsessed by a project whose purpose he had long ago forgotten. It feels like a three-dimensional realization of one of Leonardo's unfathomable drawings, or an outdoor model cobbled up out of scavenged fragments. Kant speaks of art as implying purposefulness without any specific purpose, and this characterizes *Garden Sculpture* to perfection. For some reason, Bosch's title *Garden of Earthly Delights* crossed my mind.

May 31, 2004

Banality and Celebration:
The Art of Jeff Koons

I am inclined in my aesthetic judgments to think as the true Kentuckian about whiskey: possibly some may be better than others, but all are aesthetically good. —Charles S. Peirce

I t is widely acknowledged that Jeff Koons is among the most important artists of the last decades of the twentieth century. No representative collection of contemporary art can fail to include one or more of his instantly recognized works. As with every artist, some works are more important than others, but the basis of his importance lies in the general character of his oeuvre as a whole. There is nevertheless little consensus as to how this character is to be identified, or on what basis his importance rests. Those in position to clarify this matter—the major critics of the age—are virtually to a person hostile to the work and even to Koons himself, who seems to have a gift for getting under everyone's skin, as much through his flat oracular pronouncements, which challenge one or another of the commonplaces through which the critical establishment likes to answer questions of this sort, as through the works themselves. As I was writing this essay, *The New Yorker* magazine—the cynosure of cosmopolitan sophistication—airily labeled him a charlatan. So it is not as though we can appeal to what the Institutional Theory of Art sometimes calls the Art World—a loose federation of critics and other experts who decree which objects are works of art and which artists are important. For if we were

to poll its members, we would encounter a fair amount of resistance to the idea that Koons is anything more than a clever opportunist who has pulled the wool over the rest of the Art World's eyes—the kind of thing that has been said of artists whose work made experts uncomfortable since the dawn of Modernism. That by itself would be evidence of his importance, if we reflect on how his predecessors were at first received. But surely some better answer must be forthcoming, and my purpose here is to help explain what makes Koons the important artist that he is.

Part of the answer is art-historical, if we think of art history as progressive in the way the history of science is. The conceptual development of art from Duchamp through Warhol to Koons is like the punctuated evolution of science from Galileo through Newton to Einstein. But part of it has to do with Koons's objects themselves, because of the achievements of his two main predecessors, we are prepared to accept as art now, and more like what I think of as items of manufactured ornament. They are like, or often like, objects one might encounter not in art galleries, or at least not in galleries of high art, but in gift shops—objects made to be given because they are engaging or amusing or sentimental: cute animals, pudgy pink children, comical figures doing various comical things. It is this aesthetic that drives critics, who see themselves as priests and missionaries of high art, crazy. But the objects must have some appeal to a large number of people, or they would not exist. They are not as a general rule useful, not unless they have clocks or thermometers or calendars as appendages. But they appeal to a very wide taste, and Koons might well say that the taste itself is all but universal in modern life. They appeal, one might say, to everyone who has not, to use a phrase Wittgenstein used in a parallel way in discussing philosophy, been corrupted by high art. Everyone likes Koons's work, Koons himself might say, unless they have been taught not to. Since people interested in high art have indeed been taught not to find merit in the banal exemplars of kitsch that are Koons's paradigms, there is bound to be a conflict in their souls—they like and hate Koons's work at the same time. But ordinary persons have no difficulty liking it since they feel no such conflict. Koons has found a way of making high art out of low art—but in

a way that would not have been a possibility until the conceptual rev-
olutions of Duchamp and Warhol, and that accordingly links these
artists in the progressive series that I noted.

Still, something like the conflict that Koons's situation exemplifies
today has been implicit in the structure of art since artistic production
took two directions, high and low, appealing to different markets,
which began at some point in the nineteenth century. Accordingly, it
is instructive in discussing what I call the politics of taste to situate
Koons in that historical perspective. The fictions of the American
writer Henry James made frequent use of artists and persons whose
lives were defined through some relationship to artists, and I have
found it valuable to use James as a guide, for his art world was in cer-
tain ways strikingly similar to the art world we inherited, even if there
would have been no way he or his readers could have visualized the
art of the twentieth, let alone the twenty-first, century. Indeed, there is
an artist in James's early story "The Madonna of the Future" who re-
sembles Koons sufficiently to serve as a model against whom we can
get a clearer picture of Koons's actual achievement. "The Madonna of
the Future" is one of my favorite stories, and I even appropriated
James's title for one of my books. There are obvious reasons why, if
there were real artists in the history of art who resembled James's
character, they would be entirely forgotten. What is important for my
purposes is that one of James's artists defines a type to which Koons
belongs.

In his story, James juxtaposes two types of artist, neither of whom
quite belongs to the historical moment in which his story was writ-
ten, though each defined a margin of the art world of its time and
place—Florence in the latter half of the nineteenth century. One is an
American expatriate of advancing years and meager means named
Theobald, who immerses himself so deeply in the art of the city's great
past that he has all but lost touch with the living present. He has set
himself the goal, as painter, of equaling Raphael's *Madonna of the
Chair*, which in James's time was considered the supreme ultimate of
artistic attainment. It was not, of course, Theobald's intention to copy
that masterpiece: The grand museums of Europe were filled with
skilled copyists, producing satisfying likenesses of famous master-

pieces for the tourist trade, and the parlors of the upper bourgeoisie in America were as likely as not to feature a copy of this sentimental favorite brought back as a cultural trophy. Theobald's aim, rather, was to produce a Madonna of his own, like Raphael's only in achieving the same degree of spiritual depth. James's somewhat callow narrator is skeptical not so much of the artist's skills as of whether such an achievement is possible in modern times. Artists live when they live and not at some other time. "People's religious and aesthetic needs went hand in hand, and there was a demand for the Blessed Virgin, visible and adorable, which must have given firmness to the artist's hand. I'm afraid there is no demand now."

The narrator is no less skeptical of James's other artist, who gives the public precisely what it wants from art. He fashions comical statuettes—erotic allegories in which a male monkey and a female cat, respectively dressed as man and woman, engage with one another in varying postures of licentious interaction. "It is not classical art, signore," the artist concedes, "but between ourselves, isn't classic art sometimes rather a bore?" He assures the narrator that his works have enjoyed great success. "They are especially admired by Americans. I have sent them all over Europe,—to London, Paris, Vienna! You may have observed some little specimens in Paris, on the Boulevard . . . There is always a crowd about the window."

Each of James's artists is unfazed by the contingencies of history with which James himself was obsessed. "There is always a demand!" Theobald insists of Raphael's version of female beauty. "That ineffable type is one of the eternal needs of a man's heart." So the demand would be there if the right artist came along—but "how should it appear in this corrupt age?" But the cat-and-monkey artist—we are not told his name—is equally convinced of the timelessness of his motifs. In his view, the work even embodies a philosophy. "Speaking, signore, to a man of imagination, I may say that my little designs are not without a philosophy of their own . . . Cats and monkeys—monkeys and cats,—all human life is there!" And he points out that he has invented the "peculiar plastic compound" in which they are cast: "Delicate as they look, it is impossible they should break . . . they are as durable as bronze."

James uses his artistic types to represent what is wrong with the period in which he as well as his characters live. Even if Theobald should fulfill his intention completely, the age would reject his masterpiece completely: Raphael's aesthetics belongs to the unrecoverable past. Theobald's vision is too exalted for the crassness of the age. What belongs to—what defines—the present age is precisely the animal couple cast in the synthetic material. If those flirting amorous beasts are art, the age is hopeless. Its hopelessness is demonstrated by the popularity of the cat-and-monkey figurines. One must respect James for considering them art at all. In his day, the cat-and-monkey theme was realized in ceramic figurines, which would at best have been considered amusing bits of bric-a-brac, hardly to be mentioned in the same breath as *The Madonna of the Chair*.

When I discussed Jeff Koons's work with him in his studio not long ago, I asked what response he hopes his work will have. His hope, he told me, is that viewers will become confident of their own judgment and taste. This is a theme that comes up over and over again in his interviews and writing. In speaking of the work in his 1991 show, *Made in Heaven*, at the Sonnabend Gallery in New York, he told the Canadian critic Robert Enright that "it is based on my viewing the Masaccio painting, *Expulsion from Eden*. I tried to remove bourgeois guilt and shame in responding to banality and dislocated imagery. The best vehicle for me to be able to do that is to operate on the level of sexuality." And he adds, "The work wants to meet their needs. It wants to meet their needs and create new needs which they would be dependent upon art to meet. I am trying to make art be competitive in our competitive society." In a text he composed for the catalog of his 1992 exhibition in San Francisco, he wrote, again about the *Banality* works: "I was telling the bourgeois to embrace the thing that it likes, the things it responds to: For example, when you were a young child and you went to your grandmother's place and she had this little knickknack, that's inside you, and that's part of you. Embrace it, don't try to erase it because you're in some social standing now and you're ambitious and you're trying to become some upper class. Don't divorce yourself from your true being, embrace it. That's the only way that you can truly move on to become a new upper class and not move backwards."

Using Koons's formulation, we can imagine a traveler to Italy in Henry James's time, torn between whether to carry home a hand-painted copy in oil of Raphael's *Madonna della Seggiola*, which his family, friends, and visitors might see over the mantelpiece and applaud him for a taste that is really not his, or to buy instead a couple of those amusing, naughty figurines of a cat and monkey, which he really appreciates and which honestly do reflect his taste. Koons would advise the tourist to go ahead and buy the figurines and not feel guilty or embarrassed. The imperative is: Be yourself and don't pretend to be someone else whom you believe superior to yourself. Your tastes are all right as they are. The California artist Alexis Smith said, "Bad taste is better than no taste at all." Koons would say, Bad taste is as good as taste gets if it is yours.

Koons refers to taste rather than to acquisition—to what one prefers to look at and respond to aesthetically rather than to what one chooses to purchase. Some of James's tourists were rich enough to acquire Old Masters rather than copies. The chief characters in his own masterpiece, *The Golden Bowl*, were immensely wealthy connoisseurs who devoted their ample leisure to choosing works of art for a museum to be built in an "American City" for the aesthetic edification of its citizenry. They were faced with decisions in aesthetic philanthropy: Which works would most benefit the visitors to their envisioned museum? Works by living artists were another matter, inasmuch as these would rarely find places in museums of fine art in the artists' lifetimes. It would be with reference to this market that James's narrator declared there would be no demand for *The Madonna of the Future* that Theobald aspires to paint. It would not go with the changed taste of the times.

Today, of course, the situation is somewhat different. Today's major artists are purchased for private and public collections alike. Koons himself was recently listed in *ArtNews* as among "The Ten Most Expensive Living Artists." Relatively few of those who get to see his work are likely to be buyers of it. Still, it is with reference to their responses that purchases or commissions of his work are ultimately justified. And it is exactly at this point that Koons's imperatives to

viewers to trust their taste, to have confidence in their judgments, come into play. Increasingly, acquisition committees, in deciding to spend the considerable sums required to purchase a major work by Koons, must take into consideration "the artist's contribution to art history," to quote a source cited in the *ArtNews* article. "The challenge," according to the collector Kent Logan, is to "anticipate art history rather than chase after it." And Koons's place in art history cannot easily be separated from his intuitions regarding how his work is received by "the bourgeois," namely, those whose taste he presumes in showing and making his works. In this he perhaps assumes that he and they have tastes in common, that he comes from the same population as they, and if he likes what he does, they will like it as well—if they trust their impulses. And do not worry whether they ought to prefer something members of an imagined "upper class" presumably considered artistically better. He confides to Enright, "I don't see a Hummel figurine as tasteless. I see it as beautiful. I see it and respond to the sentimentality in the work. I love the finish, how simple the color green can be painted, I like things just being seen for what they are. It's like lying in the grass and taking a deep breath. That's all my work is trying to do, to be as enjoyable as that breath."

There is nothing else to which one *could* appeal in paying the considerable sums Koons's major pieces cost. One cannot, for example, point to their workmanship, for although in most cases, and especially in the twenty *Banality* pieces, there is workmanship of a very high order, it cannot be credited to Koons himself. He does not make the pieces but has them made by craftspersons who possess the high degree of skill his works require. "I'm basically the idea person," Koons told Klaus Ottmans in an interview. "I'm not physically involved in the production. I don't have the necessary abilities, so I always go to the top people, whether I'm working with my foundry—Talix—or in physics. I'm always trying to maintain the integrity of the work. I recently worked with the Nobel prize winner, Dr. Richard P. Feynman . . . I worked with many of the top physicists and chemists in the country." But workmanship plays a significant role in Koons's concept of his art. In my studio visit with him, I asked whether he had ever had a moment of "breakthrough" in his career. He told me of an experi-

ence he had had in connection with an invitation to participate in Skulptur Projecte Münster in 1987, an invitation that meant a great deal to him. He decided on recasting in stainless steel a bronze sculpture, the *Kiepenkerl*, that has great meaning for the ordinary people of Münster, symbolizing, as he put it elsewhere, "self-sufficiency, abundance, and moral relationship with the world." The sculpture, which stands in a public space, represents a man carrying a knapsack filled with eggs, potatoes, a hare, and pigeons—like the father in Hansel and Gretel who returns home with food for his family. Koons encountered serious technical difficulties in recasting the statue and was almost ready to withdraw because of the distortions created in the process. He told me about consulting a highly skilled steelworker, who examined the casting and saw exactly what had to be done. Koons wrote, "This liberating experience offered me as an artist the opportunity to go and create my own objects in such bodies of work as 'Banality' where I did not work with direct ready-made objects but created objects with a sense of ready-made inherent in them." And this was his breakthrough. When I asked him about the use of stainless steel, which at that period was his signature material, he referred me to the "mercury balls"—those shiny spheres found in lower-middle-class gardens throughout America, as ubiquitous as pink flamingos.

Kiepenkerl was "ready-made" in the sense that it existed as a much-loved outdoor work before Koons set about having it translated into stainless steel. By contrast, he actually invented the objects that belong to the *Banality* series, as if he were chief designer for a line of gift shop novelties. Except that they were to be handmade rather than mass-produced, and on a gigantesque scale. So he consigned their execution through carving or casting to the finest craftsmen he could find. This had become an artistic possibility though Conceptualism, the late 1960s movement, where the artist would have the idea and it did not matter who executed it. Duchamp had long before expressed a certain contempt for the idea of the artist as someone possessed of a special "eye" or a "hand." Koons does not have this contempt. Indeed, he has too great a regard for the hand and eye not to recognize that he does not possess the skills he demands that his work show. What distin-

guishes him from the earlier Conceptual artists is that typically the hand and eye their works required were not especially artistic or craftsmanlike. It takes almost no skill at all to dig a ditch across a driveway, which was one of Lawrence Wiener's works of the time, or to release some containers of gas outdoors, as in a work by Robert Barry, who did not need to but could easily have opened the containers himself. Very few artisans possessed the skills needed to execute in porcelain Koons's *Michael Jackson and His Chimpanzee Bubbles*. It was part of the idea of the work that it be the largest handmade porcelain work in existence. Showing such a high degree of craftsmanship is itself part of the concept of banality. "Look at the stitching!" the Italian vendor of tablecloths says to the tourists who admire the work, when the very idea of craft has all but disappeared from the high art of the Post-Conceptual period. Koons is saying that the bourgeois admiration of fine craft is nothing to feel ashamed of, whatever the art world decrees.

Meanwhile, the attitudes of the common folk of Münster toward the monument that defined their identity exemplifies the idea of morality to which Koons so often appeals and what it means to have confidence in their own taste and judgment. In stressing this, I think, there is little doubt that Koons shares the political value of Andy Warhol, an idol as well as an influence, who after all made Koons's art possible in spirit if not in style. Koons's first show was in the windows on the New Museum of Contemporary Art in SoHo in 1980. Warhol's first show was in the windows of the upscale department store Bonwit Teller on Fifty-seventh Street in mid-April 1961. Though the art world had undergone immense transformations in the intervening two decades, neither show would necessarily have been seen as art by most persons when they were first up, despite the institutional differences between museums and department stores. Warhol's show consisted chiefly of blowups of black-and-white advertisements from the back pages of lower-class magazines—advertisements for nose jobs; cures for baldness, acne, hernias, and unattractive bodies like his own—and panels from familiar comic strips. Almost none but the most sophisticated in 1961 would have hung these on walls, just as few passersby of Koons's show in 1980 would have displayed in their liv-

ing rooms his "Pre-New" inflated plastic flowers, let alone the vacuum cleaners that Koons showed in the Broadway windows. The difference, of course, is that many passersby in SoHo might have seen these objects as art, even if they could not have said what made them art, whereas almost no one in 1961 would have seen Warhol's paintings as anything but background for the garments with which the mannequins in Bonwit's windows were draped. The difference is due to a transformation in culture, for which Warhol was as responsible as anyone.

The reason viewers would have been blind to Warhol's 1961 paintings as art was that what dominated consciousness of what was art in 1961 was the big brushy paintings by the Abstract Expressionists. Pop Art had not yet emerged as a defined movement. In the mid-1960s Pop artists were eager to abolish the distinction between high art and popular art. By 1980 this had been achieved. By 1980, indeed, Pop Art was high art. One of the amazing happenings in world art in the 1960s is the way that Pop Art became popular as high art. I think it was due in part to the fact that ordinary men and women understood immediately what it was about—it was about what they understood immediately as part of their world. They did not have to have it explained to them. Inevitably, those who made critical reputations with Abstract Expressionism were defensive. Clement Greenberg had little use for Pop, which he dismissed in interview after interview as "Novelty Art." He and many other conservative curators were as contemptuous of Pop as those angry critics who had been outraged by the Post-Impressionist paintings that the Bloomsbury critic Roger Fry exhibited in London early in the century, which were scorned as hoaxes. By the mid-1960s viewers no longer had to defer to the superior sensibilities of those with "good eyes." Everyone in the culture knew Popeye and Mickey Mouse, Marilyn and Elvis, Campbell's Soup and Brillo pads, hamburgers and hot dogs. These were as familiar to them as Jesus and Mary. Whoever had to ask who or what he or she was seeing was not part of the culture, was in effect from another planet. Pop opposed itself to the art establishment everywhere in the world—in Germany and the Soviet Union, in Latin America and the countries of the Soviet bloc, even in China and Japan. The subjects of Pop were part of

international world culture. That was part of the social revolution of the 1960s.

Koons was a beneficiary of the cultural politics of '60s art. Everyone now had confidence in his or her own tastes and values. Critics like Greenberg effectively lost the power they had possessed because of their putative "good eyes" to say what was important and good. This was in its own way a world revolution in taste, which has left such critics behind. No wonder that the secondary literature on Koons is so often judgmental and angry! There was a scandal when the Stedelijk Museum in the Netherlands paid virtually its entire acquisitions budget for the polychrome wood carving, *Ushering in Banality*, one of an edition of three. It consists of an immense pig, wearing a green ribbon, being encouraged to move by a cherub on either side, while pushed from behind by a little boy in a red headband. Koons wrote, "I've tried to make work that any viewer, no matter where they came from, would have to respond to, would have to say that on some level 'Yes, I like it.' If they couldn't do that, it would only be because they had been told they were not supposed to like it. Eventually they will strip all that down and say 'You know, it's silly, but I like that piece. It's great.'" *Ushering in Banality* is a good example of what Koons's great breakthrough of 1987 led to—"objects with the sense of ready-made inherent in them," one of the most astonishing bursts of creativity in contemporary art. It is these I would like to discuss in the remainder of this essay.

First let us return briefly to what is regarded as Koons's first exhibition, *New*, installed in the street-level windows of the appropriately named New Museum of Contemporary Art—as if it were itself a museum of the new. What Koons showed were new objects—as contrasted with "used": in particular, bright new vacuum cleaners. Smart passersby, to the degree that they were prepared to see these as art, would almost certainly have seen them as ready-mades and dismissed them as derivative from Marcel Duchamp. The "pre-new" *Inflatable Flowers* of the previous year would have met Duchamp's criterion of the ready-made: "A point which I very much want to establish is that the choice of these 'ready-mades' was never dictated by aesthetic delectation," he declared retrospectively in 1961. "The choice was

based on a reaction of visual indifference with at the same time a total absence of good or bad taste . . . in fact a complete anesthesia." That is, they were more or less aesthetically unnoticeable when part of ordinary life, much like the inflatable plastic bunny before it became one of Koons's signature works a few years later, when he cast it in stainless steel. After the *New* show, someone of considerable sophistication might have placed inflatable plastic flowers on the dinner table as ornaments for guests sophisticated enough to perceive them as "Koonses." But otherwise they would be nearly invisible in backyards or nurseries, or on tables in lower-middle-class households where they would gather dust. They would just be part of the awful furniture of middle-class life, like electric fans, plastic pails, cheap garden furniture, garden hoses—nothing anyone would look at a second time. But that's what it would have taken to qualify as ready-mades: no aesthetic distinction.

This would also have been the case with vacuum cleaners, more or less. Unquestionably their newness carried some aesthetic weight, which would be irrevocably lost had they ever been used, much in the way Koons's metal-clad glass whiskey containers, which he had refilled and resealed by the distillers, would have lost their value—or some of it—were someone to have broken the seals and drunk the whiskey. Purists can debate whether, aesthetically speaking, the vacuum cleaners qualify as ready-mades, but this overlooks the fact that Duchamp never would have displayed his ready-mades artfully, in multiple groupings of two, three, or four units, housed in Plexiglas vitrines, illuminated by means of fluorescent lightbulbs—all of which have to be considered part of the work. Koons even sees the electric cords as alluding to Duchamp: They refer to the *Three Standard Stoppages* (1913), consisting of threads, each a meter in length, that Duchamp dropped from a certain height to form curved lines. The various works that employ vacuum cleaners thus have art-historical references—they refer to what made them possible as art. And so in a way do the standard basketballs in the 1985 works in which they are submerged in tanks of water, or waterlike fluid. These works contain ready-mades—objects singled out for the roles they play in forms of ordinary life, lived in backyards, in middle-class houses,

in schoolyards, where they have what Koons would call "moral" meanings.

But the works themselves, though they contain ready-mades as components, are by no means ready-made in their own right. They are deeply imagined works, designed with fantasy and an almost Surrealist imagination. How strange, if one thinks about it, it would be to encounter a fish tank with displayed flotational basketballs, or a Plexiglas vitrine with unused vacuum cleaners lit by fluorescent lights—almost like a ready-made combined with a work by Dan Flavin, preserved in a display case like relics.

Much the same might be said of the works in two series, *Luxury and Degradation* (1986) and *Statuary* (1987), in which Koons cast ready-mades in stainless steel, "the luxury material of the proletariat." These were transformed ready-mades, having antecedent identities: luxury items of glass or crystal, which were clad in steel, giving them an "artificial value" ("degradation"); ornamental statuary, such as busts of Louis XV for the tourist trade; *Flowers*, a notch up from the inflated plastic flowers of 1980; *Kiepenkerl*. These works seem to suggest a criticism rather than a celebration of middle-class taste, as if the middle class was insufficiently confident in its taste.

The result of Koons's breakthrough, which took place when he was making his *Statuary* items, are the *Banality* works of 1988. These, in my view, constitute his outstanding achievement to date. Nothing quite like them had ever been seen in galleries of high art, and they took the New York art world by storm when shown at the Sonnabend Gallery as a group. People asked one another whether they had seen the show: It was something one had to see, like Warhol's 1964 show of *Brillo Boxes*. It was, predictably, dismissed as "a new low" in the conservative arts journal *The New Criterion*. I found them terrifying, "a vision," I wrote at the time, "of aesthetic hell."

They were not based on ready-mades, but they had, in Koons's language, "the sense of ready-made inherent in them." We all more or less know which ready-mades Koons is speaking of. Here is my description of them from 1989: "Cute figurines in thruway gift shops; the plaster trophies one wins for knocking bottles over in street carnivals; marzipan mice; the dwarves and reindeer that appear at

Christmastime on suburban malls or the crèche before firehouses in Patchogue and Mastic; bath toys; porcelain or plastic saints; what goes in Easter baskets; ornaments in fish bowls; comic heads attached to bottle stoppers in home bars." Koons, I wrote, had claimed this imagery for his own, had taken over "its colors, its cloying saccharinities, its gluey sentimentalities, its blank indifference to the existence and meaning of high art, and given it a monumentality that makes it flagrantly visible, a feast for appetites no one dreamed existed and which the art world hates itself for acknowledging." They portray, as if from within, the sensibility of the lumpen middle class, and Koons showed himself in effect to be the Cellini to this taste. The art world wants to say to Koons, You can't like these! To which Koons must reply, I can and I do. And so, in your heart of hearts, do you.

As we saw, Koons speaks of the *Banality* pieces as the result of a liberation. He was free to design objects that might have existed and hence have been ready-mades but that in fact he designed. Here, I think, we leave the somewhat austere art history with which we have been working—Duchamp-Warhol-Conceptualism—and introduce an artist who figures prominently in Koons's discourse—Salvador Dalí. Dalí wrote an important introduction to *Dialogues with Marcel Duchamp* by Pierre Cabanne, in which he argued that the very idea of the ready-made was self-defeating. But many of Dalí's objects have "the idea of the ready-made implicit within them"—his *Lobster Telephone*, for example, a telephone cast in plastic, like the cat-and-monkey knickknacks but in the form of a lobster. It is a telephone, surrealistically reimagined. And that is what the *Banality* really are—commonplace kinds of objects reimagined as surrealistic presences.

Consider just one example—the notorious *Michael Jackson and His Chimpanzee Bubbles* in glazed porcelain on a gigantesque scale, or gigantesque in any case by comparison with a tabletop ornament of the same form as it. The work is in white and gold, like a rococo sculpture from an eighteenth-century Bavarian church. The white is worth pondering. Michael Jackson and Bubbles could both be in whiteface, in which case the white represents an objective fact of the work's subjects. Or it could just be the color of the porcelain, licensing no inference as to the real color of the subjects' skin. A figurine of Jesus—or

John the Baptist—in white porcelain would imply nothing about the color of the subject's skin. So the white is ambigious, as Michael Jackson himself is ambiguous in terms both of his racial and gender identity. It would perhaps be unnoticeable if we were dealing with an ornament, say, five inches long. But the life-size scale renders the white ambiguous, as between the color of the skin and the color of the work's glazed surface. A porcelain sculpture from the rococo era of a saint, perhaps with the infant Jesus on his or her lap, could fit into a chapel. Candles would be burned before it. People would pray to it and leave little notes expressing gratitude when their prayers were answered, as with the figures of the fourteen saints in the church of *Vierzehn Heiligen* near Würzburg. Celebrities are the objects of contemporary adoration, fans form entire companies of worshippers. So there is another ambiguity. There are perhaps five ambiguities in all— I leave the others to the reader's interpretative powers to find. That is why these works belong to the posthistory of Surrealism as a movement and why they have that quality of uncanniness that Freud analyzed in a famous essay. In the *Banality* series, Koons disclosed his true artistic identity. The works are unnatural wonders.

This is as far as I want to carry my analysis. In my view, the works of explicit sexuality that celebrated his liaison and marriage with the porn star Ilona Stoller were a distraction, though the subject of sexuality in art is deep and rich, and would justify a study—to which Koons would be a footnote. In general I have reservations about Koons's paintings: I feel he has lost touch with the surface of ordinary life, which his concept of morality presupposes. Now and again in his later work—in the *Celebration* series, for example—he touches the greatness of *Banality*. An argument can be made that *Balloon Dog* is his masterpiece. It is a translation into stainless steel of a balloon twisted into the shape of a dog, something one buys for one's children at street fairs. It perhaps monumentalizes Obie, the hapless dog that serves as Garfield's stooge in the comic strip featuring that gluttonous, lazy, misanthropic cat. It stands exactly ten feet tall. "It's about celebration and childhood and color and simplicity," Koons confided to Ingrid Sischy in a 1997 interview. "But its also a Trojan horse." The Trojan horse, we know from Homer, was one of Odysseus's wily ideas, a gi-

ant hollow horse filled with Greek warriors. The Trojans brought it through the gates of Troy, and at night the Greeks massacred them. "It's a Trojan horse to the whole body of artwork," Koons said. The ancients had a saying: "Beware of Greeks bearing gifts."

Balloon Dog's double aspect—signifying childhood, color, and simplicity but at the same time insinuating certain hidden meanings, darker and more dangerous than our concept of childhood had room for until it was revolutionized by Freud—inflects the latest generation of Koons's sculptures. To outward appearance, they are ready-made: large, inflated, plastic beach toys, for example, purchased perhaps at Toys "R" Us, to be placed around suburban swimming pools or at the shore, under umbrellas, in the company of picnic coolers and sunscreen. They have the form of sea creatures—dolphins, lobsters, and turtles, or, in one case, a caterpillar—usually in the bright gay colors deemed suitable for children's toys, and with such Disneyfied features as goggle-eyes and sappy smiles. There is no such thing as good taste in beach toys: The silliness of the effigies express what Koons once called "easy fun." In fact, of course, the sculptures are remade ready-mades: Molds are made of the inflated originals, which are translated into aluminum replicas and painted to look like shiny plastic, spanking-new. So they are monuments, in effect, to beach-time, playtime, laughter, squeals, boisterousness, and joy.

But they are suspended by chains, like *Caterpillar* and *Lobster*, which in fact is hung upside down, by its tail, its dangerous claws put out of play. Koons points out the resemblance between *Lobster* and an image of some martyred figure in medieval sculpture, hung by his feet. Mussolini and his mistress, Clara Petrachi, were hung that way after they were captured by partisans. There is a system of homomorphic equivalences between these emblems of innocence and certain suppressed or repressed expressions of sexuality or violence, in a natural lexicon made up of holes and swellings.

Consider the large wrought-iron *Moustache*. It has the form of a generous, curled mustache, somewhat comical, like the mustache worn by some figure in the circus—or by Salvador Dalí. But it also looks like legs spread wide and open, in a posture of sexual accessibility. And, as if to underscore that meaning, the points of the mustache

penetrate two smiling swimming toys, hung over it at either end. It is at once innocent and insinuating. It is a tribute to its double meaning that Koons proposed to transform it into a piece of public art, to mark and celebrate the notorious red-light district of Hamburg, where it would proclaim as it disguised the traditional commerce of the site, between pleasure-seekers and *filles de joie*. 'Я toys 'Я us.

September 4, 2004

Two Installations by Joshua Neustein

To give unto them beauty for ashes, the oil of joy for mourning, the garment of praise for the spirit of heaviness. —Isaiah 61:3

Light over Ashes, 1996

Galleries are dedicated spaces, governed by a complex set of conventions that define the relationship in which works of art are intended to stand to those who enter the gallery to be in their presence. This relationship has traditionally been with paintings or sculptures, objects of high visual interest that visitors come to look at and to enjoy, but the gallery itself, which makes these experiences possible, is generally not itself a further object of aesthetic scrutiny or pleasure, and, lest it distract from the objects it makes accessible, it aspires to a certain neutrality in this regard. The architectural expression of neutrality is the well-known "white cube," uniformly illuminated and emptied of everything but its emptiness. As a space it should carry no meanings beyond those implied by its dedication. It is pure symbolic nothingness, like the blank page or the silent space of the concert chamber. But even when the gallery has an architectural identity, as when the museum that contains it is a structure that did not originate as a museum but rather as a palace or some official structure, the neutrality is achieved through the fact that the gallery forms no part of

the meaning of the works it contains. It is not something to which those works refer. This means that the works themselves have a sort of metaphysical portability. They carry their references and meanings with them, wherever they are shown, and are altogether self-contained.

It is not internal to the concept of art that works of art be metaphysically portable, but the overall effect of the museum as an institution, and the gallery as dedicated space, has been to treat them as if they were. An altarpiece, for example, refers to the kind of space for which it was made—a chapel, say—and has as part of its meaning that the figures it represents are to be worshipped. Veronese's *Wedding Feast at Cana*, now in the Louvre, referred to the fact that it was sited in a refectory, and that clerics, eating in its presence, were in tacit communion with the feasting figures in the painting, and in the presence of Jesus, responsible for the miracle of food and wine. Caravaggio's *Madonna of the Rosary*, now in the Kunsthistorisches Museum in Vienna, refers internally to the space of a chapel, in which the figures praying are part of the group kneeling at the feet of Saint Domenic. Both are powerful, beautiful paintings, but the relationships they imply are vastly more meaningful and essentially more important than those compassed by aesthetic delectation. But the conventions of the gallery space exclude our eating in the presence of the one, or falling to our knees in acknowledgment of the vision shown in the other. When the forces of Napoleon tore Veronese's masterpiece from the refectory walls and carted it to Paris, it became, like Cassandra in ancient tales, a symbol of military might and victory, stripped of its powers and reduced to an object of delectation. And so with Caravaggio's great work, whose intended site has been forgotten. It is a triumph of the Napoleonic gesture that these and other works have been deprived of their essential meaning and forced to conform to the iron commandments of the art gallery, to be related to only under the conventions that govern our relationship to visually interesting objects. Aesthetic philosophy has defined them as objects of pure distinterested perception.

An instructive exhibition of the works of Joshua Neustein could easily have been organized in the spacious Potter Gallery of the South

Eastern Center of Contemporary Art in Winston-Salem, North Carolina: drawings, models, and sculptural works arrayed along the walls of the gallery or set in display cases or on bases, together with wall texts explaining what one was looking at. That indeed is the standard form in which an artist's work is exhibited, and it would be altogether consistent with this format that the exhibition travel from venue to venue, with no differences other than those imposed by local architectural circumstance and particular curatorial taste. One cannot, of course, overestimate the extent to which these differences affect our experience of the works displayed: Seeing Brancusi's sculptures at the Centre Pompidou in Paris was palpably different from seeing them at the Philadelphia Museum of Art. Admittedly, various strategies of display and illumination in both venues were calculated to enhance our experience of the work, but these did not, except in the eyes of professionals, call attention to themselves and respect the principle of neutrality entailed by the concept of the gallery as dedicated space. So neither site formed part either of the meaning or the reference of Brancusi's works, which retained their metaphysical portability and could be set up in any suitably dedicated space. And so it would be were the Potter Gallery simply one venue for the aggregated works of Joshua Neustein.

Neustein's *Light over Ashes* renounces this format by renouncing metaphysical portability. It is installed in the gallery, but in a very different way from that in which works are customarily hung or placed in galleries, for it seeks an internal relationship to the space and indeed to the site in which the museum containing the gallery is located. The internal relationship means that the work is not in the space the way an object is in a box: It incorporates the space into itself in such a way that one does not enter the gallery to experience an artwork separate and detachable from it. One enters the artwork itself, which incorporates the space as part of what it is. The space, one might say, has been rededicated, and is now—since work and space are, for the lifetime of the exhibition—as inseparable from the work as body is from soul. "I am not in my body the way a pilot is in a ship," Descartes declares at the end of his great meditation on first metaphysical principles. Here, the work is not simply in the space—the space is in the

work. The presence of the work transforms the space into a property of itself, vesting it with a meaning internal to the work, which sacrifices its portability to achieve this intimacy. One cannot thus experience work and space separately from one another. One can only dismantle the work, returning the space to its original dedication.

The transformation of the space is achieved by the tremendous chandelier that is suspended at a negligible distance from the "floor" rather than, as is common with such fixtures, at a negligible distance from the "ceiling." I put these terms—as I would the word "walls"—in quotation marks to indicate that these components of a room have themselves been transformed through the space having been folded into the structure of the work. What had been the floor is now something else, an expanse of indeterminate dimensions holding a map of Salem, the site of the museum, at a certain point in Salem's history. The map is enlarged so that its drawn streets have become paths that constrain the visitors' movements through the space, very much as if one were walking through the city itself: One does not, after all, walk through buildings to get from one street to another. The work internalizes the complex geometry of its own site at a defining moment of its history: It is *specific* to its own site, as Veronese's *Cena* is specific to the refectory whose space it glorifies and completes. The "ceiling" is there only to mark the conventionally appropriate location of the chandelier, which instead is at the same level as we are, dislocating us spatially as the map dislocates us in terms of scale. In a way, the logic of the work is like that of a dream in which we look across and down at a fixture intended to be seen from below, and tower above the landscape like Gulliver mincing along Lilliputian streets. The space has been transformed into a bubble of dream space in which we are encapsulated, as when we dream about ourselves moving through worlds that displace the relationships that define the waking world. The Potter Gallery is a high room, twenty-eight feet from floor to ceiling. It is as well an ample room, six thousand square feet. Under artistic transformation, the space is indeterminately high, the way the sky is, and indeterminately large; its boundaries, like the edge of the dream field, circumscribe a space without being part of it. That conduces to its dreamlikeness.

Let me attempt to distinguish *transformation* from *transfiguration*, using for this purpose the presence of chandeliers. There is a chandelier, familiar to anyone who has studied the history of art, in Jan van Eyck's *Arnolfini Wedding*. It is in no way as opulently ornamental as the baroque fixture Neustein had fabricated for this work, but it is luxurious enough for its time and displays a high degree of artisanship in its facture. It is of fiercely polished brass, and, like Neustein's chandelier, it seems to have moved into a lower register of its already low room, so that one feels that it is in the same space as the connubial pair, making, as it were, a third, bestowing light upon them rather than merely illuminating the space in which they stand. In truth, it hardly illuminates at all, since it holds only a single candle where there are holders for eight, and bright daylight, sufficient to illuminate the room by itself, streams amply in through the window. These two anomalies can, of course, be given naturalistic explanations—that the lit single candle is central to a ceremony in which a sacrament intersects with the law, no matter how bright the atmosphere. It can testify to a practice in Flanders in the fifteenth century, as the room's expensive furnishings inform us of the scheme of interior decoration suited to members of a merchant aristocracy: Look at the bride's elaborate and costly gown! But in fact, according to a famous article by Erwin Panofsky devoted to this painting, the single lit candle— "symbol of the all-seeing wisdom of God"—transfigures a mere domestic interior into "a room hallowed by sacramental associations." Needless to say, this could be true of the actual bridal chamber as much as of the painted one, and what Panofsky is anxious to establish is that, in actuality or in art, we are dealing with "a *transfigured reality*." It is a transfigured reality when it exists, as it were, on two planes at once, architectural and symbolic, when "the symbols are chosen and placed in such a way that what is possibly meant to express an allegorical meaning, at the same time perfectly 'fits' into a landscape or an interior apparently taken from life." So in this remarkable work, in Panofsky's view, "medieval symbolism and modern realism are so perfectly reconciled that the former has become inherent in the latter."

The concept of transfiguration has had a great importance for me in thinking about examples of modern art in which the work so re-

sembles an ordinary object that the question becomes acute as to where the difference between them is to be located, since it is inscrutable to visual perception. The perceptual textures of both are sufficiently indiscernible that one could easily suppose, while looking at the artwork, that one were merely regarding a quite ordinary thing. So one might suppose one were looking at the depiction of a room in the *Arnolfini Wedding* and admiring it for its realism, when in truth the ordinary objects arrayed within it carry so powerful a symbolic weight that the room is transfigured into a quite special sort of space.

An art gallery could in this respect be transfigured if it were possible to experience it as an art gallery, without recognizing that it had become another kind of space. In Neustein's installation, the gallery has been not *transfigured* but *transformed*, in the sense that while one doubtless knows, in experiencing the work, that it is an art gallery, this knowledge is external to the experience of the work itself. It has been metamorphosed into a space of a different order, leaving its identity as a dedicated space behind, rather in the way the stage is transformed into the plain before Troy, or the wall before Thebes, or the island of Naxos on which Dionysus comes to claim Ariadne as his bride, or a street in Verona, or a bedchamber in Venice, or the ramparts in Elsinore. And the dramatically lowered chandelier is the main engine of this transformation.

It is part of the language of furniture that chandeliers declare that the rooms they dominate are ordinarily public spaces, and that their light is celebratory. They belong in ballrooms, in salons, in spaces of official reception, in dining rooms in which the faceted crystals of their ornaments catch the flames of candles set beneath them and are reflected in the stemware and polished plate with which the table is made ready: They sparkle in sympathy with brilliant conversation and scintillating wine. They transform everyone caught in their illumination into creatures of light, raised for this occasion to an exalted level of being, completing, like a singular accessory, the elaborate gowns, the radiant complexions, the dazzling jewels or medals or tiaras. The chandelier in Neustein's work is an opulence of cut crystal and faceted beads, effulgent pendants and swags of interreflected light, which by rights belongs to the upper part of the room it glori-

fies, where it would define a luminescent center, the way the great chandelier does in Adolf Menzel's 1852 *Flute Concerto of Frederick the Great at Sans Souci*, in which the virtuoso monarch is shown, in powdered wig, performing for a distinguished company in a mirrored salon, which reflects and rereflects its dazzle. "I only did it to paint the chandelier," Menzel said, but it is clear that the chandelier is a metaphor of and a compliment to Frederick as the embodiment of enlightenment. The audience is bathed in the chandelier's (and the monarch's) light, which creates an ambient darkness around the favored personages, an outer darkness for those distant from the music and the noble presence. Menzel has elaborated a set of symbols that relate to the role of chandeliers in life and presents us with a transfigured reality quite as much as does Jan van Eyck. A chandelier performs the same tranfigurative role, with whatever success, in a photograph of a reception at the White House by Andy Warhol in his book *America*. Warhol, with his singular pitch for symbolism, created a work (1976–86) consisting of four identical photographs, stitched together with threads, of a set of chandeliers. There are chandeliers embedded in black paint in a number of works by Ross Bleckner, such as his elegiac painting, *Fallen Summer*, of 1988. The chandelier in these works is a symbol of hope, as light always is for us, but at the same time a sign for that aspect of the human condition which occasions hope, namely, its inherent and inseparable tragedy. It is the order of hope Saint Paul has specifically in mind when it forms for him, with faith and charity, a triad of what theologians designated "supernatural" virtues, to distinguish them from the "natural" virtues of classical moral philosophy.

The first mystery of Neustein's installation lies in the fact that he has retained the symbolic connotations of the chandelier but lowered it, dramatically, so that it sits just above the ground, like a burning bush, so that there is no way for us to stand beneath it. It defines the visual center of the area the visitor traverses upon entering the space, and there can be little doubt that it defines the moral center of the space itself, radiating an aura of just the sorts of meanings the chandelier conveys in van Eyck and in Bleckner, or in Warhol. We enter from the sort of outer darkness Menzel paints so marvelously, and, be-

cause we have entered the work—because we do not stand outside it as in the standard gallery experience—we ourselves are "put in a new light," which it is up to us to interpret. The position of the chandelier implies, I believe, that the light in which we are put is indeed new. We are drawn to the light—not a possibility if the light is above us and out of reach—and we have to make our way to it by tracing the paths of the mapscape, as if a maze. The experience, at a metaphorical level, is clearly intended to be transformative.

Let us now concentrate on the street map of Salem, North Carolina, as it was drawn in 1839, seventy-three years after the first trees were cleared from its intended site in the midst of Wachovia—an area named after Wachau, the ancient seat of the Zinzendorf family in Austria, in tribute to Nicholas Lewis, Count Zinzendorf, benefactor and guide to members of what came to be known as the Moravian church. Protestant forces had been defeated in Moravia in the Thirty Years' War, and the victorious Catholics undertook to extirpate Protestantism as a religious practice, forcing its adherents to flee or to convert. The Moravian fellowship—the *Unitas Fratrum*—could scarcely resubmit to the hierarchy of Catholic authority, since its members were dedicated to reenacting in their own lives what they perceived as the lost simplicity of Christian life in Apostolic times and treating the Bible as the single authority on questions of life and faith. By opening his vast estates in Saxony to the Moravians in 1722, Count Zinzendorf had made it possible for those who succeeded in slipping across the border to form a settlement based on these convictions. The Moravian settlement in Saxony became a beacon and a model for like-minded Christians elsewhere, and it was Count Zinzendorf's inspiration that it should be exported to the New World, where haven might be found from the continuing religious turmoil of Europe and a base established for evangelical missions among the Native Americans. Salem was to be just such a haven and base of missionary operations, a site ordained, in the view of the Moravian Governing Board in Saxony, by Jesus Christ himself. Indeed, Jesus was regarded not only as the Savior but also as the chief elder of the ideal community of "brothers and sisters" that Salem was intended to be. The principal streets and squares were systematically laid out in February 1766.

The streets of Salem, in Neustein's map, are pathways through ashes, but how the ashes are to be interpreted is the second mystery of the work. Like the chandelier, ashes constitute an evocative rather than a precise symbol. The artist wavered for some time between using what he termed "common clay"—the actual soil of the region—rather than the end product of burned local vegetation—"tobacco plants, hickory wood, cotton, stubble of any kind of the region." Clay and ashes alike have both a metaphoric power and specific references to the site and history of Salem, but "Light over Ashes" and "Light over Common Clay" imply different meanings for the substance in which the map is traced. My sense is that the artist made the right choice, for though the actual soil proved suited to the manufacture of the bricks and tiles from which the town's permanent dwellings were made, the idea of rising from the ashes connects the founding of a city with the history of persecution: Jan Huss was, after all, burned at the stake. Either way, the two dominant symbols—the chandelier and the map—are knotted together in terms of nationalist heritage and possible religious history. The chandelier is specifically Bohemian glass, and Bohemia together with Moravia was the soil that nourished the *Unitas Fratrum*. Since the Baroque was the style of the Catholic Counter-Reformation, it might just be thinkable that the Baroque-Bohemian style of the chandelier emblematizes Catholicism as the map drawn either in ashes or in common clay emblematizes Protestantism. This makes room for an ambiguity as to how to interpret the cast letters—the third component of the work—that Neustein has scattered over the surface and covered with ashes in such a way that their shape remains visible. Are the letters, half buried in the "soil," driven underground by the lamp, or do they rise from the soil to be in its presence? In an earlier proposal, Neustein refers to the carpet of ashes as a "seed-bed," which assigns to the letters the role of seeds. One of the leading exiles from Moravia, Bishop Johan Amos Comenius, expressed the hope that, despite the bitter repression, there might lie a "hidden seed" in the forests of Moravia, from which a rebirth of *Unitas* might come. That happened, of course, in Saxony and then in North Carolina, so it might be possible to interpret the letters, buried but half visible, as the "hidden seed."

The complex symbolism of chandelier, ashes, and letters ought not to be treated merely as a code to be deciphered. Each evokes an aura of meanings, which overlap and interpenetrate to form an atmosphere of intersecting themes. Moreover, the meaning of the work cannot merely have to do with the circumstances of Salem's founding in the eighteenth century; it must somehow speak to us today and have something to do with our own lives. One feels that the contrast between, on the one hand, the ashes and the map site of Salem, symbolizing the possibility of the pure and simple life, and, on the other, the crystal opulence of the great chandelier, must hold the key to this work. But it is very difficult to find the key, if only because of the extreme ambiguity of the chandelier and ash field as symbols. The chandelier implies hierarchy, power, and domination. Historically it emblematizes the Counter-Reformation and the Holy Roman Empire and the Latin liturgy. The map inscribed in ashes emblematizes a community of equals, passive resistance, the Protestant Reformation, and vernacular languages that make the Bible's authority accessible to all who can read. But at the same time the lamp is what Wordsworth describes as "the celestial light" that is *lowered* to the level of "every common sight," as if, as in Christian cosmology, God mingled his luminescence with the soil and ashes of human flesh, infused history with eternity to achieve salvation for us through enfleshment—and this tremendous drama is being enacted in Salem, the New Jerusalem! After all, the distribution of the letters is at its densest in the area of greatest illumination, just under the light. Not just we who enter the work are drawn to the light: Being drawn to the light is enacted by "the hidden seed." The letters physically imply that there is some meaning beneath the ashes, which the light attempts to draw out. The letters, ashes, and lamp reenact in a way our own effort to uncover—to *unveil*—the meaning of the work we are experiencing.

The chandelier is not, as might have been expected, centered over the "commons" of Salem, even if it does define the space's visual center. It is, rather, at one of the town's boundaries, as if marking a boundary in its own right between the town and the wilderness out of which it is carved. The undifferentiated wilderness spreads edgelessly

outward: The walls of the space in which the work is installed do not mark real boundaries—the wilderness is after all not a rectangular area—which is a further mark of the difference between the space of the work and the space of the gallery. The *Stadtplan* is like a grid stamped onto the Wachovian clay, implying in its regularity that sense of well-orderness that defined the life of the founders. The Moravians were aesthetically sensitive: "The proportions of the houses are good, and with their regular placing and their tile roofs, they make a not unpleasing appearance," an eyewitness wrote in 1768. The form of life was austere but not ascetic. There was music, there was cheer, there was the sense of fulfilling Providence through founding a city, whether one saw this as rising from the ashes of history or through the imposition of a rational order onto the soil of wilderness. But whether through interpretation we can impose a rational order on the work as a whole is another question. Everything—the lamp, the ashes, the letters—is multiply ambiguous and powerfully symbolic. Furthermore, it must be remembered that we are not external to the work we seek to rationalize. We complete the work by entering it and making it our own. But each of us must complete it in a different way. And—who knows?—this may say something about using the Bible as the final authority for morality and truth. The readers complete the Bible by interpretation, and each interpretation is individual.

In the initial formulation of his proposal, Joshua Neustein wrote, "I shall look for testimony, for witnesses that will take possession of my piece. Maybe I shall discover a portion of my own missing history. Something that modifies belonging. Something belonging to me." Well, the chandelier may be read as a fixture that evolves from the candelabrum, hanging rather than sitting, fixed rather than portable, as dwellings become permanent (like the brick-and-tile houses of Salem) rather than temporary, like tents or Salem's first timbered cabins. There is a famous candelabrum in the Bible, one that a curiously finicky God orders Moses to construct. It is a very ornate candelabrum for what after all was a desert people, but it was to be placed in a sanctuary fit for God and to represent an offering and a sacrifice on the part of the children of Israel "that I might dwell among them." Perhaps light and God are sufficiently one that where there is light there

is God. The candelabrum was to be made of pure gold, and God specifies its structure in remarkable detail.

> Of beaten work shall the candlestick be made: his shaft, and his branches, his bowls, his knops, and his flowers, shall be of the same.
>
> And six branches shall come out of the sides of it; three branches of the candlestick out of the one side, and three branches of the candlestick out of the other side:
>
> Three bowls made like unto almonds, with a knop and a flower in one branch; and three bowls made like almonds in the other branch, with a knop and a flower: so in the six branches that come out of the candlestick.
>
> And in the candlestick shall be four bowls made like unto almonds, with their knops and their flowers.
>
> And there shall be a knop under two branches of the same, and a knop under two branches of the same, and a knop under two branches of the same, according to the six branches that proceed out of the candlestick.
>
> Their knops and branches shall be of the same: all it shall be one beaten work of pure gold.
>
> And thou shalt make the seven lamps thereof: and they shall light the lamps thereof, that they may give light over against it.

The specification goes on, and God commands that Moses follow a pattern that had been shown him during the time he had been with God on the mount for "forty days and forty nights." It is clear that God means for the sanctuary to be a replica of his *own* dwelling.

There were ten candelabra in the First Temple but only one in the Second Temple, to imply a continuity with the tabernacle Moses built and shaped to conform with the description in Exodus. This was taken to Rome upon the destruction of Jerusalem and housed in the Temple of Vespasian. We can still see it carried as a trophy on the Arch of Titus, as a symbol of the defeat and destruction of the Israelites. It is the emblem of dwelling and of diaspora. When one con-

joins this potent symbol with the reflection that "Salem" is an ancient and poetic name for Jeru*salem*—the emblematic capital of what was for so long a wandering, the lost homeland, how should an Israeli artist *not* belong, and how should this not be a piece of his own missing history? Home and history, loss and recovery, oppression and overcoming, light and human darkness, beauty and ashes, politics and return, the darkness of Europe and America as the New Jerusalem— these are among the themes enacted here. The rest must be found by each who engages with the work.

Domestic Tranquility, 2001

Joshua Neustein's installation *Domestic Tranquility* makes use of a number of symbols deployed in similar ways in earlier works. Each of them uses, for example, a richly elaborate chandelier suspended over a field of ashes. In each ash field a map is drawn, on a scale large enough that the streets traced in the map can be used as paths by those visitors who enter the installation. And in each installation, the chandelier reaches nearly to the ground, as low, perhaps, as the knees of those who walk their way through the map. Light and ashes are powerful symbols in their own right, but it is evidently important that in these works the light emanates from a fixture as elaborate and as intricate as a jewel—a fountain of luminous glory—rather than, say, a single bare lightbulb, lowered to a point close to the ash field, or the rotating mirrored sphere of the discotheque. There is a language of light fixtures, after all. The single bare bulb inevitably connotes abjection, the disco ball is the embodiment of abandon, the chandelier, exemplifying brilliance, declares the brilliance of the event it shines over: the ball, the reception, the concert. There is, thus, a symbolic incongruity between the chandelier and the ash field just beneath it. It hovers as a luminous, almost angelic presence, an emissary from another sphere of being, bringing to the city in ashes a transcendent kind of assurance.

For reasons already stated, these works require fairly large spaces.

It is important that visitors be drawn into the work. The paths through the ashes must then be wide enough for persons to use them, wide enough, perhaps, that two persons coming from different directions should be able to pass. But beyond that, the space must be sufficiently high to convey the truth that the chandelier has descended, dramatically and surprisingly, as if from a higher to a lower realm—to the realm of those who virtually walk the streets of the city sunk in ashes. The two substances—light and ashes—constitute what Suzanne Langer spoke of as a *presentational* form, as distinct from *discursive* forms as pictures are from propositions. The presentational forms of Neustein's installations demand interpretive response and require some application to the lives of the walkers. They project a message too urgent to be disregarded but too elusive to be paraphrased.

It was as a poetry of linked symbols that I sought to analyze *The Message in the Ashes*, in which the inscribed city was Salem at around the time of its founding—a form and order imposed on the American wilderness by refugees from the religious wars in Europe. What I had not especially thought of at the time was the possibility of the work moving from venue to venue. It seemed too linked to the specificities, cultural and historical, of the Moravian Brotherhood, who had founded Salem as a New Jerusalem. I thought of these links like roots, drawing meaning from the soil. And though I realized that it was not a permanent installation, it seemed to me that the work could be moved only if uprooted and could hardly draw sustenance from an alien soil. If the symbols meant what I supposed they did in Salem, could they carry that meaning over to Cleveland, where the work was installed in the Museum of Contemporary Art? Neustein replaced the map of Salem with a map of Cleveland, to anchor the work in the reality outside the museum. But would that make it specific to Cleveland as it had been to Salem? It would have seemed to me that the symbolic components were too interreferential and organic not to sacrifice their meaning when the work was made to denote Cleveland. Just the name Salem—a fond way of referring to Jerusalem (like the apple in the case of New York)—has connotations that do not carry over to Cleveland, named after Moses Cleaveland, who led the first surveying party in the Western Reserve, laying down a plan to which

downtown Cleveland still conforms. The chief highways of the early settlers were originally Indian trails. So a whole new set of meanings would have to be generated in the new site. There is of course a natural connection between ashes and Cleveland, as a city of blast furnaces and prosperous manufacture fallen on harsh times. But maybe thoughts of just this kind would have occurred to those who sought ways of capturing a presented meaning in words. My own interpretation of *Light over Ashes* perhaps went beyond any meaning planted in the work by Neustein, and it may be part of his artistic method to employ evocative symbols to prompt interpretative responses that will be different from site to site. Ashes in which the map of Berlin is inscribed must mean something different from those in which Salem is inscribed. To think of Berlin is to think of a city of ashes, a bombed and burned wreck of a city, from which the present Berlin has risen like a phoenix. The ashes of Salem imply no such history, nor do those of Cleveland. Nor, of course, do those in which the Israeli city of Bene Beraq is inscribed in a new work, *Domestic Tranquility*. However much one installation looks like another, each entails a different interpretation, drawing on history, on religion, on the meanings of settlement, security, and the language of social being. It was the interdependence of its symbols that caused me to feel that *Light over Ashes* was specific to its site. And yet, so powerful are the components in the complex—city, lamp, and ashes—that one is given the sense that each installation has some higher and more transcendent message than "The Message in the Ashes" I made central to my analysis of *Light over Ashes*.

The "message" I received was based on the presence in the ashes of the letters of the alphabet, made of terra-cotta. It is impossible not to believe that the letters hold a message for us, if we could but read them, but we also know that fitting the letters into words transcends our powers. When the letters are separated and scattered, the message is lost. They imply a meaningfulness with no ascertainable meaning. What is the meaning of our history? Our place? Our lives with one another? Our relationship to the splendor of light? "Meaningfulness

without ascertainable meaning" echoes the celebrated formula of Kant in connection with beauty—"Purposeness with no ascertainable purpose." All we can know for certain is that the components in the work constrain its possible meanings—ashes, city, lamp. Every interpretation must read ashes together with city, and both together with the glamorous light, scintillating so close to where daily life is lived amid the ashes.

The letters in the ashes do not belong to this complex of city, ash, and chandelier, since they do not belong to each installation as the latter do. But they serve as a clue, however indeterminate, to a promised message. The letters perhaps give us a metacritical clue as well. They direct us to seek what is peculiar to any given installation and to try to use that as a fulcrum to the work's larger proposition. Where *Light over Ashes* has terra-cotta letters in and on its ashes, *Domestic Tranquility* has sunflowers. As an operating principle, we must suppose that these flowers point to a local interpretation. At the very least we want to know what the connection is between Bene Beraq and sunflowers. There are sunflowers molded in the ashes, clustered together in a space likened by the artist to a cartouche in a map. Sunflowers appear as well in a video, shown on a monitor inconspicuously placed. The video has two segments. In one, the artist (or some surrogate) is addressing a field of sunflowers, their faces turned in seeming eagerness and interest toward him. It is of course an illusion. Were he to address the sunflowers from the other side of the field, he would see only the backs of their heads. The sunflowers are not listening to him at all. They are phototropic beings, turned always to the light. They follow the sun from horizon to horizon. The artist who believes he has the undivided attention of the sunflowers is profoundly deceived. It is an image of futility, an allegory of the impotence of art to penetrate the consciousness of those whose lives are defined by faith, as for example the devout inhabitants of Bene Beraq.

A second video image alternates with the artist addressing the sunflowers. This shows a woman, wearing some folk costume, ironing a garment. Her dress connects her to a culture somewhat alien to those who experience the work. The native dress is a declaration of where the woman feels she belongs. Ironing belongs to the fundamental hu-

man project of keeping disorder at bay. The ironed garment is an emblem of domesticity and civilization. So the woman herself is domestic tranquillity personified, performing her duties in peace, secure in her traditions. Neustein thought he might put a sunflower in a vase on a shelf behind her. Even if that were a mere decorative touch, it would transcend its meaning. The mere thought of decorative touches goes with a sense of home and of peace. "Domestic" is defined as whatever is "of or pertaining to the family or the household."

Domestic Tranquility is to be installed in the municipal museum of Herzliyya, a prosperous and secular community. Bene Beraq is a poor and pious community of Orthodox Jews, dedicated to the principles of a theocratic polity. They have no ears for the artist, supposing him to be attempting to communicate the secular values of Herzliyya. They want to be left in tranquillity, to follow the paths of meaning in a universe in which everything else is ashes, of no significance to their lives. *Domestic Tranquility* can be read as an allegory of political conflict. Neustein claims that "the politics are afterthoughts." His aim is to see Bene Beraq's "residents by their own ontologies." The monitor, with its repeated showing of its two segments, is above the plane of ashes but not in such a way as to interfere with the great chandelier of Venetian glass. It shows the way those who live in Bene Beraq view themselves. It is their consciousness from within, as in a vision. Possibly this has a message for Herzliyya as well. Whether the two populations can indeed live in domestic tranquillity, in independence of one another, is an "afterthought." But ensuring the domestic tranquillity, along with justice, defense, and the blessings of liberty, is cited as an intended result of a "more perfect union" in the Preamble to the United States Constitution.

When I was gathering some thoughts for this piece, I came across a curious photograph in *The New York Times*. It showed a man and a woman seated on the floor next to a street map painted on the floor. It is a map of a razed town. The map is in a museum dedicated to the town's memory. It had been a place in which members of different races lived together in domestic tranquillity. And it was destroyed by an apartheid government that decreed it must be replaced by another town, in which only whites were permitted to live. To this end, the

original town was destroyed, and another town—interestingly named Sonnenbloem, which is Afrikaans for Sunflower—was superimposed. Sunflower never prospered. Sunflower is today an urban wasteland, but beneath the ashes of its demolition the old town acquires a deeper and deeper meaning as an emblem of a criminal disregard for domestic tranquillity. That meaning would have been deepened and raised to the level of moral poetry had the street map been made in the ashes, in a large darkened space, lit primarily by a chandelier suspended just above. Ashes and chandelier do not constitute a formulaic device for transforming tragedy into elegy. But together with the political memory they would have given visitors to the museum the kind of evocative experience of which art is capable.

2001

Kalliphobia in Contemporary Art;
Or: What Ever Happened to Beauty?

> I hate it if I notice that I like something, if I am able to do something,
> so that I just have to repeat it, that it could become a habit. Then I
> stop immediately. Also if it threatens to become beautiful.
>
> —Dieter Roth

Dieter Roth's *kalliphobia*, to attach a clinical term to what has
been epidemic in avant-garde circles since the early twentieth
century, employs the idiom of threat for something that in any
context but that of art would be an occasion for rejoicing. Who would
say that it "threatens" to be a beautiful day except an umbrella sales-
man, or that one's daughter "threatens" to turn into a beautiful young
woman unless one feared the jealousy of the gods? In most contexts of
human life, we would speak of the promise rather than the threat of
beauty, so *kalliphobia* calls for diagnosis, since *kalliphilia*, to give it its
antonym, is what one might think of as the aesthetic default condition
for humans, connected with fortune and happiness, life at its best, and
a world worth living in. How can beauty, since Renaissance times as-
sumed to be the point and purpose of the visual arts, have become ar-
tistically counterindicated to the point of phobia in our own era?

Kalliphobia belongs to the defining syndrome of what, in my book
The Abuse of Beauty, I designated the Intractable Avant-Garde. It con-
sisted in the first instance of members of the Zurich-based Dada
movement at the time of the First World War, who decided to sup-

press beauty as a gesture of contempt toward a society responsible for a war in which millions of young men were slaughtering one another. It was a kind of strike in which rather than create beauty, artists engaged in various forms of cabaret buffoonery. Beauty became politicized through flagrant trivialization.

That beauty should become the sacrificial victim in a symbolic war against war was not itself a trivial matter: Only against a background in which art and beauty were esteemed to a degree hardly intelligible today could Dada's antiaestheticism have been deemed an effective measure by those who practiced it. Only if the Artist were in the first instance regarded as an exalted being could the sight of artists behaving as buffoons, as the Dadaists did at the Café Voltaire in Zurich, be regarded as a significant critical gesture. Only if beauty were esteemed to the point of veneration could withholding it be regarded as a significant deprivation. I drew the title of my book from a line in Arthur Rimbaud's poem of 1873, *A Season in Hell*: "One day I sat Beauty on my knees, and I found her bitter, and I abused her." I felt that this expressed exactly the attitude of the later Dada artists. They found beauty bitter because they were embittered by a society that venerated beauty. In unleashing a terrible war, their governments abused justice. In symbolic retribution, the artists abused beauty.

Here is a not uncharacteristic passage from a work published in 1853, titled *The True, the Beautiful, and the Good* by the French philosopher Victor Cousin:

> The artist is before all things an artist; what animates him is the sentiment of the beautiful; what he wishes to make pass into the soul of the spectator is the same sentiment that fills his own. He confided himself to the virtue of beauty; he fortifies it with all the power, all the charm of the ideal; it must then do its own work; the artist has done his when he has procured for some noble souls the exquisite sentiment of beauty. This pure and disinterested sentiment is a noble ally of the moral and religious sentiments; it awakens, preserves, and develops them. So art, which is founded on this sentiment, which is inspired by it, which expands it, is in its turn an independent power. It is nat-

urally associated with all that ennobles the soul, with morals and religion; but it springs only from itself.

Max Ernst had served in the artillery and joined the Dadaists after the war: "To us, Dada was above all a moral reaction. Our rage aimed at total subversion. A horrible futile war had robbed us of five years of our existence. We had experienced the collapse into ridicule and shame of everything represented to us as just, true, and beautiful. My works of that period were not meant to attract, but to make people scream." Dada gave the German artists, who knew through experience what war was really like, a mission very different from what philosophers, in the spirit of idealism, had portrayed. Rather than presenting an ennobling vision, art became a means for showing the moral ugliness of the society that had put them through such hell. The Dadaist George Grosz, who attempted suicide rather than return to the front, said, "I drew and painted out of a spirit of contradiction, trying in my works to convince the world that it was ugly, sick, and mendacious." There is nothing beautiful in Grosz's painting of that time, nor in that of Otto Dix, who had been a machine gunner, or Max Beckmann, who cracked up in Flanders, where he served as a medical orderly.

It was art, considered as a near-holy vessel of beauty, that was pronounced dead by the Berlin Dada movement in 1922. From that perspective it is difficult not to see the notorious enterprise of exhibiting avant-garde art as degenerate in 1937, as an effort to reinstate art to its previous exalted stature by Adolf Hitler. It was in the spirit of vesting the laboring classes with beauty in Socialist Realist painting that avant-garde art was criminalized in the Soviet Union. It was in the spirit of patriotic Americanism that the Regionalists represented America as beautiful and avant-garde art as subversive and alien. The history of art in the twentieth century was far more convulsive than the unfolding linear chronicle of movement after movement conveyed in such art-historical surveys as Modernism 101. In consequence of these convulsions, beauty became politicized in ways philosophers like Cousin could hardly have imagined, and the avant-garde has taken on the role of social criticism begun by Dada, to the point where the mere

whiff of beauty in one's work is tantamount to selling out to the estab-
lishment. "The adventures of the aesthetic," Hal Foster wrote in a
preface to his 1983 book, *Anti-Aesthetic*, "make up one of the great
narratives of modernity."

It is Foster's intention that his title "signal that the very notion of
the aesthetic, its network of ideas, is in question." And though very
few of the essays he put together under the title address the topic of
aesthetics directly, he interpreted the book as asking, I expect rhetori-
cally, whether "categories afforded by the aesthetic are still valid?" As
near as I can make out, Foster meant to frame an opposition between
Modernism and Postmodernism, which he gingerly identifies as anti-
aesthetic. So I interpret him as taking the kind of stand against aes-
thetic values that the Intractable Avant-Garde took in the history of
modern art. He understood Postmodernism as a political critique of
bourgeois society under the guise of a critique of the aesthetic values
with which bourgeois society was associated by those who mounted
that critique. "Antiaesthetic" belonged to the same complex of ideas
that the Death of Painting did at the time, or the Death of the Mu-
seum. Like Dada six decades earlier, antiaesthetic (read: Postmod-
ernism) was fired by an affecting faith in the power of art to achieve
political transformation by aesthetic modulation. Whatever revolution
it was that Foster and his peers may have believed in did not really
materialize. Painting did not die; the museum did not wither away.
What happened instead was what I have called "The End of Art." In
the two decades since *Anti-Aesthetic*'s publication, it has become in-
creasingly evident that ours is an era of radical openness, in which
everything is possible as art. What is perhaps less evident is that that
pluralism extends to aesthetics itself. If everything is possible as art,
everything is possible as aesthetics as well. This, I think, is in large
measure the legacy of the Intractable Avant-Garde, which opened up
the practice of art in a way that would have been unthinkable when
the pursuit of beauty was regarded as art's defining goal.

In the early days of Modernism, for reasons that to this day remain
historically uncertain, the academic paradigms of mimetic exactitude
ceased being compelling for painters and their more informed view-
ers. Perhaps the artists themselves were unclear how their works were

to be understood. Applying labels like "Fauve" or "Cubist" left entirely obscure what the explanation was for the radical departures from mimetic and at the same time from aesthetic rectitude. Characteristic explanations were that the artists were mad, that they were engaged in hoax, that they didn't know how to paint. What was Matisse really doing in *Blue Nude* or *La Femme au chapeau*? And why did he and so many others abandon the pictorial achievements that had been taken as the glory of Western civilization and as proof of its superiority? I was particularly struck by a remark made by Roger Fry in response to the barrage of critical attacks against the exhibitions he had organized of Post-Impressionist painting in 1910 and again in 1912. "A great deal has been said about these artists searching for the ugly instead of consoling us with beauty," Fry wrote. "They forget that every new work of creative design is ugly until it is beautiful." Fry took it for granted, it seems to me, that if paintings are artistically excellent, they *must* be beautiful, once we have learned to see them as they should be seen. My view, in *The Abuse of Beauty*, was the opposite of that. I thought that the contested paintings of Matisse showed that it was possible for painting to be artistically excellent and at the same time ugly. And greatly as I admire Fry for his adventure and his critical insight, I feel that his task should have been to show this, to show that it is not necessary for art to be beautiful to be good. It is worth stressing the spontaneous adjunction of beauty and consolation in Fry's argument, since that throws a certain light on Dada's refusal of beauty: Why should the artists console the war makers? It is even more relevant, however, to recognize that if Fry were right, the project of Dada would be doomed from the outset. It would be impossible to make art that was any good without at the same time making it beautiful. The immense contribution of Dada to the philosophy of art was to open a conceptual gap between art and beauty, into which other aesthetic qualities might flow, even ugliness, which made it possible for the German war artists to show the ugliness of war and to use their art as a moral mirror. Kant observed that there is, with the one exception of disgustingness (*Ekel*), nothing so ugly that it cannot be represented as beautiful, war being one of his examples. But why should artists beautify? Why should they not show the ugly *as* ugly, or

even represent what might be a beautiful woman by means of an ugly painting of her? And what would be the use of this if in the end the art were seen as beautiful?

Beauty is always easy to see. It no more requires training to perceive it than to perceive that something is red or green. Philosophers have tended to be casual in dismissing judgments that something is beautiful as merely subjective and having nothing to do with reality. Logical positivists loosely subscribed to an emotivist theory of meaning in connection with aesthetic as well as moral terms. Such terms have no descriptive meaning, in this view, but are used instead to express feelings of pleasure: Saying that something beautiful is equivalent to emitting a whistle of approval in its presence. That fails entirely to capture the effect of consolation that Fry's critics complained was lacking in the art he showed. "Many linguistic utterances are analogous to laughing," the positivist Rudolph Carnap wrote in his *Philosophy and Logical Syntax* of 1935, "in which they have only an expressive function, no representative function. Examples are cries like 'Oh, oh!' or, on a higher level, lyrical verse." Words like "right" and "good," "beautiful" and "ugly," had no objective reference.

But Dieter Roth knew precisely what to look out for in his art. It is difficult to believe, on the basis of Roth's oeuvre at its most characteristic, that it could very often have happened that beauty's intrusive presence brought him to a halt. Consider his 1978 *Tibidabo—24 Hours of Dog Barking*, which centrally consists of twenty-four hours of uninterrupted dog barking. I have experienced this work, which was playing in one of the galleries of an exhibition of his work at Barcelona's MACBA. My view of the piece is that our response to it is exactly like the response we would have to uninterrupted dog barking in life. Its gets on our nerves. It is annoying. What we are not to imagine is that someone would say, I have learned to find beauty in the constant barking of dogs. But for just this reason, I cannot imagine Roth stopping because *he* found the barking beautiful. We are all alike when it comes to the barking of dogs, and Roth cannot have been any different from the rest of us (in fact he could stand it for only a few hours, leaving it to his assistants to finish the recording). The argument is simple: The moment he were to find it beautiful, he would, given his

principles, be obliged to stop making it. And this is generally true of every work Roth achieved. In fact, I think on the evidence of Roth's oeuvre that he recognized the same things as beautiful that everyone else does. He just did not want them to be part of his art.

Roth was affiliated with Fluxus, which sometimes referred to itself as Neo-Dada. An important item in the Fluxus agenda was "overcoming the gap between art and life." Roth took this imperative more personally than any other artist known to me: He almost literally put his life into his art, which consists in large part in things that were part of his ordinary life, using, as art materials, substances from the *Lebenswelt* with no previous place in the material history of art—chocolate, cheese, excrement. These substances undergo no transformation when turned into art; they have, as art, whatever aesthetic qualities they have in life. The exhibition I saw of his work in Barcelona was called "The Skin of the World," which included photographic slides of every house in Reykjavík, Iceland, where Roth lived—thirty-six thousand slides stored in four hundred carousels. There is no effort to beautify: This is how the houses in Reykjavík look. He removed the floor from his workspace and transformed it into a sculpture, scuffs and spills included. His oeuvre embodies the aesthetics of everyday life as lived, not beautiful, not ugly, but the way things are—"the skin of the world." Kant had a trivalent scheme: the beautiful, the ugly, and the ordinary. The ordinary is what Duchamp had in mind by the "anaesthetic." We have no specific aesthetic vocabulary for most of Roth's work, but that does not mean it has no aesthetic. American teenage vocabulary gave us the word "grunge." Grunge was used in an almost Dada way, to open a gap between those who affected it and figures of authority—parents, teachers, the whole adult world. Grunge comes close to Dieter Roth's aesthetic, though there is obviously a far longer story to tell than explaining how adolescents use disarray to express their resistence.

In "A Plea for Excuses," in which the Oxford philosopher J. L. Austin set forth his distinctive program of what he considered "field work" in the philosophy of language, he wrote, "How much it is to be wished that similar field work will be undertaken in, say, aesthetics; if we could forget for a while about the beautiful and get down instead

to the dainty and the dumpy." In bracketing the beautiful with the
dainty and dumpy, Austin was clearly attempting to cut beauty down
to size, to back away from bracketing it with the true and the good in
the classical triumvirate of fundamental values. In that era of analyti-
cal philosophy, it was de rigueur to shun edification and to use the
least edifying examples one could find. When Austin discussed *akra-
sia*, or "weakness of will," for example—an important idea in moral
psychology as discussed by the ancients—he used as an example help-
ing himself to an extra piece of dessert at high table, when there was
only one piece per guest and knowing that it was wrong to do this,
rather than Euripides' example of murdering the children one loved,
as in his tragedy *Medea*. At the same time, exactly by bracketing the
beautiful with the dainty and the dumpy in a philosophical atmo-
sphere in which "beautiful" was acknowledged to have only emotive
meaning, Austin was also implying that it is a word with honest de-
scriptive work to do.

Austin's view was that "our common stock of words embodies all
the distinctions men have found worth making, in the lifetimes of
many generations: and these surely are likely to be more numerous,
more sound, since they have stood up to the long test of the survival of
the fittest, and more subtle, at least in all ordinary or reasonably prac-
tical matters, than any that you or I are likely to think up in our arm-
chairs of an afternoon—the most favored alternative method."

Oxford analysis did not long survive Austin's early death in 1958,
but I am appealing to his incidental remark in order to emphasize that
our aesthetic vocabulary is significantly wider than the traditional dis-
course of philosophical aesthetics would have led one to believe. The
classical texts, since Burke and Kant, would have adjoined "sublime"
to "beautiful" as part of what aestheticians deal with, and Kant paid
particular attention to "ugly"—though mainly in connection with
how "things that in nature would be ugly or displeasing [such as] the
furies, diseases, devastations of war, and the like" can be represented
as beautiful through the offices of artistic representation. In conclud-
ing his *Critique of Aesthetic Judgment*, Kant drew attention to further
resources from which to derive an aesthetic description: "We often de-
scribe beautiful objects of nature or art by names that seem to put a

moral appreciation at their basis. We call buildings or trees majestic and magnificent, landscapes laughing and gay, even colors are called innocent, modest, tender, because they excite sensations which have something analogous to the consciousness of the state of mind brought about by moral judgments."

Even so, and perhaps for good reason, the dainty and the dumpy rarely if ever came up in the tradition, but for just this reason, perhaps, Austin's point must have been that if we cannot come up with an account of these, what hope can there be of making headway with beauty, which comes trailing clouds of metaphysics, from Plato and Plotinus to Kant and Hegel? Admittedly, it is somewhat comical to envision a course at Oxford called "Aesthetic Inquiry: From the Dainty to the Dumpy" in which a group of dons, seated around the seminar table, work out the rules of usage for the aesthetic terms under *d* in the *OED*, proceeding alphabetically, like members of the *Académie Française*, from "dapper," "dappled," and "dashing," through "delicate" and "dirty," to "drab," "dreary," and "dull," leaving one to wonder when, if ever, it would occur to someone to ask by what criterion one can tell when a term is aesthetic. The ceramist Jun Keneko shapes large masses of clay into objects on a very large scale, which he designates *Dangos*, sweet dumplings in Japanese cuisine. "Dumpling" is a term of affection in English, when used as a metaphor of tenderness for someone embraceable and sweet. Keneko means to indicate that his works have a friendly rather than an overpowering feeling, like amiable giants to whom we are to relate in the spirit of play, and the patterns with which he decorates them underscores their ludic nature. In Dickens's *Dombey and Son* (I find this in the *OED*), a man is told that he "ought to have a nice little dumpling of a wife." That is a formula for finding not a beautiful wife, but a warm, huggable wife who might be pretty enough. Edouard Manet's wife, Susanne, was exactly a dumpling wife, and Manet adored her. The *OED* cites an 1865 text: "She had no idea that there could be any prettiness in a dumpling figure." Manet, who painted Susanne often, would have been able to tell her something worth knowing.

The word "delicate," to remain for the moment among the *d*'s, was singled out in a strikingly original and at the time (1959) widely dis-

cussed paper by Frank Sibley, "Aesthetic Concepts," in which it was argued that aesthetic concepts as a class are not "condition governed," at least in the sense that there are not necessary and sufficient conditions for their application. Sibley said we apply them with reference to taste, which was shorthand for saying that we simply perceive that something is delicate in the ordinary way of perception. This requires a distinction that Sibley does not quite draw. We use "delicate" in aesthetic as well as in nonaesthetic ways. We speak of someone as in "delicate health," for example, which means that he or she has to take precautions that ordinary healthy people can disregard. Similarly, a delicate mechanism has to be protected from shocks if it is to function properly. Most drawings are delicate in this way, which need have nothing to do with aesthetics at all. But if we speak of a drawing as delicate aesthetically, this has nothing to do with how the drawing is to be cared for. So if, to use Sibley's example, we speak of the delicacy of a Ming vase, that need not translate into how the vase should be treated to keep it from breaking. Anything made of thin porcelain is delicate in the sense that it should be handled with care. But not all porcelain objects are aesthetically delicate—bathtubs, say, or urinals. Things can of course be delicate in both ways, in the same way that things can be "Rothian" in two ways, depending upon whether they are part of life or part of Roth's artistic oeuvre.

Delicate flavors require fine discrimination to be distinguished, to be delicately described means that the author has taken care in his or her choice of adjectives, etc. But in general, delicacy belongs to what one might term the aesthetics of the ordinary—to Duchamp's *L'Air de Paris*, for example, which would have been a simple apothecary's vessel were it not a work of art, its delicacy due to its material, namely, glass.

But there is something distinctive of aesthetic concepts as a class beyond the principles of application, namely, how the objects that fall under them affect us when we perceive them. The disgusting, for example, is something that affects us viscerally in a negative sort of way, as the etymology of the term acknowledges with its tacit reference to taste. But even beyond this, there is the larger question of what its delicacy contributes to the meaning of a Ming vase. And this belongs less

to the phenomenology of aesthetic perception than to what one might call the logic of aesthetic description of works of art. The aesthetic qualities of Roth's work contribute to their meaning, and the meaning has to be eked out with reference to Fluxus considerations, and in particular in the use Roth made of them, in excluding beauty, even if, as I remarked above, there was not much of a chance that beauty should find its way into Roth's world. He flaunted his bohemian style of life in his art.

This returns me to beauty as primus inter pares in the truly vast lexicon of aesthetic terminology. There really is no reason internal to the concept of art, for artists to confine themselves to beauty or such other of the aesthetic qualities that evoke visual pleasure. But beauty has, as I noted, a role to play in human life independent of whatever role it plays in art. It would be perfectly possible—it is very nearly actual—that we should prize beauty in the *Lebenswelt* and scorn its appearance in art. Its importance to us as humans explains its status as one of the fundamental values, along with truth and goodness. It would be impossible to have a truly human form of life without truth or goodness, and it takes little reflection for us to realize that a world without beauty would not be one we would like to live in. That cannot be extended to art. An independent argument is required if we are to justify beauty in art. It is not, so to speak, the default condition for art. There has to be a reason why it is there.

The main philosophical contribution of *The Abuse of Beauty* is the distinction between what I term "internal" and "external" beauty. Beauty in art is internal when it is part of the work's meaning. Often this requires us to distinguish between a work and the object that is its material embodiment, where one has to decide whether a property of the object carries over as a property of the work or not. This usually requires interpretation. A good example is Duchamp's *Fountain*, where the object is a standard mass-produced white porcelain urinal. The urinal, it was argued in 1917 when Duchamp attempted to have it included in the exhibition of the Society of Independent Artists, is actually a beautiful form, with affinities to the sculpture of Brancusi. Let us grant this point. Does it follow that the *work* is beautiful? Only if work and object are identical. But this is not true of necessity. The

work was very daring in 1917, but the urinal itself was an ordinary fixture, not daring at all. Displaying it in the window of a plumber's supply store was not audacious—but displaying it in an art show would have been. What gave *Fountain* an important place in the history of art is different from what gave the urinal an important place in the history of plumbing. I would say that the beauty of the urinal was external to the meaning of *Fountain* and not part of its meaning at all.

Whereas the beauty of Maya Lin's Vietnam Veterans Memorial is internal to its meaning. The beauty of the work is internal to the healing process the memorial was designed to achieve in American life. That is what one hopes will happen at Ground Zero in New York. The artist Ellsworth Kelly proposed as a memorial to the World Trade Center towers a grass-covered mound, visible from New York Harbor. It would be like one of the great Indian burial mounds in Ohio. The beauty would be internal to its meaning. There is a certain beauty internal to the meaning of the *vanitas* paintings of the seventeenth century. They often contain a burning candle, for example, of the kind that was used in the spontaneous shrines that sprang up in New York in the wake of the attacks of September 11. In a *vanitas*, the candle is intended to emphasize the brevity of life and to remind the viewer to think of eternal things. But the beauty of life is part of what distracts us from our higher destiny. The dying words of the French mystic Maria Bashkiertseff, a beautiful young woman convinced that the world was well left behind, were nevertheless these: "*Maman, maman, c'etait pourtant si beau la vie.*" The *pourtant* ("nevertheless") is what gives her words their poignancy. The beauty of the world cannot be denied, even if our mind should be on higher and eternal things. That is the message of the *vanitas* as well. The beauty of the *vanitas* is intended to make the viewer think—and to change his or her life— that beauty is vain, and in vain.

2004

The World as Warehouse:
Fluxus and Philosophy

Carry me along, taddy, like you done through the toy fair.
—James Joyce, *Finnegans Wake*

In 1958 the aesthetician William Kennick urged readers of *Mind*, the leading philosophical journal in the English-speaking world, to imagine a very large warehouse "filled with all sorts of things—pictures of every description, musical scores for symphonies and dances and hymns, machines, tools, boats, houses, statues, vases, books of poetry and prose, furniture and clothing, newspapers and postage stamps, flowers, trees, stones, musical instruments." He went on: "Now we instruct someone to enter the warehouse and bring out all the works of art it contains. He will be able to do this with reasonable success, despite the fact that, as even the aestheticians will admit, he possesses no satisfactory definition of art in terms of some common denominator." Kennick was applying to the concept of art a revolutionary idea enunciated earlier in the decade by Ludwig Wittgenstein: that we are able to navigate the world without the sorts of definitions philosophers since Plato had taken it as their task to provide—of justice, knowledge, beauty, friendship, and the like. We all, Wittgenstein claimed, know how to apply these concepts and draw the necessary distinctions, though philosophers have made scant progress in their quest for definitions for more than two millennia. He illustrated this with a simple example: games. He tried to show that there is no set of

conditions satisfied by all and only the set of games. And yet we all know which things are games and which things are not. It is this that Kennick was saying about works of art. We all know which things are works of art, more or less. No definition will make us much the wiser.

What neither Wittgenstein nor Kennick considered was that there was to be a problem of distinguishing artworks from games. Neither they nor anyone at the time would have foreseen a time when various sorts of games would begin to infiltrate the imaginary warehouse of works of art. In a way this had already happened, if we consider as art the exquisite chess sets made by Max Ernst or Man Ray. Had a wanderer in Kennick's warehouse encountered one of these, he or she might decide it qualified as art because of the beauty of the design or the skill that went into its facture. It might have been classed as a marginal example of sculpture. Suppose, however, one were to encounter one of those cheap mass-produced diversions in which the task is to get a number of small metal balls to fit into holes. It would almost certainly have been set aside as a mere toy. It is, however, precisely such toys, with no claim to beauty or craftsmanship, that were about to find their way into the art world while retaining their identity as playthings. These ontological double agents—at once bits of art and mere real things—were in the service of a movement then and for some while afterward too obscure to have registered on philosophical let alone ordinary consciousness. This was Fluxus, which was part of a quiet conceptual revolution taking place in the art world along a wide front in the late 1950s and early 1960s. By an irony of history that must make us wonder about the idea of a zeitgeist, exactly the line between works of art and everything else was being called in question at roughly the same moment—"back when," according to Dick Higgins, "the world was young—that is around the year 1958"—that Kennick assured us that the line in question was fixed and firm, and part of the conceptual consciousness of those who knew how to use the expression "work of art."

Consider a corollary case. Much the same common ability to sort the artworks out from the rest of the world's inventory would have been thought easily able to distinguish music from mere noise. To be sure, many will say that music from exotic cultures sounds like so

much noise to them, but the perception that the sounds emanated from stringed instruments or sets of pipes blown through and sticks beaten together would convince them that it was being performed in a disciplined way by what their culture would class as musicians, however cacophonous, to their ears, the effect. But this would not be said of the mere noises of everyday life—the rumble of the subway trains, the rattle of the taxis, to quote from an old show tune. It was precisely this boundary that the American composer John Cage set out in the early fifties to call in question: "I had taken steps," Cage wrote in his foreword to *M*, "to make a music that was just sounds, sounds free of judgments about whether they were musical or not." He elaborated:

> Since the theory of conventional music is a set of laws exclusively concerned with "musical" sounds, having nothing to say about noises, it had been clear from the beginning that what was needed was a music based on noise, on noise's lawlessness. Having made such an anarchic music, we were able later to include in its performance even so-called musical sounds.
>
> The next steps were social, and they are still being taken. We need first of all a music in which not only are sounds just sounds, but in which people are just people, not subject, that is, to laws established by any one of them, even if he is "the composer" or "the conductor." Finally we need a music which no longer prompts talk of audience participation, for in it the division between performers and audience no longer exists: a music made by everyone.
>
> What's required is a music that requires no rehearsal.

In these crucial years, especially in and around New York, the commonplace world of everyday experience had begun to undergo a kind of transfiguration in artistic consciousness. The idea dawned that nothing outward need distinguish a work of art from the most ordinary of objects or events, that a dance can consist in nothing more remarkable than sitting still, that whatever one hears can be music— even silence. The plainest of wooden boxes, a coil of clothesline, a roll of chicken wire, a row of bricks could be a sculpture. A simple shape

painted white could be a painting. The institutions of the art world were not well suited to this moment. It was unreasonable to pay admission to watch a man not move or to listen to oneself breathe while someone, sitting before a piano, did not touch the keys. So much the worse for the institutions of the art world! At any time the weather allowed, a group could assemble to perform Dick Higgins's 1959 *Winter Carol*, listening to the snow fall for an agreed-upon period of time. What could be more magical?

Closing the gap between art and life was a project shared by a number of movements, united by a common mistrust of the claims of high art, but differing, like sects of a new revelation, with reference to which sector of common reality to redeem. Pop refused to countenance a distinction between fine and commercial, or between high and low art. Minimalists made art out of industrial materials—plywood, plate glass, sections of prefabricated houses, Styrofoam, Formica. Realists like George Segal and Claes Oldenberg were moved by how extraordinary the ordinary is: Nothing an artist made could carry meanings more profound than those evoked by everyday garments, fast food, car parts, street signs. Each of these efforts aimed at bringing art down to earth and transfiguring, through artistic consciousness, what everyone already knows. From some time in the nineteenth century, prophets like John Ruskin and William Morris had condemned modern life and pointed to some earlier historical moment as an ideal to which we must strive to return. The artists of the fifties and sixties were also prophets, reconciling men and women to the lives they already led and to the world in which they lived it. Perhaps all this was the artistic expression of the massive embrace of ordinary life after the massive dislocations of the Second World War. What could be more meaningful than building materials, canned goods, children's toys—the consumer goods against which the next generation, in the explosion of political radicalism of the late 1960s, was to turn with such vehemence?

None of these movements reached further or went deeper in this effort than Fluxus, many of whose first adherents were members of Cage's New School seminar in experimental composition. But they were not interested simply in the noise-music disjunction. They were

interested in abolishing the line Kennick supposed would be recognized by all who entered the warehouse, between works of art and whatever else there was, whatever problems there might be in deciding on which side of the line something belonged. Coffee cups are no less beautiful than the most exalted sculptures, a kiss is as dramatic as the *Liebestod*, the slosh of water in wet boots is not to be invidiously distinguished from organ music (this inventory is paraphrased from Dick Higgins's *A Child's History of Fluxus*). George Maciunas, who gave Fluxus its name and a considerable portion of its form and feeling, declared in *Neo-Dada in Music, Theater, Poetry, and Art* that "if man could experience the world, the concrete world surrounding him, in the same way he experiences art, there would be no need for art, artists, and similar 'nonproductive' elements." Maciunas's idea was that something could be art without necessarily being high art. "There's a lot, too much high art, in fact; that's why we're doing Fluxus," he told Larry Miller in a 1978 interview. "We never intended it to be high art. We came out like a bunch of jokers."

Before Fluxus, works of art were thought of in terms of high art and to have, as Kennick's argument shows, a strong independent identity through which they were distinguished from whatever else there was. They were placed first in cabinets of wonders—*Wunderkammers*—and then in museums, segregated from the flow of life. The revelation of Fluxus was that everything is marvelous. One did not especially need to single out soup cans or comic strips like Pop, industrial products like Minimalism, underwear and automobile tires like the New Realists. Art was not a special precinct of the real but a way of experiencing whatever—rainfall, the babble of a crowd, a sneeze, a flight of a butterfly, to list some of Maciunas's examples. The warehouse Kennick imagined was the world—a world without the boundary the concept of art had up to then presupposed. A collection of Fluxus objects, such as the Silverman collection in Detroit, is the reverse of those cabinets of wonders that so enchanted princelings in postmedieval times. They are cabinets of the commonplace. The ordinary is wonderful enough.

The lingering conceptual question was by virtue of what were Fluxus and so-called high art both to be considered *art*. The slogan,

from the French artist Ben Vautier, one of the stalwarts of Fluxus, that "*Absence d'art = Art*," left unresolved the question of what connection there could be between a box of matches, say, and *The Last Judgment* of Michelangelo or Raphael's *Sistine Madonna*. What was revolutionary about Fluxus was that it removed from the concept of art whatever had been thought to ground the distinction—"Exclusiveness, Individuality, Ambition . . . Significance, Rarity, Inspiration, Skill, Complexity, Profundity, Greatness, Institutional and Commodity Value," to cite a partial catalog from Maciunas's 1966 *Fluxus Manifesto*. The effort was not to deny that the history of art up to that point had been marked by these qualities. It was rather to deny that any of them was essential to a concept of art that was to include the "Simple Natural Event, An Object, a Game, a Puzzle or a Gag." The mark of Fluxus art is that much of it would be seized upon by anyone conversant with the history of art as not art at all. A paradigm Fluxus work would be precisely the kind of simple game I cited above, in which one tries to get two metal balls to settle into holes where the eyeballs are located in a crude chromolithograph of a clown's face. The frontispiece of the publication that accompanied the Walker Art Center's 1993 exhibition, "In the Spirit of Fluxus," shows George Brecht's 1975 *Valoche (A Flux Travel Aid)*—an open and partially unpacked wooden box containing or surrounded by toys: a jump rope, some balls, a top (perhaps), a children's block with a snowman painted on it, a chess piece, a plastic egg or two, and what might or might not be prizes from boxes of Cracker Jacks. Fluxus did not show that no definition of art could be given. It showed that whatever definition there was had to deal with these least prepossessing of objects and actions. Maciunas cites with considerable satisfaction a Fluxus performance by George Brecht where he turned a light on and off. "That's the piece. Turn the light on and then off. Now you do that every day, right?"

Since not every action consisting in turning a light on and off is an artistic performance, the question is what accounts for the difference. It was, it must be conceded, no part of Fluxus to answer this question. I regard it, however, as the central question in the philosophy of art, and part of why I cherish Fluxus is that it raised it in a particularly acute form. In truth, it could have been generated from many sectors

of the avant-garde art world of the 1960s—from Pop or Minimalism, and most especially from Conceptual art late in the decade, when it was no longer accepted that art even required that there be a physical object at all. In principle, the question could have been raised at any time in the history of art, but it would have made no sense to philosophers, since there would have been nothing to nourish it in actual artistic practice until the time of Fluxus. What is fascinating is that it arose from within artistic practice itself at this particular historical moment, and it has occupied philosophical attention—or at least my philosophical attention—ever since.

In addition to the philosophical problem, there is a question of historical explanation: Why at a particular moment did art take this singular and largely unprecedented turn? The best that art historians are able to offer by way of a historical explanation of Fluxus, or the other movements in the extraordinary moment to which it belonged, is that they were reactions against Abstract Expressionism. "At some point," Barbara Haskell writes in the catalog for her wonderful exhibition of 1984, *Blam!*, "Every generation feels the need to explore territory different from that occupied by its elders." She is entirely right in emphasizing the degree to which Abstract Expressionism's exaltation of the artist as a hero, and of art itself as a probe into the deepest recesses of spiritual reality, became a target of revulsion or ridicule for the generation that followed. There is no question that there was a reaction against the excessive romanticism of Abstract Expressionism, but that cannot account for the different forms the reaction took in Fluxus, Pop, Minimalism, and Conceptual art, each of which admittedly shared some traits. Minimalists, for example, were often disposed to use vernacular materials, like bricks or plywood. In this Minimalism resembled Fluxus. But Fluxus entirely shunned the reductionism of Minimalist art. Pop artists were attracted to throwaway imagery—to labels on canned goods, bubblegum wrappers, advertising boilerplates, pictures in comic books or movie magazines—but their effort was to turn these into oil paintings on the same monumental scale favored by Abstract Expressionists, to make them into "works of art" in a fairly conventional sense. Fluxus too was interested in these images but had no interest in doing anything to them. Wittgenstein said that philoso-

phy should leave the world as it found it. Something like that is true of Fluxus as well. George Brecht said, "Between art and everyday life, there's no difference . . . I take a chair and I simply put it in a gallery. The difference between a chair by Duchamp and one of my chairs is that Duchamp's is on a pedestal and mine can still be used."

For what it is worth, there were in philosophy certain developments that paralleled what was happening in art at the time. The efforts to deflate the pretension of high art were matched by the effort to rid thought once and for all from the pretensions of what one might call "high philosophy," say, the kind of metaphysical speculation exemplified in the somewhat tortured prose of Martin Heidegger. I cannot think of anything that better expresses this deflationist attitude than a work by Dieter Roth, who transformed into so many wursts the separate volumes of Hegel's *Gesammelte Werke*, which he hung in rows as they would be found in a German delicatessen. "Whatever can be said can be said clearly," Wittgenstein had written in *Tractatus Logico-Philosophicus*. "Most propositions and questions, that have been written about philosophical matters, are not false but senseless. We cannot answer questions of this kind at all, but only state their senselessness."

How were we to do that? Here positions varied. Some philosophers felt that the methods of science offered the best model of clarification. All we needed to do was to specify the kind of observations that would verify a proposition, and that would take care of matters entirely. Indeed, if we cannot connect language with observation, that is to acknowledge that we are speaking nonsense. Other philosophers felt that if we pay close attention to the way we use ordinary language, we will see that that suffices all our intellectual needs. In the fifties and sixties, avant-garde philosophy consisted either in the logical examination of the language of science or in the close reading of the way ordinary men and women use language in the everyday scenarios of common life. In a somewhat loose way, these two strategies could be said to correspond to the reductionist agenda of Minimalism or to the reversion to ordinariness we find in Pop or Fluxus. I think these parallels between advanced philosophy and avant-garde art would have taken place whether or not philosophers and artists knew of one an-

other's existence, and that the explanation of why this took place would tell us a great deal about the direction of culture in the second half of the twentieth century. But I have no general explanation of my own to offer.

Whatever the general explanation may prove to be, it seems clear that Fluxus attitudes derive from two related sets of ideas that flowed through Cage's teaching. One was the philosophy of Zen Buddhism, the other was the example of Marcel Duchamp. These connect with the two chief forms of Fluxus art—the performances, including the performance of Fluxus compositions (which often consist in a set of simple instructions), and the objects, which bear a certain relationship to Duchamp's ready-mades. I'll discuss each of these ideas separately.

Dr. Suzuki's seminar in Zen Buddhism at Columbia University was one of the most influential cultural events of the later 1950s in New York. Since Cage was an enthusiast of Zen, his seminar together with Suzuki's were the two main conduits through which these remarkable ideas entered American avant-garde consciousness in the postwar years. Part of what explains the form that avant-garde reaction to Abstract Expressionism took was Zen's belief that enlightenment can be attained through the most ordinary of practices, that, to cite a famous book, even motorcycle maintenance offered a path to higher truths. One need not detach oneself from life and practice an esoteric discipline. The conduct of daily life offers all the possibilities that those who seek a spiritual life require. The world of ordinary objects is itself the nirvanic state to which Buddhism aspired. Dr. Suzuki tells of a Zen master of the ninth century who was asked, "We have to eat and dress every day, how can we escape from all that?" The master replied, "We dress, we eat." "I do not understand you," the questioner said. "If you don't understand put your dress on and eat your food." Suzuki comments, "There is nothing mysterious in Zen. Everything is open to full view. If you eat your food and keep yourself dressed, you are doing all that is required." As George Segal said, the ordinary is the extraordinary. The samsara world and the nirvana world are one.

Eating and dressing figure in many of Fluxus's performances, such as Ben Vautier eating of "Fluxus Food" in 1963, and food and gar-

ments constitute—or constitute parts of—Fluxus objects, such as the false fruits and vegetables and fried eggs with which Claes Oldenberg filled a drawer in a cabinet of drawers titled Flux Cabinet (another drawer had partitions containing Excreta Fluxorum). Food offered opportunities for a variety of practical jokes, which is an important constituent of Fluxus sensibility, but jokes calculated to induce enlightenment play a definite role in Zen as well. Alison Knowles's performance *Proposition* (1962) consisted in making a salad. Her performance *Identical Lunch* involved several performers eating the identical lunch in the same diner over several days. In the main, Fluxus performances were exceedingly simple events, consisting of a single occurrence—like George Brecht's turning a light on and off. Except against a background of theatrical expectations, they were chosen to have zero degree of excitement.

"I would give to George Brecht a lot of credit for extending that idea of ready-made into the realm of action," Maciunas observed. The idea of a ready-made action—like the idea of a ready-made object—is not without certain constraints. A ready-made object has somehow to be ultraordinary, an object with nothing extraordinary about it. A ready-made action has similarly to be the kind of action simply and easily performed by anyone at anytime—an action that requires no particular training and the acquisition of no particular skills, the kind of action that would offer itself as an example for Zen. Yoko Ono, who had been instructed in Zen teaching and practice in Japan, created a number of exceedingly simple performances early in her career. *Lighting Piece* of 1955 is a good example: "Light a match and watch till it goes out." In point of simplicity, *Lighting Piece* bears comparison with the kind of art that Duchamp, as far back as 1915, had begun to make out of ordinary objects, selected from what phenomenologists designate as the *Lebenswelt*. His so-called ready-mades were, for the most part, manufactured objects of known utility, available to anyone who needed to shovel snow or dry bottles or groom dogs. Anyone with a few dollars could in principle walk into a hardware store and walk out with a work of art. But the ready-mades would certainly have been overlooked by anyone walking through Kennick's warehouse. In art-historical truth, Duchamp's ready-mades were not en-

tirely in the spirit of Zen, for they were chosen with reference to rather definite criteria, namely, their utter lack of aesthetic interest. "A point which I very much want to establish is that the choice of these 'ready-mades' was never dictated by aesthetic delectation," Duchamp wrote in 1961. "The choice was based on a reaction of visual indifference with at the same time a total absence of good or bad taste . . . in fact a complete anesthesia." Duchamp polemicized against what he ironized as "the retinal shudder!"—the gratification of the aesthetic eye. At one point, Duchamp raised the idea of what he termed "reverse ready-mades," objects with a high degree of aesthetic interest put to a certain use in which their beauty played no role. His example was a Rembrandt painting turned into an ironing board. There is something even more revolutionary in the reverse ready-made than in the ready-made as such. It anticipates a political gesture that was to become institutionalized in some of the radical egalitarian movements of the twentieth century, like turning artists and poets into night-soil workers under the Cultural Revolution in China. The idea of making a tool into an artwork and an artwork into a tool is, as we who have lived through the twentieth century know, a shattering political analogy. In Cambodia under Pol Pot, even wearing glasses was enough to get one into terrible trouble—it implied literacy.

The thought of bringing high art down, however, was entirely in the spirit of Dada, which was the first of the century's movements to produce an art that was antithetical to fine art in every way. The spirit of Dada was a refusal of high-mindedness, an endorsement of nonsense and buffoonery, and a rejection of beauty as a form of consolation. Its repudiation of high art was based on the recognition that Europe, which claimed cultural superiority to the rest of the world on its art, had been responsible for an event of unprecedented horror, the Great War, in which thousands upon thousands of young men went to their pointless deaths. Perhaps Dada inherited from the nineteenth century the idea that art would somehow save us—a promise that achieved its most extreme form in Wagnerism—but it would be a very different kind of art, an art not of heroes but of comedians—or what Maciunas spoke of as "jokers"—dedicated to play instead of sacrifice. The First International Dada Exhibition held in Berlin in 1922

proclaimed the Death of Art. "We have gotten beyond venerating works of art as divine and worshipping them," Hegel had written a century earlier, but until Dada no one could have known how *far* beyond worship the attitude toward art could go. "Thought and reflection have spread their wings above fine art," Hegel wrote in advancing his stunning thesis that "art in its highest vocation is and remains for us a thing of the past." Dada might have responded that there could be no higher vocation for art than to destroy that quasi-religious intoxication that drove nation to battle nation in the blood frenzy Europe had just staggered through.

As we saw, Maciunas referred to Fluxus as Neo-Dada. But he also had a certain political vision that has affinities to some of the most radical movements of the century. He had definite collectivist ideals. "Fluxus aspirations," he wrote in 1964, "are social (not aesthetic)." He envisioned a time when fine art can be totally eliminated . . . and artists find other employment. In his view, "Fluxus is a collective." No individual artist, but only the collective itself, should benefit from art done in the name of Fluxus. But beyond that Maciunas's manifesto specifies Fluxus art as having the "impersonal qualities of a simple natural event." In this respect, some of Duchamp's ready-mades would be ideal as Fluxus works. His metal grooming comb was so undistinguished, so "monostructural" in its flat metallic grayness, that, as he said, nobody had ever tried to steal it. And, if anyone did, one could always find another just like it. That is why Fluxus objects, as understood by Maciunas, should be essentially mass producible and radically inexpensive, like printed flyers. Maciunas held up as exemplary certain of the political virtues enjoined by a collective that called itself LEF—"The Left Front of the Arts," which changed its name in 1929 to "Revolutionary Front." In a letter of 1964, Maciunas wrote, "Fluxus is definitely against art-object as non-functional commodity—to be sold & to make livelihood for the artist. It could temporarily have the pedagogical function of teaching people the needlessness of art including the needlessness of itself. It should therefore not be permanent." Maciunas's radicalism was not necessarily shared by other Fluxists, but one could hardly have chosen better illustrations for "the needlessness of art" than the characteristic works that they

produced. They are art and they serve no need beyond themselves, not even those "higher needs of the spirit" that Hegel says art once served. There is an ingratiating lightness to Fluxus art, even a certain playful innocence. In part this is because so much of it consists of playthings—cheap objects from the five-and-ten, like the balls and marbles Joseph Cornell vested with such magic when he juxtaposed them in boxes behind glass. Indeed, exactly the things that turn up in Cornell's boxes, including vintage engravings, are to be encountered in Fluxus objects, together with a great deal more. But none of it is really intended to induce the sense of uncanniness and beauty one feels in the presence of Cornell's work. Often the objects are fitted together in valises, like Duchamp's portable museum of his own work, but with a heterogeneity and purposelessness that leave one with few options but to unpack and repack, since there is little to do with the components on their own. The unifying element in Fluxus work is Maciunas's intoxicating style of graphic design, strong black letters arranged to form words that have their own mystery, such as the cover he made for George Brecht's 1963 *Water Yam*.

Though I was certainly around in the early sixties in New York, and even preoccupied by the kinds of questions Fluxus was raising at the time, I knew nothing about it, nor did I encounter Fluxus until I saw Barbara Haskell's 1984 exhibition, *Blam!*, at the Whitney Museum of American Art. My first essay in the philosophy of art, "The Art World," was published in the *Journal of Philosophy* in 1964. It concerned itself precisely with the question of what makes something an artwork when something else, exactly like it, is merely an object. My paradigm was the *Brillo Box* of Andy Warhol, and though the art world was filled with other possible paradigms had the Brillo box not existed, it was the Brillo box—an object so crushingly ordinary in the way it looked, that Warhol's 1964 exhibition was visually of a piece with what one would see in the stockroom of a supermarket—that became the agency of my own philosophical enlightenment. Though I knew no one who belonged to the downtown art world that drew its inspiration from Cage and Maciunas, my office in the philosophy department at Columbia was on the same floor as the seminar room in which Dr. Suzuki held his classes. And Zen ideas found their way into

"The Art World." I cited a passage from Ching-Yuan, which I had found in one of Dr. Suzuki's books: "Before I had studied Zen for thirty years, I saw mountains as mountains and waters as waters. When I arrived at a more intimate knowledge, I came to the point where I saw that mountains are not mountains and waters are not waters. But now that I have got the very substance I am at rest. For it is just that I see mountains again as mountains and waters once again as waters." What moved me in this wonderful passage was the idea that there would have been nothing internal to the three experiences that could distinguish them from one another. I could imagine, if Ching-Yuan were an artist, that he might have painted three indiscernible landscapes answering to these three moments of his spiritual itinerary. You could not see any difference among the landscapes exemplifying his pre-enlightenment, his false-enlightenment, and his postenlightenment vision of the world, since in principle they looked all alike. But the differences, however necessarily inscrutable, were obviously momentous. I think in the early sixties, we were thinking in a similar way that a world of artworks and a world of mere things might look exactly alike, though the difference there as well should be momentous.

In the Whitney show, a dense array of Fluxus objects filled a few display cases. I could make very little of them at the time, though I might have reflected that Fluxus paid a price in anonymity for the unassumingness of most of its products. Some time later, when I was at the Getty Center in Santa Monica, I was shown a room full of Fluxus objects the institution had just acquired. They were piled on the floor, or placed on steel shelves, and as an ensemble it made a vivid impression on me. I could tell very little about what I was looking at, though it gave an impression not unlike that of a warehouse, to revert to Kennick's imaginary example. But little of it would have been selected as among the artworks had someone entered Kennick's warehouse circa 1958. In fairness to him, none of the standard philosophical theories of art would have helped anyone in making the right choices at that time. What Fluxus helped us see is that no theory of art could help us pick out which were the artworks, since art can resemble reality to any chosen degree, including zero. Fluxus was right that

the question is not which are the artworks, but how we view anything if we see it as art. Meanwhile, it has struck me ever since my experience at the Getty—and more recently at the Silverman collection of Fluxus in Detroit—that the warehouse provides just the right context for viewing Fluxus. Willem de Ritter's *European Mailorder Warehouse/Fluxshop* of 1965, which the Silvermans and the curator of their collection, Jon Hendricks, went to remarkable lengths to reconstruct, is the showpiece of their collection and somehow the embodiment of the Fluxus spirit—a toy fair for sophisticates, the commonplace transfigured, the world as warehouse.

2001

Painting and Politics

I recently came across a wry Father's Day card my younger daughter sent me when she was living in France. It reproduces as a paper doll the famous official portrait of Louis XIV by Hyacinth Rigaud done in 1701. It is as political a painting as I can imagine, as much so as those standard Socialist Realist portraits of Stalin, ironized by the witty émigré painters Komar and Melamid in such marvelous pastiches as *Stalin and the Muses* or *The Origins of Socialist Realism*, which are brilliantly political in their own right, as irony often is. Anyone who thinks that Rigaud's masterpiece is just a striking likeness of the great Bourbon monarch must be numb to what one might call the visual poetics of awe. It is political the way that Versailles itself is in creating an architectural embodiment of absolute power. Everything about Louis XIV, from his heavy ermine wrap to the delicate body language—it is as if the king enacts a little power dance, like the god Krishna or Adolf Hitler at the news that Paris had fallen—the baroque wig, the way his scepter conducts the flow of power between himself and his crown, is meant to translate into visual terms the ne plus ultra of seventeenth-century sovereignty. In contemporary arguments in favor of monarchy, recourse was often made to the design of the universe, with the sun in the dominant position. Louis XIV is the *roi soleil*, the supreme ruler, and all his representations are configured to convey his absolute power, with the political order of society symbolically implied through the complex of his attributes.

Someone might say, That's not art, it's propaganda. What then would we say about Leonardo's colossal equestrian sculpture of Lu-

dovico Sforza commissioned by his son Francesco? A contemporary described it as "the most gigantic, stupendous and glorious work ever made by the hands of man." It would have stood thirty-one feet and weighed seven tons. It was meant to intimidate, if you were an enemy of Milan, and to dominate, if you were his subject. When the French, under Louis XII, conquered Milan in 1499, their bowmen used Leonardo's terra-cotta model for target practice. Whoever believes that to have been mere philistinism is blank on the meaning of iconoclasm. Francesco had already ordered that the bronze, into which the sculpture was to have been cast, be melted down for cannons. War, it is famously said, is politics conducted by other means. And there is a natural moral equation between political art and armaments. When the Declaration of Independence was read aloud in New York by George Washington on July 9, 1776, a rowdy crowd pulled down a gilded equestrian statue of George III, which in time was converted into forty-two thousand musket balls—"melted majesty," a wit commented at the time.

I have always been dubious regarding the various rules of art criticism that take the form "If A is X, then A is not art" for any chosen value of X. These make it inherently impossible for something to be art and X at the same time, giving the critic a tool for a priori dismissal. But what is left over when we subtract from most works of art the factors that at various stages in the history of criticism have formed the basis for ruling them out as art—or, better, that we are enjoined to disregard in approaching them as art? In *Other Criteria*, Leo Steinberg discusses an injunction by Alfred Barr regarding the *Demoiselles d'Avignon* to see it as a kind of geometrical diagram, which means to erase from critical consideration the raucous eroticism of the work—not so much "If A is erotic, then it's not art" but "If A is erotic, then its eroticism must be bracketed in addressing it as art." "Can we be looking at the same painting?" Steinberg wondered aloud. In bracketing out as not pertinent to art the features for the sake of which the art was originally made, we may find that we have robbed art of its entire point and function. Seeing a painting as a geometrical diagram was as good a way of blinding viewers as can be imagined. Formalism was a way of seeing all art in much the same way.

In discussing with the critic Pierre Chabanne his *Large Glass*—a

work, since we have touched upon eroticism, whose proper title is *The Bride Stripped Bare by Her Bachelors Even*—Marcel Duchamp made it plain that in "looking at" the glass in "the aesthetic sense of the term," one was addressing only a part of the work, which consisted in the glass itself, together with the notes he gathered in what is referred to as the book: "One must consult the book, and see the two together. The conjunction of the two things entirely removes the retinal aspect, that I don't like." What Chabanne refers to as Duchamp's "antiretinal attitude" is in effect an antiaesthetic attitude. I want to emphasize that Duchamp was not saying in effect that if something is aesthetic, it isn't art. Rather, he was opposing the narrow identification between art and the aesthetic, opposing the "too great importance given to the retinal," that is, the aesthetic. And he elaborates: "Since Courbet it's been believed that painting is addressed to the retina. That was everyone's error. The retinal flutter! Before, painting had other functions: it could be religious, philosophical, moral . . . Our whole century is completely retinal, except for the surrealists, who tried to go outside it somewhat. And still, they didn't go so far! . . . Down deep [they're] still really interested in painting in the retinal sense. It's absolutely ridiculous. It has to change; it hasn't always been like this." My sense is that it is whatever is designated by the term "retinal" that people have had in mind as what is really art, in contrast with the various factors Duchamp mentions—"religious, philosophical, moral"—to which we may as well add erotic and political. So that art, or at least painting, is all and only what is retinal, everything else being "not really" art. It behooves us, then, in asking what is wrong with art being political, to address retinality with some care.

In the defining work of eighteenth-century aesthetics, Kant's *Critique of Judgment*, the perception of beauty was understood in terms of disinterested contemplation. But there was more implied in this formulation than just looking at something. For one thing, Kant did not believe that beauty was an objective quality of things. It was not like looking at something's color or shape. Rather, the perception of the thing put the perceiver into a subjective state, which Kant identified as pleasure and which Duchamp eroticizes with his witty expression "retinal flutter." It was like a visual *jouissance*. Santayana, in his late-

nineteenth-century *The Sense of Beauty*, analyzed the perception of beauty as the projection onto the object of perception of the pleasure felt upon seeing it, so that beauty was, in his formulation, pleasure objectified. The idea that beauty is visual pleasure is too obvious not to be nearly as old as philosophical reflection itself: Saint Thomas wrote *Pulcrae sunt quae visa placent*. What was novel with Kant was this: To claim that something is beautiful is to imply that everyone who perceives it ought to feel the same pleasure as I feel. It is in effect to universalize the pleasure, which makes beauty, in Kant's striking formulation, the symbol of morality, since moral judgments in their nature must be universalizable if they are valid. Hence the judgment of beauty is disinterested, and that would be enough to extrude politics from the experience of beauty, since politics is interestedness through and through.

But Kant drew no distinction between artistic and natural beauty, and in the eighteenth century, aesthetics cut across the art-nature borderline, which was wholly understandable since art was understood as the imitation of nature. So if a work of art was political, aesthetic judgment screened that out: One saw it as one would see a natural object, and the pleasure it induced would have nothing to do with its political content. Thus one sees *Ludovico on a Rearing Horse* as one would see Ludovico on a rearing horse. Hence its being political had nothing to do with its being art. There are some rough edges in the "hence," but that is what Duchamp found fault with in the retinal theory of art. There is a lot more to the *Large Glass* than what meets— or pleasures—the eye.

A far deeper but unfortunately far less influential view was set out in Hegel's *Lectures on Aesthetics*, which was composed only a few decades after Kant's book was published. Hegel distinguished sharply between natural and artistic beauty, the latter, in his wonderful phrase, being "born of the spirit and born again" (*Aus den Geistens geborene und wiedergeborene*). It meant, as I see it, that artistic beauty was in some sense an intellectual rather than a natural product. Hence more was involved in perceiving art than retinal flutters. To perceive artistic beauty required that the meaning be "born again" in the mind of the beholder through an act of interpretation. A work of art embodies a

meaning, and the meaning must be grasped if the work is to be grasped. Otherwise the work is no different from a mere natural object. And the artist, rather than someone who fashions pleasing objects, is accordingly someone who communicates meanings through the objects he or she fashions. And that means that, for Hegel, the perception of art is a cognitive activity: Grasping a work of art is like grasping a thought. Or better: It *is* grasping a thought, not so much expressed through words as expressed through objects. That is the power and the limitation of art. But Hyacinth Rigaud's magnificent portrait of Louis XIV does just that: Rigaud has had to find visual equivalents for the idea of absolute majesty viewers must understand if they are to grasp the thought the king wished to have conveyed through his portrait, viz, I am King Louis, greater than whom no mortal can be conceived.

Hegel held to the view that art, philosophy, and religion are three moments of what he termed Absolute Spirit. Art is limited in a way that philosophy is not by virtue of the fact that it is constrained to use objects (or images) as the medium through which to express thoughts. I don't want to get my feet too deeply tangled in Hegel's views, but it is not difficult to see why he thought art was historically so important. Art was able, through objects, to convey ideas that illiterate worshippers had to grasp for the sake of their salvation but that they could not grasp in abstract truth—ideas, say, like "God is One" or "God is all-powerful." Typically, the artist would have recourse to size, as Leonardo did in portraying Ludovico on a colossal scale. He made Ludovico, relative to the statue's viewer, more like a god than like a mortal. It diminished the viewer in exalting the subject of the work.

But how do we get contemporary political ideas into art? How do we convey, through images, that all men are equal? How do we convey through images the inalienable rights of life, liberty, the pursuit of happiness? Not so easy, if we think, for an example, of Norman Rockwell's "Four Freedoms" paintings. But still, limited as his representation of these abstract ideas are, what else would an artist do charged with the brief to give visual embodiment to exalted political ideals? Hegel had an interesting and famous idea in this connection. It was that the end of art had been reached, not in the sense that artists had

run out of ideas, or that the history of art was over, but in the sense that artists could no longer hope to express the kinds of ideas philosophy was capable of expressing, say, as in Hegel's own book of political philosophy, which discusses freedom as subservience to the state. And indeed it is difficult to see how one would paint that, until we think of what we feel our relationship must be to the king as portrayed in Rigaud's portrait if we are his subjects. But those limitations, so far as they are real, do not mean that it is illegitimate for art to convey political ideas in general, or that artists should confine themselves to inducing retinal pleasure in their viewers. The truth is that philosophy has hardly evolved to the point that it alone can deal with all the political and moral ideas we have to deal with in modern life. Humankind is far behind the point that Hegel believed he had attained in his philosophy. But it is far ahead of the political thought that is embodied in the political portrait of Louis XIV by Hyacinth Rigaud! Indeed, we can see the history of art as having attained the level of pluralism that is needed to make vivid the thoughts about love, identity, fear, and hope that define modern life. We need from artists all the help we can get—of expressing, through performances and installations, the complex political ideas we need to master in order to navigate modern life.

Meanwhile, it is important to recognize the way meaning inflects aesthetics itself. The eighteenth century had far too simple a concept of the retinal in restricting it to visual pleasure. Its central concept was that of taste and, really, the "ought" of universalization does not entail that everyone in fact will be fluttered by the objects that give us pleasure, but that they should be and will be as their taste is trained according to certain rules. Kantian aesthetics is more an agenda of education than something entirely modeled on morality, which he in any case says is only symbolically related to it. Or: There are interesting equivalences between moral education and aesthetic education. Kant wrote that if someone does not respond to something I feel he ought to, he lacks taste. But more than half the *Critique of Judgment* is taken up with the sublime, and Kant adds that if someone does not respond to what I see as sublime, he lacks feeling. Already his century had felt taste to be too thin a concept to deal with the more intense experiences either of nature or of art—storms at sea, volcanoes, or the

vastness of Saint Peter's Basilica. But the range of aesthetic qualities is far wider than that acknowledged in his book, or, for the matter, in any book. The feeling of awe Hyacinth Rigaud aspired to elicit is a case in point. Or the feeling of patriotism that the flag elicited in Americans after 9/11. But these are feelings inseparable from meanings embodied in those representations.

Let's consider, as a final example, Jacques-Louis David's great painting, *Marat Assassiné* of 1793. One has to know something about Marat and the French Revolution to see it as a political painting, but when David painted it, everyone knew this and knew the circumstances: that Marat, the fierce polemicist, had been treacherously murdered by a young woman, Charlotte Corday, who had hoped to restore order in France by killing Marat. She was the female suicide bomber of the French Revolution. David did not depict the act of killing but rather the effect, through what Baudelaire describes as a visual poem. The painting looks like a descent from the cross. Marat is holding a pen through which he was to perform an act of kindness for his assassin by signing a petition. A knife is on the floor, blood stains the sheet, which has become his shroud. One is to see Marat as Jesus and be moved by pity to identify with his cause and his sacrifice. We know the feelings we are intended to have, but we don't quite have those feelings since we are not part of the reality of the painting's moment. We cannot translate into action the feelings we have, but the actions the painting is intended to arouse are political, as the feelings themselves are, and if we can do little more than look at the painting, that does not mean that the feelings and the intentions they enjoin do not belong to the experience. It was meant to arouse, and that power is still felt. As a philosopher, what strikes me is that visual beauty is, in this work, internal to its political effect. The beauty underwrites the metaphor between Christ and Marat, and validates his suffering. He died for you. So what are you going to do to demonstrate he did not die in vain? *Allons enfants de la patrie!*

2003

The Fly in the Fly Bottle: The Explanation
and Critical Judgment of Works of Art

> Give therefore thy servant an understanding heart . . . that I may discern between good and bad: for who is able to judge? —I Kings 3:9

In an essay titled "A Quiet Crisis," which appeared in a recent issue of *Art in America*, the poet and critic Raphael Rubenstein deplored certain currents in contemporary art criticism. "Is there a serious breakdown in the dialogue around contemporary painting?" the subheading of his piece asks. "Should art critics get back into the business of making value judgments?" The second of these rhetorical questions is intended to explain the first: The breakdown consists in the fact that critics have gotten out of the business of making value judgments—judgments of good, better, and best—which means that they sit no longer as judges, figuratively charged with awarding blue, red, and yellow ribbons for best in the show and the runners-up. So what are art critics doing instead? Rubenstein cites a pioneer survey, sponsored by the National Arts Journalism Program at Columbia University, which attempted to discover how the 160 practicing art critics surveyed view their practice. He finds it startling that nearly 75 percent believe that "rendering a personal judgment is considered by art critics to be the least important factor in reviewing art," while 91 percent feel it their main role to "educate the public about visual art and why it matters." I not only associate myself with this view of the critic's task but also was startled in turn to discover that, in

Rubenstein's view, I am in some large degree responsible for the crisis.

> This has been a period of interpretation rather than judgment, which is no doubt why the philosophically inclined Arthur Danto has been the most widely read and cited critic of the last decade or so. As Danto says explicitly in the introduction to a recent collection of articles (which, significantly, is subtitled "Essays in a Pluralistic Art World"): "The freedom to choose my subjects makes it possible for me to select only those artists whose work already has quality sufficient enough so that nothing needs be said beyond explaining the way they embody their meanings."

A young correspondent asked how I determine "sufficient quality," and the answer to this interesting question is that it is a fairly complex inference, based on a lot of data, much of it connected with institutional factors. Quality is not an aura around a work or body of work, and nimbuses in any case were shorthand for holiness, which refers a complex body of actions and certain relationships to invisible and perhaps unrepresentable forces. One primarily reviews exhibitions, and the fact that an artist's work has been selected for a museum exhibition, for example, is evidence that a number of individuals, who have undergone training and acquired the experience that entitle them to make such decisions, have come to the shared conclusion that the work merits display and that the public will benefit in various ways by seeing the work in this format. The work will have made its way somehow into the consciousness of the art world, and a consensus will have emerged as to where it stands and what it does. The art world is defined by an ongoing conversation—a dialogue—among its members, who know something about the history of art and the present state of art, and the concept of quality is connected with the work having become part of this conversation. The latter will convey the reasons people are talking about it, and these in turn give the critic a reason for wanting to see the work and to enter the conversation through writing a review. The reasons vary from artist to artist and

time to time. Sometimes they are aesthetic, sometimes they are ethical, sometimes there is just the issue of the work's making a contribution to contemporary sensibility. In one of the more recent of the reviews collected here, the one on John Currin, there had been a lot of buzz, not all of it favorable, which laid an imperative on critics to address it as something people would want to know about and perhaps to see, and make their minds up. Nobody who is a critic lives in isolation from this framework. We are all part of a complex in which we depend upon one another a lot, in art as elsewhere.

Rubenstein commented on the passage he quoted by saying that "something more than explaining and advocacy is called for, that it's not enough simply to present the things you like in isolation, that even in a radically multi-polar artistic environment, value judgments must somehow be made, and articulated."

What then should I be doing differently? Let's consider what Rubenstein, as a critic of critics, has in mind. "I'm talking," he says, "about something on the order of looking at a painting made in 2002 by Brice Marden and asking how it stands up in terms of visual engagement against a canvas painted in 1956 by Joan Mitchell." Half a century separates the two bodies of work, though both artists— Mitchell posthumously—were accorded exhibitions in 2002, hers a major retrospective at the Whitney Museum, his a show of recent paintings at a major New York gallery, Matthew Marks. Both shows turned up in one or another of the "Top Ten Exhibitions of the Year," to which *ArtForum* invites a number of art writers to contribute. I'm not particularly fond of the format, but I have contributed my lists whenever the publication asks me to, and had I been asked in 2002, Mitchell's show would have been close to my top choice, and Marden's, though it appeared in more than one top-ten list and thus had its admirers among presumed experts, might not have been on mine at all, and certainly not on Rubenstein's. Marden has, he writes, "a dead hand and a cautious esthetic," though "he is supposed by many to be our best abstract painter."

In that show, as I saw it, Marden had thrown aesthetic caution to the winds. Since about 1990, he had been practicing a kind of abstract calligraphy, painting, to use Hegel's poetic phrase, "gray in

gray," in the spirit of a certain genre of Chinese watercolor dedicated
to conveying the feeling of watery landscapes—Mountains Viewed
Through Spring Rain, to fabricate a generic title. For perhaps twenty
years before that, Marden favored monochrome painting in muted
values, until he felt he had exhausted that option. On the verge of giv-
ing up painting altogether, he saw a show of Asian calligraphy, which
he adapted in a body of work he called *Cold Mountain*. In the new
show he had broken away from his characteristic palette into loose
tangles of nearly saturated reds, changing the mood entirely, or trying
to. It reminded me of an anecdote I learned from my Chinese friend
Chiang Yee, who told of a great painter of bamboos pestered for a pic-
ture by a collector. The painter finally yielded but used as his medium
the red ink ordinarily reserved for artists' seals. The collector was
happy to have the work but wondered where the artist had ever seen
red bamboos. The artist responded by asking the collector where he
had seen *black* bamboos. Red or gray, the show had not excited me,
and though Marden is important enough as a painter for me to have
devoted an essay to his work, I was not certain enough of where he
was heading to write one. Had I written about it, though, it would
never have occurred to me to compare his work with Mitchell's,
whose work, especially her masterpieces of the early fifties, I had al-
ways loved.

If asked to juxtapose for purposes of evaluation a work like
Mitchell's 1956 *Hemlock* with any painting I might choose for the ex-
ercise from Marden's 2002 show, I would have to beg off: I would
have said that there was no comparison. You can only really compare
like with like. *The New York Times* has a column called "Wines of the
Times," in which experts report on a tasting. A recent issue was titled
"From the Loire, Whites with Bite," and it canvassed two sets of
sauvignon blancs, Sancerre and Pouilly-Fumé. "Sancerre is the best of
the lot," the reporter observes, "with Pouilly-Fumé a close second."
Local experts have difficulty telling them apart, though some experts
say "the Fumés are a bit fuller bodied and richer." "Fuller bodied and
richer" is not the criterion implied in ranking Sancerres ahead of the
Fumés. So if someone demands that the best of the Sancerres be com-
pared with a sauternes like Château d'Yquem, one would have to say

there is no comparison, or that any comparison is a forced one, based on the coincidence that both are French white wines. I could say a great deal more, of course. Château d'Yquem is a great and powerful wine, whereas Sancerre is, if the best of the sauvignon blancs from the Loire region, in another class altogether. It has a wonderful flinty taste and goes perfectly with *crottin*, a cheese from its region, and I would not consider it a favor if a waiter said that they were out of the Sancerre and offered me Château d'Yquem instead. It is a wholly different kind of wine, no substitute at all. Connoisseurs recommend that one drink it with fois gras: It is luxurious and it needs the context of opulent flavors. It is a memorable experience, like conversation with a brilliant wit like Isaiah Berlin, rather than a quiet talk with someone one enjoys being with. The two wines define different scenarios, and if you are, as they say, into wines, each is wonderful in its own way.

I have the most vivid memory of having been knocked off my horse by Mitchell's *Hemlock* when I first saw it in the late fifties. Marden would not have had that impact on me at any stage of my life. His is a quieter, more ruminative form of achievement. But that is a contrast, not a comparison. *Hemlock* overwhelmed me in a way that had to do with who I was when I came upon it in Martha Jackson's gallery. I cannot remember when I first saw Brice Marden's work, but I was by then a very different person, and I wonder what would have had to be different about me to have been overwhelmed by it the way I had been by *Hemlock* maybe twenty years later. To compare the two paintings would in effect be to compare two stages of my life.

Squabbling in the Cedar Tavern over who was greater, Bill or Jackson, was part of living in the art world in the fifties, but I'm not sure, apart from the undoubted fact that Pollock had made the great liberating breakthrough, that the quarrels were very different from those of Sancerre over Pouilly-Fumé. At best they might serve the purpose of what the literary critic Paul de Man called "close reading," but they were essentially irresoluble. Asked to compare either of them with Franz Kline or Mark Rothko or Barnett Newman, my sense is that there would be no comparison. Each was bent on something very different. They were all great in a way that, forced to make a judg-

ment, I would say that Clyfford Still was not. I would compare Joan Mitchell, I suppose, with de Kooning if anybody, rather than Brice Marden, mainly because she was engaged with the same philosophy of painting as he, and because her paintings were importantly referential to landscape motifs. But she was in the second generation, and one has to say that de Kooning and Kline made her possible in a way that, really, she made nobody possible: The line ended with her. She went on doing Abstract Expressionist paintings when the movement itself was long over with, historically speaking, and she was living in France, and there was *nobody* with whom to compare her. That may be why her painting fell off later in her career. Painters challenge one another, egg one another on. That is why being part of a movement is so important.

On the other hand, she may just have had her run. Critics too have runs. Greenberg outlived his moment and had nothing to say of the moments that followed when, for example, I found my footing as a critic. He could do nothing with Duchamp or Warhol except insult their effort, dismissing it as "novelty art." But how long can one go on saying that? The kinds of value judgments he was good at making had no relevance in explaining why, say, Warhol was greater than Wesselman. How would we compare, in terms of value, any of the great Abstract Expressionists with any of the great Pop artists—and what would be the point? We are here in the world of incommensurables, which makes life so rich and so varied.

But I want to say something more forceful. I don't think there is a crisis of criticism at all, at least not the kind that Rubenstein is needlessly alarmed by. I really don't, any more than the majority of those who responded to the National Art Journalism Program questionnaire believe that "rendering a personal judgment" is a particularly important thing for art critics to do. And I don't believe that Greenberg felt that it was either. He believed that he was singularly qualified to render impersonally valid judgments about art, that he possessed a remarkably good eye. The difference between his moment and mine is that today the eye is a less important critical organ than it was at the high moment of Abstract Expressionism. What we are increasingly dealing with in the visual arts today is what I call *visual*

thinking, and it is the thought that has to be unraveled and assessed in addressing the art of our time and the way the thought is embodied in the work. Christopher Knight wrote that "criticism is a considered argument about art, not a priestly initiation of the unenlightened into a catechism of established knowledge." But I don't for a moment believe, if indeed I am as much an authority as Rubenstein believes, that the critics who described their role as educating the public mean "initiating the unenlightened into a catechism of established knowledge." Wittgenstein described his agenda as showing the fly how to get out of the fly bottle. That is what education is in art—helping people find their way. Knight's is a caricature of what education is. Education is not training people to say, Mitchell's *Hemlock* is better than Marden's *Cold Mountain.* It is rather explaining how and why each of them is good in its own way.

Let me illustrate with an e-mail I recently received from a young writer about a highly regarded conceptual artist, Janine Antoni.

> I question deeply what it is Janine is doing, and why, as the work does not really speak to me in aesthetic or conceptual terms. I was raised with an art that equated beauty, even different norms of beauty, but it was all for the most part poignant and thrilling and accessible. You could see the WORK in it, the painter's or the sculptor's vision and skill, you could recognize some aspect of the struggle, you could appreciate the beauty of the result: it looked like something that spoke to you, whether a nativity or a hill in Tuscany or two marble nudes lightly embracing. Why has all that been so de-legitimized?

My correspondent is a sensitive, informed, and earnest young person. She is far from a philistine, as you can tell from her writing. But she was, one might say, caught in the fly bottle, and here is my response, intended to show her the way out:

> In Janine's case, her art responded to many contemporary preoccupations, especially female preoccupations, and especially about the body. She found ways of articulating these in her art.

The piece that made her famous was called *Gnaw*, and it was widely seen as about eating disorders, especially bulimia, since it involved biting off pieces of chocolate and spitting them out, and then making something beautiful out of that. Her pieces were about fat, about body image, about love. Many of them involved an ordeal, like washing the floor with her hair, which suggested abasement, or drawing with her mascaraed eyelashes, making butterfly kisses on paper. That is the kind of thing a lot of art today does. It addresses issues that engage people through symbolic enactments. The issues are often very intimate, and the art very remote. I deal with it a lot. You have to get inside it a bit. Once you start writing about it, you may find yourself liking it. I keep myself open.

When I wrote about Antoni's piece in my review of a Whitney Biennial, that is what I tried to explain. I think Antoni's work really is personal, but I don't consider it a personal statement. It is more than that: She is speaking for young women everywhere, but speaking to everyone about issues we all can understand. I would want to understand it before I set out to compare it with anything else, and then I'd need to know that what I was comparing it with was trying to make the same kind of point, only doing so better than or not as well as *Gnaw*. She somehow hit on the idea of making her point through two large blocks of matter—six-hundred-pound blocks of chocolate and of lard. Some critics wrote about her work in terms of blocks, but that seemed to me oblique and formalistic. What I know is that it was good art, and perhaps her best piece, or her best so far. I've seen a piece by Antoni consisting of a pair of nipples cast in gold and displayed in a jewelry box, like a set of ornamental buttons for a blazer. I imagine they have to be her own nipples, to be consistent with her work, and there is something saucy in the thought that her nipples are worth their weight in gold. And in an age in which breast cancer is a burning issue, a work like that can be a memorial to mastectomy. It is not a criticism of the work that it is not as good, because it is not as deep, as *Gnaw*, to which I would have given a blue ribbon for Best in the Biennial if I were a judge, but I have no formula for that kind of

judgment. I would have to describe the other works in the show in comparable detail to get my fellow judges to see it as the inevitable top choice. But if the panel also consisted of Hilton Kramer, Jed Perl, and Robert Hughes, I am by no means certain I could bring it off. We would have a terrible fight, trading nasty insults. People in the art world today don't have fistfights, as they did in the fifties. Is that what Rubenstein feels is missing?

Let's consider at this point a work I have spent a great deal of time thinking about ever since I first saw it, Andy Warhol's *Brillo Box* of 1964. It happens to have been one of the works Janine Antoni's piece was compared to because of its being a block, though this is the same kind of forced basis for comparing as Sancerre and sauternes. Like Joan Mitchell's *Hemlock*, *Brillo Box* knocked me out, but I cannot imagine myself thinking about her piece for nearly forty years, the way I have about Warhol's work, which, for reasons I will explain, I am not even sure is his masterpiece. I think *Hemlock* is her masterpiece, and I can think of looking at it for a very long time, getting more out of it all the time. From that perspective, Warhol's work is almost laughably uninteresting. Its success is due not to its visual but to its intellectual depth. In my case, it has to do with its great philosophical interest. And though in a sense, this says as much about me as about it, what gives it its philosophical interest is almost the same as what gives it its artistic interest.

What interested me—what obsessed me—when I first saw the exhibition in which it was shown for the first time at what was then the Stable Gallery, was the fact that the show consisted of facsimiles of shipping cartons placed in piles as they would have been in the stockroom of a supermarket. There were six or eight kinds of cartons, constructed of stenciled plywood, made to look like the boxes in which grocery items familiar to everyone in America were sent from warehouses to stores. The question for me was why they were works of art while their nearly indiscernible real-world counterparts were purely utilitarian objects with no claim to the status of art. Until that time I had no idea of how to think philosophically about art, though, as my experience with *Hemlock* indicates, I was pretty deeply engaged by contemporary art in 1952 when I first saw it. I was not a "philosophi-

cally inclined" art critic in 1964. I was a philosopher with an interest in, even a passion for, art. I would not actually become an art critic for twenty years.

When I wrote my first philosophical paper on art, in response largely to the Stable show but really to the art that had taken over the art world in the mid-1960s, I wrote primarily about *Brillo Box*—though the problem I addressed could have been raised about any of the five or six kinds of cartons Warhol showed. I have lately begun to think about what made *Brillo Box* the obvious outstanding piece in the show and have realized that it was its great merit as a piece of commercial art. Here is the art criticism for Brillo boxes, which celebrate the product they contain.

The box is decorated with two wavy zones of red separated by one of white, with blue and red letters. Red, white, and blue are the colors of patriotism, as the wave is a property of water and of flags. This connects cleanliness and duty, and transforms the side of the box into a flag of patriotic sanitation. It gives two connected reasons for using Brillo, which is printed in proclamatory letters B-R-I-L-L-O, the consonants in blue, the vowels—I O—in red. The word itself is dog Latin, viz., "I shine!"—which has a double meaning, one of which is consistent with the condition of embodied meaning. The word conveys an excitement that is carried out in the various other words, in which the idioms of advertising are distributed upon the surfaces of the box, the way the idioms of revolution or protest are boldly blazoned on banners and placards carried by strikers. The pads are GIANT. The product is NEW. It SHINES ALUMINUM FAST. The carton conveys excitement, even ecstasy, and is in its own way a masterpiece of visual rhetoric, intended to move minds to the act of purchase and then of application. And that wonderful band of white, like a river of purity, has an art-historical origin in the hard-edged abstraction of Ellsworth Kelly and Leon Polk Smith. It could not have been done before that movement, the clean edges of which give a certain palpable contemporaneity to Brillo.

This would not be the right art criticism for any of the other cartons, and I think it fair to say that Warhol deserves no credit for it. He did not design the box, though it was, I was to discover, designed by an artist, James Harvey, an Abstract Expressionist hopeful, who died soon after the Stable show. What would be the right art criticism for what Warhol did? From my perspective, what Warhol did was transfigure a set of particularly unpromising commonplace objects into works of art. That, one might say, was his artistic mission, much as it was Monet's mission to draw our attention to the landscapes of the Île de France, or Cézanne those of the area around Aix. Warhol's first exhibition was in the windows of Bonwit Teller, and the paintings were on display for one week only in mid-April 1961. His images were vernacular, familiar, and anonymous, drawn from the back pages of blue-collar newspapers, the cover pages of sensationalist tabloids, pulp comics, fan magazines, junk mail, publicity glossies, boilerplate for throwaway advertisements. In 1961, it would have been almost impossible to believe one was looking at art. *Advertisement* is based on a montage of black-and-white newspaper ads: for hair tinting, for acquiring strong arms and broad shoulders, for nose reshaping, for prosthetic aids for rupture, and for ("No Finer Drink") Pepsi-Cola. Bonwit's window also included *Before and After*, advertising the nose you are ashamed of transformed into the nose of your dreams. The remaining paintings are of Superman, the Little King (on an easel), and Popeye. The ads reflect Warhol's personal preoccupations—impending baldness, an unattractive nose, a loose, unprepossessing body. But the placement of the original images—in back-page ad sections of the *National Enquirer* and comparable publications of mass consumption—testifies to the universality of such nagging self-dissatisfactions and the inextinguishable human hope that there are easy ways to health, to happiness, and to "Make Him Want You." I think these works of Warhol great, but I would sound like a lunatic if I were to say that the images in their normal venues were great. My art criticism would have to justify my judgment of their value. In their way, those early images of Warhol's make suddenly visible what one might call the mind of a culture. They are somehow like what Joyce achieved in *Finnegans Wake*. They are a mirror of the American

mind. And there is something profound when one takes them in conjunction with the garments they set off in Bonwit's windows, those expensive fashionable fluttery garments, to be worn by women whose thoughts are taken up with worries about acne, about whether their noses are too big, and how they are going to be able to "make him want you."

This is obviously not visual art criticism of the sort I wrote in response to a painting like Joan Mitchell's *Hemlock*, in my review of her 2002 show (see page 197). It is, rather, conceptual art criticism like that I have devoted to Warhol's *Brillo Box* on the many occasions on which I considered it as a vehicle of philosophical and cultural meaning. I have no sense of what it would mean to compare Mitchell with Warhol, and comparing her work with that of Brice Marden is nearly as pointless. It is, on the other hand, both interesting and helpful to compare her with Franz Kline as a painter, and to show how she succeeded where Kline failed, without for a moment suggesting that this made her the greater painter.

When, in the passage that Raphael Rubenstein quoted, I stated that I select only those artists whose work has already quality enough that "nothing needs be said beyond explaining the way they embody their meanings," I meant to imply that the fact that I write about one show or artist rather than another is already a value judgment. I get to write perhaps ten pieces a year, and my essays are about three thousand words in length. My criterion for choosing a subject is a judgment that it has a certain cultural importance, not just for the art world, but for everyone, since *The Nation* is not an art magazine, and its mission to is to help readers think about issues of great immediate moment. I want to feel confident that knowing about Leonardo or Malevich or Matthew Barney are culturally important by that criterion, and not just where the work stands in relationship to everything else that is on view. The magazine's founders were disciples of John Ruskin, who felt that nothing in society was more important than its art, and some tincture of Ruskinism continues to inflect current editorial attitudes. My readers are vastly more likely to visit museums than galleries, but since I want them to see the art I write about, if that means going to a gallery, then I am up against some fairly stringent time constraints that belong to the reality of being a critic for a weekly

magazine. I have to see the work almost immediately; be sure there will be space in the magazine; write three thousand words, which takes some days; have the work edited, set, and corrected—and, with luck, the piece will appear the last weekend, if it is a gallery show. I have to have great confidence in the importance of a work or body of work to take on something that exigent.

The last time this happened was with Shirin Neshat's film *Rapture*, which I happened already to have seen in Chicago. It was being shown at a Chelsea gallery, D'Amelio Terras, when I returned to New York, and I felt I had to stop everything else and write it up. I believed it a masterpiece, a work of exceptional importance, something I really wanted people to see—something I felt it urgent that they see. I could not read the Persian calligraphy with which it begins or understand the words that accompanied the urgent music. But the moment the choreographed action began—a group of women in black chadors, a group of men in black pants and white shirts, the men on the ancient battlement of some castle, the women acting as a chorus, close to one another, on a stony desert outside the castle walls, responding, commenting, and finally reacting to what seem like the pointless and frivolous conduct of the men—I felt I was witnessing something ageless and profound. And when at last the women take action, lifting their heavy skirts at the sea's edge, pulling a heavy boat out into the surf, and then, a group of them, sitting in it like nuns, allowing themselves to drift out and be carried away, abandoning themselves to Allah as they head for some undetermined and perhaps unimaginable destination, I felt I was seeing some spiritual enactment, religious and political at once. I compared it to an early Greek tragedy, which made use of two choruses.

This bare description gives no sense of the extraordinary beauty of the black-and-white photography and the remarkable choreography with which the Men but especially the Women, are deployed in their very different spaces. Nor does it give an idea of the powerful music by the Iranian composer and singer, Sussan Deyhim. The music gives voice to the various actions. It expresses what the linked sequences show. It combines with the ululation, the clapping, and the drum tattoo—the only sounds the two groups make.

What is it all about then? What has taken place and what is its meaning? What occasions the women's triumph? Is it that they have gone off on their own, or is it that they place themselves at Allah's mercy? The work seems to have something urgent to communicate, but it does so in the way a solemn ballet would do. Neshat is still not pointing fingers. "From the beginning," she says, "I made a decision that this work was not going to be about me or my opinions, and that my position was going to be no position. I then put myself in a place of only asking questions but never answering." It is not a self-portrait. And the actions are too emblematic to furnish an agenda for social activism in the Middle East. Yet they seem to belong to some immemorial enactment, which has been ritualized and repeated. The work is mesmerizing, and if you are like me, you will want to see it again and again. It is an allegory of obscure but inescapable meaning.

I wanted my readers to say to themselves, I have to see that. And indeed they did. I had the satisfaction of learning how crowded the gallery was the last weekend of her show, after my piece appeared. I felt my writing had some impact. This, to be sure, to use Rubenstein's term, is advocacy. But what more would I have had to do by way of making a value judgment?

Rapture is part of a trilogy by Shirin Neshat. I think it better than the other two films that make it up, and that the trilogy as a whole is superior to her work that has come since. But that is how it is with masterpieces, and that is how it is with life. As an art critic, I am not an art teacher doing studio crits, pointing out strengths and weakness, prodding them to become better artists. Nor am I advising collectors interested in wanting only the best for their collection but in any case needing to make sure they have not settled for something inferior or bad. Even when I have reservations about the work I write about, as I sometimes do, my task is to give my readers something to think about—about art, about life, and about the relationships between them.

2003

Index